DATE DUE

MY 5 '95			
MY 30 '96			
MY 5 '99			

DEMCO 38-296

The New Look Design in the Fifties

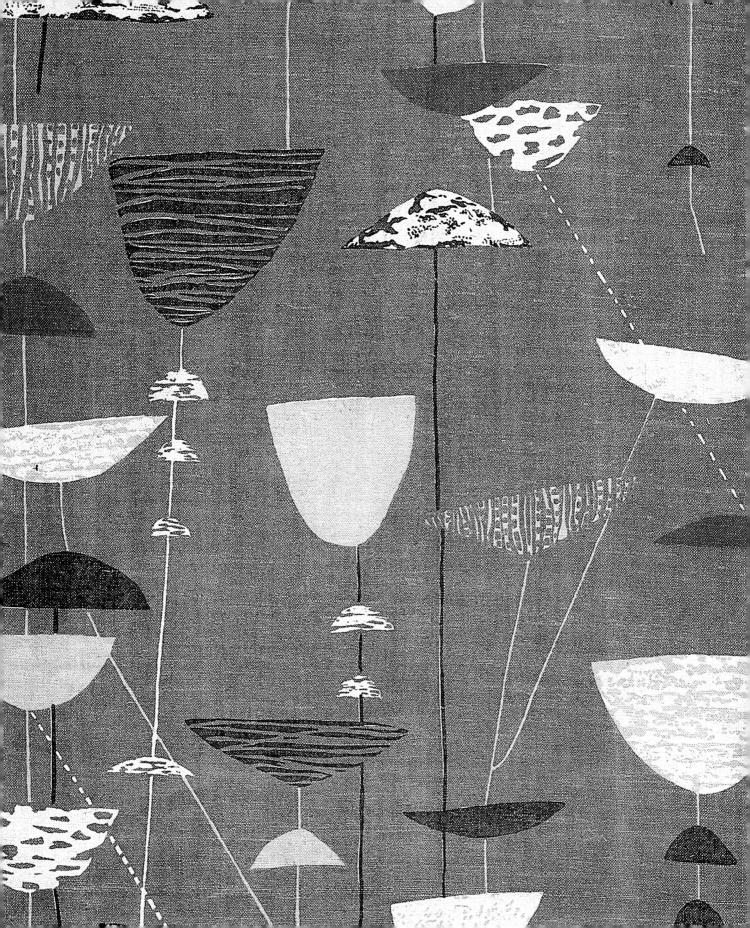

The New Look
Design in the Fifties

LESLEY JACKSON

With 266 illustrations,
86 in color

THAMES AND HUDSON

For Ian and my family

This book is published on the occasion of the exhibition
The New Look – Design in the Fifties (Manchester City Art Galleries:
13 October 1991 – 5 January 1992; Glasgow Art Gallery
and Museum: 31 January – 5 April 1992).

Frontispiece "Calyx," designed by Lucienne
Day for Heal's, 1951.

First published in the United States in 1991 by
Thames and Hudson Inc., 500 Fifth Avenue,
New York, New York 10110

Library of Congress Catalog Card Number 91-65322

Printed and bound in Spain by Cayfosa, Barcelona

Contents

Acknowledgments

In October 1956 Manchester City Art Galleries hosted an exhibition called 'Modern Italian Design' organized by the Compagnia Nazionale Artigiana, which included a wide variety of applied arts by leading designers and manufacturers. This exhibition affirmed Italy's status as one of the new design superpowers of the 1950s, along with Finland, Denmark, Sweden and the USA, and it highlighted the revolution in aesthetics that had taken place since the war. Thirty-five years later, in October 1991, Manchester City Art Galleries have mounted a major international exhibition of applied arts called 'The New Look – Design in the Fifties', and this book has been prepared to accompany the exhibition. The book brings together the type of material that was first seen at the legendary Milan Triennales of 1951, 1954 and 1957, as well as illustrating a range of everyday objects. The principal author, Lesley Jackson, Assistant Keeper of Decorative Art, is also the curator of the exhibition. The Fashion section in the Directory has been written by Anthea Jarvis, Keeper of Costume.

Many people have assisted with the extensive research and photography entailed by this publication. We are particularly grateful for help and advice from the following: Marianne Aav, Morce Ambler, Janet Barnes, Mr and Mrs Battye, Valerie Baynton, Stella Beddoe, Gerald Benney, Malcolm Bishop, Brian Blench, Professor Carlo Bojani, Antonia Campi, Marco Capuani, Anna Casati, Waistel Cooper, Andrew Cox, Mitzi Cunliffe, Lucienne and Robin Day, Irena de Guttry, Stuart Devlin, Roger Dodsworth, Daphne Dorman, Georgina Fantoni, Liliane Fawcett, Amanda Fowler, Thomas Frei-Herrmann, Terry Friedman, Bernd Fritz, Marika Genty, Virginia Glenn, Leslie Gooday, Saffron Grant, Sarah Green, Satu Grönstrand, Jennifer Harris, Gunnel Holmér, Lesley Hoskins, Mr W. Ismay, Lorna Jackson, Michael Valeur Jensen, Kaisa Koivisto, Maija Koskinen, Marjut Kumela, Miles Lambert, Esa Leskinen, Inga Lindén, Maria Vittoria Lodovichi, Ebba Lonholdt, Donald Lowe, Helena Dahlbäck Lutteman, Camilla Mainetti, David Revere McFadden, David Mellor, Dr Ernst Wolfgang Mick, Brian Murray, Kathy Niblett, Inger Nordgren, Anty Pansera, Cherrill Payne, Alan Peat, Anders Reihnér, John Robinson, Judy Rudoe, Jessica Rutherford, Mogens Schlüter, Mary Schoeser, Jessie Tait, Naomi Tarrant, Julian Treuherz, Mr and Mrs W. Treuherz, Mark Turner, Alexander von Vegesack, Maude Wallace, Rosemay Ransome Wallis, Karin Walton, Adrian Webster, Robert Welch, Vibeke Woldbye, Christine Woods. Finally, we are very grateful to Alan Carter for providing free access to his private collection.

The author would like to thank Ian Fishwick and Howard Smith for their active support and encouragement during the preparation of this book.

Financial assistance towards this project has been received from the European Community's Platform Europe award scheme, the Museums and Galleries Commission, the Arts Council of Great Britain, the Crafts Council, the Henry Moore Sculpture Trust, the Swedish Embassy, the Swedish Institute, and the Finnish Ministry of Education. We are extremely grateful to all these organizations, and to our sponsors: Pilkington's Tiles, Kemira Fertilisers, Gustavsberg Porslin, Holmegaards Glasvaerker and Arflex. The author's research trip to Scandinavia in 1989 was funded by the Danish Embassy and the Swedish Embassy.

RICHARD GRAY,
Director,
Manchester City Art Galleries

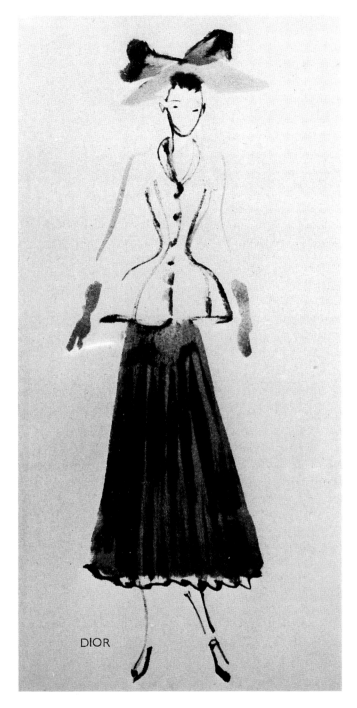

The dramatic 'Bar' Suit from Christian Dior's first New Look Collection, Spring 1947, with its 'tight tussore jacket, padded to a teacup curve'.

1·The New Look

'Dior is the new name in Paris. With his first Collection he not only shot to fame, but retrieved the general situation by reviving interest in a somewhat uninspired season ... His house was newly decorated, his ideas were fresh and put over with great authority, his clothes were beautifully made, essentially Parisian, deeply feminine.' VOGUE, April 1947.

Although the term 'New Look' is often used in a general way to refer to the re-design of a familiar object or place, when the phrase is applied in a more specific context, it is inextricably associated with the world of post-war haute couture – with Christian Dior's New Look.

In February 1947 Dior startled the world with his Spring Collection. Rejecting the idea of austerity tailoring, he transformed the unflattering square-shouldered outlines of women's wartime fashions overnight. In their place he created a sculptural fantasy, exaggerating the natural curves of the female figure where they existed; redefining them where they did not. The new figure resembled an hourglass. 'The waist is breath-taking', declared *Vogue* in October 1947. The contours of the bosom were emphasized by literally skin-tight tailoring; hips were padded to exaggerate the slenderness of the waist; new 'hipbones' were created from the stiffened peplums of the jacket; and the skirt was full and extravagant in its use of fabric: this was the essence of Christian Dior's New Look.

Dior was not alone in his tendency towards the sculptural exaggeration of the female figure. 'Wasp waists' were also a feature of Christobal Balenciaga's Spring 1947 Collection. In *Vogue* these two couturiers, one French, the other Spanish, were presented as allies. Balenciaga's 'black taffeta jacket' with 'rippling collar' and 'umbrella hips' was illustrated in the same double-page spread as Dior's influential 'Bar' Suit, with its 'tight tussore jacket, padded to a teacup curve'. Balenciaga, it seems, created his own New Look at exactly the same time as Dior.

The main outcry against the New Look, not surprisingly, centred on Dior's lavish use of textiles. In Paris a model wearing a New Look outfit had her dress torn from her back,

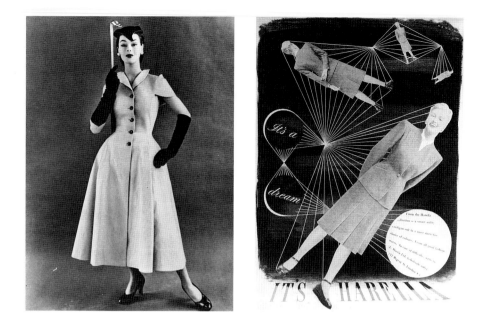

The New Look (far left) as interpreted by the British couturier, John Cavanagh, in 1953, and the Old Look (left) as seen in a Utility suit in 1946.

whilst as far afield as Chicago the designer was met by crowds of angry women bearing placards saying 'Burn Mr Dior' and 'Christian Dior Go Home'.[1] At a time when, throughout Europe, there were still serious shortages of raw materials, and in Britain rationing and the Government-controlled Utility scheme were still in operation, Dior's New Look was startling indeed. In France, by contrast, the situation was quite different – at least where haute couture was concerned. Fashion being the nation's acknowledged design forte, the top French couturiers were positively encouraged by their government to develop their controversially extravagant collections. Dior himself received significant backing in his enterprise from a wealthy textile manufacturer, Marcel Boussac, without whose support and unlimited supplies of fabric the New Look could never have been conceived.

In retrospect, however, more important than the initial media controversy surrounding the introduction of the New Look was the radical shift in aesthetic that the collection signified. Once public indignation about wastefulness and indulgence had abated, it did not take long before the basic principles of the new style were accepted – not half-heartedly, but with relish. Within the space of fifteen months even Utility dresses would be produced in a simplified New Look style.[2] With hindsight it can be seen quite clearly that the New Look brought about a fundamental change in the conception of the female shape that was not just the whim of a season, nor simply a reaction against wartime austerity: it heralded the arrival of a New Look for a new decade.

This book, however, is not just about fashion, but about a more widespread shift in design aesthetics during the late 1940s and early 1950s. The year 1947 marks a turning point in international design. Hence the reason for the reapplication of the phrase, the New Look, out of its original context to describe the nature of these changes. In Italy, for example, the late 1940s was a time of regeneration and revitalization for design – what the Italians themselves called 'ricostruzione'. In the USA there was a huge consumer boom after the war creating new markets for new products, and ample wealth for enlightened manufacturers to re-invest in design. Through their bold and confident achievements in abstract art and modern design during the 1950s, the Americans asserted their cultural identity and attracted international esteem. In Finland, Denmark and Sweden this period marks the emergence of the Scandinavian Modern aesthetic, a renaissance in design which transformed every aspect of the applied arts.

Although this is a potentially vast area to cover, there are benefits to be gained from surveying the field internationally. It is fascinating to study the process of cross-fertilization between different designers, different media and different countries. It is also illuminating to examine the impact of art on design. The one acknowledged limitation of the book is that it deals with design in the sense of interior design rather than product design. Cars, radios, fridges and jukeboxes are all well illustrated in other books on the 1950s, whereas the applied arts have yet to be fully explored.[3] Although it takes its name from fashion, therefore, this is basically a study of

furniture, furnishings and household accessories. Its aims are to highlight the creative achievements of the 1950s, and to define the visual characteristics of the New Look.

The years 1946–48 – the period during which Dior's New Look was conceived and consolidated – were the time when a new generation of outstandingly talented international designers first made their mark in the fields of ceramics, glass, silver and furniture. These designers represented many different countries and were part of a growing international movement: organic modernism. They included Tapio Wirkkala and Timo Sarpaneva in Finland, Stig Lindberg and Nils Landberg in Sweden, Henning Koppel and Hans Wegner in Denmark, Carlo Mollino and Paolo Venini in Italy, and Charles Eames and Eero Saarinen in the USA. Selective as it is, this list reveals the scale on which these transformations were taking place. Together these designers were responsible for re-shaping the basic forms of the applied arts, and for creating a New Look which, like Dior's, would revolutionize the mainstream design aesthetics of the 1950s.

The New Look arrived in two distinct waves. The first wave, organic modernism, took sculpture as its primary source of inspiration and affected the shapes of three-dimensional design and architecture. The second wave transformed patterns, and reflected the influence of recent developments in abstract painting on the decoration of textiles, wallpapers and ceramics.

The year of the New Look, 1947, was also the year in which Jackson Pollock created his first large-scale action paintings. This 'dynamic new aesthetic', as Sam Hunter described it,[4] caused tremendous controversy and excitement in the art world, and it was not long before the influence of abstract expressionism could be discerned on two-dimensional pattern-making. In general, however, the New Look in pattern design took hold somewhat later than the New Look in three-dimensional design, especially in the more conservative manufacturing areas, such as wallpapers and industrial ceramics. But despite initial resistance, once it got underway, the transformation was as rapid and comprehensive as that which had taken place several years earlier in other branches of the applied arts.

These and other innovations in the fine and applied arts all point to 1947 as the year in which the tide turned. At the heart of it all was the special relationship that existed at this time between painting, sculpture and design. Significantly, 1947 was also the year in which Picasso took up ceramics. His work in this medium had a decisive effect on studio potters throughout the world – Italy and Britain, in particular – and his fresh approach to an unfamiliar material can be seen as yet another dimension of the New Look. One of the reasons, in fact, why Picasso adopted ceramics was in order to make a

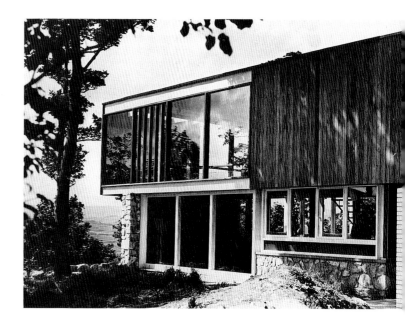

Farnley Hey, designed by the British architect, Peter Womersley, in 1953, and winner of a RIBA Gold Medal in 1957. One of the first New Look houses to be built in Britain after the war.

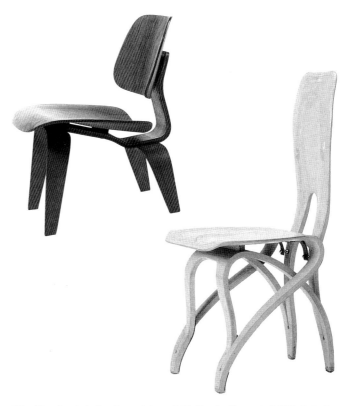

The New Look in furniture: (above left) Charles Eames's LCW chair for Herman Miller, designed in 1946; (above right) Carlo Mollino's bentwood and plywood chair for the Casa Cataneo-Agra, 1952.

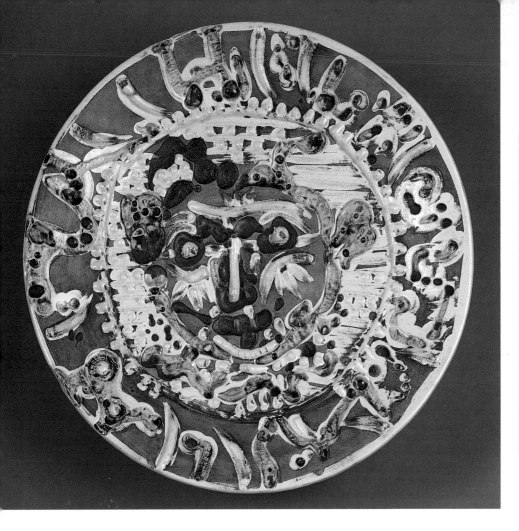

The New Look in ceramics: (left) 'Faun's Head' plate designed by Pablo Picasso, 1956; (below) hand-painted faience bowl of a type designed by Stig Lindberg at Gustavsberg from the 1940s onwards.

decisive break from the art he had been producing before and during the war. He looked upon this challenging new medium as a vehicle for discovering a new and original form of expression, and in doing so he opened up a whole range of possibilities for those potters to whom the medium was already familiar.

Further justification for the broader application of the phrase 'the New Look' is provided by its contemporary usage in magazine commentaries and advertising. An article by Dora Billington in *The Studio* magazine in 1955, for example, is entitled 'The New Look in British Pottery', and describes the recent work of three potters, William Newland, Margaret Hine and Nicholas Vergette, whose visual ideas had been transformed by the revelation of seeing Picasso's fresh approach to ceramics: 'To all who saw the work of these three potters . . . it must have been apparent that English studio pottery is at last acquiring a "New Look", more in tune with current ideas in house decoration and design

generally. Gay, amusing, colourful . . . an exciting mixture of sculpture, painting and potting.' The use of inverted commas around the words 'New Look' indicates that the writer is conscious of lifting the phrase out of its original context. Billington's conclusion that the work of these potters is 'made to fit into the contemporary scene' adds fuel to the argument that changes within each individual branch of design should not be considered in isolation, but must be seen within the context of a broader shift in aesthetics.[5]

Bernard Leach, the grand old man of English studio pottery, was particularly scathing about these new post-war developments, and especially the idea of an untrained artist being able to contribute anything of value to the craft of the potter. He contemptuously dismissed Picasso's British disciples as 'the Picassettes', and his reaction, like the anger directed against the 'New Look' in fashion, shows how dangerous (in the sense of being threatening to the establishment) these new departures were perceived to be.[6]

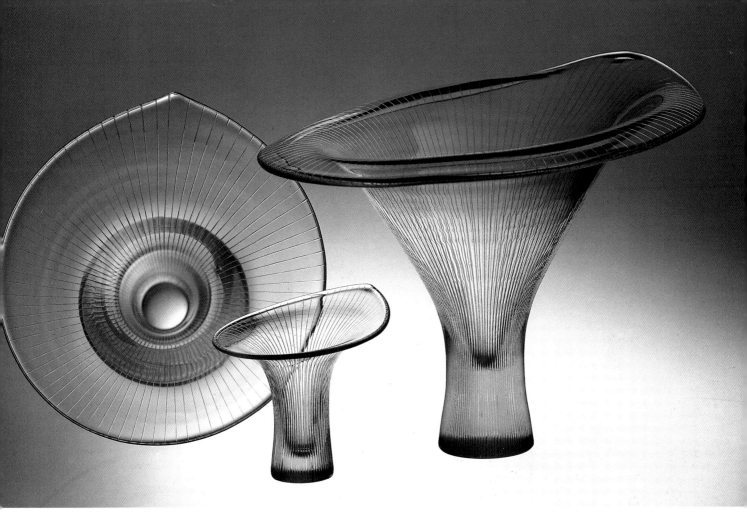

The New Look in glass (above): Tapio Wirkkala's 'Kantarelli' vases for Iittala, created in 1946. The New Look in silver (left): a sculptural bowl designed by Henning Koppel for Georg Jensen in 1956.

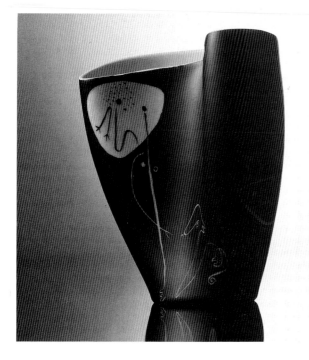

Rosenthal's 'New Look' vase by Beathe Kuhn, one of a new range of organic shapes launched in 1955.

The phrase, the New Look, was also adopted by the German firm, Rosenthal, to describe their new range of organic porcelain in 1955, and by *Vogue Export* to describe the new abstract printed textiles being issued by firms such as David Whitehead and Edinburgh Weavers at the time of the Festival of Britain in 1951: 'The new look of furnishings is stimulating and satisfactory to both top and middle-price markets. Their modern manner, designed for a new approach to living, fits, like a glove, the mood of a new generation of decorators.'[7] Later in the 1950s, when the New Look in home furnishings – by this time called the 'contemporary' style – was de rigueur, it is not surprising to find a downmarket British wallpaper merchant, Heath, relying on the very modernity of its abstract designs as their major selling point. Its 1959 collection, 'Effects by Heath', was described on its opening page as 'the book with the "look"' – meaning, of course, the New Look.[8]

Interestingly, it appears that certain avant-garde developments in the fine arts, such as abstract expressionism, became more rapidly accepted by the general public during the 1950s simply because of their widespread adoption within the applied arts. What was difficult to accept in the form of a vast canvas in an art gallery was much more palatable in the form of curtains or wallpaper in the home, or the fabric of a dress. The artist, Paule Vézelay, commented on her abstract

furnishing textiles that 'many people . . . would be bewildered by the same design if it were an oil painting and shown in an art gallery.'[9] At this date the fine and applied arts were more closely allied and more intimately inter-related than ever before, and much of the reason for this intimacy appears to be the particular appropriateness of abstraction as a means of visual expression for the applied arts. For as long as the fine arts remained rooted in the principle of realism and representation, there would always be a divide between painting, sculpture and the decorative arts. A mutual reliance on abstraction brought them closer together, so that the 1950s was to become a period of 'applied' art in the truest sense of the word.

The New Look marked a fundamental transformation in the concept of form and surface decoration. It lifted the applied arts on to a higher level of creative expression. Undeniably, by the second quarter of the 1950s, a debased version of the New Look was being exploited commercially by many manufacturers as a mere style, but that is not to deny its purity of purpose in the hands of its originators. The reason why many people have such a poor opinion of 1950s design, however, is that they are only familiar with the New Look in its bastardized form. Isamu Noguchi commented bitterly: 'Plagiarism, of which I have been a constant victim, is not as painful when a thing is copied outright as when it is distorted and vulgarised in an attempt to disguise the theft.'[10] Innovation and plagiarism went hand in hand on a national and an international level throughout the 1950s and, without seeking to pass judgment, this book aims to differentiate between the New Look and the New Lookalikes.

This leads to the second main point of significance about post-war developments in the applied arts: the trends within modern design and the fundamental changes that were taking place were more strongly international than at any other time in history. Such development had been incipient before the war, but came to fruition during the 1950s, partly as a result of world-wide disruption and the displacement of architects and designers from Europe to the United States, and partly because of improved communications amongst the design fraternity and the revival of major international design exhibitions, such as the influential Milan Triennales.

After the war almost every Western country had its design strength and the creativity of some, considering the damage inflicted on them during the war, was quite remarkable. French haute couture is a case in point, as is the renaissance in Czechoslovakian glass, and the resurgence of British textile design. Certain countries undoubtedly swung back into production (or, in the case of Finland and Italy, simply swung into production) more quickly than their neighbours,

sometimes, but not always, as a result of foreign investment. Others, such as Britain, were so badly affected by shortages and trade restrictions in the early years after the war that development in certain areas, such as furniture, was retarded, and in other areas, such as glass, was brought to a standstill. For these reasons it soon became apparent that certain countries were visibly in the ascendant as early as 1947, a mere two years after the cessation of hostilities. By the early 1950s the undisputed hothouses in design had emerged as Sweden, Denmark, Finland, Italy and the USA.

Apart from the three Scandinavian giants, the main force in European design during the 1950s was Italy. Whereas Sweden, Denmark and Finland fed off each other, and thus produced an overall unified aesthetic, Italy stood entirely alone. Italian furniture, lighting, ceramics, glass, silver and textiles were wayward and unique. The Italians had no rule book; they were governed by pure instinct, which sometimes led them, if not to excess, then at least beyond the bounds of acceptable 'good taste'. In many cases, as in the flamboyant lighting devices of Gino Sarfatti, the dividing line between creative flair and kitsch is a difficult one to draw. One of William Blake's 'Proverbs of Hell' comes to mind when trying to sum up the nature of Italian design in the 1950s: 'Enough, or Too Much', meaning the only way of defining what is enough is by going to excess.[11] The creative benefits of this impulse were recognized by Gio Ponti in his comments on the uninhibitedly organic work of the Brazilian architect, Oscar Niemeyer: 'Niemeyer is such a genius that almost anything is forgiven, genius is allowed to sin by excess.'[12]

The Italians used the brightest colours, created the most extravagant forms, painted in the crudest styles, exploited the most unconventional manufacturing techniques, and ran their workshop-businesses on the smallest scale, and yet, paradoxically, they were by far the most sophisticated, artistically inspired, technically advanced, and commercially successful of all the Western European nations during the early 1950s. Moreover, the speed of their recovery after the war was miraculous: there was literally an explosion of design creativity. In the words of Andrea Branzi: 'If we look today at the products of Italian design in the fifties, they never, or almost never, appear to be truly industrial products or authentic expressions of popular culture. The positive feelings they undoubtedly stimulate are more of an expressive than a cultural nature . . . Furnishings were developed individually in a way that was opposed to the unitary trend characteristic of the sixties. Tables, chairs, ceilings, doors, vases and lights were all designed to be expressive as single objects.'[13]

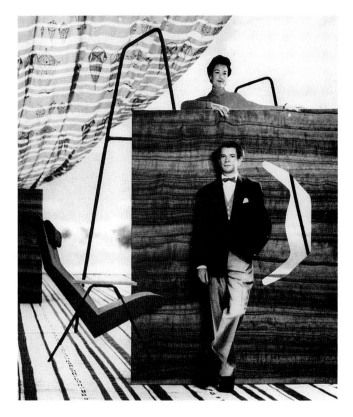

Robin and Lucienne Day, the husband-and-wife team who were Britain's leading designers during the 1950s.

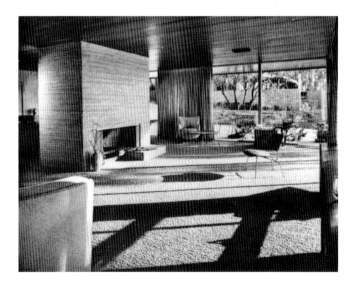

Richard Neutra's airy open-plan interiors provided the ideal setting for the furniture of leading progressive American designers, such as Charles Eames.

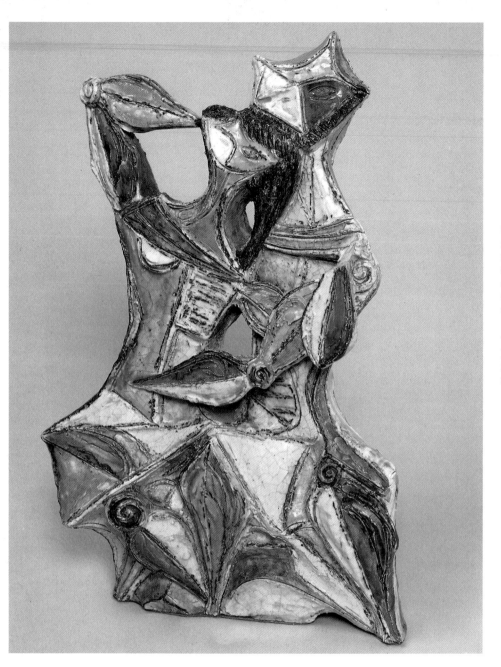

Uninhibited by conventional ideas of 'good taste', the Italians were responsible for some of the boldest creations in the applied arts during the 1950s. Art and design were fused in the ceramics of Marcello Fantoni (left) and Antonia Campi (below). Campi's spectacular wall panel was created for the Milan Triennale in 1951.

The influence of abstract painting resulted in a New Look for textiles, as seen (opposite) in this furnishing fabric by Friedlinde de Colbertaldo for David Whitehead in 1960.

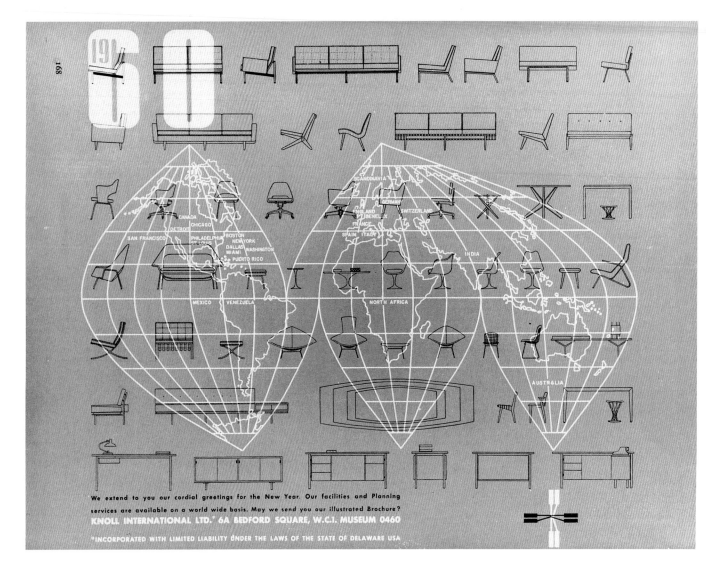

We extend to you our cordial greetings for the New Year. Our facilities and Planning services are available on a world wide basis. May we send you our illustrated Brochure? KNOLL INTERNATIONAL LTD.' 6A BEDFORD SQUARE, W.C.1. MUSEUM 0460
*INCORPORATED WITH LIMITED LIABILITY UNDER THE LAWS OF THE STATE OF DELAWARE USA

The small firm of Knoll Associates had expanded by the end of the decade into Knoll International.

How different this was from the climate in America, where the discussion of what constituted 'good design' took on moral overtones. In the USA 'good design' was championed from the 1940s onwards by no less an institution than the Museum of Modern Art in New York. In these circles frivolity was not encouraged. Good sense was the order of the day, as embodied in the idea behind MOMA's 1948 competition for the design of low-cost furniture. Furniture and architecture were, in fact, America's outstanding achievements during the 1950s, and they were often engineered by the same individuals, such as Charles Eames and Eero Saarinen. Other leading architects, such as Richard Neutra, invariably selected Knoll and Herman Miller furniture to complement their interiors.[14] Along with interior designers such as Florence Knoll, it was the architects who revolutionized the treatment of the interior. They created the ideal spaces – airy, open and uncluttered – in which to display the new organic clean-lined furniture to greatest effect.

American painting after the war was characterized by two divergent tendencies, one towards restraint (colour field painting), the other towards excess (abstract expressionism). These two extremes are also to be found in American design of the post-war period, for it was in America that the greatest excesses in terms of design styling were undoubtedly committed. This was most apparent in the field of cars and consumer goods, but it was inherent in the wider impulse towards over-consumption that characterized the period.

Within the official design establishment, however, such excesses were considered an anathema. Perhaps because the Americans had never previously received much international recognition for their art and design achievements, when they did finally develop their own distinct design identity, the establishment treated this achievement with great reverence. Scale was important here, too. Whereas in Italy production was limited in capacity, in the USA successful firms aimed at large-scale mass production. Both Herman Miller and Knoll may have started as small family businesses, but once they took off they soon became powerful international corporations.

Of the Scandinavian countries, Sweden's pre-eminence was the least surprising, considering the purposefulness of its achievements in the applied arts throughout the 1920s and 1930s. Its early achievements in the fields of ceramics, glass and furniture paved the way for the rapid acceptance of the phenomenon of Scandinavian Modern design which swept through Europe and America after the war. There was a degree of continuity in the development of Swedish design which was lacking in other countries, the most obvious explanation for which was Sweden's neutrality during the war, and the consequent reduction in disruption within its manufacturing industries. Whereas in other countries an almost entirely new generation of designers took over after the war (Gio Ponti in Italy being a notable exception), in Sweden several designers continued to play a major role both before, during and after the war.[15] These designers worked comfortably and creatively alongside the new younger designers, thereby doubling the strength of Swedish design after the war.

When people talk about the importance of Scandinavian furniture in the 1950s, they are generally referring to Denmark. Denmark produced a string of gifted furniture designers, working in a wide variety of materials and in many diverse styles, both traditional and modern. They also covered the different levels of the market, from expensive hand-crafted items to cheaper mass production. Underlying the success of the Danes in commercial terms was their skill in promoting and exporting their goods abroad.[16] The Danish furniture industry was set up in such a way as to be able to adapt to meet all these various demands. Denmark was also distinguished in the luxury silver market. The enlightened firm, Georg Jensen, secured the services of the sculptor, Henning Koppel, immediately after the war, and he produced a series of remarkable organic designs for them over the next fifteen years. In fact, Denmark was the most complete all-rounder in the 1950s, making valuable contributions in almost every field of three-dimensional design, as well as in textiles and wallpapers.

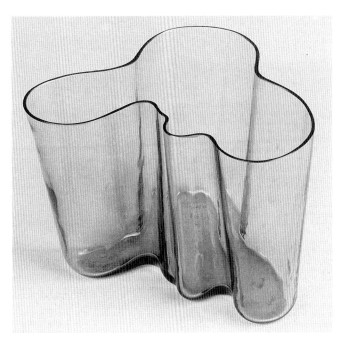

The organic curvilinear forms of Finnish ceramics and glass: Aalto's initiatives of the 1930s at Karhula (above) led to Friedl Kjellberg's experiments at Arabia during the late 1940s (below).

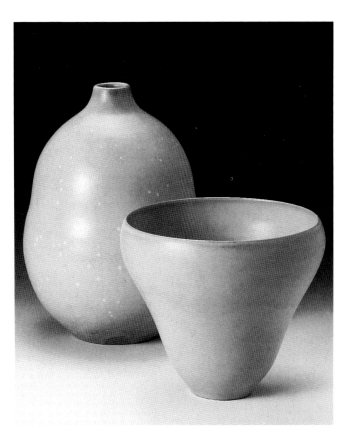

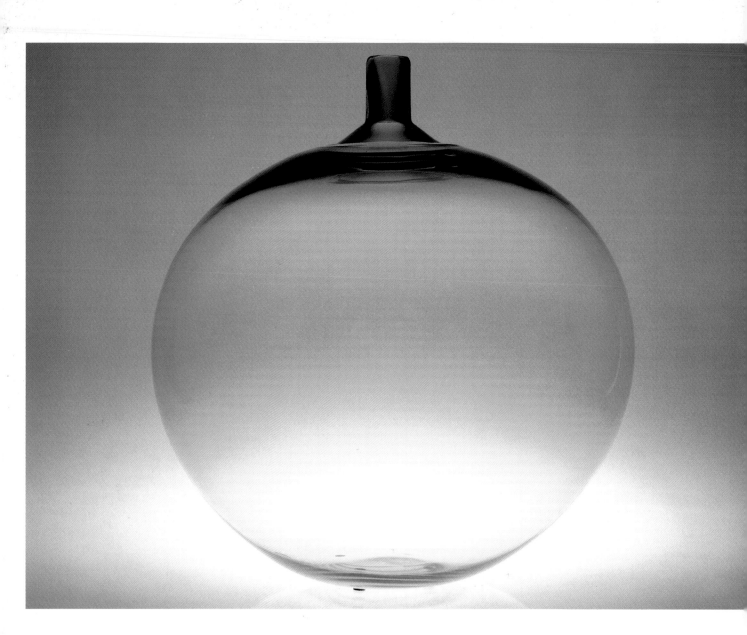

Ingeborg Lundin, the Balenciaga of glass, created this stunning 'Apple' vase at Orrefors in Sweden in 1957.

As well as furniture, the Danes also excelled in lighting design, as seen in Poul Henningsen's 'Artichoke' lamp (opposite) designed for Louis Poulsen in 1958.

By comparison with Sweden and Denmark, the revolution in Finnish design is less easy to comprehend. How and why did this hitherto obscure country suddenly rise to such creative heights and to such a peak of international pre-eminence after the war? In many ways circumstances were against it, Finland having fared badly during the war.[17] Indeed Finland's transformation, looked at in purely material terms, seems quite unaccountable until one begins to appreciate fully the creative and technical genius of one individual before the war: the architect, furniture and glass designer, Alvar Aalto. Aalto, and his spiritual disciples Gunnel Nyman, Tapio Wirkkala, Timo Sarpaneva, Kaj Franck and Ilmari Tapiovaara, demand that we acknow-

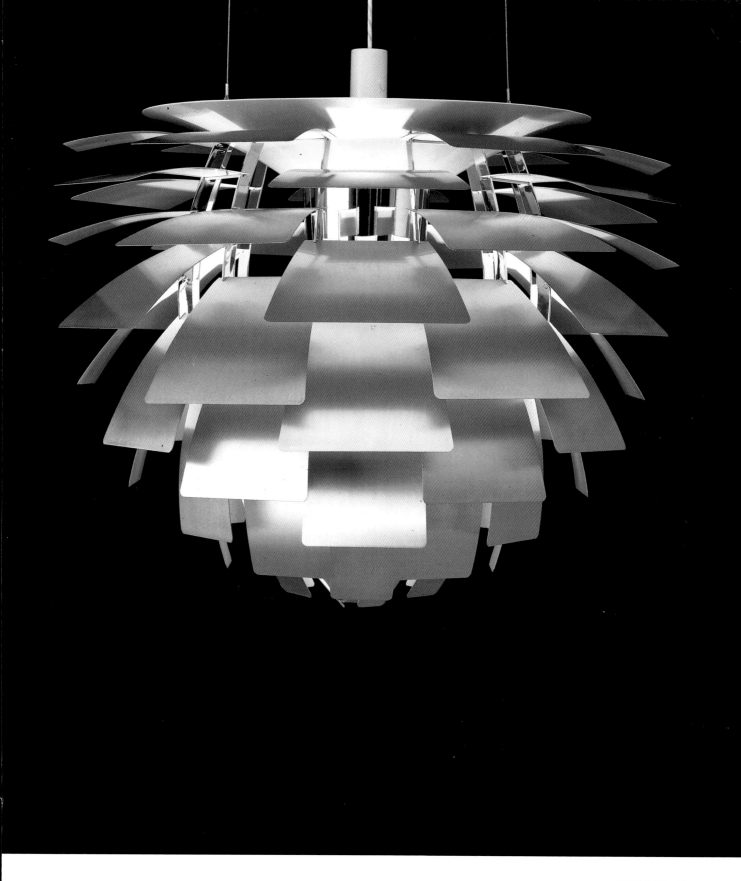

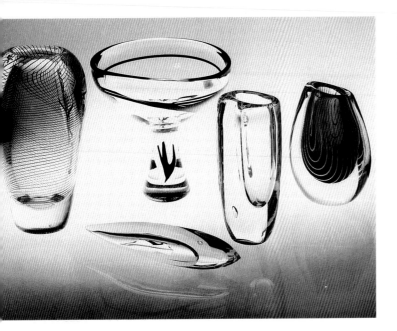

Vicke Lindstrand, well known before the war for his engraved glass at Orrefors, expanded his range considerably during the 1950s at Kosta.

ledge their work as being essentially Finnish, rather than simply Scandinavian. Aalto's designs could not have been conceived anywhere other than Finland, and his organic modernist aesthetic had a profound and enduring effect on the Finnish design psyche. After Aalto, design in Finland would never be the same again. He brought about the national design revolution that modernists throughout Europe had been seeking – but not achieving – throughout the 1930s. Until the post-war period their achievements remained largely theoretical rather than practical, whereas Aalto had been demonstrating in actual buildings, in domestic furniture and in household glass, the technical and visual merits of his clear-sighted solutions since the beginning of the 1930s.

Aalto's natural mode of expression was organic, and it was this profoundly satisfying visual solution that converted the faint-hearted to the otherwise austere and unacceptable face of Modernism. Aalto's success in creating abstract forms that were at the same time overtly rooted in nature, made such an impact on the principal furniture and glass manufacturers in Finland that, after the war, they abandoned all their reservations, embraced the concept of modern design, and converted their entire production. This view is confirmed by the astute commentator, Ulf Hård Af Segerstad: 'The completely decisive factor in the evolution of Finnish design during this period is that the industries now

became devoted to current design trends in an entirely new way.'[18] Segerstad warns, however, against overly simplistic interpretations of the Finnish post-war design phenomenon: 'Countless enthusiastic and kind-hearted writers . . . have tried to explain Finland's success in the applied arts by pointing out supposed features in the character of the people or describing the inspiring Finnish countryside. The Finns have been touched and perhaps a trifle amused by the interpretations of "their primitive instinct for art" and the magic power of their most familiar lakes and woods . . . Finland's international reputation, since the Second World War, as the home of modern design is really due to a few first-class artists, ably supported by a small group of large companies, effectively introduced at exhibitions and by the mass media.'[19]

In addition, there is something in the nature of Finland's geographical, cultural and linguistic isolation that accounts for the strength of its designers' determination. This feeling comes through clearly in the words of Saara Hopea, one of Finland's leading post-war designers, when she describes how the Finns responded to the stimulus of international competiton: 'The Milan Triennales were especially important in the '50s. They stimulated Finnish design by placing it in competition with that of other countries . . . This notice helped Finnish consumers to accept not only these prize winning products, but also other industrial designer products.'[20] Hopea highlights another important factor in the reason for Finland's success, the positive attitude of Finnish consumers. Had they not taken heed of the international recognition that their designers were achieving at these exhibitions, the progressive momentum in Finnish design could not have been sustained. It had to be commercially as well as aesthetically successful – and it was.

These, therefore, were the new design superpowers of the 1950s. Each played a major role in shaping the New Look during the late 1940s, and they all moved into top gear shortly after the war. Before the war, resistance to change had been strong and the pioneering designers of the 1930s made only a limited impact on production. After the war, public resistance to change was weakened; in fact, people were ready for it. When the New Look arrived in 1947 the changes that took place were radical, rapid and irreversible: basic concepts of form were totally transformed; ideas about pattern design were revolutionized; and for the first time this century modern design became the popular idiom. In the words of Timo Sarpaneva, one of the prime movers in this revolution: 'The end of the war signalled the dawning of a new age; it was a fresh start. The aim was to create a different framework for a new age, which everybody hoped would be better than the preceding one.'[21]

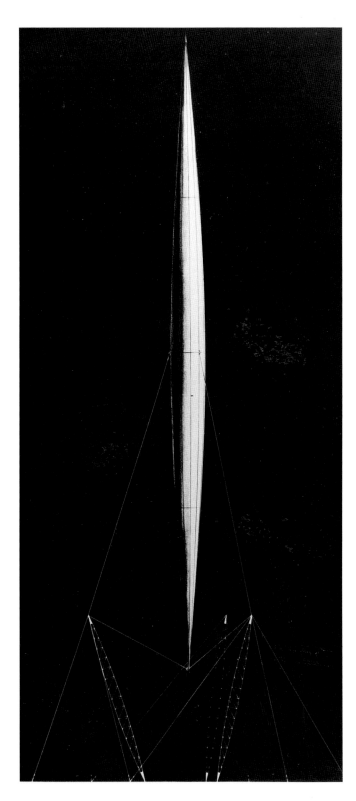

The shape of Powell and Moya's Skylon at the Festival of Britain may have been inspired by Brancusi's sculpture from earlier in the century.

2·The Emergence of The New Look

COMMENTATORS on the 18th century have traced how the Rococo sprang out of the Baroque, and how the latter contained within it the genesis of its wayward offspring.[1] It is equally illuminating to stand back from our own century and trace the first stirrings of the New Look in the Modern Movement. Without exaggerating these parallels, there does seem to be a recurrent pattern to the course of the aesthetic developments in these two centuries, which was clearly lacking during the eclectic and stylistically confused years of the intervening 19th century. A familiar series of developments emerges: pronounced shifts from symmetry to asymmetry, and back to symmetry again, with the New Look in the mid-20th century playing a role equivalent to the Rococo in the mid-18th century.

Fanciful as they might seem, these parallels have been noted on occasion by other commentators. For example, Viggo Sten Møller in his book on the Danish silver designer, Henning Koppel, writes that Koppel's 'acceptance of the spout, body and handle as separate elements is a remnant of the Rococo tradition, found here in the modern idiom.'[2] In the work of the Italian ceramicist, Antonia Campi, there were strong stylistic similarities to Rococo, and it was no coincidence that she could choose the name 'Fantasia' to describe her experiments with form. Interestingly, just as Rococo designers went to extremes in the asymmetrical and wayward forms they created, after which they reacted against this degree of extravagance and adopted the regular symmetrical forms of Neo-classicism, so Henning Koppel at the end of the 1950s reverted to a much simpler style and more regular and cylindrical forms. In the words of E.H. Gombrich, describing the inevitable reaction against Rococo: 'Reason or, as the psycho-analysts would call it, regression into fantasy, had gone so far that the cry arose in the Age of Reason for a return to control and discipline.'[3]

The Modern Movement emphasized the primacy of function, and the need for form to follow function. The New Look introduced the idea that function need not be threatened by a more adventurous expression of form, and

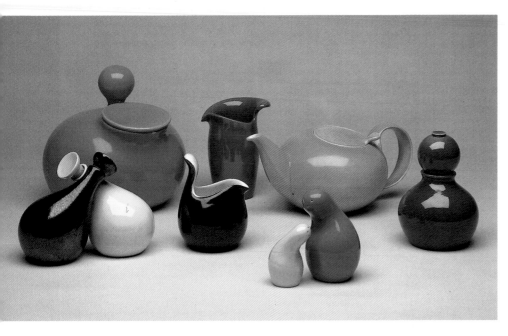

Eva Zeisel's 'Town and Country' tableware (left) for the Red Wing Pottery in 1946, demonstrating her expressive use of line and colour. In Zeisel's opinion, 'form does not follow function'.

'Malino' (opposite), a wallpaper designed by the Willy Herrmann studio for John Line in the late 1950s, showing the creative impact of fine art on design.

'Fantasia' tea service (below), designed by Antonia Campi for the Società Ceramica Italiana in 1955, showing clear parallels with the Rococo style of the mid-18th century and marking a decisive break with the clean-lined Modernist aesthetics of the 1930s.

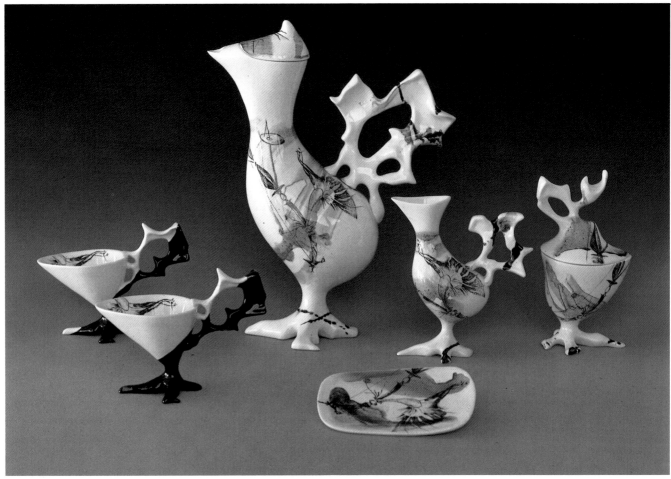

indeed that an object's function extends beyond the parameters of its measurable usefulness. As the ceramic designer, Eva Zeisel, argued: 'the designer must understand that form does not follow function, nor does form follow a production process. For every use and for every production process there are innumerable equally attractive possibilities.'[4] The pioneers of the New Look set out to pursue a positive new aesthetic which would transform the austere face of Modernism. By making Modernism more visually and creatively satisfying, the ideas embodied within it would thus become more accessible to a wider audience. The New Look inherited from the Modern Movement a commitment to purity of form, clarity of outline and the paring away of superfluous details, but it acknowledged the expressive potential of the line itself, which could be used more freely and creatively.

The engineers of the Modern Movement sought to embody the nature of an object in the shape dictated by the object's usage. They thought they could achieve this in a totally objective way without adopting any style. With hindsight it is quite clear that Modernism was itself an expression of a style, and that it is impossible to dissociate

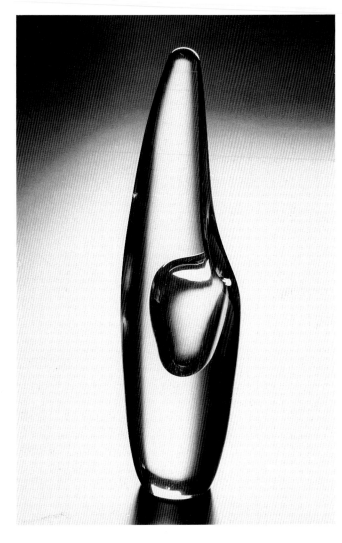

'Orchid' sculpture by Timo Sarpaneva for Iittala, 1954.

The relationship between the fine and applied arts, however, was not as straightforward as it might at first appear. Whilst some of the developments in textiles and wallpapers followed hot on the heels of the original innovations in painting, others showed the influence of aesthetic developments from several years earlier during the 1930s. This circumstance was even more pronounced in terms of the relationship of sculpture to form. The influence of contemporary sculpture was much less important in determining the aesthetics of three-dimensional form than sculpture from much earlier in the century, dating back several decades before the war.

It is in sculpture, in the work of Constantin Brancusi (1876–1957), that the first stirrings of the New Look can be seen. Although he was working at the start of the century, and it may, therefore, seem far-fetched to claim his work as a formative influence of 1950s design, he actually had a more profound effect than any other sculptor this century.[5] Through Brancusi all the other sculptors who appear to have exerted a more demonstrable effect on the 1950s design aesthetic can be traced in a direct line of descent: Arp, Noguchi, Calder, Moore and Hepworth, for example. In the words of H.H. Arnason, 'The subjects of Brancusi were so elemental and his themes so basic that, although he had few direct followers, nothing that happened in sculpture seems foreign to him.'[6] The same could be said of his influence on 1950s design.

Brancusi actually lived through most of the decade in question, but this is less significant than the fact that already, by the second decade of the 20th century, his sculpture prefigured the aesthetics of the period forty years later. Only then were his ideas about abstracted and elemental forms finally adopted by architects and designers. Some designs are so close as to be almost plagiaristic. If one looks, for example, at Brancusi's bronze 'Bird in Space' of 1919, its

style from design; style can be minimized, but it cannot be denied altogether. The New Look acknowledged from the outset that it was the embodiment of a style, but it asserted that to have a distinctive style was not in itself an obstacle to good design. Through associating in a meaningful way with the fine arts, style could be considered as a positive rather than a negative attribute, and as something quite distinct from 'styling'.

The strongest forces shaping the New Look came from painting and sculpture. Across the board, in all branches of the applied arts, designers openly acknowledged their debt to the fine arts. It was this which gave credibility to their decision to adopt a 'style with a style', and justified their partial abandonment of the 'less is more' approach to design.

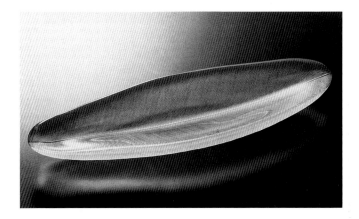

Leaf bowl by Tapio Wirkkala for Iittala, 1951.

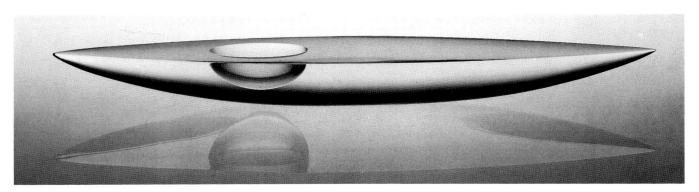

'Kayak' sculpture by Timo Sarpaneva for Iittala, 1954, showing the clear influence of Brancusi on the creation of pure abstract form.

similarities to Skylon (Powell and Moya's vertical feature at the Festival of Britain) are striking.

Since Brancusi's treatment of his subject was so far removed from literal representation – an abstraction of an idea or a concept, rather than of a physical entity – the designers who responded most positively to his work were those who absorbed his way of thinking rather than the more superficial aspects of his style. It was in Finland that his aesthetic was incorporated most meaningfully into the applied arts by the two leading Finnish glass designers, Tapio Wirkkala and Timo Sarpaneva. Glass was particularly well suited to the creation of abstract forms. Although Sarpaneva's 'Kayak' glass sculpture and Wirkkala's leaf bowls in glass, silver and laminated birchwood bear strong formal resemblances to Brancusi's sculptures, however, they are in no way derivative. Wirkkala and Sarpaneva reinterpreted Brancusi's aesthetic so that it became an expression of their own unique cultural environment. Consequently it is these two designers who should be thought of as Brancusi's true heirs, rather than any of his better-known disciples. They inherited the gift of being able to create mesmerizingly beautiful and deeply satisfying abstract forms.

The second sculptor to play a major role in shaping the design aesthetics of the post-war period was Jean Arp (1887–1966). Arp's concept of mass was different from that of Brancusi in that it took on more overtly organic characteristics. As a result, their method of handling abstract form was different and, in fact, Arp claimed that his work was not abstract at all because of its physical and organic qualities. Instead he used the term 'concretion' to describe his sculpture, explaining the term in the following way: 'Concretion designates solidification, the mass of the stone, the plant, the animal, the man. Concretion is something that has grown.'[7] This description seems particularly apposite in the context of 1950s design.

Whilst some designers in the 1950s adopted the cooler metaphysical ethos of Brancusi – Timo Sarpaneva in glass, Hans Coper in ceramics, Lino Sabattini in silver, Christobal Balenciaga in fashion, Poul Kjaerholm in furniture, Le Corbusier in architecture – others were attracted towards the creative energy of organic form. The two elements co-existed throughout the period but it was organic design that was to become the dominant force determining the mainstream aesthetics of the period. The first decisive pre-war adherent was Alvar Aalto, and some of the earliest post-war practitioners included Per Lütken in glass, Stig Lindberg in ceramics, Henning Koppel in silver, Christian Dior in fashion, Charles Eames in furniture and Eero Saarinen in architecture. What attracted them all was the expressive quality of the organic line, an attraction not dissimilar to the appeal of Hogarth's 'line of beauty' from an earlier age of asymmetry and organic design.

It was Arp who first prefigured the 'line' of the New Look in his wooden relief sculptures of the 1920s. One in particular, called 'Navel', was inspired by the shape of a viola, but actually represents a naked female torso, nipped in at the waist, just like Dior's mannequins were required to be.[8] It is interesting to consider the work of Arp and Aalto together because they were obviously closely related. Aalto provided the vital link between art and design: his freeform glass designs acted as the bridge between Arp's organic concretions and 1950s organic modernist design. However, it was Arp's progression from two-dimensional collages to three-dimensional relief sculptures that made this cross-over possible.

Arp's amorphous shapes were influenced partly by landscape, partly by the contours of the human body, and partly by other more primitive lifeforms in the plant and animal kingdom, anything from cotyledons to amoebae. This last analogy is the most pertinent. Amoebae have a physical being and perform physical functions, but to all

appearances they are physically featureless, that is, they appear abstract in their natural form. For an artist seeking inspiration in the natural world for a non-representational, non-naturalistic form of expression, one can see the appeal of these simple micro-organisms. In Aalto's view too: 'The best standardisation committee in the world is nature herself, but in nature standardisation occurs mainly in connection with the smallest possible units, cells. The result is millions of flexible combinations in which one never encounters the stereotyped.'[9] Aalto's sketches for glass designs are a fascinating document recording just some of these 'flexible combinations'.

There have been various conjectures as to Aalto's sources of inspiration. He himself light-heartedly referred to a design submitted to the 1936 Karhula-Iittala glass factory competition as 'Eskimoerindens Skinnbuxa', or 'Eskimo's Leather Pants'. But, like Arp, his visual ideas were rooted in the physical landscape, and the most commonly repeated assertion is that his freeform glass designs were inspired by the shapes of lakes, of which there are tens of thousands in Finland. Aalto may also have been influenced by the physical contours of the land, and even the lines marking the contours of the land on a map.[10] This suggestion is supported by one design in particular, 'Aalto's Flower', a set of four organic-shaped stacking glass bowls and vases. When viewed from above, the concentric outlines of the rims of these four vessels closely resemble the contours of a small irregularly shaped hill, or a geological rock formation in cross-section.

After Aalto, the designer most strongly influenced by Arp was Henning Koppel. His amoeboid designs for silver earrings and bracelets have the same two-dimensional quality as Arp's collages and low relief sculptures of the 1930s, but in terms of shape they take on the freer, more biological qualities of his three-dimensional sculpture of the 1940s onwards.

Drawing closer to the 1950s, another primary influence on organic design was Henry Moore (1898–1986). Moore was important for two reasons: firstly, because during the 1930s he helped to formulate the organic modernist aesthetic in the minds of the designers who would become important after the war; and secondly, because it was during the early post-war period that he finally achieved international recognition, and he was, therefore, in a strong position during the 1950s to influence directly the leading contemporary designers of his day. Whereas Arp and Brancusi had prefigured later developments, Moore was directly in tune with contemporary events in the design world. Moore's influence can be traced through a wide variety of applied arts, including furniture, ceramics, glass and silver. In fact, considering Moore's relevance to the shaping of three-dimensional design, it is rather surprising that his only direct involvement with the applied arts came through textile design.[11] What

Henning Koppel's silver bracelet for Georg Jensen, 1947, resembling the interlocking bones of the spine.

Arp's organic relief sculptures had a decisive effect on the glass and furniture designs of Alvar Aalto during the 1930s. 'Constellation According to the Laws of Chance' (top) by Arp, *c*.1930. Nest of stacking bowls and vases known as 'Aalto's Flower' (above), 1939, and a shallow bowl (right) from 1936, both for Karhula.

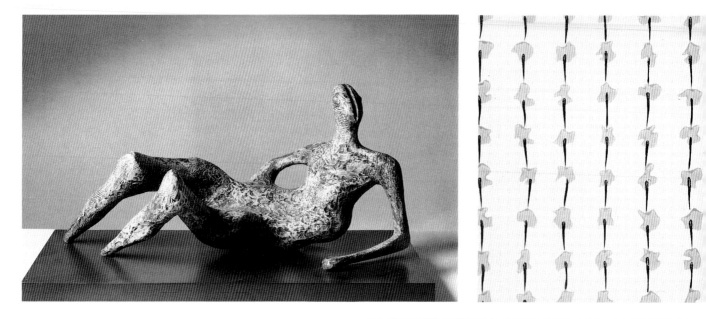

Maquette for 'Reclining Figure' by Henry Moore, 1957, and wallpaper showing the use of organic motifs in pattern design, produced by the Wall Paper Manufacturers in 1958.

distinguished Moore from his predecessors was the plastic quality of his sculpture, which inspired designers working in plastic materials. He was instrumental in formulating the idea of the applied arts as an independent branch of sculpture, thus giving the applied arts the freedom to develop in their own direction, rather than being reliant on sculpture to take the lead.

The number of well-known sculptors who became actively involved in design during the 1950s was very significant. The list includes Harry Bertoia, Lucio Fontana, Henry Moore, Isamu Noguchi and Pablo Picasso. In addition, many individuals well known today as designers originally trained as sculptors before finding their vocation in the applied arts, among them Tapio Wirkkala, Ettore Sottsass, Antonia Campi and Henning Koppel.

This idea of the designer as a sculptor, whether consciously acknowledged or not, was a very potent one during the 1950s. It was central to the formulation of the New Look in fashion design because it was sculpture that determined the new outlines adopted by the female figure. There was a literal dimension to the analogy of the couturier as a sculptor, his clay the female flesh, his tools the outfits shaped to contain it. That designers such as Dior and Balenciaga were thinking along these lines is indicated by the physical demands they imposed on the female body, and the complicated alterations and additions made to their basic tailoring in order to sculpt their desired forms. Dior's

'Pot Hole' sculpture by Timo Sarpaneva for Iittala, 1952, showing the influence of the sculpture of Henry Moore and Barbara Hepworth.

methods were described in quasi-sculptural terms: Dior '*builds* corsets and busts into the dresses *so that they practically stand alone*' (my italics), suggesting that, like a piece of sculpture, such an outfit could almost be displayed on its own without a human body inside.[12] The implied correspondences between fashion and sculpture at this time were numerous, and it is, therefore, interesting to discover in a 1946 issue of *Vogue* an article on Henry Moore illustrated with some of his sketches of pointed forms, not entirely dissimilar to the hourglass shapes of Dior's New Look the following year.[13]

The enforced shaping – many today would call it mis-shaping – of the human figure to achieve a desired line is not, of course, a new phenomenon in the history of fashion. (The contortions inflicted on the female body during the 19th century were much more extreme in physical terms.) But the closeness of the relationship between the development of new shapes in fashion during the late 1940s and early 1950s, and the emergence of new shapes in contemporary sculpture, architecture and the applied arts during the same period, is certainly worthy of note. The first indications that such a relationship was developing, and that it might prove fruitful, occurred in the field of millinery. As early as 1945 *Vogue* was illustrating Schiaparelli's overtly sculptural high-sweeping tricorne hat, a sort of Sydney Opera House in miniature,[14] and a year later there were adverts and features on the curious creations of the Danish milliner, Aage Thaarup. By the 1950s these apparent correspondences between fashion accessories and sculpture would take on a more literal aspect with the marketing of mini Calder mobiles as earrings.[15]

The witty and engaging mobiles of Alexander Calder (1898–1976) reflected a positive mood in post-war art and design: they captivated people with their organic motifs, their bright colours and their delicate currents of movement. They were the embodiment of the most advanced trends in organic abstraction, and yet somehow people generally, not just art lovers, found them easy to appreciate. The degree to which they were accepted is reflected by their early appearance in a popular advertising campaign mounted by Schweppes in 1953. In this image the shapes suspended from the mobile were replaced by pieces of organic furniture, in which the inhabitants of a surreal world are seated. Although idiosyncratic and whimsical, the image was indicative of the way in which Calder's mobiles were represented during the 1950s, specifically in the context, not of an art gallery, but of a domestic interior. Another example occurs in a pattern book by the Swiss wallpaper firm, Salubra. As well as giving samples of different wallpapers, the book includes inset photographs showing these papers in situ, complemented by a Noguchi lamp, a Bertoia chair or, in one case, a Calder

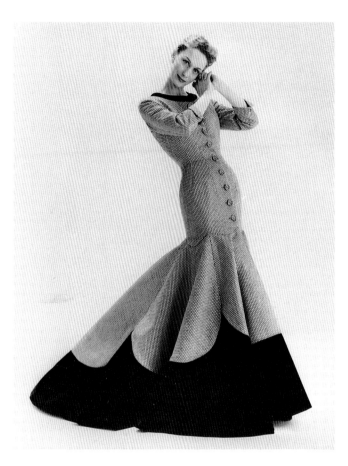

Fashion as sculpture: a dress by Owen of Lachasse, 1955.

mobile.[16] This implies two things: firstly, that these mobiles were considered suitable for display in the average home; and secondly, that they were treated as home furnishings, on the same level as a lamp or a chair. Their acceptance, therefore, seems to have been based on the public's perception of them as examples of design rather than art.

It was Calder's choice of materials and his techniques of construction that were his most original contributions to the development of sculpture, and it is not surprising to learn, therefore, that he trained originally, not as an artist, but as an engineer. Calder also had a natural instinct for colour and form – the expression of the painter and the sculptor combined – and during the 1930s he was a close friend of both Miró and Arp. This explains why Calder's influence was so pervasive throughout the fields of art and design. He inspired a number of artists to produce their own mobiles – Lynn Chadwick, for example – as well as directly influencing specific designs for lighting, textiles and jewellery.[17] Inspired by the distinctive colour schemes of Mondrian, Calder was also very influential in his application of colour. He

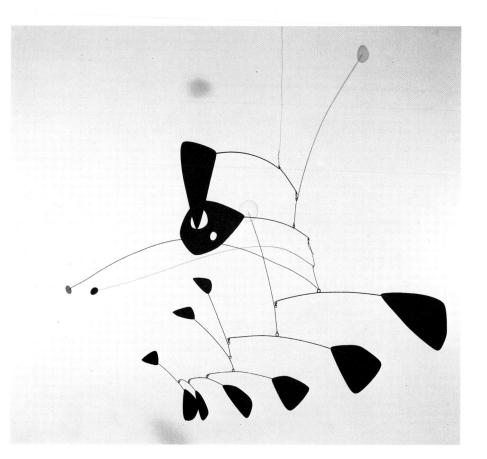

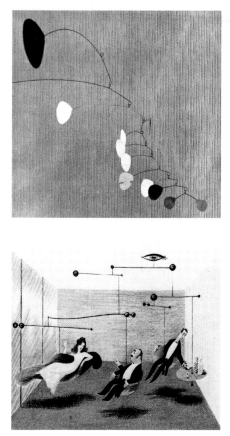

'Antennae with Red and Blue Dots' by Alexander Calder, 1960. The all-pervasive influence of Calder's mobiles during the 1950s is illustrated by their appearance in a textile design by June Lyon for Heal's in 1954 (below), and advertisements for Salubra wallpapers (top right) and Schweppes (bottom right).

popularized what Mondrian pioneered. His technique was to highlight key elements of his sculpture in bright primary colours, as seen in 'Antennae with Red and Blue Dots' from 1960.[18] This strategic positioning of bold contrasting colours was to have a decisive impact on mainstream design aesthetics in the 1950s.

Many of Calder's shapes and colours, and indeed his sense of humour, can be traced back to the surreal abstractions of Joan Miró (1893–1983) from the 1920s onwards. Miró had a major influence on 1950s pattern design. In fact, it was his paintings that determined the New Look in textile design at the start of the 1950s. In Lucienne Day – the most tirelessly inventive force in pattern design at this time – Miró found his true disciple. Miró's 'Woman and Bird in Moonlight' of 1949 is a veritable directory of design motifs for the 1950s.[19] This painting incorporates many shapes, such as crescents, kidneys, stars and antennae, all of which crop up repeatedly in 1950s design. The colours (red, yellow, blue, green and black) reflect exactly the type of colour contrasts that designers in the 1950s were aiming to achieve. Also influential in this respect, and in terms of the graphic style and the surreal quality of his fantastical drawings, was Paul Klee

'Woman and Bird in Moonlight' by Joan Miró, 1949. Miró had a very strong influence
on the shapes, colours and mood of pattern design in the early 1950s.

(1879–1940). But because Klee's work was so varied stylistically it is not as easy to plot his influence as clearly as with the paintings of Miró, which are more consistent in their style and visual imagery. Undoubtedly, however, the influence of both these artists was crucial in determining the development of post-war design aesthetics.

To return to sculpture, there was one final development during the pre-war period that was to influence the course of post-war design. This was the constructivist sculpture made by Naum Gabo and his brother, Anton Pevsner. Their primary concern was with concepts of space rather than mass, thus differentiating them from the organic abstractionists. Pevsner worked in metal and gave his works titles such as 'Projection into Space' and 'Construction in Space'. The pieces that were to influence 1950s design were those representing spiralling and rotating planes wrapped round each other in dynamic motion. Large-scale works such as 'Dynamic Projection in the 30th Degree', commissioned by the University of Caracas in 1950, had a strong influence on the most avant-garde and adventurous architecture of the period. Little of this remains, however, as it was mostly produced in the form of short-lived pavilions at international exhibitions, such as the structures of Luciano Baldessari at the Milan Fairs, and the Philips Pavilion by Le Corbusier at the Brussels World Fair in 1958. The early plans for the Festival of Britain also involved tented structures representing dynamic projections on Pevsneresque lines.[20]

Also influenced by Pevsner were the progressive Italian ceramics by individuals such as Marcello Fantoni and Antonia Campi, and by their commercial imitators, such as ViBi of Turin. The latter created elaborate looped vessels which spiralled back on themselves, terminating in sharp pointed projections. It was the Italians, in fact, who responded most positively to this particular sculptural initiative. Ettore Sottsass, for example, spent some time working with Pevsner, an experience that influenced some of his later architectural experiments.[21] In furniture, the aggressive projecting legs and arms of the structures designed by Carlo Mollino were shaped by ideas deriving from Pevsner's sculpture, whilst in Finland, some of Tapio Wirkkala's experimental laminated birchwood sculptures also bear a resemblance to Pevsner's work.

Pevsner's influence can also be detected in other branches of the applied arts, such as fashion. After the introduction of the New Look, Christian Dior rapidly moved on to ever more daringly sculptural outfits. His Spring 1948 Collection included not only an 'Envol' jacket, narrow at the front but flaring widely at the back, but also an 'Envol' skirt, with an astonishing sculptural projection, like an open bustle, at the back. The following autumn Dior introduced a highly sculptural wing-back dress, with a tall stiffened pointed collar rising up on both sides of the head above the ears.

Naum Gabo's impact on design was twofold. Some of the more ambitious and experimental three-dimensional designers attempted to emulate the stringing mechanism of his linear constructions. Ettore Sottsass's pendant lamps for Arredoluce used stringing to suspend the various sections of the lampshade, and the Italian shoe designer, Ferragamo, created a pair of plastic shoes, the heels and toes of which were composed of loose nylon threads.[22] A fellow sculptor who succeeded in transferring Gabo's aesthetics into a series of chair designs was Harry Bertoia. His steel wire 'Diamond' armchair, with its graceful spreading arms, resembles one of Gabo's linear constructions; the wire grid of the seat is like the taut radiating threads stretched across a frame. Not surprisingly it was the spatial elements of these chairs that Bertoia focused on when he commented: 'The chairs are studies in space, form and metal too. If you will look at them you will find that they are mostly made of air, just like a sculpture. Space passes right through them.'[23] More commonly, however, designers turned to Gabo's sculptures as a source of inspiration for two-dimensional patterns, or for the

Many Italian ceramics, such as this bowl by ViBi of Turin, were influenced in their extravagant projecting shapes by the sculptures of Anton Pevsner.

Maquette for 'Winged Figure' (left) by Barbara Hepworth, 1957. The stringing effect on Hepworth's sculptures influenced many surface pattern designs of the period, such as the wallpaper called 'Element' (below) by the Willy Herrmann studio for John Line, and the pottery by Lucie Rie (overleaf).

Wire chair (below left) designed by the sculptor, Harry Bertoia, for Knoll, 1952. Sculptural Italian furniture (below), created in the style of Carlo Mollino, and also influenced by the sculpture of Pevsner and Gabo.

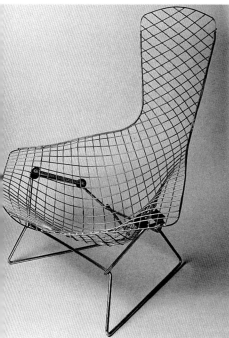

Group of vessels by Lucie Rie, the two vases showing the use of sgraffito line decoration.

Surrealism, which had been a major force within the fine arts during the 1930s, continued to exert an influence on the applied arts during the 1950s, as seen in these three vases (left to right) from Italy, Denmark and Sweden.

surface treatment of three-dimensional objects. Sometimes complete sculptural motifs were reproduced in a fairly literal way; at other times it was simply the familiar thread-like stringing effect that was employed. Studio potters were fond of decorating their pots with finely incised lines, and Tapio Wirkkala's 'Kantarelli' vase was finely engraved on the exterior with thread-like lines. All these surface effects were indirectly influenced by the sculpture of Naum Gabo.

One of Gabo's associates during the 1930s and 1940s was Barbara Hepworth (1903–75). Her work, like that of Henry Moore, received considerable international exposure after the war and she, therefore, exerted a considerable influence in her own right. The main point of similarity between Hepworth and Gabo was the use of stringing across apertures within a frame. Hepworth, however, provides a bridge between the geometric constructivism of Gabo and the organic abstraction of Arp, Calder and Moore. In many ways, therefore, she was more in sympathy with the prevailing aesthetics of the New Look than Gabo, whose work was rooted in the constructivist experiments of an earlier period.

These, therefore, were the principal artists and sculptors of the pre-war generation to exert a demonstrable influence on the New Look of post-war design. The interaction between the fine and applied arts increased after the war, when designers drew not only on these already familiar sources, but on the new paintings and sculptures of their own time as well. This double dose of artistic influences – recent and contemporary – probably accounts for the headiness and potency of the concoction that emerged in the applied arts during the 1950s. Timo Sarpaneva, for example, cites four different artists and sculptors spanning the 1930s to the 1950s as the major sources of inspiration on his glass designs: 'Salvador Dali's fluid objects, Joan Miró's flowing rhythms', 'Barbara Hepworth's spatially innovative wood sculptures', and 'Jackson Pollock's spontaneous paintings of massed, densely coloured lines'.[24] The influence of Jackson Pollock, abstract expressionism and 'tachisme', and of contemporary sculptors, such as Giacometti and Paolozzi, will be discussed in the following chapters.

The new 'soft forms' of organic modernism evolved during the 1930s by Alvar Aalto can be seen in this curvilinear wooden screen.

3·New Shapes

'Soft Forms' – The Rise of Organic Modernism

In 1938 the Swedish ceramicist, Wilhelm Kåge, working at the Gustavsberg factory, designed a range of domestic pottery with distinctly rounded organic shapes. The service was called 'Mjuka Formernas', or 'Soft Forms', and included a bowl, the rim of which folded inwards, as though the walls of the vessel had collapsed during firing. The title of the service was significant because it gave one of the first indications of the radical departure about to take place in the applied arts, from the hard-edged geometrical forms of the 1930s to the freeform organic shapes of the 1950s. Twenty years later the 'Soft Forms' service was still in production and still looked modern. It successfully combined the clean lines of Modernism with the softened edge of organic design.

Wilhelm Kåge, however, was by no means the originator of organic modernism. The founding father of the movement was Alvar Aalto. Without Aalto, organic design would probably only have existed in a marginal way, as an offshoot of surrealism. It is interesting to study in greater detail the process of Aalto's adoption in the United States, as this was more significant in global terms than the dissemination of Aalto's ideas through Finland's neighbouring countries in Scandinavia. His furniture was being exported to the USA from the early 1930s, and by 1938 he had achieved such recognition that his work was singled out by the all-powerful Museum of Modern Art in New York for a one-man exhibition entitled 'Alvar Aalto: Architecture and Furniture'. As J. Stewart Johnson notes: 'The 1938 exhibition, the first in any museum to be devoted to Aalto, served to bring to the attention of a broad American audience a growing body of work that had up until then been known primarily to a small group of architects and designers.'[1] The New York World's Fair of the following year re-emphasized Aalto's international pre-eminence, and confirmed that the way forward for American design lay in the practical realization of organic modernism. For the Finnish Pavilion Aalto designed a huge curvilinear wooden screen system, a larger version of his domestic screen of several years earlier. People

'Soft Forms' tableware designed by Wilhelm Kåge for Gustavsberg in 1938.

entering this pavilion must have felt as though they were being literally engulfed by organic design.

In 1940 MOMA held a competition entitled 'Organic Design in Home Furnishings'. At this date the definition of organic design was still rather imprecise, with connotations both of philosophical wholeness and of rounded physical shape, two quite different, but not mutually exclusive, concepts. It was Frank Lloyd Wright (1867–1959) who had originally popularized the term, but Wright's contribution was not even acknowledged in the 'Organic Design' exhibition catalogue, implying that the concept had not, as yet, been fully thought through. Although the competition was invaluable in crystallizing the ideas that were emerging in America at this time, it is only with hindsight that a broadly satisfactory definition of organic design has been proposed, taking into account its multi-faceted character. According to Cherie and Kenneth Fehrman: 'The concept of "organic design" stems from living organisms, therefore precluding the possibility of interchangeable parts . . . An ideal in organic design was the concept of a single harmonious unit of one-piece construction.'[2]

The American organic modernist movement, triggered off by the 'Organic Design' competition, was spearheaded by Charles Eames and Eero Saarinen. Amongst their several joint entries for the competition was a series of chairs with plywood shell seats, the armchair versions moulded to curve in two different directions. The Eames/Saarinen armchair won first prize in the 'Seating for a Living Room' category of the competition, and it was to act as the inspiration for a series of major works produced by these two designers individually over the next two decades. It led on directly to

Eames' moulded plastic armchair of 1952, for example, and to Saarinen's 'Womb' chair of 1946. Moreover, the competition had a decisive impact on the development of Saarinen's architecture during the 1950s, and it was through his major architectural projects, such as the TWA Terminal at Kennedy Airport, that the organic modernist message was communicated to a wider audience.

The first indications that the tide in international architecture was turning occurred when two leading architects of the Modern Movement 'went Organic' shortly after the war. The first was Frank Lloyd Wright who, although one of the originators of the concept of organic design, did not adopt an overtly organic visual style himself until after the Second World War. His design for the Guggenheim Museum in New York was conceived in 1947 (the year of the New Look), but was not completed until 1959. The circular theme was not a new one in his work, for he had already begun to explore this idea in the Johnson Building of 1936. But in the Guggenheim Museum he went off at a tangent and created a spiral expanding from the base upwards like a broken spring.

The building was a huge public success, and a triumph for individual creative expression over the rationalism of orthodox modernists such as Miës van der Rohe, whose Seagram Building of 1958 was at completely the opposite end of the architectural spectrum. But this creative and energetic organic approach to architecture was very demanding in engineering terms, and was only ever carried out successfully by a handful of the most talented architects, such as Oscar Niemeyer in Brazil, and Pier Luigi Nervi and Carlo Mollino in Italy. A valiant attempt was also made soon after the war with the impressive temporary structures at the Festival of Britain, notably the Dome of Discovery by Ralph Tubbs (the precursor of Nervi's Sports Palace in Rome), and the Festival Station by Gordon Tait, constructed from parabolic arches. By the 1960s, however, the Miësian approach, being less demanding on the creative faculties of the average architect, had become the dominant mode in international architecture, a fact lamented by Gio Ponti who was a passionate advocate for organic architecture. In an article on Niemeyer in *Domus* Ponti wrote: 'Niemeyer is such a genius that almost anything is forgiven, genius is allowed to sin by excess. It is a lucky nation Brazil where such experiences are possible, and a lucky nation could be our own if we manage to free ourselves from the cage of "posts and beams" towards the difficult path of structural concrete composed according to the inescapable classic rule of our architectural expression. We have a master: Nervi with the classic composure of his Turin Hall, we have an architect Mollino, whom we can expect to design daring things . . . We would like to see a lively dialogue of Italian and Brazilian architectures.'[3]

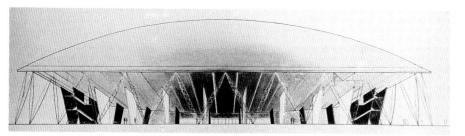
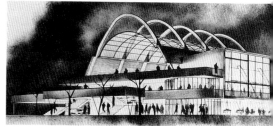

Organic architecture at the Festival of Britain: Dome of Discovery (left) by Ralph Tubbs; Festival Station (right) by Gordon Tait.

The second pioneer of modern architecture to adopt the organic mode after the war was Le Corbusier (1887–1965). Le Corbusier's design for the church of Notre Dame du Haut at Ronchamp (1950–54) was astonishingly original, combining geometrical abstraction in its interior with organic abstraction on its exterior. The roof swells like a wave, and is a masterpiece of sculptural form. The interior, on the other hand, is more introspective, with its shafts of coloured light transmitted through randomly placed stained glass windows. The cresting roof was by no means an aberration in Le Corbusier's oeuvre: it appeared again in an even bolder form in his Assembly Building at Chandigarh, built between 1959 and 1962.

Of the new generation of post-war architects, Eero Saarinen was the most outstanding. In his TWA Terminal at Kennedy Airport he created a building with two distinct moods, one expressive, the other self-contained – as Le Corbusier had done in his church at Ronchamp – but in Saarinen's case, both the interior and the exterior were statements of total, rather than partial, commitment to organic modernism. If the exterior of the building resembles a swooping bird, the interior is like the bowels of such a creature. In describing organic design, organic analogies often seem the most appropriate, a fact underlined by Saarinen's use of an extended organic metaphor to describe his perception of the 'organic unity' of an ideal interior: 'it grows the way chromosomes multiply out of the original sperm and the thinking is carried down to the smallest detail.'[4] Saarinen was constantly striving throughout his life to achieve this 'organic unity', and although he himself was never entirely satisfied with the results, he realized in practice what others only dreamed of. To most people in the 1950s, Peter and Alison Smithson's design for a 'House of the Future' seemed like a futuristic science-fiction fantasy – which indeed it was at the time.[5] Saarinen, however, lived out his fantasies. When the TWA Terminal opened in the early 1960s, passengers arriving in it must have wondered if they had landed on another planet.

In Saarinen's second terminal, Dulles Airport at Chantilly, Virginia, he moved away from asymmetry and a preoccupation with the more biological aspects of organic design, towards a simpler expression of abstract form. In this building, whilst the walls soar upwards and outwards, the floating roof dips downwards and inwards. It is graceful rather than vigorous, and reflects a preoccupation with poise and rhythm. For the emergent designers of the post-war generation the re-birth of Modernism in these various forms of organic modernism was inspirational. 'Post-war architecture, strange as it may sound, had a profound influence on pottery and glass design', commented Timo Sarpaneva, and he singled out the work of Eero Saarinen and Frank Lloyd Wright as being particularly important.[6] New departures in architecture during the late 1940s and 50s opened up a vision of a renaissance for the applied arts.

'Eel' dish by Henning Koppel for Georg Jensen, 1954.

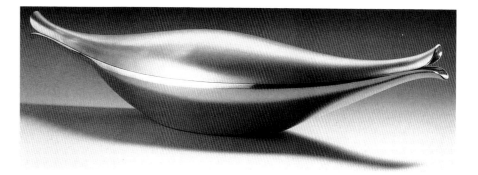

Saarinen's development in architecture is to some extent paralleled by the career of the Danish silver designer, Henning Koppel. Koppel's early designs, such as his amoeboid jewellery of the late 1940s, were organic in an overtly biological way, whereas his later designs were simpler and more abstract. It is as though, whilst the concepts of organic modernism were still being formulated, designers felt the need to lay particular emphasis on the biological quality of their designs. Koppel, for example, designed a jug with a swollen body called 'The Pregnant Duck' in 1952, and Saarinen, of course, was the creator of the 'Womb' chair during the 1940s. Saarinen was rather worried about causing offence through the use of this slightly risqué title for his chair, but ultimately it was retained for want of something more appropriate. His comments on this subject are illuminating: 'I have been thinking about a printable name for that chair, but my mind keeps turning to those which are more *biological* rather than less *biological*.' (My italics).[7] Later in

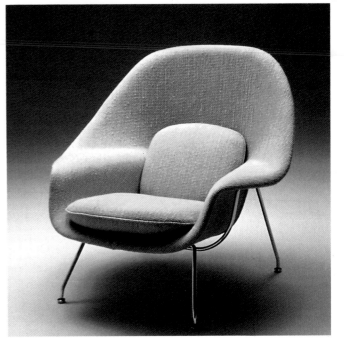

Eero Saarinen's 'Womb' chair for Knoll, 1946, described by the designer as 'biological'.

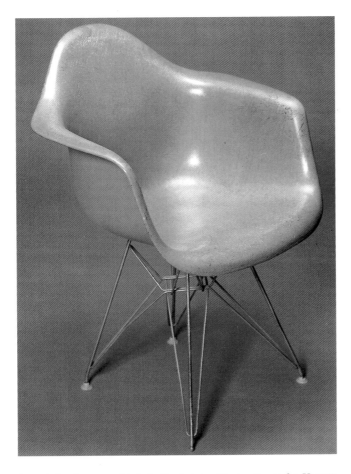

Organic furniture: moulded plastic chair by Charles Eames for Herman Miller, designed in 1952.

the decade, when organic design was well established, there was less need for over-emphasis, and the late 1950s witnessed a reversion to a purer, more abstract form of Modernism, typified by Koppel's elegant silver fish dishes, such as the 'Eel' of 1954. Their quality of line links them directly with Saarinen's Dulles Airport design.

This differentiation between a more literal, biological form of organic design – one in which a resemblance to the original source of inspiration is still apparent in the final shape – and another form of organic design based on pure abstraction, has a wider application than to Koppel and Saarinen alone. The division is not always a chronological one. Often it reflects the character of a particular individual. Axel Salto and Carlo Mollino, for example, were naturally inclined towards the biological, whilst Lino Sabattini and Timo Sarpaneva opted for greater abstraction. Generally speaking, however, those designers who covered a full range of organic expression in their work – such as Stig Lindberg – usually developed from the biological to the abstract in the course of their career.

In organic modernism derived from pure abstraction, the form is generalized to such a degree that it bears no resemblance to any specific object in nature, except by association. An example is Timo Sarpaneva's 'Orchid' glass sculpture: the mental image of an orchid is unlikely to arise spontaneously when someone looks at this vessel but, once

suggested, it seems an appropriate association. Tapio Wirkkala's leaf bowls or 'Etana' ('Snail') sculpture, on the other hand, evoke their source of inspiration more immediately. The differentiation is between the Brancusi aesthetic and the Arp aesthetic, although in sculpture it is interesting that it was Brancusi who preceded Arp, whereas in the development of design, the process was reversed.

Those organic designers who looked to vegetable forms for inspiration, such as Axel Salto, produced work which was quite distinct from that inspired by animal forms, such as the furniture of Carlo Mollino. In general, designers opted instinctively for either one form or the other. Salto's themes are embodied in a printed textile called 'Gro', which represents bulbs sending out shoots and roots, and which quivers with vegetable organic energy.

Carlo Mollino's furniture was altogether more aggressive and more sensuous. The sculptured seats of his wooden chairs were inspired by the curves of the female body, and were shaped to match their contours intimately. Some chairs had contorted bentwood legs and arms, intended to be deliberately provocative. Mollino was also fascinated by the structure of the skeleton. Several of his glass-topped dining tables had visible spines, constructed from a complicated

Hans Wegner's legendary design called 'The Chair' for Johannes Hansen, 1949: an example of Danish organic furniture at its most sophisticated.

'San Luca' armchair by Achille and Piergiacomo Castiglioni for Gavina, 1960, embodying the cursive energy of Italian organic design.

arrangement of bent plywood joints representing the interlocking bones of the vertebrae. As these examples show, Mollino's work, as well as being organic, was also strongly coloured by surrealism. Surrealism freed his imagination and inspired him to live out his design fantasies. His furniture was organic in the most literal sense of the word: it had a life of its own.

For Mollino, the organic was his intuitive mode of expression; everything he designed was shaped by it, even when his source of inspiration was entirely abstract. In his 'Arabesque' table, for example, Mollino captured the essence of an abstract linear flourish – Mackmurdo's whiplash motif, or Hogarth's 'line of beauty' in an updated form. This table epitomizes the unique cursive quality of Italian organic design in the 1950s, which is lighter in mood and freer in spirit than the creations of either the Scandinavians or the Americans. The Italians had a way of capturing movement in their designs – not the gentle currents of movement in a Calder mobile, but the swirling dynamism of an action painting by Jackson Pollock. At times their designs were frenetic, as in the neon lighting installations created by the artist, Lucio Fontana, for the Milan Triennale in 1951. At other times they were simply energetic, as in Achille and Piergiacomo Castiglioni's 'San Luca' armchair, with its unsupported springy curves. In this design it was as though

the designers had watched a rubber ball bouncing, and then sought to encapsulate those lines in the outline of a chair. Lino Sabattini's silver designs for the French firm, Christofle, also had a springiness about them, as in the scooped out forms of his 'Como' tea and coffee service. This was the organic design of Dior's 'New Look', extravagantly curvilinear, and unencumbered by excess weight.

Although none of the Danish cabinetmakers ever allowed themselves to 'sin by excess' in the way that the Italians were inclined to do, the designs of Finn Juhl were lavishly sculptural. Whereas Hans Wegner focused attention on the frame of the chair, in Juhl's furniture the visual interest lay in the unusual organic shapes of the seatbacks and armrests. Seats were scooped out, seatbacks were heart-shaped or sculpted like sycamore wings, and armrests were paddle-shaped. The most sculptural of all Juhl's creations was the 'Chieftain's' chair, so called because of its size and its authority. It has a tremendous presence, rather like a throne. Sculpted in teak and upholstered in leather, it was one of the major achievements of Danish 1950s organic design.

Hans Wegner's basic understanding of, and sympathy for, wood comes over very forcefully in his furniture. His work was organic in the sense of the oneness of his designs and his materials. Unlike Mollino he did not push wood to extremes in the demands he made upon it; he used his familiarity with and fondness for his material to bring out its subtler hidden qualities. Most of Wegner's chairs had titles which reflected a specific source of inspiration in nature, such as the 'Shell' chair, the 'Peacock' chair and the 'Cowhorn' chair. Only in the near legendary design known simply as

'The Chair' did Wegner create a totally abstract organic work. This chair is so comfortable that the sitter becomes part of an organic whole.

Unlike Juhl and Wegner, whose work was dependent on the skilled craftsmanship of the cabinetmaker, Arne Jacobsen designed for mass production. In his three major 1950s chair designs – the 'Ant', the 'Swan' and the 'Egg' – his main preoccupation was with the organic as an expression of an all-in-one unified seat form, rather than simply as an expression of a rounded shape. Like Saarinen's 'Womb' chair, Jacobsen's chairs fall into the category of the biologically organic: the essence of the ungainly ant, the graceful swan and the enveloping egg are embodied within them, although their detailed physical characteristics have largely been abstracted.

Although Jacobsen's chairs look comfortable in almost any setting, they are undoubtedly most at ease in buildings created by the architect himself. In St Catherine's College, Oxford, Jacobsen extended the idea of organic wholeness from individual items of furniture to the creation of a complete environment. Unlike Saarinen's, however, Jacobsen's architecture was designed to contrast with his furniture rather than to mirror its organic shapes: the building is conceived as a series of geometric planes, which has the effect of highlighting the 'soft forms' of the furniture instead. For the High Table in the Dining Room Jacobsen created a new high-backed chair made of plywood, with an elegant wavering curvature to the seatback. The 'Oxford' chair, as it has become known, was the culmination of Jacobsen's organic furniture designs from the 1950s.

'Arabesque' table (left) by Carlo Mollino, 1950, demonstrating the link between organic modernism and Art Nouveau. An unusual organic chair (right), designed by Tapio Wirkkala for Asko, clearly influenced by the work of Mollino.

The three masters of Danish organic furniture: Arne Jacobsen's 'Oxford' chairs (above), designed for St Catherine's College in the early 1960s; settee (below left) by Finn Juhl for Niels Vodder, 1957; Hans Wegner's 'Shell' chair (below right) for Fritz Hansen, 1949.

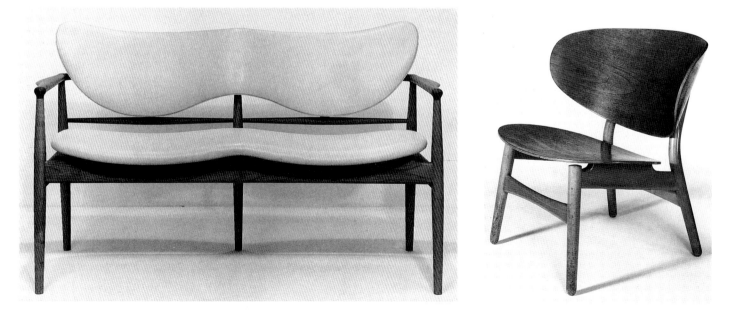

In the opinion of Timo Sarpaneva, there was something in the character of organic design that appealed on a basic level to the Scandinavian psyche, which explains why it was adopted so early and with such enthusiasm throughout Sweden, Denmark, and Finland. The medium in which all these countries were jointly pre-eminent was glass, and Sarpaneva comments: 'The effect of the organic was felt immediately in glass design, and specifically in Scandinavia. Simplicity, abstraction, and asymmetry were clearly evident in the shapes of studio glass.'[8]

After Aalto's pioneering work in the 1930s, Gunnel Nyman led the way in Finland during the 1940s with freeform designs such as her 'Rose Petal' bowl and 'Serpentine' vase. The former was made of opaque white glass and, with its undulating rim and shallow well, it resembled the broken fragment of an eggshell. The undulating rim became a characteristic of glass bowls produced throughout Scandinavia during the 1950s, and later became a feature of ceramic vessels as well, Stig Lindberg at Gustavsberg being the first to make use of it in his studio stonewares of the 1940s. Nyman's 'Serpentine' vase was also influential, both in its shape – swollen at the base, tapering towards the top – and its decoration – a finely trailed serpentine line encased within the glass, an extended 'line of beauty' spiralling upwards.

Nils Landberg, working at Orrefors in Sweden, was also producing 'Serpentine' bowls and vases at this time. Later he produced two sharply contrasting series of vessel designs, one of astonishing lightness and thinness – his 'Tulip' glasses – the other thick-walled and monumental – his dark green underlay vases. Together they represent the aesthetic polarities of organic design.

It was largely through domestic ceramics and glass that the organic modernist aesthetic was disseminated amongst a wider public. In this field during the course of the 1950s almost every designer and manufacturer became affected in one way or another by the shift in popular aesthetics. Although the products of the pioneer organic designers – such as Antonia Campi and Flavio Poli in Italy, and Stig Lindberg and Gunnar Nylund in Sweden – would only have been seen and used by a small proportion of the population, their ideas soon spread throughout the manufacturing world.

A well-documented example of the transfer of ideas in ceramics from one country to another was the case of Roy Midwinter, who went on a sales trip to the USA in 1952, and returned full of enthusiasm for the organic forms of Russel Wright and Eva Zeisel. His version of organic modernism, called 'Stylecraft', appeared shortly afterwards and later he

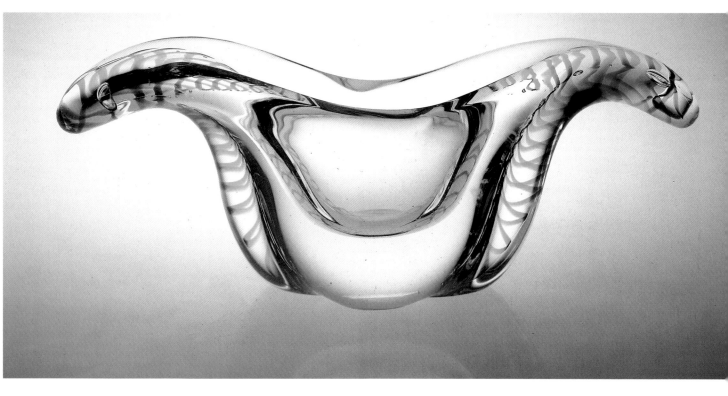

'Serpentine' bowl by Nils Landberg for Orrefors, dating from the mid-1940s.

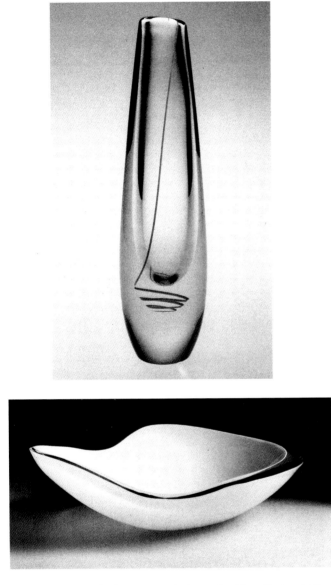

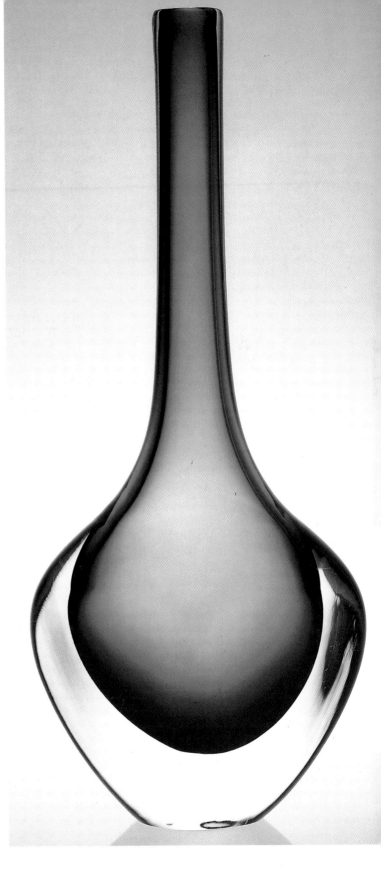

Scandinavian organic glass: 'Serpentine' vase for Nuutajärvi and 'Rose Petal' bowl for Iittala (above), both by Gunnel Nyman from the late 1940s; vase (right) by Nils Landberg for Orrefors, 1956–60.

Many aspects of the new 'Fashion' shape introduced by Roy Midwinter in 1955 were derived from Eva Zeisel's 'Tomorrow's Classic' tableware in America.

developed the 'Fashion' shape; these were both marketed as 'Midwinter Modern'. These tradenames emphasized the modernity of the designs, and the importance to the consumer of keeping up with fashion. Midwinter's initiative had a knock-on effect throughout the industry: as soon as other manufacturers realized the commercial potential of organic modernism, they were just as eager to exploit it. In this way the overall quantity of organic design increased, but the overall quality decreased: the message became diluted and misrepresented, as in a game of Chinese Whispers. Whilst the early organic designs were created in a meaningful attempt to achieve 'organic unity', later commercial exploitation resulted in a nonsense of superficial styling.

The Tulip Phenomenon – The Exaggeration of Form

The manipulation of the basic shape of an object into an attenuated or distorted form is one of the hallmarks of 1950s design. It is for this reason that Skylon was such a potent symbol of its age. Although it was not until the 1960s that plastics themselves became significant as independent and original media for design, in the 1950s other materials – ceramics, glass, silver, steel, and wood – were treated as if they had suddenly and miraculously assumed the physical properties of plastics, and could be thrown, blown, cast, bent

or moulded into the most extravagant shapes. Furniture legs taper to an incredible slenderness, glass vessels are blown to an unbelievable thinness, and the necks of ceramic vessels are tightened almost to the point of suffocation. In silver, bodies are swollen, handles raised, and spouts drawn out to double their expected length.

A clear example of this perverse phenomenon can be seen in fashion, in the exaggerated hourglass shapes of Dior's New Look outfits, with their narrow waists, their padded bodices, and their full, flared skirts. Each season fashion commentators would rack their brains to think up the most evocative names to describe the exaggerated new shapes and lines of the latest Paris collections. 'Hourglass', 'Triangle' and 'Cocoon' are just some of their analogies. Occasionally these descriptions provide a useful vocabulary for describing broader aesthetic trends in the applied arts. In March 1953, for example, *Vogue* described one of Dior's most recent creations as a 'black "tulip" suit, padded to curve out round the bust, and to swell at the shoulders into short puffed sleeves. The closely moulded waist slides into a straight stem skirt.'[9]

The comparison of the outfit to a tulip – with the 'inflated bodice' as the flower, and the tight skirt as the stem – is significant because this metaphor crops up again in the context of at least two other branches of the applied arts: furniture and glass. Moreover, on both these occasions the objects illustrate clearly the exaggeration of form so characteristic of the period. At Orrefors Nils Landberg's 'Tulip' glass vases of the mid-1950s, hand-blown to wafer thinness, with long drawn-out bowls and needle-like stems, are one example; and Eero Saarinen's 'Tulip' chairs for Knoll, dating from 1956, with their round aluminium pedestal bases and organic bud-shaped moulded white plastic seats, are another. Saarinen's range of furniture later inspired the high-backed fibreglass 'Tulip' armchair of 1960 produced by the American firm, Laverne, illustrating the survival of the tulip phenomenon right through to the end of the decade. It is significant that when plastic and fibreglass were used in 1950s furniture design, these materials were chosen not just for their malleability alone, but because they could so easily be moulded into the more extreme organic shapes to which the designers of the time aspired.

The tulip symbol is a potent image for describing this distinctive new trend in three-dimensional design whereby forms are drawn out to a phenomenal extent, or they swell and taper abruptly from one extreme to the other. It is as though the applied arts were being nurtured under special hothouse conditions at this time, encouraging rapid but not entirely natural spurts of growth resulting in attenuated forms. In the hands of accomplished designers and techni-

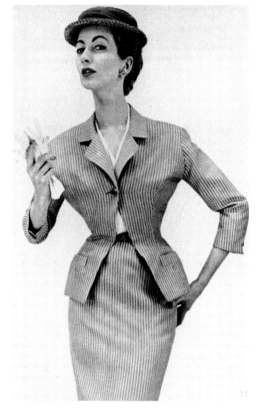

The tulip phenomenon, as demonstrated by a 'Tulip' light fitting (above); a 'Tulip' suit by Christian Dior from 1953 (above right); 'Tulip' glasses by Gunnar Ander for Lindshammar and Nils Landberg for Orrefors, 1957 (left); and a 'Tulip' chair by Eero Saarinen for Knoll, 1956 (right).

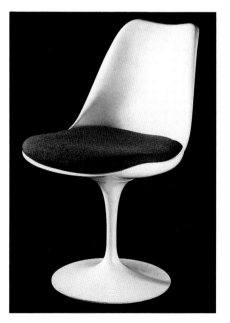

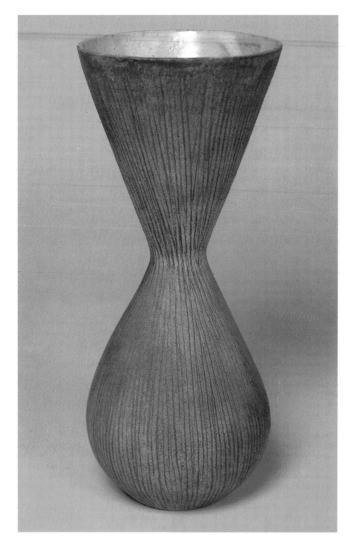

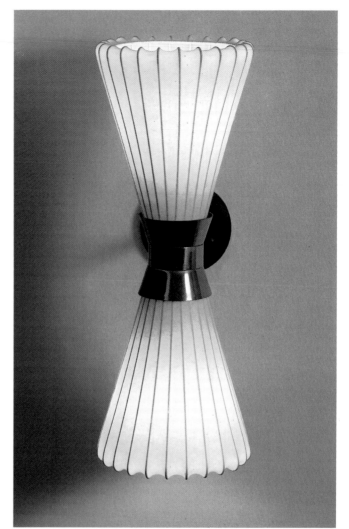

Hourglass forms as seen in a vase by Waistel Cooper (above); a wall-lamp (above right); and 'Service 2000' (right) by Raymond Loewy and Richard Latham for Rosenthal, 1954.

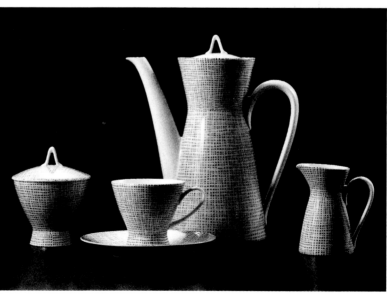

cians, such as Landberg and Saarinen, this enforced growth was expertly controlled to create forms of great refinement and sophistication. But in the hands of the less gifted, there was always a danger – to extend the hothouse analogy – that the plants would bolt through being starved of natural light, and would end up looking straggly and etiolated.[10] The metaphor highlights both the advantages and the dangers of working under these unnatural conditions: the hothouse creates an environment in which ideas are generated rapidly and prolifically, but some designs appear grotesque and ungainly simply because of the speed of their execution and their uneven rate of growth.

Of all the forced and exaggerated shapes which crop up in the 1950s, the most characteristic and the most common was the hourglass form. In addition to fashion, it affected vessel shapes of every kind, as well as furniture and lighting design, and even the motifs on textiles and wallpapers. In ceramics it defines the shape of the coffee pot in Rosenthal's 'Service 2000'. In furniture it is seen in the plywood seatback of Arne Jacobsen's 'Ant' chair. In lighting it was the common shape of many spun aluminium and plastic-coated wire lampshades mass-produced during the 1950s. In textiles it appears as a linear pattern in Paule Vézelay's 'Elegance' furnishing fabric for Heal's. But perhaps the most vivid of all the hourglass images from the 1950s was that of Marilyn Monroe. Had Dior not popularized the hourglass shape in women's fashion, Monroe's hourglass figure might never have achieved its legendary status.

The propensity of vessels to swell and taper to extremes is typical of 1950s studio pottery, and it is particularly characteristic of potters working in Britain and Scandinavia. Sometimes the hourglass formula was adopted, as in the attenuated figures of Birger Kaipiainen; sometimes the hourglass was turned inside out to create a pod-shaped form, swollen at the waist, but tapering towards the base and rim, as in narrow-necked vases by Stig Lindberg and Waistel Cooper. Alternatively a bowl by Lucie Rie or Wilhelm Kåge might flare widely from a narrow foot, and a vase by Kyllikki Salmenhaara might flare and then taper again from one extreme to the other. Salmenhaara's vases often had such narrow bases that it seems remarkable that they can even stand upright, a characteristic they share with Timo Sarpaneva's 'Lancet' glass sculptures.

In the 1950s potters also produced numerous narrow-bodied and bottle-necked vases, which are now instantly recognizable as dating from this period. One of the first potters to experiment with these shapes was Toini Muona in her elegant, wavering 'Grass' vases of the late 1940s. Later Axel Salto produced some remarkable large-scale ceramic sculptures composed of groups of conjoined tapering vessels,

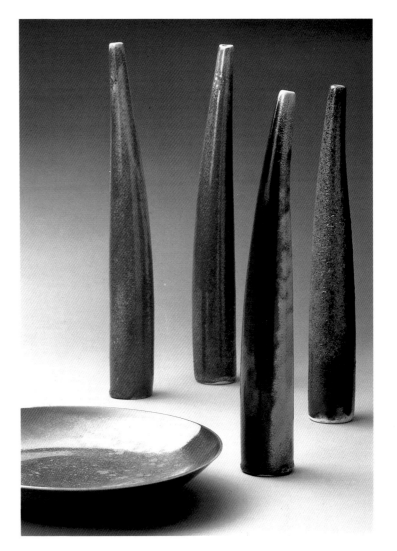

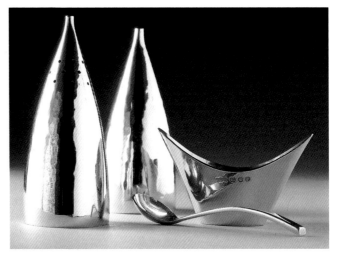

Toini Muona's attenuated 'Grass' vases for Arabia, 1946. Condiment set by Gerald Benney, 1956, showing pod-shaped cruets.

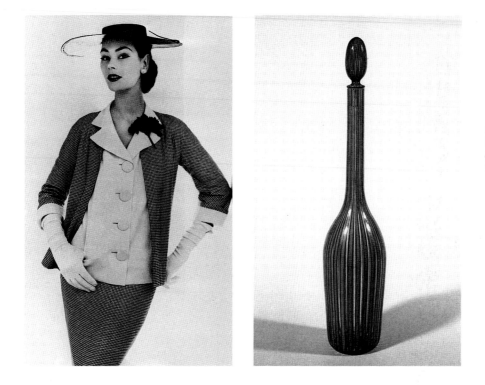

A cotton suit (far left) by Lachasse from 1953, following the pencil line established by Balenciaga in 1950. Tall long-necked decanter (left) by Venini, *c.*1960.

suggestive of biological organisms. Kyllikki Salmenhaara in Finland also produced bottle-necked vases, as did William Newland in the UK. Sometimes the necks of vessels were so tight as to appear almost pinched, as in the cruet sets produced in the early 1950s by Lucie Rie.

The optical effect of attenuation – the drawing out of matter to an unusual length and an uncommon thinness – was skilfully manipulated by the fashion industry to glamorize their creations. Dior's New Look of 1947, although it dominated the ensuing decade, was not the only New Look of the 1950s. Some couturiers opted instead for an attenuated pencil line. An ensemble such as that created by Balenciaga in his Spring 1950 Collection, with a 'mustard tweed box jacket' over a 'stem-slim skirt', created the impression of extreme thinness and exaggerated height.[11] In April *Vogue* officially announced the change of line, no doubt much to the chagrin of all those females still aspiring to the original New Look proportions: 'The figure which French fashions have idealised for so long is not, this spring, the ideal of the French designers. They like the close waistline – but without breath-taking indentations . . . They like a smooth torso . . . And they like especially a length of pretty, pretty legs, usually made to seem prettier and more slender because of the high, pointed heel.'[12] Shoes themselves became increasingly attenuated during the 1950s (Holmes of Norwich, for example, produced a range called 'Vamps' in

1952),[13] culminating in the stiletto heel, tapering to a dagger-like point, at the end of the decade.

The attenuation aspect of the tulip phenomenon was particularly pronounced in Italian design. In a highly sophisticated form it is embodied in Gio Ponti's elegantly tapered Pirelli Tower, and in the long thin legs of his apparently weightless 'Superleggera' ('Super Light') chair. Modern as it looked when it first appeared, the 'Superleggera' was, in fact, directly based on the 'Chiavari' chairs which had been made for several generations by the Sanguinetti family of Genoa. These elegant chairs, with their delicately narrow tapered legs and finely woven cane seats, were originally produced for the use of the local Genoese fishermen, when suddenly in the 1950s they became massively popular with a wider audience throughout Italy. They had a strong influence on the work of several leading furniture designers such as Gio Ponti and Ico Parisi, who produced a series of designs for chairs with slender legs and exaggeratedly high seatbacks. An indication of their renewed popularity is the inclusion of an updated 'Chiavari' chair in the exhibition of *Modern Italian Design* organized by the Compagna Nazionale Artigiana, which toured Britain during 1955–56.[14] Also featured in the same exhibition were several tall elegant narrow-necked glass decanters designed by Gio Ponti for Venini.

A more grotesque form of attenuation can be seen in the

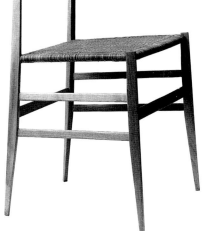

furniture of Carlo Mollino, particularly his armchairs, with their hind legs stretching out alarmingly at the rear, and their sharp armrests projecting perilously at the front. After his extravagances were included in the *Italy at Work* exhibition which toured North America during 1950–51, they were mimicked by the New York furniture designer, Vladimir Kagan, throughout the rest of the decade, although Kagan's designs never quite capture the spirit of daring and excess which came so naturally to the Italian designers.

The tulip phenomenon, however, was not without precedent in the history of Italian art and design. A tendency towards attenuated mannerism can be traced right through, from the paintings of Tintoretto and Parmigianino in the 16th century, to Guardi in the 18th century, and Modigliani in the early 20th century. A closer parallel still can be found in contemporary sculpture in the work of Alberto Giacometti (1901–66), Swiss by birth, but whose name reflects his father's Italian origins. Before the war Giacometti was a surrealist, but after the war he concentrated on sculpture which explored the distortion and attenuation of the human figure. In his 'Femme Debout' of 1949 the body of the standing female figure is drawn out to a stick-like thinness, with exaggeratedly large feet and a tiny head.

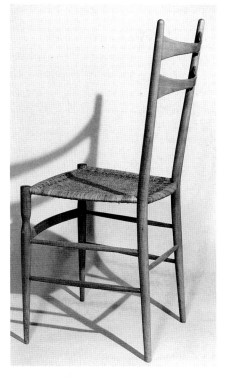

Attenuation in Italian furniture: Gio Ponti's 'Superleggera' chair (above) for Cassina, 1957, a refinement of his earlier 'Leggera' chair of 1952; 'Chiavari' chair (right) by Sanguinetti, the traditional design that inspired Ponti.

Giacometti set the trend for attenuation in sculpture with figures such as his 'Femme Debout' (left), 1949.

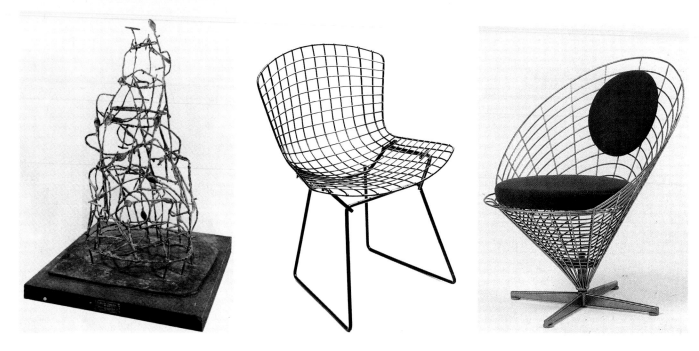

'The Cage' (above) by Eduardo Paolozzi, 1951, typical of the trend towards wiriness in British sculpture.

Wire furniture by the sculptor, Harry Bertoia, for Knoll, 1952 (centre) and by Verner Panton for Plus Linje, 1959 (above right).

Giacometti's sculpture was widely exhibited during the late 1940s and 1950s. Its aesthetic must, therefore, have had a direct influence on the designers of the time, whether consciously or unconsciously absorbed. In general, the more extreme attenuated applied art designs date from the second half of the 1950s, which would allow a suitable time lapse between the introduction of Giacometti's sculptures to a wider public and their influence on the direction of mainstream design.

In Britain Giacometti influenced the austere aesthetics of the new 'iron age' sculptors who emerged after the war, including Lynn Chadwick, Eduardo Paolozzi and Reg Butler. Their work was described by Herbert Read in 1959 as 'close to the nerves, nervous, wiry'[15], a particularly appropriate and evocative description for Chadwick's skeletal 'Dragonfly' mobile, Paolozzi's tense and contorted sculpture, 'The Cage', and Butler's fleshless 'Woman Resting'. Read had noted in 1952 that 'these British sculptors have given sculpture what it never had before – a linear, cursive quality.'[16] Wiriness – attenuation taken to its farthest extreme – was also the main characteristic of much of the furniture and many of the accessories popular in the 1950s, particularly those made from steel rod and steel wire. Both sculptors and designers alike responded in a positive way to metal as a medium for design, and created an aesthetic that was in sympathy with the prevalent mood of the time. The

young Ettore Sottsass, for example, created frenzied abstract expressionist fruit bowls and flower-pot holders out of twisted brass rod.[17] Charles Eames produced a series of designs for steel wire chairs for Herman Miller in the early 1950s; Harry Bertoia created his 'Diamond' chairs for Knoll in 1952; while Verner Panton designed his wire 'Cone' chairs at the end of the decade.

During the 1920s and 1930s tubular steel had been pioneered as the new material for use in furniture design, but it was steel wire, steel rod and steel bar that took over during the 1950s. Whether solid or tubular, increasingly narrow gauges of steel were selected for production, giving post-war furniture its characteristic spindly-legged insect-like appearance. Ilmari Tapiovaara created a range of chairs called 'Daddy Long Legs', while Arne Jacobsen became well known internationally for his famous 'Ant' chairs. In the UK steel rod was first seen in Ernest Race's 'Antelope' and 'Springbok' chairs, designed for the Festival of Britain. By the mid-1950s the market was swamped by steel rod and steel wire accessories of every conceivable shape, size and function, from wall sculptures and fruit bowls, to coat hooks, wall lamps, magazine racks, umbrella stands and tea trolleys. Being so malleable, steel could be bent into just about any shape or form. It was the ideal material for the sculpture-led decade of the 1950s.

A propensity towards attenuation was also characteristic

Attenuation in silver: cutlery (above) by Geoffrey Bellamy, 1957; coffee set (right) by Stuart Devlin, 1959.

of several leading British silversmiths during the second half of the 1950s. Typical of the period were the elegant long-spouted coffee pots made by Gerald Benney, and one of the most striking designs of the decade was Stuart Devlin's silver and nylon coffee set of 1959, the components of which were almost double the height of normal vessels. Cutlery was another area in which metalwork designers indulged their propensity for exaggerated forms. Geoffrey Bellamy produced stunning silver cutlery during the 1950s, characterized by elegantly distorted forms and by extra-long super-thin handles. David Mellor's stainless steel 'Pride' cutlery for Walker and Hall, although less exaggerated in shape, still had an attenuated elegance. In Scandinavia high-quality practical stainless steel cutlery was designed by Folke Arström for Gense in Sweden and by Arne Jacobsen for Michelsen in Denmark. In the latter's 'AJ' range, the handles, the blades of the knives, the prongs of the forks and the wells of the spoons were all conceived as a unified whole, with no unnecessary swelling or tapering of form along their length.

The tulip phenomenon was a difficult device to master, and only designers of the highest calibre, such as Jacobsen, managed to exploit and harness its potential in such a controlled and calculated way. The tendency with most designers was to lose sight of functionalism, and many of their creations, however beautiful, were ill-suited to the practicalities of everyday use, or the commercial demands of mass-production. Jacobsen, however, succeeded twice over in both furniture and cutlery. His work reflects the two extremes of shape to which the post-war designer was drawn, curvilinear form and attenuated form. The former can be seen in the nipped-in contours of his bent plywood 'Ant' chair; the latter in the sleek forms of his 'AJ' cutlery. Yet whilst both designs embody extremes of forms, they are thoroughly practical to use and thoughtfully calculated for mass production. Their success, and the continued appeal of the tulip phenomenon, are indicated by the fact that, over three decades later, both designs are still in production.

Three Legs or Four? – The Problem of Asymmetry

Traditionally, asymmetry in design has always caused controversy. In the mid-18th century commentators opposed to the new French fashion for Rococo were vehement in their criticisms. They interpreted the asymmetrical aspects of the new style as being 'corrupt', 'absurd', and even 'evil'.[18] In 1746 the German critic, Reiffstein, complained that, 'The dislocated and lopsided curvature of these decorations is . . . a French whim', and blamed France for being 'the mistress of so many absurd fashions', and 'the

The master of the tulip phenomenon, Arne Jacobsen, created his 'AJ' cutlery for Michelsen in 1957 (top), and his 'Ant' chair for Fritz Hansen in 1952 (above).

inventor of this corrupt taste'.[19] Similarly, at the end of the 19th century the English designer, Lewis F. Day, warned about the immoral temptations of Art Nouveau: 'We have to be on our guard against a certain spirit of anarchy which appears to have taken possession of so many modern artists. There is a class . . . which will repudiate, not only the laws of art, but the need of all law whatsoever.'[20] By the 'laws of art' he was referring to the classical principles of symmetry and order. In *The Sense of Order*, E.H. Gombrich analyses why people reacted in such a violent way to the introduction of asymmetry into design, and why they felt so threatened by it. His study extends only to the early 20th century, however, and he makes no comment on the most recent flowering of asymmetry in the applied arts after the Second World War. It is this aspect of 1950s design which forms the subject of the final section of the chapter.

The rock and shell motifs of Rococo and the sinuous plant forms of Art Nouveau illustrate how, on two separate occasions, the minute observation of nature resulted in the evolution of a vocabulary of asymmetrical forms. A preoccupation with nature also underlies the inspiration for organic modernism, but because art in general had become increasingly non-representational during the first half of the 20th century, designers no longer felt any obligation to depict nature in a literal way; organic design, therefore, assumed an abstract form.

Underlying this development was the increasingly scientific examination of nature. Under a microscope living organisms take on distinctly abstract qualities and assume a natural, rather than an imposed, asymmetry. Asymmetry in an abstract form was evidently not considered so disturbing as asymmetry in the guise of naturalism, so there was less of a stir when these ideas began to enter general circulation. Peter and Alison Smithson, for example, drew attention to some of the analogies between abstract art and natural phenomena in their photomontage for the *Parallel of Life and Art* exhibition at the ICA, London, in 1953, and it became generally accepted during the 1950s that asymmetrical design based on scientific discovery was a valid reason for defying the established 'sense of order'. This accounts at least in part for the absence of polemic surrounding the re-introduction of asymmetry after the war, another reason being that the old arguments against asymmetry – that it presented nature in a corrupt and perverted form – were no longer relevant. By this date society itself had changed so radically in terms of its moral values and beliefs that ethical criticisms which linked asymmetry with immorality were considered to be inappropriate.

These are some of the negative reasons as to why asymmetry should not have been rejected after the war. The

Asymmetrical vases by Antonia Campi for the Società Ceramica Italiana, 1952.

reason why it was actually welcomed lies not simply in the desire for novelty on the part of the consumer – although no doubt this did play a part in its acceptance – but because asymmetry was perceived in a positive light by both designer and consumer alike as providing a vehicle for greater individuality and self-expression. For the architect, Eero Saarinen, this potential made it particularly attractive: 'Especially in a world of standardisation of people as well as things, this coherent, clear expression of one's own individuality is a necessary goal.'[21]

The emergence of asymmetry in design is often associated with the discovery of a new-found freedom, and with breaking away from an established 'sense of order'. In Italy the Art Nouveau movement was called 'stile liberty', taking its name from the famous department store, but with connotations also of a 'free style'. When asymmetry re-emerged in the late 1940s in the guise of organic modernism, the Italians called this new development 'neo-liberty'. Other people have called it 'freeform' or 'freeflow', but whichever term was used there was always the same emphasis on

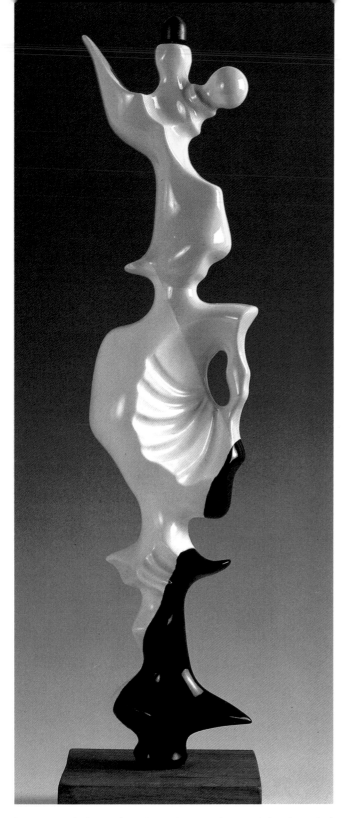

An asymmetrical ceramic sculpture by Antonia Campi for the Società
Ceramica Italiana, 1955, influenced in its shape by motifs in the paintings of
the Surrealist artist, Yves Tanguy.

liberation. Organic modernism enabled the designer to
create his own personal 'sense of order', carrying with it the
freedom, but not the obligation, to explore the potential of
asymmetry.

Asymmetry had an influence in all fields of three-
dimensional design. It was adopted at a surprisingly early
stage by couturiers, who relished the freedom it gave them to
explore the surreal and fantastical possibilities of fashion.
Significantly, the arrival of asymmetry in fashion coincided
with the emergence of Dior's New Look: 'In Paris diagonal
lines and asymmetry are leading trends to follow', *Vogue*
announced in April 1947.[22] In his Autumn 1948 Collection
Dior introduced both the asymmetrical neckline and the
asymmetrical skirt. By the following spring diagonal asym-
metry was all the rage and was reported in the collections of
almost all the leading designers. Quite how comfortable
these outfits were to wear is not recorded. To judge from the
stiff projecting draperies of Dior's 'Envol' skirt, they appear
to have been rather impractical. But the mere fact that the
phenomenon was adopted at all indicates the visual impact it
was deemed to have at the time. Skilfully manipulated it
could be stunning, as in Dior's black satin 'Scissor' skirt of
October 1949. The key to Dior's success was restraint. Other
designers, such as Dessès and Fath, were less disciplined:
they submitted to the temptation of incorporating not just
one, but several, asymmetrical features in a single outfit. The
results were excessive.

Since asymmetry was a spontaneous offshoot of organic
design, naturally the designers who used it most were those
for whom organic design was an instinctive form of
expression, notably the Scandinavians. Finnish glass,
Danish silver, and Swedish ceramics represent the highest
creative achievements of asymmetrical organic modernism.
Of all these media, glass is the most well suited to the
adoption of asymmetrical forms, its natural inclination
being to run out of shape unless contained within a mould.
The glass-maker is constantly countering the gravitational
forces of his raw material in its fluid state.

In Denmark, Per Lütken discovered the potential of glass
to 'design itself' at an early stage in his experiments at
Holmegaard, whilst in Sweden, Gunnar Nylund carried
these initiatives to their logical conclusion in his adventurous
creations at Strömbergshyttan later in the 1950s. In the
hands of these designers, the molten glass was blown, teased,
sheared and pierced into shape, or rather into 'mis-shapes',
for nothing regular would do when something irregular
could be created instead. At Flygsfors, Paul Kedelv created
his wayward and fantastical 'Coquille' bowls, loosely based
on shell forms, and emphasizing the plasticity of the molten
glass.

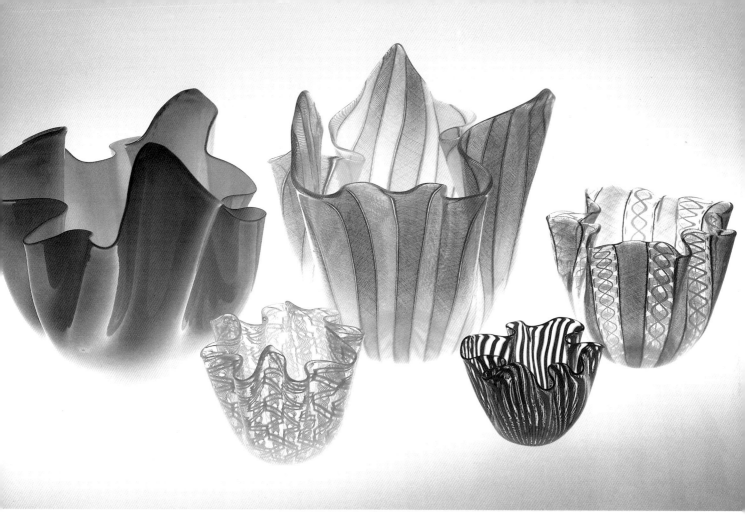

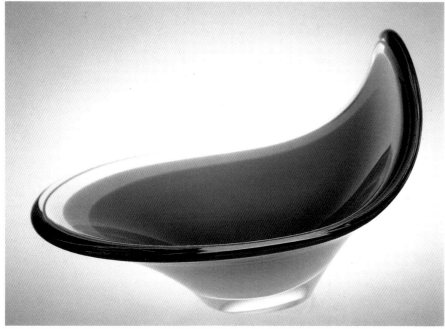

Asymmetry in glass: a group of 'Handkerchief' vases (above) by Venini; 'Coquille' bowl (left) by Paul Kedelv for Flygsfors, 1958, one of an extravagantly asymmetrical series called 'Fantasia'.

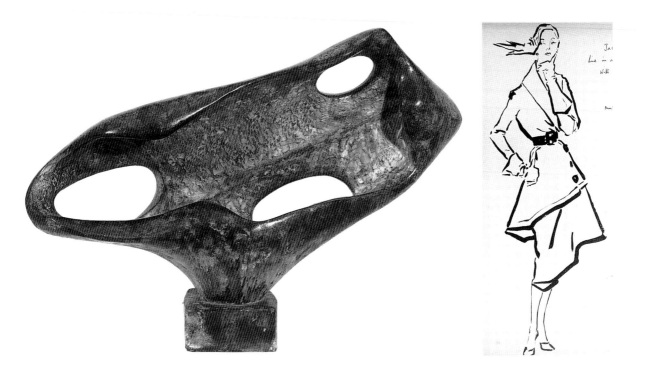

'Sea Form – Porthmeor' (above left) by Barbara Hepworth, 1958. The asymmetrical aspect of Hepworth's work clearly had a strong influence on the work of Timo Sarpaneva, as shown by his 'Pot Hole' sculpture (below) for Iittala from 1952.

An asymmetrical dress (top right) by Jacques Fath from 1951.

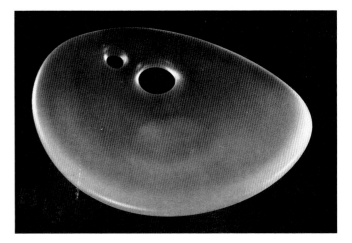

In Finland, Tapio Wirkkala and Timo Sarpaneva exploited moulds for the blowing and casting of irregular-shaped vessels. Wirkkala concentrated on creating 'natural' surfaces, his repertoire including chunks of ice, tree stumps, lichen, and leaves. Sarpaneva's work was more abstract, as in his elegant paddle-shaped 'Lancet' sculptures, and his lopsided 'Orchids'. His most strikingly asymmetrical designs, however, were the pierced 'Pot Hole' sculptures of 1951, also known as 'Devil's Churns', which were strongly influenced by the sculpture of Henry Moore and Barbara Hepworth.

The standard asymmetrical glass bowl from the 1950s was characterized by a gently undulating rim. In Italy, Paolo Venini took this formula to extremes in his 'Handkerchief' vases. His effects were much more contrived and self-conscious than the techniques of the Scandinavians, and revealed the closer affiliations of Italian design with the distorted and melted forms of Daliesque surrealism than with the pure organic surrealism of Arp, to which the Scandinavians were indebted. As this example illustrates, asymmetry not only defied the 'sense of order', in most industries it also undermined the logic of mass production. The hand-made glass of the Italians and the Scandinavians, therefore, was particularly well suited to the adoption of asymmetry. Other European manufacturers were initially more hesitant in their adoption of asymmetry. For them asymmetry was simply the latest in a series of rather bizarre fashions that they were obliged to copy in order to survive commercially. In Germany the respected firm, Rosenthal,

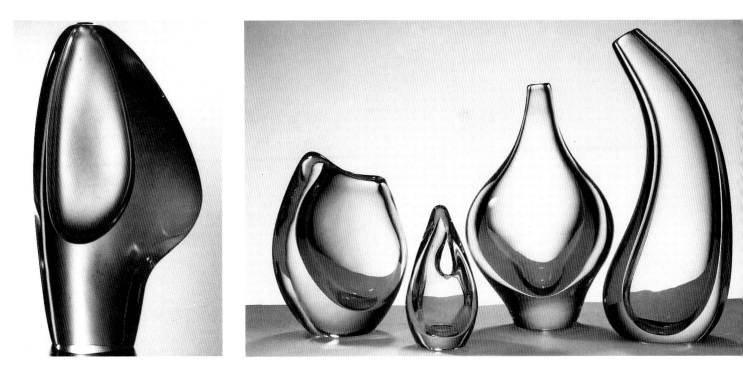

Glass, the most plastic of all the applied arts, could be manipulated into some of the most boldly asymmetrical forms. 'Lancet' sculpture (left) by Timo Sarpaneva for Iittala, 1952. Vases (right) by Gunnar Nylund for Strömbergshyttan.

finally leapt on to the bandwaggon in 1955 with the launch of their 'New Look' range of porcelain designed by Beathe Kuhn, some pieces inspired by Venini's 'Handkerchief' vases. The vogue for asymmetrical tableware and ornaments consequently became particularly pronounced in Eastern Europe, where firms such as Royal Dux in Czechoslovakia and Cmieløw in Poland vied with each other to produce the most extravagant creations.

In the USA and Scandinavia several ceramics firms had embraced the concept of organic design during the 1940s, so that by the 1950s their manufacturing processes were flexible enough to deal with the greater technical demands of increased and advanced asymmetry. In Sweden, where the factory system was particularly supportive of studio pottery, Stig Lindberg freely experimented with organic and asymmetrical forms in his stonewares from the early 1940s, and it was as a result of his breakthroughs in this field that he was able to create designs of such freshness and unconventionality in his production work. This was the beauty of the Scandinavian factory system, that a business geared towards industrial production and financial profit should nurture within it and subsidize a craft from which the creative ideas

for mass production would also flow. Within the industry there was no sense of hierarchy – a hand-made pot was considered to be of equal value to a machine-made pot – but it was recognized that by encouraging experimentation in the field of studio pottery, there would in time be direct benefits for the industry. In the case of Stig Lindberg at Gustavsberg, this was a shrewd investment. The diversity of Lindberg's achievements during the 1940s and 50s was remarkable, from studio stonewares, to serial-produced faience, to mass-produced earthenware and bone china tableware. Into each of these very different ceramic genres he introduced elements of asymmetry, sometimes in shape, sometimes in pattern, sometimes through a combination of form and decoration.

Eva Zeisel's shapes were overtly sculptural, some pieces from the 1940s being strongly influenced by Arp and Moore, such as her organic asymmetrical 'Town and Country' cruet set for the Red Wing Pottery. In her 'Tomorrow's Classic' tableware she seems to be conscious also of recent initiatives in Swedish glass, because the forms in this service aspire towards an increasing plasticity of form, particularly the loop-handled bowls, which resemble pieces from Paul Kedelv's 'Coquille' series at Flygsfors. Few commercial manufacturers in Britain demonstrated as much control as Eva Zeisel. Beswick, for example, produced a range of extraordinary ornamental bowls and vases which defied all the laws of rationality and good taste. Their designs included U-shaped vases, tripod bowls, loop-handled bowls, wavy-edged and shell-shaped bowls, all determinedly asymmetri-

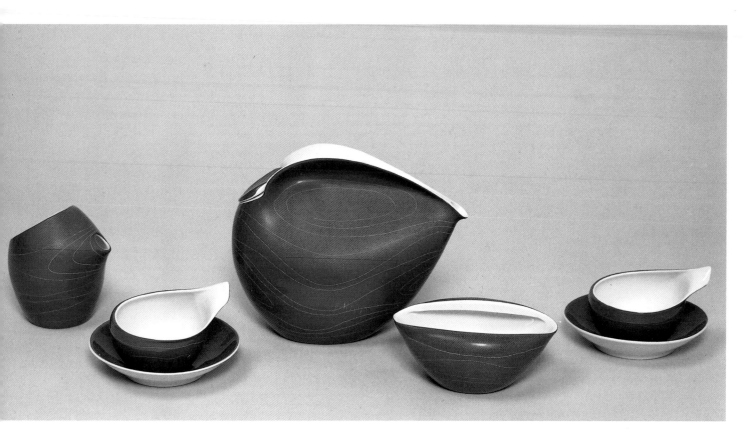

Tea service made by the Polish firm, Cmieløw.

Asymmetry in furniture: Isamu Noguchi's coffee table (above) for Herman Miller from 1945; palette-shaped table (right) made by the British firm, Dennis and Robinson.

cal in form and overloaded with extravagant and gaudy decoration. In the hands of Beswick this was asymmetry gone mad, and it accounts for the strength of the reaction against it in the early 1960s, when vessel shapes once again became almost exclusively cylindrical.

Designers of glass and ceramics had much greater opportunities for creative licence than furniture designers. If a vase or a bowl was outrageously impractical because of its asymmetry, its practical shortcomings could be accepted because it performed a role simply by virtue of being decorative. Furniture, though, had to be functional, and of all the applied arts it took the longest to design and to bring into production. Whereas manufacturers of smaller items could afford to take risks and to experiment, furniture manufacturers could not afford to make mistakes, otherwise their entire business might collapse. This explains why, apart from exceptional circumstances when a designer had his pieces made up independently by a specialized cabinetmaker (as in the case of Carlo Mollino), asymmetry is more rarely found in furniture design. The farthest that most manufacturers were prepared to go was a kidney or palette-shaped coffee table or a chair with three legs – the archetypal asymmetrical coffee table was produced by the sculptor, Isamu Noguchi, for Herman Miller.

Asymmetry taken to extremes in the astonishing creations of Albert Hallam for Beswick, 1954–63 (above).

George Nelson's 'Coconut' chair for Herman Miller, 1955 (below), one of the more successful three-legged chairs from the 1950s.

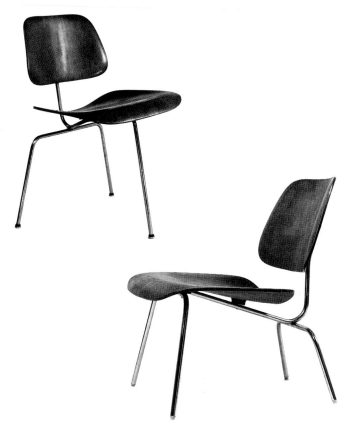

Three legs or four? The DCM and LCM range by Charles Eames for Herman Miller, 1946, seen in its three-legged and four-legged versions.

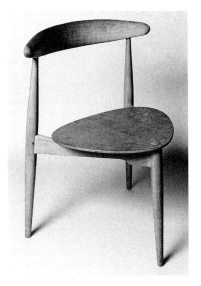

Hans Wegner's popular three-legged chair for Fritz Hansen from 1951 which, like Jacobsen's three-legged 'Ant' chair, was widely exported.

Many of the leading furniture designers of the 1950s experimented with three-legged furniture. Stools were somewhat simpler than chairs. Aalto had succeeded in the 1930s with his bentwood stools, and later in 1954 he came up with another excellent design for a fan-vaulted three-legged stool. Post-war designers working with metal rather than wood, however, encountered serious problems. Tubular steel or steel rod was of a much narrower gauge than bent wood, and it proved less stable when supporting uneven weight distribution. Some designs, such as Charles Eames' DCM plywood chair, were produced initially in three-legged form, but afterwards, when it proved to be unstable, with four legs. Arne Jacobsen's three-legged 'Ant' chair remained in production because of its immense popularity, but Eames had to admit defeat and his three-legged chair was withdrawn. George Nelson achieved greater success with his 'Coconut' chair of 1956, but this was because of its entirely different structure. Whilst two legs were attached to the base of the wedge-shaped seat, the third projected from higher up in the middle of the seatback, thereby offering stability against the risk of over-balancing. In addition, the tubular steel legs were themselves cross-connected by a series of steel rods which further strengthened the understructure of the chair.

A different solution was reached by several Scandinavian designers. Instead of attaching the legs to the underside of the chair seat, they created a separate frame to which the legs were then connected, acting, in effect, like stabilizers on a bike. Such a stool or chair could not so easily be rocked or toppled because the weight of the sitter was re-distributed around the frame, rather than simply travelling down through the legs. Most of the examples along these lines, such as Hans Wegner's three-legged chair of 1951 for Fritz Hansen in Denmark and Ilmari Tapiovaara's 'Tale' stool of 1953 for Asko in Finland, were wooden framed with solid wood legs. Paul Kjaerholm's three-legged 'Armchair II' from 1957 had steel legs forming the verticals to which a curved wooden seatback was attached.

Alexander Calder's solution to the problem of weight distribution was to suspend his asymmetrical sculptures from above, and thus the term 'mobile' evolved. His work had a liberating effect on the Italian lighting designer, Gino Sarfatti, whose asymmetrical pendant lamp (model 2072) from 1953 was an illuminated version of a Calder mobile. As with all asymmetrical design, these pieces stand or fall on the strength of their engineering. In this design Sarfatti proved triumphantly – and against all the odds – that asymmetry was both technically viable and aesthetically worthwhile.

Rug with an organic abstract design made by Danish Carpets.

4·New Patterns

From 'Doodledash' to 'Pythagoras' –
New Directions in Pattern-Making

In the early 1950s international design was hit by the second wave of the New Look. After the re-shaping of three-dimensional form came the re-structuring of pattern. During the course of the decade people gradually became less intimidated by unadulterated abstract design. There was still a widespread distrust of contemporary abstract painting, but by the end of the 1950s the fashion in interior decoration was for modern design based closely, sometimes directly, on the latest developments in abstraction. Abstract patterns not only permeated but came to dominate all levels of the market – a process of assimilation that Jennifer Harris has described as the 'democratization of avant-garde design'.[1] The market was literally swamped, and abstract patterns seemed a natural choice for a much wider range of people than ever before.

There was a noticeable quickening of pace in the acceptance of abstract design, reflected in the degree to which it became generally available. For most people setting up home during the late 1950s it was a genuinely popular choice. For abstract pattern design to have become a mass instinct shows how deeply it had been absorbed into the public consciousness. By the end of the 1950s the New Look in abstract decoration had penetrated into almost everyone's home, whether in the form of a formica-topped table, kitchen curtains, living-room wallpaper, bathroom linoleum, or a bedroom rug. E.H. Gombrich comments on this quickening of momentum during the 20th century and remarks: 'Any number of Ph.D theses await being written about the influence of Cubism, of Tachism, of Op or Pop art on fabrics and wallpaper and about the decreasing time lag with which these inventions are taken up and spread throughout industry.'[2] What follows is a preliminary investigation into this subject.

To study in detail every manifestation of abstraction in the applied arts during the 1950s would be an impossible task. In addition to textiles, wallpapers and ceramics,

'Landscape Study' by Nicolas de Staël, 1952. This type of painterly abstraction using bold brushstrokes had a strong influence on many textile designs produced during the second half of the decade.

abstraction also appears in glass, and in new materials such as vinyl and formica. Furthermore, each country produced its own variation or set of variations on this theme. These differed according to circumstances, such as the exposure given to certain artists or certain types of abstraction within a particular country, and the amount of freedom and encouragement given to designers by the manufacturers for whom they worked. The situation is complicated by the fact that, whilst some of the sources of abstraction in the applied arts are readily apparent, others are more obscure because of the decline in the reputation of particular artists who were popular at the time. Many people are familiar with the names of artists such as Jackson Pollock, Sam Francis and Nicholas de Staël, for example, but they are less familiar with many of the Paris-based artists and the flourishing abstract art scene in post-war Italy. It should also be remembered that it was not necessarily the major artists who acted as the primary source of inspiration on pattern designers; their work was not always appropriate for transformation into a design, being perhaps too complex, too bold or too individual. What designers responded to were paintings that could be easily assimilated by the viewer and easily broken down into the constituents of a pattern. Sometimes it is the less ambitious works by well-known artists that bear the closest similarities; sometimes it is simply the works of lesser artists. Except in rare instances – usually involving the artists themselves working as designers[3] – it is generally impossible to pin down

the precise source of inspiration (in other words, a specific painting) that can be linked with a particular design. Moreover, designers themselves took on the role of artists and played a part in forwarding the progress of the visual arts. Some of the best designs of the period should be considered in this light.

What, then, were the main variants of abstraction, and which branches of the applied arts did they influence most strongly? During the early 1940s, except in those countries unaffected by the war, such as Sweden, there was a hiatus in the development of pattern design. At Gustavsberg, Stig Lindberg evolved a fresh new pattern style based on organic motifs, sometimes abstract, sometimes representational, which he adapted both to hand-painted ceramics and, from around 1947, to his printed textiles for Nordiska Kompaniet. Thus originated the close links between industrial ceramics and textile pattern design that were to continue to develop during the first half of the 1950s in Britain and Scandinavia. The style of these proto-abstract patterns was simple, small-scale and rhythmic, with designs composed of controlled linear or curvilinear patterns. It reached its peak of refinement in the hand-painted ceramics designed by Alfred Burgess Read at Poole Pottery from 1952 to 1958.

As indicated in Chapter Two, the artists who had the strongest influence on pattern design in the early years of the 1950s were Paul Klee and Joan Miró. The vibrant colours, primitive style and quirky imagery of Paul Klee were

Artist-designed and art-inspired textiles were an important British contribution to 1950s design.

'Elegance' (above left) by Paule Vézelay for Heal's, 1956. 'Spectators' (above right) by Lucienne Day for Heal's, 1954. Textiles for David Whitehead by John Piper (left) and Henry Moore (below right).

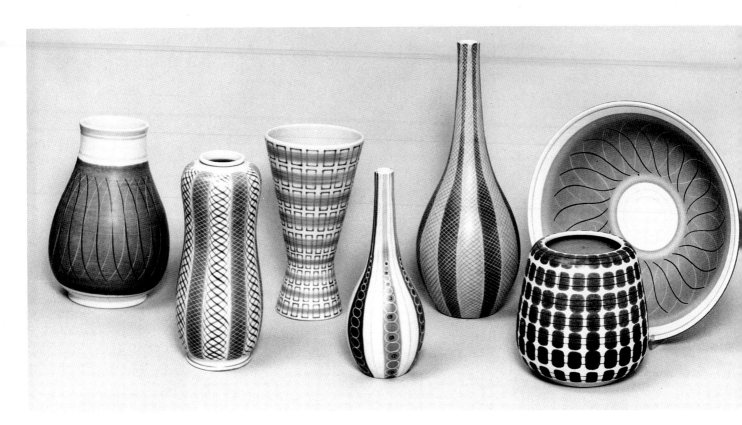

Group of Poole Pottery with designs by A.B. Read, hand-painted in a rhythmic linear abstract style.

particularly important influences on the aesthetics of pattern-making in the 1950s. For Klee, 'Colour was energy. It was emotion that established the mood of the painting within which the line established the action.'[4] His work had a decided appeal for the Italians, whose approach to colour and pattern was similarly uninhibited. During the 1940s Miró had produced a series of paintings called 'Constellations', composed of a multitude of teaming linear and organic motifs scattered all over the canvas like a galaxy of stars. Many of the textiles produced by American designers such as Paul McCobb and Ben Rose exploited a similar formula. Whereas some designers, such as McCobb, made their representational designs appear abstract by reducing the size of the motifs, others, such as the Finnish designers Maija Isola, and Annikki and Ilmari Tapiovaara, reversed the process, blowing up their designs onto a huge scale, as seen in the Tapiovaaras' '2 & 3' nursery textile for Heal's.

Miró's linear graphic style was clearly a source of inspiration for the spontaneous and energetic textile designs of Lucienne Day although she herself also points to the stimulus of Klee on her work. Unlike some designers, Day absorbed the Miró aesthetic without resorting to copying his style in a literal way. She had the designer's skill of transforming a potential painting into a pattern by identifying and isolating the repeatable elements, reducing or enlarging their scale, and reordering them into a varied but visually cohesive system. This ability to differentiate between what was appropriate for an abstract painting and what was suitable for an abstract textile was at the centre of Day's achievement, and is a measure of her creative genius. The design for which Lucienne Day is justly well known is 'Calyx', produced as a printed linen for Heal's. The cupped shapes and spindly lines of this textile were to become hallmarks of 1950s pattern design.[5] Also innovative was Day's choice of colours, and the use of several different overlaid abstract patterns within the composition. 'Calyx' represented a statement of total commitment to the concept of abstract pattern-making.

In this work the New Look in textile design was born, the first of two New Looks in pattern design to emerge in the 1950s. Shortly afterwards Day was commissioned by British Celanese to design prints for the new synthetic fabric, acetate rayon. Her solutions were startlingly original, and the combination of these designs with this material was a major innovation. One of the best of them is 'Perpetua' (1953),[6] whose springy rhythms have a tremendous physical dynamism. As Paul Reilly commented in 1952: 'These patterns are not stepping stones bridging the gulf between the traditional and the experimental. They are boldly

original and advanced.'[7] Day's work was always instantly recognizable for its freshness and originality. Like Miró and Klee her designs were intended to stimulate both the eye and mind, and they sometimes incorporated amusing visual puns, such as the abstracted bespectacled figures in 'Spectators', which also shows the indirect influence of Giacometti in the attenuation of the stick-like people in the crowd.

Miró's influence was particularly strongly felt in Germany, where some of Elsbeth Kupferoth's textile designs were close and fairly literal transcriptions of Miró's aesthetic formula. At Rosenthal, Beathe Kuhn devised linear sgraffito patterns for her 'New Look' range of freeform porcelain bowls and vases which were also overtly inspired by the work of Miró. Rosenthal commissioned shapes and surface patterns from designers working in many different fields, including Lucienne Day, illustrating that, as in Sweden, the links between ceramics and textiles were becoming increasingly well established. Similar ties between the two industries also evolved in the UK and Italy at this time. Terence Conran, for example, designed patterns for both David Whitehead textiles and Midwinter tableware. In one case, with a design called 'Chequers', the same pattern was reproduced in the two different media.

In Italy, Gio Ponti designed co-ordinated ceramics and table linen, inspired no doubt by his friend and collaborator, Piero Fornasetti, whose unusual decorative printed designs were exploited in just about every branch of the applied arts, from lampshades, to porcelain plates, to wooden furniture, to metal umbrella stands, to printed dress fabrics and

Some surface patterns were considered suitable for different media: 'Graphica' (above), a printed textile by Lucienne Day for Heal's in 1954, reappeared in a slightly modified form as a wallpaper for Rasch the following year; Terence Conran's 'Chequers' tableware for Midwinter (left), 1957, was originally conceived as a furnishing fabric for David Whitehead in 1951.

The splash paintings of the American abstract expressionist, Sam Francis, such as this watercolour from 1957 (opposite above), clearly had an influence on contemporary textiles and wallpapers.

be considered suitable as a wallpaper in another country – as in the case of a Lucienne Day design which appeared in the UK as a textile called 'Graphica' produced by Heal's, and in Germany as a wallpaper called 'Prisma' produced by Rasch. However, during the 1950s various American companies, such as Schumacher, and independent designer-makers, such as Ben Rose, began to produce both textiles and wallpapers; and in Germany, Elsbeth Kupferoth was the first to design co-ordinated textiles and wallpapers, working for the firm of Emtex.[9] Nevertheless, in general at this date it was still rare for textiles and wallpapers to be produced with the same design, particularly in countries such as Britain where the two industries were structurally entirely separate, and it was rarer still to find ranges of co-ordinated textiles and wallpapers. People tended to look for colour and pattern contrasts within their interior schemes, rather than the type of co-ordination that has become fashionable today.

Textile manufacturers tended to take the lead over wallpaper manufacturers in adopting the more progressive forms of abstract design. The reason for this was the different uses to which their products were put. Wallpapers were used to cover a large area within a room, and were not expected to be over-dominant. Furnishing textiles, on the other hand, generally acted as a highlight within an interior, and were expected to be more eye-catching. During the 1950s,

tablecloths. Ettore Sottsass, another chameleon figure from the Italian design scene of the 1950s, also designed textiles and ceramics during the course of the decade, although in his case the designs for each medium were unrelated. It seems, however, that most designers who made a habit of working in the different disciplines usually recognized an opportunity for a cross-over between the two camps. The multi-disciplinary nature of pattern design, particularly abstract pattern design, was the basic principle underlying the innovative Festival Pattern Group scheme in 1951, whereby abstract patterns based on crystal structures were devised for application within a variety of different media.[8]

The work of Lucienne Day, June Lyon, Cuno Fischer and Elsbeth Kupferoth, who all worked as textile and wallpaper designers during the 1950s, illustrates the increasingly strong links between these two media. In addition, there were also a number of commercial studios that served the two industries concurrently, such as Willy Herrmann in Berlin and the Werkkunstschule at Krefeld in West Germany. Interestingly, what was acceptable as a textile in one country, might

Both Cliff Holden's 'Carnival' wallpaper (opposite below), produced for
John Line at the end of the decade, and Harold Cohen's dramatic 'Vineyard'
furnishing fabric (above), designed for Heal's in 1959, show the impact of
this 'dynamic new aesthetic'.

'Number 23' by Jackson Pollock, 1948. The swirling lines of Pollock's action paintings inspired many textiles (opposite), as well as silver and glass (overleaf).

however, as wallpaper manufacturers began to produce strongly patterned abstract prints, they had to invent for their consumers an entirely different way of decorating a room, in order to avoid an excess of visual over-stimulation. Their solution was to promote the idea of using either two contrasting wallpapers in different areas of the same room, one a background paper, the other a primary design intended as the focal point of the scheme; or else to combine some plain painted walls with papered walls or alcoves, so that the effect of the whole was not too overwhelming, and the eye had somewhere to rest without being bombarded by pattern. Magazines such as *House and Garden* worked closely with manufacturers to promote new ideas in home decoration.

During the second quarter of the 1950s the second wave of the New Look in pattern design began to sweep through America and Europe. This time the inspiration came from the most recent developments in contemporary painting – from American abstract expressionism and European 'tachisme' – and because of the second wave's immediacy there was a tremendous sense of urgency and excitement about its introduction. Designers were conscious of participating in a revolution, and the liberation in painting techniques and aesthetics was to have a direct impact on the development of the applied arts. Two main varieties of abstract patterns emerged, based on different techniques of expressionist or tachist painting (from the French word 'tache' meaning blot, drip or stain). One group of designs was based on the drip paintings of Jackson Pollock, rhythmic,

swirling and strongly linear; and another group was based on the paint-splash effects of Sam Francis.

As with the New Look in shape design, the first and boldest initiatives in the revolutionizing of pattern design took place in the field of fashion. This time, however, it was not the couturiers who led the way but the textile manufacturers who served them. In the world of haute couture there was a distinct shift in emphasis during the second quarter of the 1950s which gave increased prominence to printed dress fabrics. Innovative fabric manufacturers, such as Ascher, rose to international prominence. The art-conscious Zika and Lida Ascher were, in fact, the first manufacturers in any media to appreciate the design potential of the new developments in abstract painting. As early as 1947 Gerald Wilde designed a bold abstract print for Ascher which captured all the excitement of action painting just as it was breaking onto the international art scene.[10] Scaled down and toned down as it is when compared to the vast and colourful canvases of Jackson Pollock, this print nevertheless captures the rhythm and energy of abstract expressionism. It was, however, unrepresentative of the majority of designs being produced by other manufacturers immediately after the war, with the exception of the fabric and dress manufacturer, Horrockses, which produced a series of interesting scribbly and blotted abstract patterns from the late 1940s onwards. In general it was not until 1953 that abstract expressionist-inspired dress fabrics were widely produced, which makes the early initiatives of Ascher and Horrockses all the more remarkable.

The adoption of abstract expressionist dress fabrics by top couturiers was one of the most exciting new developments in fashion design during the early 1950s. Always receptive to new initiatives in fabric design, Christian Dior created a ready-to-wear suit in 1953 made from silk printed with a startling tachist blot design. In the same year Horrockses produced an evening dress printed in black with an ink splash pattern. Adverts show that within a year the New Look in dress fabrics had permeated the mass market: in 1954 Jollita nylon dresses were printed with scribbly abstract patterns, and Marchington was advertising its 'Everglaze' cottons, including an evocative design called 'Dot Dash'.[11]

Abstract expressionist furnishing textiles began to appear on the market at about the same time. A Morton Sundour print called 'Pirouette', designed by Azia Martinelli, was illustrated in the *Studio Yearbook* of 1953–54. It reproduced the effect of a Jackson Pollock painting very closely and was printed in primary colours: 'Naples yellow, celadon, stained glass blue and Pompeian red'.[12] Also in 1954 the Swedish firm, Stigens Fabriker, launched their new photoprinted

fabrics. This innovative technique enabled them to reproduce in exact detail the most complex artistic designs, amongst which was an astonishing abstract expressionist pattern by the normally restrained designer, Astrid Sampe.[13] Although this design was clearly a one-off, it showed the force of the impact that Pollock's work must have had on Sampe for her to have temporarily abandoned her dictum, 'Order is Liberty'.[14] For other artists, such as Aagaard Andersen in Denmark and Louis Le Brocquy in Britain, it was not so surprising that they should respond so immediately and enthusiastically to the work of Pollock and Francis. In 1956 the progressive Danish textile firm, Unika-Vaev, produced two prints by Andersen called 'Doodlepoint' and 'Doodledash', the latter representing a free pattern of criss-crossing lines in the manner of Jackson Pollock, and the former reproducing the blurred paint-splash effects of Sam Francis. As their titles indicate, these works did not purport to be entirely serious – they were lighthearted 'doodles' aping the styles of the Americans – but that did not make them any less powerful as furnishing fabrics.

Different countries responded at different rates, depending on the exposure given to the new painting in terms of exhibitions. Denmark was an important art centre in the 1950s, being part of the pan-European CoBrA movement linking Copenhagen, Brussels and Amsterdam. Britain was rather more isolated and it was not until the mid-1950s that major exhibitions of American abstract painting were finally held there. Consequently, it was only towards the end of the decade that the effect of this aesthetic was fully absorbed into

Dress fabrics were liberated by the freedom of abstract expressionism: 'Dot Dash' dress (inset, above left) by Marchington, 1954; detail of printed cotton (background, above left) by Horrockses, c.1953; detail of printed silk (above right) in a dress sold by the Edinburgh department store, Jenners, 1960; suit (right) by Christian Dior, 1953.

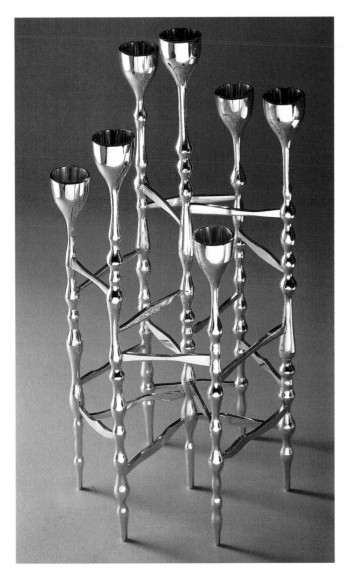

Silver candelabrum by Robert Welch, 1958, inspired by a visit to a Jackson Pollock exhibition.

and later in other parts of Europe – in which trails of coloured glass were swirled around within a matrix of clear crystal. At Maastricht, in the designs of Max Verboeket, the vessel shapes themselves were also manipulated into twisted and exaggerated forms. Finally, in Norway, the glass designer, Arne Jon Jutrem, devised a method of decoration which was closely based on that of Pollock, in which molten coloured glass was trailed on the surface of the vessel, thereby replicating the actual technique of action painting.

As well as the vigorous American-style abstract expressionism there were a number of other forms of painterly abstraction current in the applied arts during the 1950s. The painters of the School of Paris – some of French origin, others from different parts of Europe – explored many different abstract styles, some forceful and expressionistic, some lyrical and impressionistic. Nicolas de Staël painted blocks of colour in dynamic configurations, sometimes harsh, sometimes harmonious; Hans Hartung exploited the calligraphic potential of the brushstroke in a quasi-oriental manner; whilst Roger Bissière used all-over grid patterns to provide a cohesive structure for his carefully wrought abstractions. Of the three, Bissière, although the least well known, was probably the most important and influential. Many of the younger generation of French abstract artists who came to prominence during the 1950s studied with him, including Jean Bazaine, Alfred Manessier and Gustave Singier, and he instilled in his pupils the importance of technical control. His advice to his pupils was 'Ne vous jetez pas sur votre papier ou sur votre toile et ne commencez pas à les couvrir au hasard.'[15] ('Don't throw yourself at your paper or your canvas, and don't begin to cover them in an arbitrary way.') It is this quality of restraint which distinguishes Bissière from his American counterparts (excluding Philip Guston) and which makes his work so suitable for assimilation by abstract pattern designers.

Italian and American textiles from the mid-1950s, and British wallpapers and Czechoslovakian glass from the late 1950s, all show abstract design being widely exploited in a mature and confident manner. In Italy, particularly, the links between art and design were very strong at this time. Architect-trained artist-designers, such as Ettore Sottsass and Roberto Sambonet, moved freely from one medium to another, and artists and sculptors such as Gio Pomodoro and Lucio Fontana switched effortlessly from art to design. In the UK and the USA, when an artist was invited to design a textile it was presented as something rather out of the ordinary, and the resulting design was often self-conscious. In Italy artist-designed or art-inspired textiles were considered perfectly normal, and their creators achieved an enviable spontaneity.

textiles and wallpapers. The excitement of the new art also triggered off aesthetic responses in three-dimensional design. The metalwork designer, Robert Welch, for example, responded enthusiastically to an exhibition of Jackson Pollock's work at the Whitechapel Art Gallery in 1958, producing a seven-light candelabrum which was a three-dimensional version of a drip painting. As in the case of Sampe, Welch's other work from this period was controlled and understated, which makes his buoyant response to Pollock all the more interesting and significant. Pollock's work was the inspiration for the abstract expressionist glass – produced first of all in Sweden by Vicke Lindstrand at Kosta,

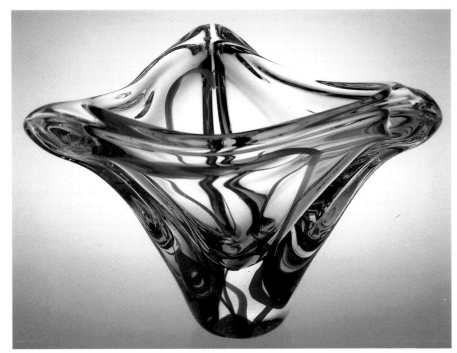

Painterly abstraction was adopted in many branches of the applied arts during the late 1950s: furnishing fabric (above left) by Donald Hamilton Fraser for David Whitehead, 1960; glass bowl (left) by Max Verboeket for Maastricht; plate (top, above) by Jessie Tait for Midwinter, 1959; glass vase (above) with enamelled tachist decoration by Vladimir Kopecký, 1959.

Abstract expressionism in glass: surface decoration on a vase by Arne Jon Jutrem for Hadeland, 1955; 'Abstract' vase with internal decoration, by Vicke Lindstrand for Kosta.

'Pythagoras' furnishing fabric by Sven Markelius for Nordiska Kompaniet, 1952, illustrating the taste for geometric abstraction in Sweden.

The evocation of texture as a form of abstraction became increasingly important during the course of the 1950s in textiles and later in wallpaper. In America bold textural abstract printed textiles, such as the designs of Sara Provan for Konwiser, were also being produced from the first half of the 1950s. Rolf Middelboe in Denmark created some stark textural designs for Unika-Vaev; whilst in Britain David Whitehead successfully recreated the textural effects of Donald Hamilton Fraser's bold abstract oil paintings.

Textiles and wallpapers were not the only media to be decorated with art-inspired abstract designs. Ceramics and glass also provided a surface which could be decorated either by hand or by mechanical means with abstract patterns. Jessie Tait, the resident pattern designer at Midwinter during the 1950s, produced over thirty different patterns during the course of the decade, many in the 'contemporary' abstract style. It was rare, however, to find a medium other than textiles or wallpapers being used creatively as a means of furthering the development of abstract art, the one remarkable exception being Czechoslovakian glass. In Czechoslo-

vakia some of the country's most talented artists were employed as glass designers. Leading abstractionists producing avant-garde designs included Karel Vaňura and Vladimír Kopecký. The latter used opaque enamels like oil paint, completely covering the surface of his vessels with painterly tachist abstractions.

The final development in abstract pattern design during the 1950s occurred when the textile designers finally caught up with, and in some cases outstripped, the artists. At the forefront of these initiatives was Sweden, whose course of development in textile design had remained independent of trends elsewhere in Europe after the war. In the 1950s two major designers emerged, Astrid Sampe and Viola Gråsten, whose geometrical printed and woven designs went against the prevailing fashion for organic abstraction and overtly painterly textiles at the time. The almost mathematical approach of the Swedes was epitomized in a design called 'Pythagoras' by Sven Markelius. Markelius had been an important designer during the 1930s, so it is possible that he had never entirely renounced his attachment to geometrical abstraction from this earlier period. Whatever the reason for the singularity of the Swedes, their work undoubtedly prefigured Op art and other forms of geometric abstraction during the 1960s.

Mix and Match – New Ideas About Colour

Colour, along with everything else, had been strictly rationed during the war. For more than half a decade Europe had been starved of visual stimulation, so that when austerity came to an end, widespread indulgence in extremes of colour, whether in curtains, carpets or shades of lipstick, was peculiarly intense. There is an unfair tendency, however, to think of the 1950s as a period of complete anarchy in the use of colour. Liberated it certainly was, but anarchic it was not, a fact underlined by initiatives such as the carefully planned *House and Garden* colour scheme launched in the early 1950s. Furthermore, in Sweden and the USA there was a growing interest in colour psychology during the 1940s and 50s, which was the motivation behind many of the developments taking place.

In Sweden, for example, Stig Lindberg designed a series of faience vessels called 'Spektralöv' or 'Spectrum Leaf' in 1947, painted with bands of stylized leaves in the different colours of the spectrum. Lindberg also employed a wide range of bright colours in his lively organic textile designs for Nordiska Kompaniet in the late 1940s. A more rigorous analytical approach to colour planning was apparent in the work of Astrid Sampe, head of the Textile Design Studio at NK during the 1950s. Her geometrical 'Windy Way' printed textile was restricted to one colour only, such as green or black, printed in graduated bands of varying tonal intensity.

The use of bright colour and intricate patterning in 1950s glass is usually associated with Italy rather than Sweden, in particular the multi-coloured 'Patchwork' vases produced by Venini and Barovier and Toso. At Orrefors, however, Sven Palmqvist had been experimenting with the use of colour in his 'Ravenna' bowls since 1948. Inspired by the colourful Byzantine mosaics at Ravenna, Palmqvist perfected a technique whereby pockets of coloured glass and gilding were encased in arch-shaped windows in the thick walls of the vessel. The visual effect of these pieces is of the translucency and vividness of stained glass combined with the richness and pattern of mosaic.

During the early 1950s Sven Palmqvist also developed the functional 'Colora' range of centrifugally cast bowls, produced in a variety of opaque colours, such as yellow, orange, blue, green and black, and intended for combined mixed-colour use. The concept of 'mix and match', however, was not a Swedish one: it derived from Russel Wright's 'American Modern' tableware at the end of the 1930s. This service was revolutionary for two reasons: its organic streamlined shapes, and its co-ordinated coloured glazes. 'American Modern' was produced initially in four colours: Seafoam Blue, Bean Brown, Granite Grey and Chartreuse Curry; later three more colours were added, so that altogether seven different colours could be combined within a single table setting. Following Wright's lead, Eva Zeisel also exploited mixed colour glazes in her 'Town and Country' dinnerware

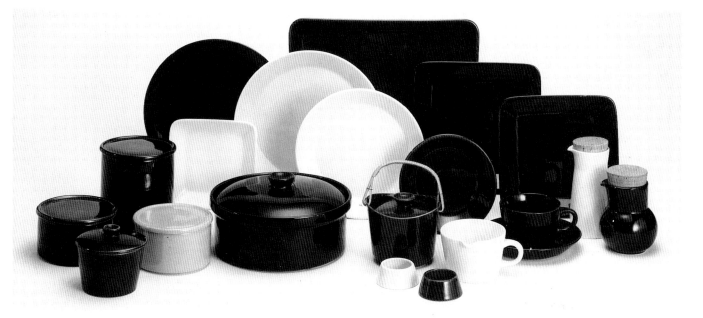

Mix and match: 'Kilta' tableware designed by Kaj Franck for Arabia in 1948, based on the principle of mixed colour use.

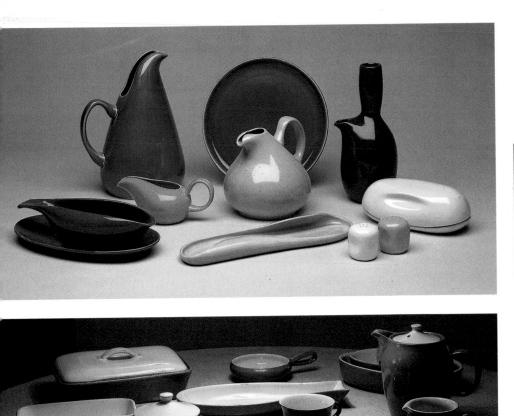

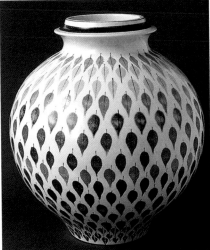

Colour planning in ceramics: Russel Wright's 'American Modern' tableware for Steubenville from the late 1930s and his 'Casual China' for Iroquois from the mid-1940s were the earliest examples of the mix-and-match concept in ceramics (above left); two-tone tableware by Denby, giving a new look to traditional stoneware (left); 'Spectrum Leaf' vase by Stig Lindberg for Gustavsberg, exploiting the bright colours of tin-glazed earthenware to calculated effect (above).

for the Red Wing Pottery in 1946. Through their relaxed and flexible approach to colour co-ordination, Wright and Zeisel created a casual style of tableware in tune with the increasingly informal lifestyle being adopted in America at this time. The 'Town and Country' service was so flexible, in fact, that even the different coloured lids were interchangeable.

These revolutionary ideas about 'mix and match' tableware quickly caught on in other countries, although not always for the same reasons as in America. Kaj Franck's 'Kilta' dinnerware in Finland, for example, was produced in a range of five colours: white, black, green, blue and yellow.

It was created shortly after the war in 1948 in response to the urgent need for a basic range of inexpensive functional tableware, highly flexible in both form and decoration, which, at a time of continued shortages, would break the public habit of purchasing specialized and inflexible dinner services. Franck later extended this 'mix and match' colour concept to his functional glassware for Nuutajärvi, and Saara Hopea applied similar principles to her richly coloured stacking tumbler set of 1952 for the same firm. At Iittala, Timo Sarpaneva adopted the same ideas in his 'i-glass' series of coloured plates, bottles and drinking glasses in 1956. They were produced in delicate shades of lilac-grey, blue-grey,

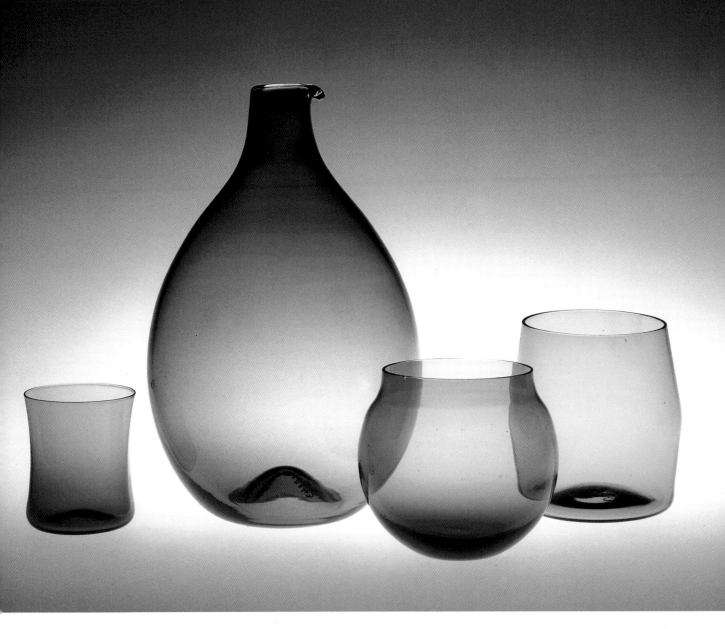

Colour planning in glass: Timo Sarpaneva's 'i-glass' series for Iittala, 1956, making use of the mix-and-match concept originated in ceramics; 'Ravenna' bowl (below) by Sven Palmqvist for Orrefors; vase (right) by Floris Meydam for Leerdam, exploiting the potential for rich, controlled colouring in glass.

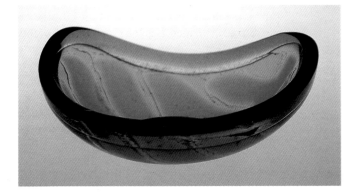

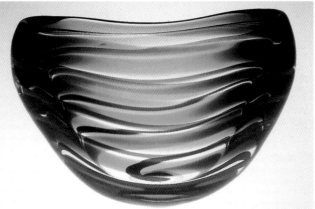

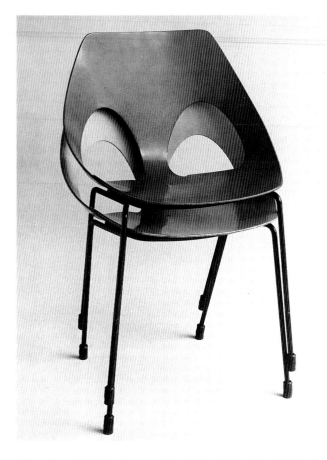

Mix-and-match in furniture: stacking chairs designed by Carl Jacobs for Kandya, 1950, painted in primary colours influenced by Mondrian.

smoke-grey and green-grey, and each of the colours was subtly related so that they blended perfectly in any combination.

As the work of these designers shows, the distinctiveness of 1950s colour schemes goes far beyond the use of clashing colours, although bright colours and sharp colour contrasts were a feature of the period, as seen in the ceramics of Marcello Fantoni and Salvatore Meli, and the glass of Fulvio Bianconi and Flavio Poli in Italy. Extremely popular during the 1950s were the so-called 'Harlequin' pottery services, in which each place setting was supplied in a different colourway. This idea evolved from Frederick Rhead's 'Fiesta' tableware, produced from 1937 by the Homer Laughlin China Company in New Jersey, in which the various components were glazed in bright colours such as red, yellow, blue and green. The 'Harlequin' concept was refined during the 1950s so that plain coloured surfaces were also co-ordinated with patterned surfaces. A typical coffee service, for example, might have rainbow-coloured saucers with interchangeable multi-coloured patterned cups. The

'Harlequin' concept was also applied to other products apart from ceramics, most notably furniture. Seat furniture, such as Charles Eames's moulded plastic chairs, Gio Ponti's 'Superleggera' chairs, Ernest Race's 'Antelope' chairs, and the popular stacking chairs produced by the British firm, Kandya, were all supplied in a range of bright colours.

Also evolved during the 1930s, but popularized during the 1950s, was the concept of two-tone tableware. According to this formula the interior and exterior surfaces of each vessel were decorated with glazes in contrasting colours. The best-known example was Poole Pottery's 'Twintone' service, produced in combinations such as Sepia and Mushroom or Seagull and Ice Green, but the same idea was used by many other manufacturers, such as Denby, which produced an attractive service in the popular colourway of yellow and grey.

Some of the influences on the use of colour in 1950s design date back to the art of previous decades. The use of primary colours, for example, can be traced back to the paintings of Piet Mondrian from the 1920s and 30s. In his uncompromising grid structure compositions, Mondrian concentrated on the visual impact of pure geometric abstract form and pure colour. His aesthetic was the main source of inspiration for the designers of the De Stijl movement, and later, similar colour effects were also used by Miró and Calder. Whilst Mondrian's paintings of the 1920s and 30s have an oriental purity and simplicity, when he moved to New York in the 1940s, there was a sudden change of mood in his work. Paintings such as 'Broadway Boogie Woogie' from 1942–43 pulsate with a new exuberance and vigour, inspired by the rhythms of jazz and the tempo of city life.[16] It was this more positive upbeat use of colour and the increased dynamism of its application that influenced the aesthetic of the American abstract expressionists after the war. Through these younger artists, and also through the mobiles of Calder and the paintings of Miró, Mondrian's colour principles were adopted by a second generation of designers in the 1950s. This time they were to have a much more widespread and profound impact on the applied arts than the limited and localized effect of the De Stijl movement.

Their influence can be traced directly in the work of certain designers, such as Gino Sarfatti. As we have seen, in his model 2072 hanging lamp of 1953 for Arteluce the debt to Calder in the structure of the mobile lighting device is undisguised. Colour is the key to the success of this striking and unusual hanging lamp, which is composed of five suspended circular convex lampshades in blue, red, yellow, white and brown perspex. Sarfatti demonstrates that the use of contrasting primary colours need not result in disunity or disharmony. It is, in fact, the stunning use of colour that acts

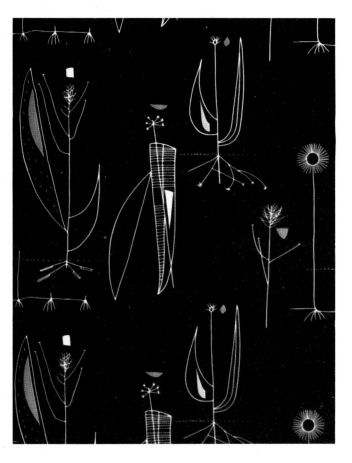

Many British 1950s textile designs made bold use of primary colour highlights, as in Lucienne Day's 'Herb Anthony' furnishing fabric for Heal's from 1954.

as the main focal point in this design. Calder's mobiles directly inspired at least one British textile design – June Lyon's 'Mobile' printed cotton for Heal's of 1954 – and indirectly influenced the colour schemes of many more, such as Lucienne Day's 'Herb Anthony' (also 1954), which used dynamic highlights in primary colours. In 1952 *Vogue Export* commented on some of the reasons for the New Look in textile colourways: 'The new fabrics use colour intensively, although the fourteen to twenty colours used in traditional fabrics have been reduced to between three to six colours used in sharply defined colour masses. Strong colours are often accentuated by the introduction of black into the pattern. Colours are now truer and brighter than they were before because technical improvements have increased the number of colours available in fast vat dyes and allow them to be used in stronger concentrations.'[17]

It was during the second half of the 1950s that some of the more astonishing colours and colour combinations came into circulation, with American designers taking the lead in their development. The textile divisions at Knoll and

Herman Miller played a key role in manipulating public taste: they not only produced printed curtain materials, but also woven upholstery fabrics and coloured vinyls for use as seat coverings on their company's furniture. Eszter Haraszty at Knoll, for example, introduced the hitherto taboo combination of orange and pink. Her innovations attracted international attention. *Domus* presented a special feature on 'The Colours of Eszter Haraszty' showing a living room in three different shades of shocking pink.[18] Also fearless and iconoclastic in his use of colour was the architect, Alexander Girard, head of Herman Miller's textile division from 1952. Speaking of the early 1950s he recalls: 'In those days a brilliant pink or magenta carried a connotation of double-barrelled horror',[19] yet these were exactly the sort of colours he sought to introduce. A feature on Girard's design for the new Herman Miller showrooms in San Francisco in *Domus* captures the essence of his highly decorative approach to furnishings and interior design.[20]

The photographs in this feature were taken by Charles Eames, confirming that, in spite of the purist label which has been pinned on him retrospectively, he was as accepting of and enthusiastic about the excesses of colour planning in the 1950s as his colleague, Alexander Girard. His own moulded plastic chairs, for example, were created in colours such as Lemon Yellow, Seafoam Green, Red, Dark Blue and Mustard, and in the Herman Miller showroom his famous lounge chair and ottoman are shown upholstered in bright red leather. Red or orange were also the colours in which the woven upholstery fabrics of Eero Saarinen's 'Womb' chair and George Nelson's 'Coconut' chair were often dyed, whilst the most popular colour combination for the vinyl cushions on Nelson's 'Marshmallow' Sofa was orange, pink and purple. All the leading American designers of the 1950s, therefore, were in favour of these vibrant colour schemes.

These examples show how essential it is when evaluating the use of colour in the post-war period to examine authentic documented colour schemes, rather than to draw conclusions retrospectively. *Domus* provides a fascinating record, including colour features on Gio Ponti's astonishing diamond-patterned blue and white two-tone interior for 'La Diamantina' country club in Caracas,[21] and an apartment in Genoa by Ettore Sottsass, the furniture, furnishings and lighting all ablaze with colour, and the rooms decorated with colourful contemporary sculpture, paintings and ceramics.[22] Perhaps the most evocative and colourful image of all, however, is the cover of the magazine in January 1953, showing an aerial view of a large group of Marco Zanuso's easy chairs for Arflex, each one upholstered in a different coloured or patterned fabric, emphasizing the infinite variety and inventiveness of Italian design in the 1950s.

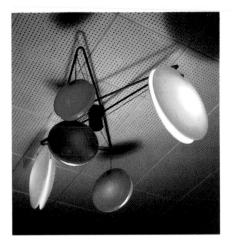 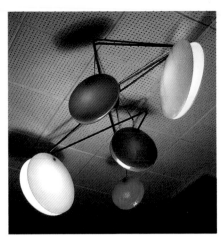

Two views (left) of a hanging lamp designed by Gino Sarfatti for Arteluce, model 2072 from 1953. Both the form and the colours were influenced by the mobiles of Alexander Calder. The acoustic tiles on the ceiling are typical of the period.

Bright clashing colours were very popular during the 1950s. Pink, orange and purple was the most popular colour combination for the cushions on this 'Marshmallow' sofa (below) designed by George Nelson Associates for Herman Miller in 1956.

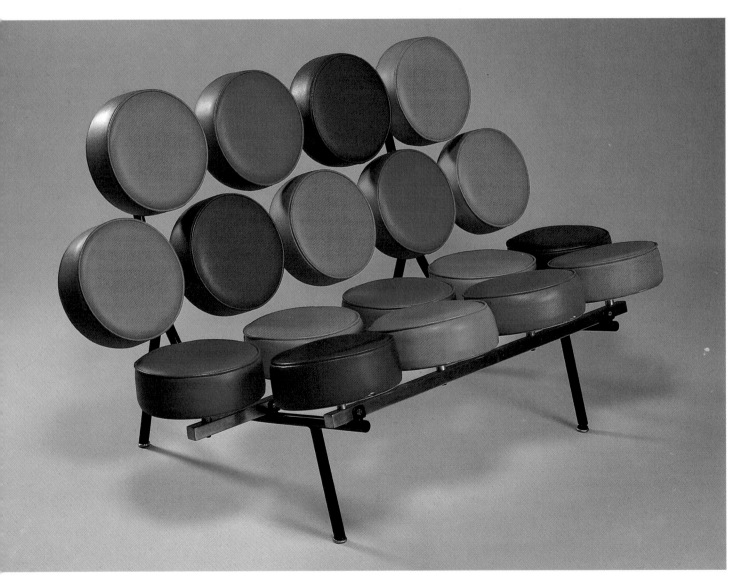

'Nylon Homespun' – The Feel of Things to Come

'To the architect, pattern and texture are the spices of design.'
CHRISTOPHER GOTCH – 'Pattern and Texture in Architecture'
in *Decorative Art Studio Yearbook*, 1954–55.

By the mid-1950s, not just in Britain, but throughout Europe and the USA, there was a heightened awareness of the value of texture as a creative force within home furnishings. In Scandinavia, for example, there was a revival of interest in the traditional long-pile 'Rya' rugs made by designers such as Viola Gråsten, whilst in Italy, Renata Bonfanti adopted a similar medium for her richly coloured and textured abstract rugs. Hitherto the emphasis in interior decoration had been almost exclusively on flat pattern applied to a smooth surface. During the 1950s there was a new appreciation of the textural qualities of the materials used in the applied arts.

In general, designers working with traditional materials were more innovative in their approach to texture than those who adopted new materials. Many of the latter simply tried to emulate the effects seen in other forms of the applied arts, instead of conceiving a new aesthetic. Christopher Gotch observed, for example, that, 'Few forms of plastics lend themselves to good decorative work at present.'[23] Only the most committed designers, such as Charles Eames, involved themselves in the complexities of materials technology. Eames worked closely with the firm of Zenith Plastics, for example, in order to ensure that the resin-impregnated fibreglass shell which he wished to use for his moulded plastic chairs had the aesthetic qualities and the surface texture he intended. His achievement contrasts with that of Eero Saarinen, who had to submit to defeat in the manufacture of his 'Tulip' pedestal furniture because the technology was not available in 1956 to produce the all-in-one smooth plastic chair he wished to create.

During the 1950s there was a curious uncertainty about how to use and decorate many of the new miracle materials that came on the market, and consequently, from a decorative point of view, the results were often unsatisfactory. A case in point was fibreglass fabric which, in its raw state, had a glittery and slippery surface. Several textile manufacturers – such as Nordiska Kompaniet in Sweden, Elenhank in the USA and Tootal in Britain – tried to use this material for printed designs. The results, although interesting from a technical point of view, were not successful aesthetically, and presented no improvement on the range of natural and synthetic fibres already available. Textile weavers, on the other hand, had greater success in incorporating synthetic fibres into their mixed composition woven

This architect's drawing of a proposed living room at Roundwood House, Harefield, reveals the careful attention paid to the colour scheme of the furnishings. The house was designed in 1956 by Keith Roberts.

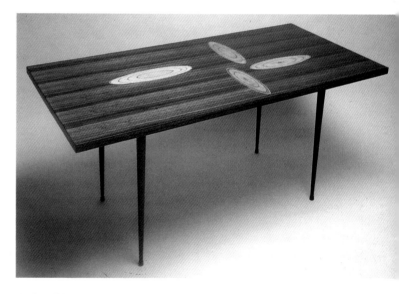

Tapio Wirkkala explored many different surface textures in his sculpture, his furniture and his glass (overleaf). In this table (above) for Asko (1958), inlaid woods represent a leaf vein pattern.

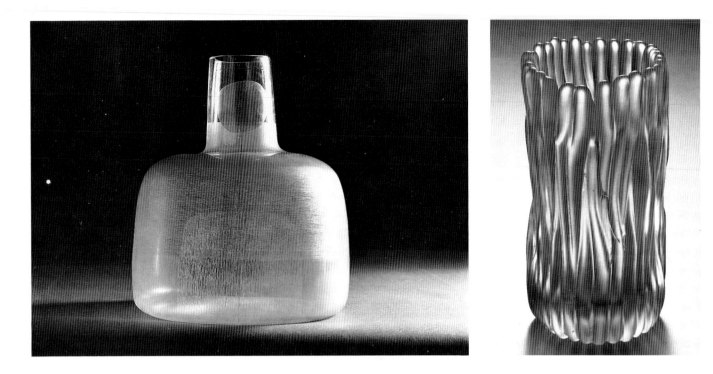

Surface textures on glass created by etching, engraving and submersion in acid: vase (above left) by Karel Vaňura, 1959; 'Lichen' vase (above right) by Tapio Wirkkala for Iittala, 1951.

fabrics, because this enabled them to create genuinely new textural effects. Jack Lenor Larsen was a tireless innovator in this field, and at Knoll, Suzanne Huguenin created the remarkable 'Nylon Homespun' using 100 per cent synthetic fibres. Confused perceptions about the validity of man-made fibres in their own right were evidently still rife at the time, however, judging from the ambiguity of the title given to this textile, with connotations both of extreme modernity (nylon) and of reassuring tradition (homespun).

The new decorative plastic laminates, manufactured by firms such as Formica and Warerite, were treated in two different ways: sometimes as plain smooth brightly coloured surfaces; sometimes as a ground for printed patterns.[24] Undecorated laminates were favoured in Europe, where they were seen as a durable replacement for painted surfaces. Bright primary colours were especially popular with the furniture designers who entered the regular *Domus*-Formica competitions, for example.[25] Patterned surfaces, on the other hand, were popular in the UK and the USA, where they were widely used on furniture, particularly table tops, and in kitchens. Lucienne Day's 'Linea' pattern was reproduced both as a textile for Heal's and as a plastic laminate used on furniture made by Kandya. Laminate patterns often simulated textural efffects, such as the loose weave of woven textiles, or the type of textural abstraction seen in contemporary wallpapers.

Real, rather than simulated, textural effects were intro-

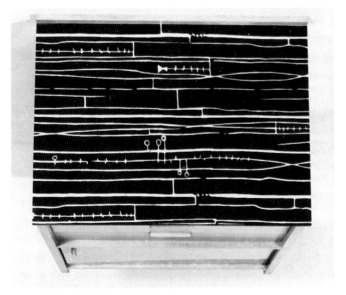

Texture was often simulated through flat pattern in Formica, as seen here in Lucienne Day's 'Linea' design, transformed from a textile to a plastic laminate, and used to decorate the top of a cupboard made by Kandya.

duced into many other branches of the applied arts, the most sophisticated being the surface treatments applied to glass. Tapio Wirkkala was undoubtedly the most responsive and innovative designer in this respect, his aesthetic being shaped by the natural habitat of Lapland. In his moulded ice block bowls the rough uneven surface texture of frozen ice was captured, as well as the jagged form. The shapes of leaves and the textural pattern of leaf veins were also recurrent themes in Wirkkala's work, and in his lichen bowls and vases, both the irregular form and the texture of this unusual fungus were embodied in the surreal vessel shapes he created. The lichen series was bathed in acid to produce its frosted matt surface, and the roughness of this finish was intensified through sand-blasting in Timo Sarpaneva's 'Pot Hole' sculptures, which resembled the eroded forms of pebbles and rocks. During the 1960s Wirkkala and Sarpaneva experimented further with surface textures inspired by natural phenomena.

In Czechoslovakia, Karel Vaňura made use of etching and engraving techniques in his subtly textured abstract designs. Italian glass designers were largely preoccupied with colour rather than texture, although Paolo Venini developed the 'inciso' technique, which involved covering the surface of coloured glass vessels with a pattern of finely incised concentric lines, creating a blurred matt texture overall. The Swedish designer, Erik Höglund, tried to create a more primitive and genuinely earthy appearance in his coloured glass vessels by using raw materials containing impurities.

In metalwork Gerald Benney was extremely influential in introducing textured surfaces into both hand-made silver and industrially produced base metals. His breakthrough design was a parcel gilt chalice made in 1957, the stem of which was decorated with an irregular pattern of finely incised lines. In 1958 Benney designed for Viners a pewter martini set with a matt textured surface, and during the 1960s a similar formula was applied to the handles of his highly successful stainless steel cutlery. At the end of the 1950s Benney also chanced upon another interesting textural effect, which he used in a series of silver rosebowl centrepieces. A wrinkled surface finish was obtained by deliberately overheating the silver so that a puckered skin formed on the outside of the molten inner metal. Initially this discovery was made as the result of an accident; later it was intentional.[26]

Chance mishaps in firing also led to the creation of some of the most interesting glaze effects created by the studio potters, Gertrud and Otto Natzler, during the 1950s. Their pitted and bubbled glazes resembled volcanic lava, and the Natzlers used evocative names such as 'Pompeian' and 'Crater' to describe these coarse and ruptured surfaces. In

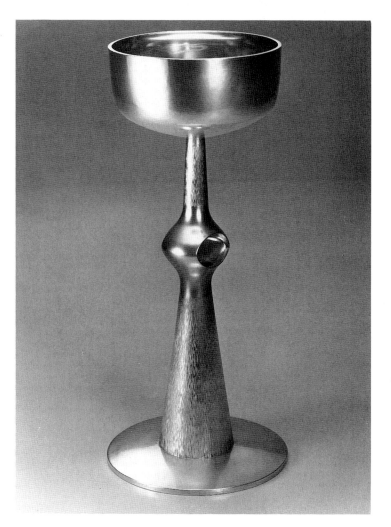

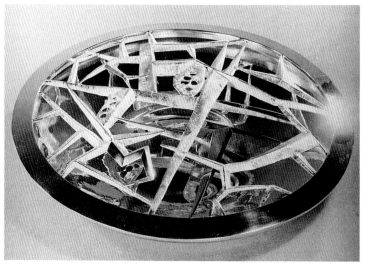

Gerald Benney was the first to introduce textured effects into silver design. Chalice (top), 1957. Rosebowl centrepiece (above), 1958, given to the newly established Leicester University by its first Chancellor, Lord Adrian.

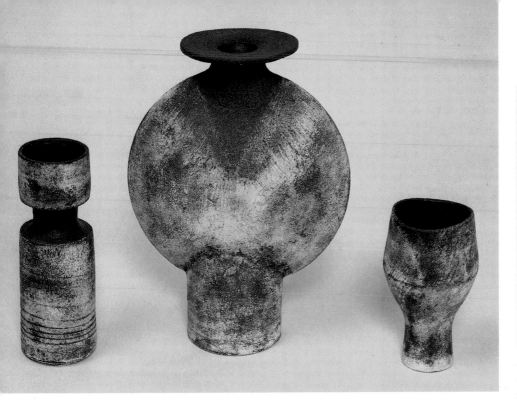

New textures on ceramics: abraded surfaces on the vessels (above left) of Hans Coper; relief-moulded decoration on Stig Lindberg's 'Reptile' vase and bowl (left) for Gustavsberg; pitted and bubbled glazes on a jug by Guido Gambone (above).

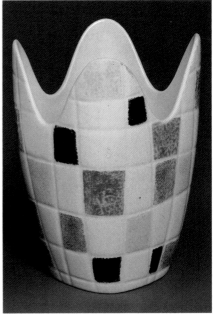

Pattern and texture are combined in Jessie Tait's relief-moulded 'Mosaic' vase for Midwinter, 1960, with its grid design and mottled sponged colouring.

Audrey Levy's 'Pebble' wallpaper for the Wall Paper Manufacturers' 'Palladio 3' range, 1958, creating a similar mock texture to Robert Jefferson's 'Black Pebble' tableware design (overleaf).

Italy the thick glazes used by Guido Gambone were often rich to the point of saturation, resulting in lumpy surfaces and blemishes such as burst bubbles. Raw or rough finishes on vessels made by other studio potters were increasingly common during the 1950s, the work of Fausto Melotti being a typical example. In Italy, crudeness of form and roughness of surface were an integral part of the aesthetic appeal of studio pottery. Potters in other countries were less casual, but their work shared some of the same visual traits as the Italians. A significant feature of Hans Coper's vessels was the coarse quality of their abraded surfaces, a process which added significantly to the resonance of his unusual forms. His pots were coated with several layers of dark-coloured metal oxides and light-coloured liquid clay slips, each of which was abraded and roughened, and then, after firing, the surface was further burnished. The result was the creation of the type of patina normally only acquired by an object as the result of being buried in the ground over several centuries.

Relief decoration of ceramics was also common during the 1950s. Abstract hieroglyph-type motifs were created in raised relief on the surface of Marcello Fantoni's vessels of the late 1950s.[27] In Denmark, Axel Salto continued to create extravagantly organic vessels in which rich treacly glaze effects were combined with lumpy vegetal forms. At Gustavsberg, Wilhelm Kåge concentrated on surface decoration incised or impressed into the clay body in his 'Farsta' stonewares, whilst Stig Lundberg was relentlessly innovative in the creation of new shapes, patterns and textures for his studio wares. His 'Reptile' vessels, for example, were relief-moulded with the scaly texture of lizard skin. Lindberg was also one of the first ceramic designers to introduce relief-moulded textured effects into tiles. This trend can also be seen in the work of Gio Ponti for Ceramica Joo. Tiles used architecturally on both the interiors and exteriors of buildings were extremely popular in Italy, and Ponti employed them extensively on his own buildings.[28] In Britain they were mostly used for fireplace surrounds, where the new textured tiles produced by Poole Pottery were the favourite choice with architects. In Finland, at Arabia, Rut Bryk created intricate hand-made relief decorated tiles, used in a highly original way to create large decorative wall panels.

Many European wallpapers, such as those produced by Salubra, relied almost entirely on embossed texture rather than printed pattern. In Italy Lucio Fontana simulated the abstract relief sculpture effects of his lighting installations in flat patterns printed on textiles.[29] Towards the end of the 1950s British wallpaper and textile designers turned their attention to the creation of textural effects through flat abstract patterns, a trend which grew out of developments in contemporary abstract painting, such as the works of William Gear and Clyfford Still. Eduardo Paolozzi and Nigel Henderson, for example, produced a black and white textile design called 'Coalface' for Hull Traders, and Audrey Levy created a wallpaper called 'Pebble' for the Wall Paper Manufacturer's 'Palladio' range, the textural qualities of which are conveyed by their titles.

'Black Pebble' tableware, designed by Robert Jefferson for Poole Pottery, 1959. 'Coalface' furnishing fabric (right) designed by Eduardo Paolozzi and Nigel Henderson for Hull Traders, 1959.

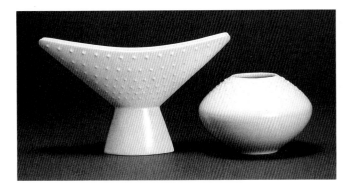

'Home Decor' vases designed by John Clappison for Hornsea Pottery, 1960. The piece on the right resembles a sea urchin and points towards the increasing importance of textural effects in the applied arts during the ensuing decade.

Some industrial tableware manufacturers extended this idea of simulating textural effects to the printed patterns on their ceramics. At Poole Pottery, Robert Jefferson designed a dense all-over printed pattern called 'Black Pebble', designed for application by means of a Murray Curvex printing machine.[30] At Rosenthal Margret Hildebrand created a printed pattern called 'Raffia' to decorate Raymond Loewy's 'Service 2000'. Jessie Tait had produced a series of confidently abstract 'contemporary' designs for Midwinter since the early 1950s. Later her patterns became increasingly concerned with the textural abstraction. 'Savanna', for example, was printed in black with a broken mesh of fine criss-crossed lines, with additional visibly textured sponged decoration applied in yellow. This development culminated in 'Mosaic' of 1960, in which a grid pattern was actually relief-moulded into the walls of the vessels. Moulded linear and embossed textures also formed the basis of the new 'Home Decor' range produced by Hornsea Pottery at the end of the decade, presaging trends which would be consolidated during the early 1960s.

Scientific imagery in the fine arts: 'Microcosmos' (Plant Cycle), 1951, a print by Richard Hamilton (top); 'Lute and Molecules' (above), a hand-coloured screenprint by Ben Shahn, 1958.

5·New Imagery

The Appliance of Science

Earlier chapters have focused largely on the importance of abstraction in the fine and applied arts. Although this accounts for a large proportion of the work produced after the war, by no means all 1950s art and design was non-representational. In every age, changing social behaviour, current events, new discoveries and 'l'esprit du temps' all have a bearing on the development of art and design. During the 1950s, in the aftermath of the war, people were, understandably, keener to look forward rather than back. There was tremendous faith in the future, in the material prosperity that people would be able to enjoy. People put their faith in science and technological advances to achieve these goals, and to provide the answers to all their problems.

In an article on John Tunnard shortly after the war, the writer noted how the artist 'gains stimulus from scientific and mechanical developments'.[1] The machine aesthetic had strongly influenced artists such as Léger during the 1930s, but the interest in science that developed after the war was an entirely new development. 'My inspiration comes from the future rather than from the known present or past', Tunnard is quoted as saying. Although by the 1940s scientific development was so advanced that it could no longer be comprehended by anyone other than the trained expert, scientific imagery became increasingly prevalent in both art and design. Several other British artists from the 1950s displayed an active interest in science or scientific imagery. Richard Hamilton produced a series of prints entitled 'Microcosmos (plant cycle)', 'Structure' and 'Heteromorphism'. These prints were based on photographic images from microscopy and X-rays, and on botanical and biological illustrations. Other members of what was to become the Independent Group shared Hamilton's interest in the imagery of science. In the exhibition, *Parallel of Life and Art*, Peter and Alison Smithson created a photomontage that juxtaposed images from the natural world and science with images from contemporary abstract art, in order to show the similarities, sometimes coincidental, sometimes conscious, between nature and art.[2]

Two wallpapers produced by John Line for the Festival Pattern Group scheme in 1951, using designs based on crystal structures: 'Insulin' (left) by Robert Sevant; 'Boric Acid' (right) by W.J. Odell.

The use of scientific imagery in the fine and applied arts was by no means confined to Britain. It crops up repeatedly in commercial graphics, painting and sculpture throughout Europe and the USA. In 1958, for example, the American artist and poster designer, Ben Shahn, produced a hand-coloured screenprint with the unlikely title of 'Lute and Molecules'. Whilst admitting that the bizarre juxtaposition of imagery in this work was fortuitous, Shahn commented that he was struck 'by the similarity between the keys of the lute and the atomic structure of the molecule'.[3] Although the scientific content of his work has no deep significance or symbolism, the fact that the shape of the molecules should have inspired the artist in the first place reflects the preoccupations of the age. It is not coincidental that 1958

was also the year of the Brussels World Fair, which was dominated by the imposing structure of the Atomium.

Interest in science became a significant artistic preoccupation during the 1950s. In summing up, at the end of the decade, the major new developments amongst the international artists of the School of Paris since the war, Marcel Brion made some astute comments on this phenomenon: 'It can . . . be conjectured that scientific progress may have influenced art, that the unique beauty of some unusual representations (photographs of nebulae, of crystals, of microscopic sections) discloses a new visual world to the artist, in which he finds not models, but creative stimulus. In short, new aspects of nature, rarer, more surprising, more varied, testifying to the majestic beauty of cosmic life, arouse the painter's emotions even though he may have no scientific training and may merely come across such powerfully inspiring images in popular magazines.'[4]

In this commentary, written in 1959, Brion makes a

number of interesting suggestions about the influence of science on art: firstly, he identifies the three main sources of scientific inspiration during the 1950s as space exploration, chemistry and microbiology (add nuclear physics to the list and it will then be almost complete); secondly, he points out the way in which artists absorb this material as a general or even a peripheral source of imagery, rather than as the main subject matter of their works; thirdly, he accounts for the fact that it is not necessary for the artist to have an in-depth knowledge of science in order to exploit its visual potential; and fourthly, he indicates that most artists pick up their knowledge of science through the media ('popular magazines') rather than as a direct result of their own investigations or research. All these points are equally relevant to the designer.

There was one important design initiative in the 1950s, however, that did have a sound scientific basis – the Festival Pattern Group – and for this reason alone it is worth examining in more detail. The Festival Pattern Group was established in 1949 to design patterns based on crystal structures for use at the Festival of Britain. According to Mark Hartland Thomas, the initiator of the project, 'To many crystallographers the chief incentive [for their research] was sheer delight in the beauty of the patterns in the basic structure of nature that were revealed.'[5] A group of designers working in a number of different media – ceramics, glass, textiles, wallpapers, metalwork, furniture, lighting, linoleum and plastics – were provided by a Cambridge scientist, Dr Helen Megaw, with accurate blueprint drawings of the crystal structures of various substances and materials, such as insulin, quartz and polythene. Their brief was to use these as a direct source of inspiration for abstract pattern designs, the idea being that science was the most relevant source of imagery for contemporary design, and abstraction the most appropriate vehicle for contemporary designers, therefore the two should be combined. In the words of Hartland Thomas: 'these crystal structure diagrams had the discipline of exact repetitive symmetry . . . they were essentially modern because the technique that constructed them was quite recent, and yet, like all successful decoration of the past, they derived from nature – although it was nature at a submicroscopic scale not previously revealed.'[6]

Some of the materials that were used for these patterns were themselves of recent development, such as Dunlop's polyvinyl chloride sheeting, thus further emphasizing the relevance of the links between applied art and science. One important new material co-opted for use in the scheme was plastic laminate. Martin Rowlands produced several designs for Warerite based on the structure of haemoglobin, beryl and afwillite, which were used for tabletops and trays, and as

The Festival Pattern Group and its spin offs: 'Festival' tableware (top) designed by Jessie Tait for Midwinter, 1955, loosely based on crystal structure patterns, such as that seen on the Wedgwood plate overleaf; 'Surrey' (above), a woven furnishing fabric by Warner and Sons for the Festival Pattern Group scheme, 1951, designed by Marianne Straub and based on the crystal structure of afwillite.

The abstract patterns devised for the Festival of Britain were based on accurate crystallography diagrams prepared by a Cambridge scientist. 'Helmsley' (far left), a woven textile by Marianne Straub for Warner and Sons, based on the structure of nylon.

Bone china plate (left) by Wedgwood, decorated lithographically with a crystal-structure border based on insulin.

back plates for wall lamps. New printing processes were often called for in order to transfer patterns on to these materials. A firm called Vernon Industries participated in the scheme with their 'Oxvar' decorative finish, an offset printing process whereby a 'decorative wearing surface was applied to many different materials'. The printing technique used in ICI's new mural rexines and vynides, a range of nitrocellulose-coated fabrics recently developed by their Leathercloth Division, intended for use as wall coverings and upholstery fabrics, was, however, not entirely successful.

Other unusual participants in the scheme included the firm of G.A. Harvey, which made pierced metal sheets for use as ventilator grilles and wastepaper baskets; Chance Brothers, who produced sheets of figured rolled glass; Wood Brothers, who made moulded glass ashtrays; Elkington, who made silver-plated cutlery with designs stamped on the handles; and Poole Pottery, who created a large tile panel with a design based on the structure of zinc hydroxide. Textiles offered perhaps the greatest opportunities for designers involved in the Festival Pattern Group scheme, and within this field many different manufacturers were involved. The results included machine-woven lace, carpets and a wide range of printed and woven dress and upholstery fabrics. Of these the most visually successful were S.M. Slade's 'Afwillite' screenprinted rayon for British Celanese, and Marianne Straub's 'Helmsley' and 'Surrey' woven furnishing fabrics for Warner and Sons. The former, based on the crystal structure of nylon, had a geometric design composed of circles joined by lines; the latter, also based on afwillite, was composed of large-scale amoeba-like forms woven in a mixture of wool, cotton and rayon fibres. 'Surrey', reflecting the current interest in organic forms, was one of the triumphs of the Festival Pattern Group scheme. The screenprinted wallpapers produced by John Line were

also successful, and it was as a result of participating in this project that John Line established its lasting commitment to progressive design.

The last area into which the Festival Pattern Group ventured was ceramics. Two Staffordshire firms, Wedgwood and R.H. and S.L. Plant, produced bone china tableware lithographically printed with crystal structure borders. Although these initiatives had little identifiable impact on the industry at the time, a spin-off design by Jessie Tait called 'Festival' was produced several years later in 1955 by Midwinter. This all-over pattern, loosely based on a generalized crystal structure, was an aesthetic as well as a commercial triumph, and illustrated the positive effect that the Festival Pattern Group exerted on the modernization of ideas about pattern.

Chemicals manufacturers, such as ICI in Britain and Montecatini in Italy, played an important role in the design world in the 1950s. ICI were the creators of new synthetic materials such as perspex, new synthetic fibres such as terylene, and new synthetic pigments used in paint, printing inks and dyes, all of which gave the post-war designer greater scope for experimentation. Artists occasionally benefitted indirectly as well: during the 1940s Naum Gabo was introduced by John Sissons, Head of Research at ICI, to the new lighter forms of perspex being developed at ICI's acrylics division, and later to ICI's new nylon thread. These lightweight materials were ideal for Gabo's sculpture, and enabled him to realize what he had hitherto been prevented from achieving due to the lack of suitable materials.[7] Judging from the thrust of ICI's public relations campaign after the war, it perceived a role for the company in almost every aspect of everyday life – not just in the world of science and industry, but in the field of the fine and applied arts as well. Thus it advertised in *The Studio* magazine every month from

the mid-1940s onwards, and also in *Vogue* and in *The Ambassador*, the magazine for the textile and furnishing trade.

Other companies concentrated their publicity efforts on impressive promotional displays at exhibitions. The British firm, BX Plastics, commissioned the graphic designer and illustrator, Laurence Scarfe, to paint a huge mural depicting the molecular structure of plastic. In Italy, the chemicals giant, Montecatini, mounted many stunning exhibitions at the Milan Fairs during the 1950s, involving complex installations illustrating the nature of its research. The company adopted the vocabulary of its own creations, using top architects and designers, such as Enrico Ciuti and Erberto Carboni, to exploit the creative potential of this imagery.[8]

Scientific and futuristic imagery also dominated major national and international exhibitions during the 1950s. The Festival of Britain, for example, was crowned by the magnificent Dome of Discovery, an entire pavilion devoted to achievements in science, including nuclear energy, space exploration and medicine. Resembling a huge space ship, it was itself a major feat of engineering, being at that time the largest dome in the world, measuring 365 feet in diameter and 97 feet in height. The most memorable exhibition structure of the decade, however, was undoubtedly the Atomium, built for the Brussels Expo in 1958. It represents on a huge scale an accurate model of an atomic molecular structure. Conceived by scientists and designed by engineers, the Atomium was one of the most impressive sculptural and architectural achievements of the 1950s, as well as providing a powerful symbol of the Atomic Age.

Similar preoccupations with science and technology were a recurrent theme throughout the applied arts during the 1950s. The Editors of the *Decorative Art Studio Yearbook* for

Science formed part of the popular imagery of the day, and was used by companies to promote their products. Exhibition stand (above left) designed by Leslie Gooday for Tube Investments, 1960. Detail of a mural (above right) by Laurence Scarfe for BX Plastics.

Group of souvenirs (right) commemorating exhibitions and scientific achievements during the 1950s: 'Atomium' plate from the Brussels Expo, 1958; 'Satellite' cigarette dispenser and musical 'Sputnik' model, made after the launching of the first satellite by the Russians in 1957; 'Skylon' pen from the Festival of Britain, 1951.

1952–53 evoke the spirit of their time as 'an age spinning with the wheels of machines, dancing to the tune of electronics and bouncing to the detonation of exploding atoms.'[9] The excitement caused by a series of important scientific breakthroughs during the 1950s caught the popular imagination. Crick and Watson's well-publicized discovery of the structure of DNA in 1953, based on the form of a double helix, was almost certainly the inspiration behind Kenneth Martin's 'Screw Mobile' of the same year, a version of which was exhibited in the Independent Group exhibition 'This Is Tomorrow' at the Whitechapel Art Gallery in 1956. The helix was also an ideal structure for lighting devices. It was at this time that Heal's installed the imposing helical chandelier in the stairwell of their London store.[10]

To give some idea of the scientific images with which people were being bombarded in the media, it is worth listing several of the major scientific achievements of the 1950s. In medical science, the Pill was invented in 1952, and Dr Jonas Salk discovered an anti-polio vaccine in 1955. In technology, the De Havilland 110 jet fighter broke the sound barrier in

Atomic imagery was all-pervasive during the 1950s. 'Atom' clock (opposite, top) by George Nelson for the Howard Miller Clock Company, popular throughout the decade. 'Zelda' wallpaper (left) by Els Calvetti for John Line, showing the use of patterns based on atomic structures.

The imagery of chemistry affected glass design in particular. These carafes (above) by Kaj Franck for Nuutajärvi, 1954, resemble laboratory glassware.

Pattern design during the late 1940s was strongly biological. This tapestry (right) by Matisse from 1951 is called 'Polynésie – La Mer' and is one of two designs originally conceived as printed wall-hangings for Ascher.

1952; a transatlantic telephone service was set up in 1956; the radio telescope at Jodrell Bank, UK, was completed in 1957; a US submarine passed beneath the North Pole in 1958; and Hovercrafts arrived in 1959. In space exploration, the Russians launched Sputniks I and II in 1957; the Americans launched their Explorer satellite the following year; and in 1959 the Russians launched their Luniks, which sent back the first photographs of the far side of the moon. The 1950s has been called the Atomic Age and it was undoubtedly a period of frenzied research and experimentation in this field. In 1950 it was announced that the USSR was in possession of an atomic bomb. The Americans carried out a thermo-nuclear explosion in 1952; the Russians exploded an H-bomb in 1953; the neutrino particle was discovered in 1956; the first nuclear power station opened in the same year; and the first nuclear-powered ship was built by the Russians in 1959.

Images from nuclear physics, chemistry, micro-biology and space exploration were freely co-opted by designers seeking a new contemporary vocabulary for shapes and patterns appropriate to the modern world. George Nelson's 'Atom' clock, with its twelve painted wooden knobs project-ing on radiating metal spokes, designed in 1949 for the Howard Miller Clock Company, was one of the most influential products of the decade, and it spawned thousands of lesser imitators throughout Europe and America. After this date coloured knobs and ball feet were to be found on

every conceivable household accessory from fire irons, to wastepaper bins, to plant stands.

The influence of biology and micro-biology on three-dimensional design has already been discussed in the context of organic modernism. A less literal interpretation of biological motifs is to be found in Matisse's scarves and wall-hangings for Ascher, based on the organic shapes of the flora and fauna of Polynesia. Two of these designs, 'Polynésie – La Mer' and 'Polynésie – Le Ciel', depicting seaweed, fish, birds and clouds, were woven into tapestries in 1951. Images from chemistry were somewhat rarer, although they did appear occasionally in graphic designs. In Scandinavia much of the functional glass from the 1950s bore a close resemblance to laboratory instruments. Carafes, bottles and decanters were often thin-walled and clinical, sometimes recalling the shape of a retort.

Rocket imagery abounds during the 1950s, particularly in graphic design, although concrete achievement in the field of space exploration did not actually materialize until 1957 with the launch of Sputnik. Before that date space travel was based on fictional conjecture, such as the adventures of Colonel Dan Dare in the popular UK comic, *Eagle*. The architect, Leslie Gooday, relied heavily on rocket and spaceship imagery drawn from the *Eagle* in the creation of his aerial display for the 'Hulton's Boys and Girls Exhibi-tion' at Olympia in 1956 on the theme of flight in the year 2000. The press release for this exhibition explained: 'This

The exploits of the comic hero, Dan Dare, formed the subject of a special aerial display (left) at the 'Hulton's Boys and Girls Exhibition' at Olympia in 1956, designed by Leslie Gooday.

Synthetic fibres were still a novelty during the 1950s, and were vigorously promoted by organizations such as British Nylon Spinners Ltd. The woman in this advertisement from 1950 is wearing a New Look coat.

famous series has, in the past, mirrored with amazing accuracy some of the real life enterprises which are at present being planned, not only in this country, but in America.'[11] Around the mid-1950s, there was a craze in the USA for flying saucer spotting, at which date flying saucer hats and flying saucer lampshades came into vogue. Several one-off designs appeared to celebrate the launch of Sputnik, the most astonishing of which was a piece of 'Ariel' glass designed by Edvin Öhrström at Orrefors in Sweden, in which the image of the satellite was captured in air bubbles in a glass sculpture.[12]

Many of these examples reveal that the reason for the adoption of scientific imagery in the applied arts was the desire to project an image of modernity. The keys to real, as opposed to simulated, progress in design, however, were the developments made in the creation of new materials. In 1951 the Editors of the *Decorative Art Studio Yearbook* referred to an increasing 'confidence in new materials and a growing

knowledge of their potentialities and limitations', which they considered an important impetus for innovation in product design.[13]

Plastics were already important by the 1950s, and were to become even more so during the 1960s. Perspex dates back to 1936 and was used during the 1950s for both shoes and lampshades; it was followed in 1942 by polythene and polyester; and then in 1957 came polypropylene. During the 1950s the resin-based plastics used in furniture had to be reinforced with polyester-based fibreglass because they were not strong enough on their own to stand up to the degree of strain imposed by the human body. Fibreglass was also exploited as a material in its own right. Synthetic fibres were forcefully promoted by their manufacturers, such as ICI, when they introduced terylene on to the British market, and British Celanese, when advertising their rayons and nylons. The text from a 1947 advertisement for British Celanese is interesting because it makes a virtue of the company's

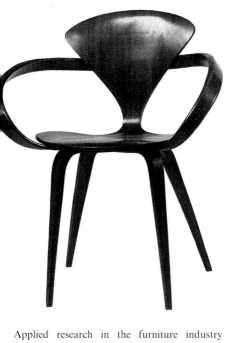

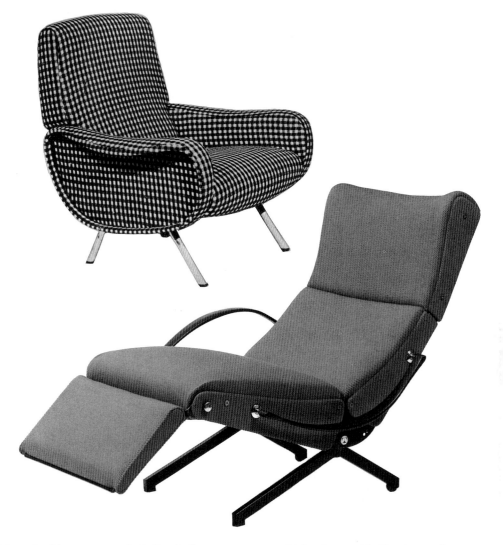

Applied research in the furniture industry resulted in major technological advances. Arm-chair (above) by Norman Cherner for Plycraft, 1956, taking advantage of breakthroughs in plywood technology. 'Lady' chair (centre) by Marco Zanuso for Arflex, 1951, making use of rubber webbing and foam rubber produced by its parent company, Pirelli, for the upholstery. P40 chaise longue (right) by Osvaldo Borsani for Tecno, with a mechanism allowing the chair to be positioned at many different angles, and even folded up completely.

scientific research: 'A Scientist writes his hieroglyphics on a piece of paper . . . and soon your feet will sink into the silent luxury of a carpet woven from man-made fibre. More hieroglyphics . . . and then comes the formula for cobweb-fine window net . . . And because it is man-made, each synthetic fibre created by the Celanese Scientist is destined from its inception to specific needs. The potentialities are tremendous . . . your suit, your scarf, your stockings, your slippers, your gloves – all will be made from a "Celanese" Yarn created to suit the product. Such is the flexibility of modern creative chemistry.'[14] In the early 1950s, British Celanese commissioned the talented young designer, Lucienne Day, to design a range of prints for their new acetate rayons, which were then marketed by the established firm of Sanderson.

Technological advances were even more directly relevant to the field of furniture, where major developments in materials science were embodied in Marco Zanuso's 'Lady'

chair for Arflex, a company which, along with Cassina and the American firms, Knoll and Herman Miller, invested years of research in their products. More than ever, the successful furniture designer had to be an engineer as well as an artist, a fact illustrated by the mechanical complexity of Osvaldo Borsani's reclining seat furniture for Tecno. The supreme example of the engineer-designer was Charles Eames. He spent more time refining the materials from which his furniture was to be made than in deciding upon the shape, a tendency that was evident right from the start of his career with his award-winning plywood chair designs for the Museum of Modern Art's 'Organic Design in Home Furnishings' competition in 1940. Eames was encouraged by his success in this competition to experiment further with the technical possibilities of plywood, and in 1941 he and his wife, Ray, set up the Moulded Plywood Division of the Evans Products Company in Venice, California. An early commission to design moulded plywood stretchers and leg

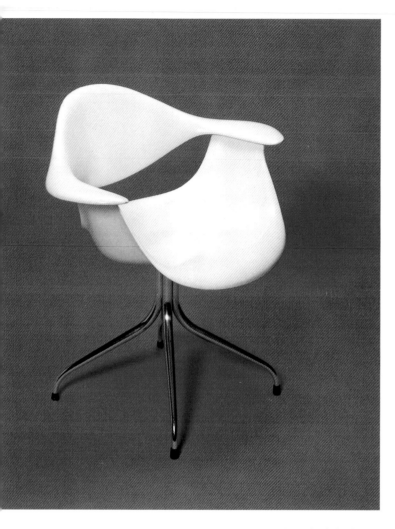

After Charles Eames's success in creating a moulded plastic chair, George Nelson designed this elegant armchair with tapering tubular swagged legs.

his materials, Eero Saarinen's vision outstripped the technical possibilities of his chosen materials. In his 'Tulip' chair of 1957 he would have preferred to use just one material – plastic – in order to realize his dream of creating a chair that was organic both in the sense of its unified shape and also its materials. The plastic available at that time, however, was not strong enough to act as the pedestal as well as the seat of the chair, and Saarinen was obliged instead to use a combination of enamelled aluminium for the base and plastic for the seat. Similarly, Verner Panton's design for a moulded plastic stacking chair did not advance beyond the prototype stage during the 1950s, and it was not until the late 1960s that it was produced in fibreglass-reinforced polyester.

Without his fundamental commitment to science and engineering, Charles Eames would never have progressed beyond the drawing board or prototype stage for most of his designs, because they were simply not realizable, at the time when they were conceived, without significant progress in materials and technology. The American Society of Interior Designers summed up the fruitful cross-fertilization between art and science in the designs of Charles Eames when they praised him for 'bringing to design the quality of thinking associated with the sciences, and for bringing to science the kind of imagination associated with design, and for showing us that they are inescapably part of the same process.'[15]

Reclining chair by Robin Day fror Hille, 1952. This chair appears as one of the images on the 'Homemaker' plate overleaf.

splints for the U.S. Navy resulted in Eames being given access to valuable technical information about the manufacture of British Mosquito bombers. At Venice he also developed the evocatively named KZAM! machines which were used in the making of his DCM, LCM and LCW chairs. Having mastered plywood, Eames next moved on to fibreglass. Working with a team of engineers from the University of California, he developed a moulded fibreglass version of his earlier plywood shell chair, which he entered successfully in the Museum of Modern Art's 'Low Cost Furniture Competition' in 1948. The resulting design – the DAX, DAR, and DAT range – was produced from 1952 by Herman Miller in fibreglass-reinforced moulded plastic.

Whereas Charles Eames achieved complete mastery over

'Homemaker' and the Imagery of Contemporary Life

During the 1950s the Italian graphic designer, Piero Forna-setti, issued a series of printed plates called 'Themes and Variations'. The theme was a woman's face taken from an engraved print; the variations, which amounted to five hundred in total, were the different ways in which this image could be cut up, enlarged, distorted and edited to create a variety of visual effects. Fornasetti's treatment of his theme was unashamedly decorative, and it was decoration which used itself as the vehicle for its own creative experiments. Although Fornasetti was very much an isolated figure, and although, graphically speaking, his work has greater relevance to the 1960s, his 'Themes and Variations' series illustrates a trend that can be perceived in other areas of 1950s applied art. During the 1950s the design world began to turn in on itself, becoming increasingly self-conscious and self-referential in its designs. In Fornasetti's obsessive re-working of the same theme we see one of the earliest manifestations of this peculiar tendency.

Whereas Fornasetti chose a remote and academic image with which to play, the theme of much 1950s design was contemporary life itself. One of the most familiar images from the 1950s is the ubiquitous 'Homemaker' tableware pattern. Designed by Enid Seeney, it was produced by Ridgway and retailed through Woolworths between 1955 and 1967. 'Homemaker' was decorated with a printed design of everyday household accessories, all of which had by this time become icons of 'contemporary' British design. The background of the design was decorated with a fibrous

These salad bowls by Piero Fornasetti from 1955 were the inspiration for the type of imagery used on Terence Conran's 'Salad Ware' vase for Midwinter (far left) of the same year. Fornasetti considered any household accessory as a suitable vehicle for his decorative designs, even a lowly wastepaper bin (left).

'Homemaker' tableware designed by Enid Seeney for Ridgway Potteries in 1955, decorated with emblems of 'contemporary' taste, such as spindly legged plantstands, tripod lamps, attenuated cutlery, a boomerang-shaped table and Robin Day's reclining armchair (illustrated on p.94).

abstract line pattern, also self-consciously typical of the New Look. Although 'Homemaker' was one of the most overtly self-conscious designs of the period, numerous other examples can be cited. Sanderson, for example, produced a wallpaper in 1956 called 'Illuminata' featuring a design of 'contemporary' lampshades, showing the full gamut of shapes available at the time. June Lyon used contemporary sculpture as the source of inspiration for her wallpapers and textiles. The knobbly abstract forms in her 'Gyro' wallpaper for John Line bear distinct similarities to Eduardo Paolozzi's sculptures, whilst her 'Mobile' furnishing fabric for Heal's was clearly inspired by the mobiles of Alexander Calder.

The patterns and shapes of the New Look in tableware were the subject of another printed ceramic design by Burgess and Leigh called 'Fantasia', illustrating a range of organic and attenuated ceramic bowls, cups and vases decorated with linear and abstract patterns. It reflected the popular taste of the 1950s in a genuine and unpretentious way, and was in no way hampered by the self-referential nature of its imagery. The question still remains, however, why did people want to see this kind of imagery on their tableware? The answer seems to be that in Britain, in spite of the fact that the New Look had become the dominant aesthetic, the foundations of the public's commitment to modern design were still rather shaky. 'Homemaker' served to confirm to people that they had made the right choice in opting for modern, rather than traditional, design. Being still a little unsure about their decision, the reassuringly familiar imagery became an important part of the justification process for adopting the New Look.

'Picknick' tableware (above) by Marianne Westman for Rörstrand, 1956. 'Fantasia' plate (right) by Burgess and Leigh, 1959, decorated with the shapes of 'contemporary' ceramics.

In the hands of designers working in an environment more obviously favourable to modern design, such as Sweden, the use of contemporary imagery did not have quite the same connotations. It was more spontaneous, and much less self-conscious. Stig Lindberg provides a good example because, working as a designer of both ceramics and textiles, it was natural for him to make cross-references between different media, as he did, for example, in his textile design, 'Pottery'. The Danish ceramic and textile designer, Axel Salto, also produced a design in 1950 called 'Keramik', in which the pattern was composed of a series of vessels. Designers who worked solely with two-dimensional pattern, however, tended to be more self-conscious in their use of this kind of imagery, as in Warner's furnishing textile, 'Painted Vases', created in 1954 by the commercial studio of Willy Herrmann in Berlin.[16]

Stig Lindberg also produced designs for brightly coloured hand-painted faience which were a joyous celebration of contemporary life in all its minute details. Because he treated this subject in such an inspired way, as in his amusing plate decorated with washing hanging on a line, he transformed the everyday into the enchanting. The Swedish glass designer, Vicke Lindstrand, had a similar gift and, coincidentally, he too produced a design of a woman hanging out washing on a line. Another Swedish ceramic designer, Marianne Westman, produced colourful printed designs of fruit and vegetables to decorate pots used for cooking and serving food. As in Lindberg's work there is a joyous quality about her designs which affirms the positive aspects of domestic life in the 1950s. Her 'Picknick' range for Rörstrand incorporated herbs, peapods and cross-sections of onions and tomatoes into the design. In the USA, Herndon Papers produced a kitchen wallpaper called 'Slices' which also exploited similar sliced fruit and vegetable motifs, and it was their instant familiarity that was at the heart of their appeal.

Both Westman's 'Picknick' and Herndon's 'Slices' were honest attempts to provide a form of decorative imagery appropriate to the environment for which they were created – the kitchen. This was true of many other designs from the 1950s which are now considered kitsch, but which at the time were not perceived as such. This was a period of increasing democracy in design, illustrated by the decreasing gap between the subject matter and aesthetic of upmarket and downmarket designs. Often it is difficult to differentiate between the two. The taste for this type of subject matter was not confined to one particular audience, but was popular amongst all sectors of the buying public. The imagery of the New Look resulted in a style of design that was democratic and non-elitist.

'Forms on a Bow' by Eduardo Paolozzi, 1949. Paolozzi's sculpture invites comparison with the motifs in June Lyon's 'Gyro' wallpaper for John Line, illustrating another aspect of contemporary imagery co-opted as a subject for the decorative arts.

The democratization of design was partly achieved through increasing mass-production, and partly through the adoption of accessible popular imagery. 'Slices' wallpaper (left) by Herndon Papers, 1953. Faience plate (above) by Stig Lindberg for Gustavsberg, 1942–49.

'Plantlife' tableware by Terence Conran for Midwinter, c.1957. 'Pottery' printed linen (right) by Stig Lindberg for Nordiska Kompaniet, 1947.

Stig Lindberg's 'Pottery' furnishing fabric (opposite), Axel Salto's 'Kera-mik' textile (overleaf), and 'Painted Vases' (above), a printed cotton designed by the Willy Herrmann studio for Warner and Sons in 1954, all use contemporary ceramics as their subject of decoration.

'Keramik' furnishing fabric by Axel Salto for L.F. Foght, 1950. Both Lindberg and Salto were ceramic designers who also produced textiles, a fact reflected in the imagery of their designs.

A young British designer with a decidedly democratic approach to design, who was particularly influential in promoting the imagery of contemporary life, was Terence Conran. One of the few British designers who was fully aware of post-war design initiatives on the Continent, Conran absorbed creative influences from both Fornasetti in Italy and Lindberg in Sweden. The creative results of this can be seen in his pattern designs for Midwinter, such as 'Saladware', decorated with a host of colourful vegetables, and 'Plantlife'. The principal motif in this service was a large rubber plant in a conical pot with a three-legged metal rod plantstand. Conran himself had designed the device, and the use of it as a decorative motif represented the closest form of self-reference that a designer could make.[17]

The work of Terence Conran illustrates that it was difficult, but not impossible, for designers to perform the tricky juggling act between popular imagery and aesthetic rigour. This was the key to the success of many of the Italian designers, such as Gio Ponti, whose range of expression was astonishingly expansive. Whilst some of Ponti's furniture and architectural designs were severely geometrical and abstract, such as his 'Distex' armchair for Cassina and the Pirelli Tower in Milan, he also had a propensity towards decoration, as a result of which he established a highly successful partnership with Fornasetti, producing the carcase furniture designs for the latter's decorative chests, desks and bureaus. Ponti's view of design was inclusive rather than exclusive, and there was no sense of discord or incongruity in his shift from one idiom to another.

Ponti's equivalent in America was George Nelson, who produced a similarly wide range of furniture and accessories. Some designs, such as his 'Platform' bench of the mid-1940s, were purely functional, whereas at other times Nelson was in playful mood, as when creating his 'Atom' clock, his 'Bubble' lamps, his 'Coconut' chair and his 'Marshmallow' sofa. The 'Marshmallow' sofa was, in fact, designed not by George Nelson alone, but by his design company, George Nelson Associates. However, the fact that Nelson allowed this design to be issued under his own name indicates that he approved of it, and that he was fully responsive to the fresh ideas it embodied. Through his furniture, clocks and lamps Nelson opened up the range of imagery on which designers could draw for their ideas. Whilst other American furniture designers, such as Bertoia and Noguchi, looked to sculpture as a source for their design ideas, Nelson went beyond art to look at life itself as the subject for design.

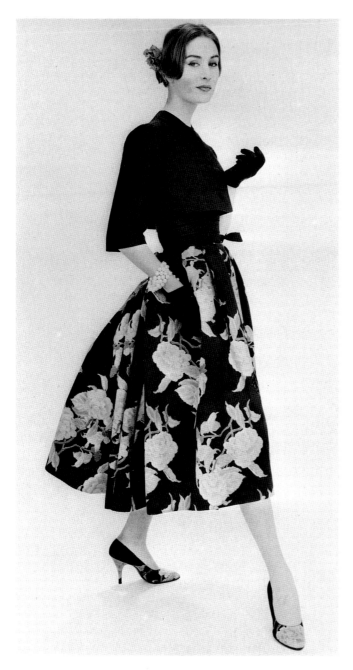

Christian Dior's New Look was swiftly adopted by all the leading couturiers of the day. The influence of Dior can be seen in this outfit by Jean Patou, commissioned by the Cotton Board for their Couture Collection of 1956.

6·The New Look and the New Lookalikes

'One day, somebody told me of a sign in a window, "Noguchi-type lamps." The manufacturer to whom I complained, said he had "Calder-type" and "Moore-type" lamps as well. If I didn't like mine, why didn't I design him one? When I devised what I thought was a contribution, all he could say was, "Sorry, that's not a Noguchi-type lamp."' ISAMU NOGUCHI – *A Sculptor's World.*[1]

The New Look became a victim of its own success. Because it was so visually distinctive, it rapidly became the target for unscrupulous plagiarists who re-worked the superficial characteristics of its style, and regurgitated them in a bastardized form. Noguchi's frustrating experiences emphasize how widespread the problem was, particularly in America, where the markets were so large and the commercial gains so high.

What Noguchi himself found most difficult to accept was not the simple fact of plagiarism taking place, but the debasement of his designs during the copying process. These were not 'Noguchi' lamps, but 'Noguchi-type' lamps; in other words a false re-interpretation by the plagiarist of his own idea of a Noguchi lamp. Noguchi fiercely resented being publicly associated with this sham, and he abhorred the bitter irony of a genuine Noguchi design being rejected by the plagiarist as untypical of the designer's own work. Because of the scale of the fraud which was being committed, however, the consumer was unable to differentiate between the original and the pastiche, rejecting the former in favour of the latter, simply because this version was more familiar. Noguchi's anecdote points to the fact that it was the boldest innovators, such as himself and his fellow sculptor, Alexander Calder, who were subjected to the highest degree of plagiarism. In Noguchi's case this made him so indignant that he became increasingly reluctant to expose himself to such ignominy, with a consequent reduction in the number of objects he designed.

Noguchi was not an isolated case. The Italian designer, Antonia Campi, was similarly high-principled. When she discovered that the aesthetic ideas which she had evolved in

'Butterfly' chair (left), produced in huge quantities by many different manufacturers throughout the USA during the 1950s. Knoll tried but failed to establish the copyright on this design.

The 1950s was an extremely creative period for Italian design, and standards of manufacture and craftsmanship were generally extremely high. Many designers were trained as architects, such as Franco Cavatorta, the designer of this desk (right), produced in the Rome workshop of his father, Silvio Cavatorta, in 1952.

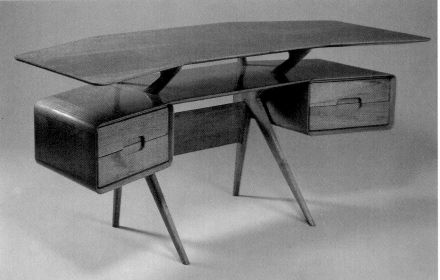

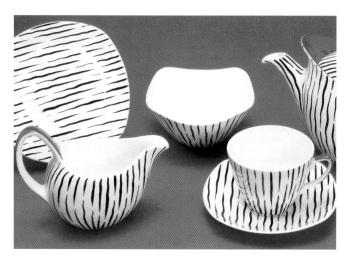

The New Look and the New Lookalikes: Jessie Tait's 'Zambesi' pattern on Midwinter tableware (above), *c*.1957, was copied by Beswick on their zebra-striped wares (below) designed by Albert Hallam and Jim Hayward, which remained in production until 1963.

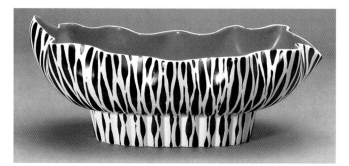

Plagiarism was rife in close-knit manufacturing communities such as Staffordshire and Murano. This Murano vase (right) is in the style of Flavio Poli, the resident designer at Seguso Vetri d'Arte.

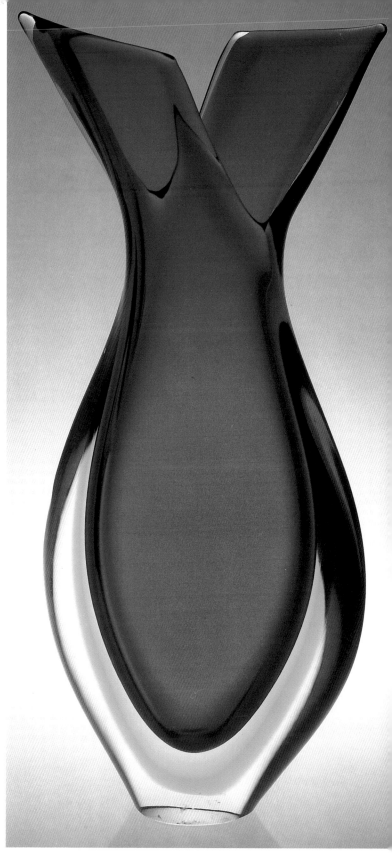

her surreal sculptural ceramics at Laveno were being mimicked by commercial manufacturers such as ViBi of Turin, she discontinued her exciting work on the development of the 'Fantasia' series in order to concentrate on the less glamorous – but consequently less plagiarized – field of sanitary ceramics.[2]

Designers working in geographically close-knit communities, such as those at Murano and Staffordshire, were, if not immune, then at least hardened to the existence of breaches of copyright. Paolo Venini's 'Handkerchief' vases, for example, were widely copied by other Murano factories, but rather than trying to put a stop to his competitors, Venini saturated the market with his company's products, and by

'Quarto' furnishing fabric by Lucienne Day for Heal's, 1960. The British did not appreciate their native design talents in the same way as the Scandinavians and the Italians.

expanding the range of shapes, sizes and patterns available, he succeeded in dominating the market.

Jessie Tait, the innovative pattern designer working at Midwinter, accepted plagiarism as a fact of life in the Potteries. She was philosophical about the fact that her zebra-striped 'Zambesi' pattern was so widely copied by other Staffordshire manufacturers that little credit for the original invention was accorded to the designer.[3] Roy Midwinter's solution to the problem of plagiarism was always to keep one step ahead of his rivals by encouraging his designers to produce ever greater numbers of new designs, as well as commissioning patterns from outside artists and freelance designers. Jessie Tait, for example, saw well over thirty of her designs put into production during the 1950s – a remarkable achievement by today's standards – as well as overseeing the adaptation of designs supplied by outsiders, such as Hugh Casson and Terence Conran. Roy Midwinter also introduced the practice of applying personalized back-stamps to each new pattern, which drew particular attention

to the name of the designer, the manufacturer and the design. In this way he aimed to make Midwinter well known and immediately recognizable for its association with named designers.

Plagiarism, therefore, had two distinct and opposing consequences: one negative and one positive. Some designers became deeply disillusioned and renounced their work in protest against seeing it so widely copied and debased. Enlightened manufacturers, however, realized that the only way of overcoming the problem of plagiarism was through relentless design innovation, and by overwhelming their competitors with the sheer quantity and variety of their products. On the whole this ploy was much more successful than that adopted by manufacturers embarking on costly and largely unproductive lawsuits. Knoll were singularly unsuccessful, for example, in attempting to prove their copyright on the popular 'Butterfly' chair, and even had they done so, they would still have been confounded by the sheer number of protagonists they would have had to fight through the courts.

Plagiarism in itself, therefore, did not put a stop to the New Look. Through clever marketing, manufacturers were able to overcome some of the problems that it raised.

According to Russel Wright, whose 'American Modern' tableware was copied on a huge scale by over ninety different manufacturers, the demise of the New Look was the result, not of plagiarism, but of post-war affluence, which undermined the democratic ideals upon which the movement was founded. Wright had wanted 'to convert the masses – to design for middle- and lower-class Americans a way of life expressive of what I thought was basic American taste'. By the mid-1950s, however, he had to admit defeat: 'My religion, which I had pioneered for twenty years, was losing.'[4]

The situation in Scandinavia was rather different because, in these countries, production was dominated by a relatively small number of manufacturers, amongst whom, throughout the decade and well into the 1960s, there was a spirit of healthy competition. In Finland, for example, there were only three main glass factories – Iittala, Nuutajärvi and Riihimäki – and one principal ceramics factory – Arabia; and in Denmark there were two main glass factories – Holmegaard and Kastrup – and two major ceramics factories – Royal Copenhagen and Bing and Grondahl. Because the New Look was widely accepted in these countries by both the public and manufacturers alike, and because high standards of design had been achieved over a period of several years, there was a much surer foundation for further progress than in America and the UK.

In the USA, in spite of huge markets, only a relatively small number of high-profile companies had ever taken any initiatives in design – such as Knoll and Herman Miller – whilst the rest had simply been content to follow as commercial trends dictated. In America increasing affluence meant that consumers were very much fashion-led. The regularity with which they changed their car, their carpet, their curtains or their kitchen was a visible symbol of their wealth and status. This is why Wright bemoaned the negative effects of post-war affluence. Affluence encouraged the consumer to pay less attention to quality and more attention to style, thus leading to the damaging and destructive concept of built-in obsolescence. After excessive design plagiarism in the USA during the late 1940s and early 1950s came a period of excessive design styling. Manufacturers were motivated by a desire to create, not something better, but simply something new, which led to the adoption of increasingly extravagant styling. Cars, with their astonishing tailfins, were the most obvious example of this trend, but it was a phenomenon which extended through almost every sphere of design: in particular, colours were brighter and patterns were stronger than they had ever been before.

In an article on 'The New Look' written in 1963 by the journalist, Pearson Phillips, the writer describes how, in

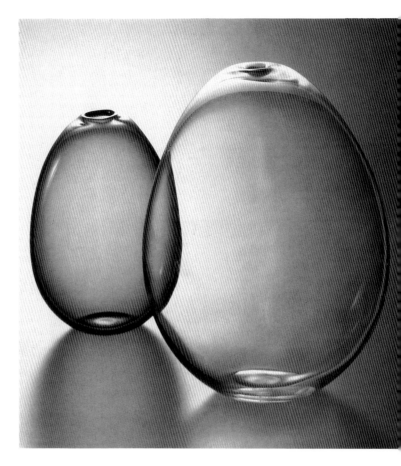

Scandinavian Modern design in the 1950s attained an unrivalled standard and consistency. 'Bubble' vases by Kaj Franck for Nuutajärvi, 1954.

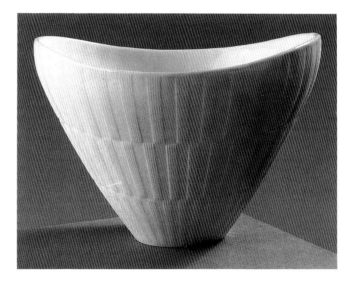

'Randi' pressed glass bowl by Arthur Percy for Gullaskruf, turning serial art wares into mass-produced everyday household accessories.

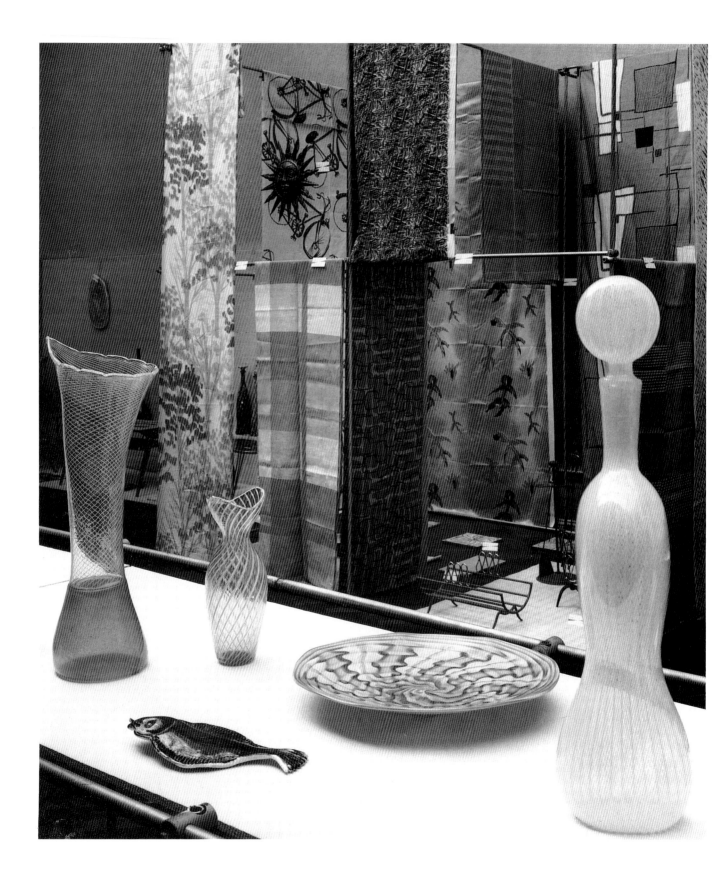

According to Russel Wright, whose 'American Modern' tableware was copied on a huge scale by over ninety different manufacturers, the demise of the New Look was the result, not of plagiarism, but of post-war affluence, which undermined the democratic ideals upon which the movement was founded. Wright had wanted 'to convert the masses – to design for middle- and lower-class Americans a way of life expressive of what I thought was basic American taste'. By the mid-1950s, however, he had to admit defeat: 'My religion, which I had pioneered for twenty years, was losing.'[4]

The situation in Scandinavia was rather different because, in these countries, production was dominated by a relatively small number of manufacturers, amongst whom, throughout the decade and well into the 1960s, there was a spirit of healthy competition. In Finland, for example, there were only three main glass factories – Iittala, Nuutajärvi and Riihimäki – and one principal ceramics factory – Arabia; and in Denmark there were two main glass factories – Holmegaard and Kastrup – and two major ceramics factories – Royal Copenhagen and Bing and Grondahl. Because the New Look was widely accepted in these countries by both the public and manufacturers alike, and because high standards of design had been achieved over a period of several years, there was a much surer foundation for further progress than in America and the UK.

In the USA, in spite of huge markets, only a relatively small number of high-profile companies had ever taken any initiatives in design – such as Knoll and Herman Miller – whilst the rest had simply been content to follow as commercial trends dictated. In America increasing affluence meant that consumers were very much fashion-led. The regularity with which they changed their car, their carpet, their curtains or their kitchen was a visible symbol of their wealth and status. This is why Wright bemoaned the negative effects of post-war affluence. Affluence encouraged the consumer to pay less attention to quality and more attention to style, thus leading to the damaging and destructive concept of built-in obsolescence. After excessive design plagiarism in the USA during the late 1940s and early 1950s came a period of excessive design styling. Manufacturers were motivated by a desire to create, not something better, but simply something new, which led to the adoption of increasingly extravagant styling. Cars, with their astonishing tailfins, were the most obvious example of this trend, but it was a phenomenon which extended through almost every sphere of design: in particular, colours were brighter and patterns were stronger than they had ever been before.

In an article on 'The New Look' written in 1963 by the journalist, Pearson Phillips, the writer describes how, in

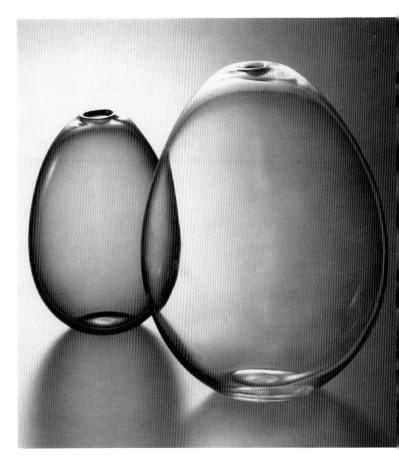

Scandinavian Modern design in the 1950s attained an unrivalled standard and consistency. 'Bubble' vases by Kaj Franck for Nuutajärvi, 1954.

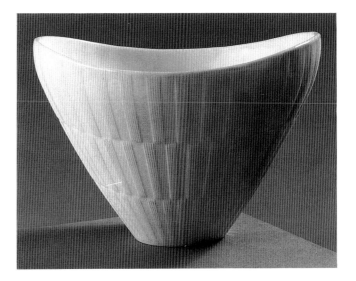

'Randi' pressed glass bowl by Arthur Percy for Gullaskruf, turning serial art wares into mass-produced everyday household accessories.

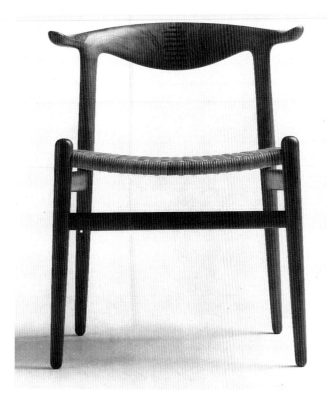

'Cowhorn' chair by Hans Wegner for Johannes Hansen, 1952, stylish but not overly exaggerated, a New Look designed to last.

Britain, the socialist ideals of the late 1940s soon began to falter, and the phrase, 'the New Look', which had been co-opted as a symbol of hope, soon became jaded through over-use: 'There was a New Look in daffodils, a New Look in housing, a New Look in furniture, and a New Look Labour Party . . . The phrase was disastrously over-worked.'[5] By the second quarter of the 1950s, when the period of austerity was over, there was a belated consumer boom in Britain, at which point the ideals of the New Look 'were replaced by a much more brash and confident concept, characterised by the word "contemporary".'[6] This new term, 'contemporary', was, in fact, much more over-worked during the 1950s than 'the New Look' had been during the late 1940s, and whereas the New Look was based on the idea of fundamental change, 'contemporary' was simply the name of a fashionable style that inevitably became out-dated.

Only in those countries in which the New Look had been based on firm foundations, and had been widely adopted by the majority of the leading designers and manufacturers, was progress sustained until the end of the decade. Italy, Finland, Denmark and Sweden all went on to make further achievements in the applied arts during the course of the 1960s – achievements which were backed up by considerable commercial success and the consolidation of increasingly valuable export markets. This brought wider prosperity for these nations and, as Ulf Hård Af Segerstad points out with regard to Scandinavia, this had a positive knock-on effect throughout the economy: 'Products of the applied art industry acted as ice-breakers on the international market. Denmark exhibited ceramics and exclusive teak furniture in order to sell butter and bacon . . . Sweden presented the beautiful everyday article, quickly changed the subject, and started talking about machinery and iron ore. Finland provided a concoction of noble ryijy rugs and gleaming glassware as an aperitif before bringing on the wood-pulp.'[7]

For all these countries, and for Italy too, the period of the New Look between 1947 and 1960 was an extremely important phase in their development. Unlike America, which in some respects burnt itself out, and Britain which never really appreciated the strengths of its own achievements, Italy and Scandinavia learnt to appreciate good design and to use this as a vehicle for achieving national prosperity. Scandinavia, with its all-round design excellence, never really had a problem with the 'New Lookalikes', and, except in rare instances, the same was true of the Italians because of their innate individuality. In these countries, therefore, the New Look flourished, resulting in some of the most remarkable design achievements of the century.

Directory of 1950s Design

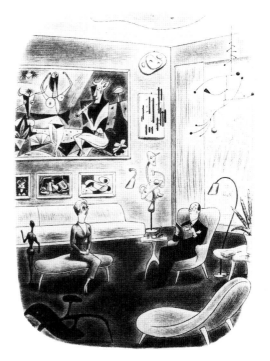

'*George, I don't know how you're going to take this, but I've grown tired of modern*'. Cartoon from *The New Yorker* by Richard Taylor, 1950. © Richard Taylor. Courtesy of *The New Yorker*.

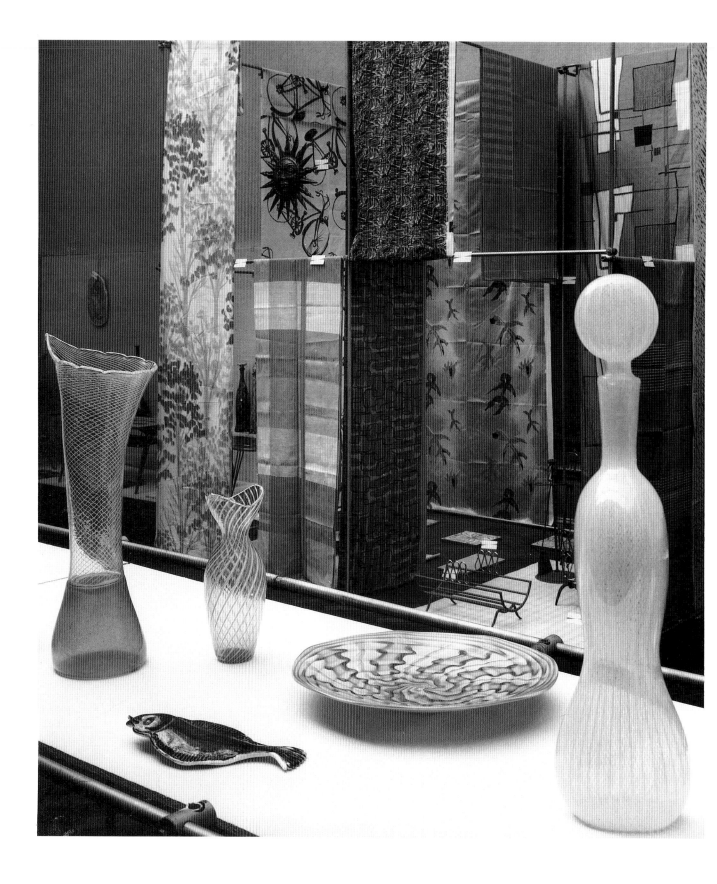

Ceramics

American Ceramics

The two leading American ceramics designers of the period were **Russel Wright** (1904–76) and **Eva Zeisel** (b.1906). The main characteristic of their work was a commitment to functionalism, tempered by bold exploration of the expressive potential of organic modernism. Russel Wright spread his talents liberally across many fields, including ceramics, glass, cutlery, plastics and furniture. His ceramics were just one of many products marketed under the general title of 'American Modern'. In choosing this title Wright's message was clear: the way ahead for American design was through wholeheartedly embracing the concept of modern design. Originally designed as early as 1937, and produced from 1939 onwards by the **Steubenville Pottery Company** (founded 1879), the 'American Modern' service remained in production throughout the 1950s, selling over 80 million pieces during the twenty-year period, 1939–59. It also spawned countless imitators and, therefore, directly and indirectly, it dominated American ceramics during the 1950s. Whilst the streamlined shapes reflected their pre-war origins, the rimless plates and the 'soft forms' of the vessels heralded the New Look. Also innovative were the unusual coloured glazes (seven in all) with which the service was decorated. In 1946 Wright designed a not dissimilar dinnerware range called 'Casual China' for the **Iroquois China Company**. This had a stronger body which was less prone to chipping, and which was suitable for oven-to-tableware use.

During the 1920s and 1930s, whilst working in Europe, the Hungarian-born Eva Zeisel had followed the prevailing geometric trends in ceramic design. On emigrating to the USA in 1938, however, her style changed completely and she adopted the newly emerging shapes of organic modernism. The change was first seen in her 'Museum' service, designed in 1942 as a result of a commission from the Museum of Modern Art in New York, which was at this time championing organic design. The new forms were curvilinear: the coffee pot and milk jug tapered elegantly towards the rim and had distinctive curled underlips on their spouts. The jug was also remarkable for having no handle, an example of organic form taken to its logical extreme. The 'Museum' service was put into production in porcelain by **Castleton China** shortly after the war in 1946.

Other early post-war designs by Zeisel reveal the strong biological influence of organic abstract sculpture. Her 'Town and Country' salt and pepper shakers designed for the **Red Wing Pottery** (founded 1870s) in 1946, for example, were inspired by the biomorphic forms of Jean Arp and Henry Moore. Zeisel has also commented on the importance of the paintings of Salvador Dali on the aesthetics of this period: 'In the 1940s modern tables, containers, and all sorts of things suddenly began to melt, to become soft. What had influenced so many designers simultaneously? I thought at the time it might have been Salvador Dali's paintings, one in particular, with the melting watch.'[1] The plastic quality of the clay was also highlighted by other details within the 'Town and Country' dinnerware range, such as the handles on the lids of the vessels, which resembled the impression made by a thumbprint.

In 1952 Zeisel's popular 'Tomorrow's Classic' earthenware dinnerware was produced by **Hall China**; with this she further refined her ideas about organic form. All the shapes have a relaxed fluidity, which extends through from their basic contours to details such as undulating rims and cresting or looped handles. The ideas for these shapes may well have come from Scandinavian glass, as there are distinct similarities between them and the work of Paul Kedelv at Flygsfors in Sweden, particularly his 'Coquille' bowls. In Zeisel's second earthenware service for Hall China, the 'Century' range of 1957, these plastic tendencies were even more pronounced, the oval plates of the 'Tomorrow's Classic' service being drawn out into tear-shaped forms. A series of bowls and platters from this service was designed so that they would nestle one within the other, an idea not dissimilar to Alvar Aalto's glass flower from the 1930s.

The most original studio potters working in the USA after the war were of European origin. The Austrian-born **Gertrud** (1908–71) and **Otto** (b.1908) **Natzler** arrived from Vienna in 1938 to set up their studio in California. Gertrud was the thrower and Otto was the glaze specialist. Small in scale and simple in form, their pots were inspired by the classic glazed stonewares produced in Sung Dynasty China. Of their work, the Natzlers have said: 'We are not attracted to the large scale pot; it is the intimate that attracts us. We feel that pottery is to the visual arts what chamber music is to the art of music.'[2] The most distinctive feature of the Natzlers' work was the textural quality of many of their glazes, which were often thick and bubbled like lava. The titles given to these glazes – such as 'Pompeian', 'Lava' and 'Crater' – emphasize their volcanic associations. Otto was continually experimenting with glaze effects, and many of his discoveries came about as a result of accidents, such as the glazes with melt fissures or pieces marked by smoke or fire in the kiln. Towards the end of the decade Otto experimented with unusual colours, such as bright Applegreen, which appears on a number of pieces dating from 1960.

The second couple to dominate American studio pottery during the 1950s were **Edwin** (b.1910) and **Mary** (b.1910) **Scheier**. Unlike the Natzlers, who avoided surface decoration other than the colour and texture effects of glazes, the

Vase with Applegreen glaze by Gertrud and Otto Natzler, 1960.

opposite 'Modern Italian Design' exhibition held at Manchester City Art Galleries in 1956, showing a representative selection of Italian applied arts from the mid-1950s.

Stoneware bowl by Hans Coper, mid-1950s.

Freeform bowl designed by Mitzi Cunliffe for Pilkington Tile and Pottery Company, early 1950s.

Scheiers specialized in linear graphic designs incised into the clay or through the glaze slip by means of sgraffito. Whilst some of their abstract designs reflected the stylistic influence of Miró, the majority of the Scheiers' pots were decorated with curious primitive figure drawings, often Biblical in subject matter. Significantly, from 1950 onwards the Scheiers were based at Oaxaca in Mexico, where they clearly absorbed local influences. They were also some of the earliest potters to respond noticeably to Picasso's ceramics, but their subject matter was highly personal, and throughout the 1950s they worked in an isolated and independent vein.

British Ceramics

The British ceramics industry had an extremely slow start after the war. A tendency towards insularity in Staffordshire, where the industry was centred, resulted in an overwhelming ignorance of the revolutions in shape design that had been taking place on the Continent during the 1940s. In this context it is all the more surprising, therefore, to learn of the interesting initiative in Lancashire at the **Pilkington Tile and Pottery Company** (founded 1891) in the early 1950s when the company made the enlightened decision to employ an American-born sculptor, **Mitzi Cunliffe** (b.1918), to design a new range of shapes. The thick-walled bowls she designed were strongly sculptural and confidently asymmetrical in form. Cunliffe adopted the organic contours which were already popular in American ceramics at this date, but which were still unfamiliar in the UK. These progressive freeform bowls only remained in production until 1957, however, when the pottery department was closed down. Although by no means avant garde in an international context, this range arrived too early to be accepted by the British market. Until the mid-1950s most Staffordshire manufacturers tried to convince themselves that the New Look in ceramics was a minority taste with no viable commercial basis.

Roy Midwinter (1923–90) proved them wrong. Brought in to work for the family firm of **W.R. Midwinter** (founded 1910) after the war, he returned from a sales trip to the USA in 1952 overwhelmed by the dynamic new organic-shaped ceramics of Eva Zeisel and Russel Wright, and determined to try similar experiments at home. A self-taught shape designer, he was able through his 'Stylecraft' range of 1953 to trigger off a revolution in the British ceramics industry. Even more daring was Midwinter's second range – 'Fashion', designed in 1954 – in which he introduced projecting and undulating rims, high strap handles and solid grip knobs. Roy Midwinter was also an enlightened patron of innovative pattern design. He encouraged the firm's staff designer, **Jessie Tait** (b.1928), to create patterns in the new 'contemporary' abstract style, such as 'Primavera' (1954) and

'Cuban Fantasy' (1957), and it was these brightly coloured patterns that converted the consumer to 'Midwinter Modern'. Roy Midwinter also commissioned outside designers, such as **Hugh Casson** (b.1910) and **Terence Conran** (b.1931), to design surface patterns, including 'Riviera' (1954) and 'Cannes' (1960) by the former, and 'Chequers' (1957) and 'Plantlife' (c. 1957) by the latter. Summing up the positive impact that Roy Midwinter's initiatives exerted on the ceramic industry, the designer **Colin Melbourne** (b.1928) has commented: 'Roy was great with young artists and designers. Unlike many manufacturers he "liked" new design . . . Most young designers looked to Roy as a kind of hope sign. The great thing was that Midwinter was selling well and seemed so fresh and optimistic.'[3]

Following Midwinter's successful venture into the 'contemporary' market, other Staffordshire manufacturers soon followed suit, including **Ridgway Potteries** (founded 1955) with their popular 'Homemaker' tableware designed by **Enid Seeney** (b.1932), and **Burgess and Leigh** (founded 1862) with their 'Fantasia' pattern. Hitherto conservative manufacturers, such as **John Beswick** (founded c. 1927), now jumped on the New Look bandwaggon. Beswick produced a range of wavy-edged, loop-handled, tripod-footed and twin-necked bowls and vases designed by **Albert Hallam** (c.1912–76) during the mid-1950s. These shapes were decorated with a variety of patterns, the most successful being the hand-painted, zebra-striped pattern designed by **Jim Hayward** (b.1910), inspired by Jessie Tait's 'Zambesi' ware. Beswick also commissioned Colin Melbourne to design a range of 'contemporary' ornaments in 1956. Known as the 'CM' range, these stylized animals and figure groups were strongly influenced by the sculptures of Henry Moore. During the early 1950s Melbourne also worked in the experimental studio at **Wade, Heath and Co.** (founded 1922), although none of his work there ever went into production. Later he formed a design consultancy with **David Queensberry** (b.1929), known as **Drumlanrig & Melbourne**, specializing in 'contemporary' design. David Queensberry was to become well known for his Midwinter shape designs during the 1960s. During the 1950s he created shape and pattern designs for **Crown Staffordshire** (founded 1948). A bone china vase from 1957 has a distinctively modern angular cylindrical shape and a printed pattern of irregular thread-like lines.[4]

Outside the Staffordshire area the most creative and progressive firm during this period was **Poole Pottery** (founded 1895). It is best known for its popular 'Twintone' dinnerware, the original 'Streamline' shapes and 'Vellum' glazes for which were actually designed before the war by **John Adams** (1882–1953) and **Ernest Baggaley** (b.1904), respectively. The concept of a two-tone colour scheme remained popular throughout the 1950s. It was not until the end of the decade that a new shape was finally introduced to replace the 'Streamline' range: this was 'Contour', designed by **Robert Jefferson** (b.1929) in 1959.

For the two periods 1951–55 and 1957–58, Poole employed **Alfred Burgess Read** (1898–1973) to design their new modern decorative ranges. Read made a clean break with the traditional floral designs with which the company had become associated. In terms of abstraction his elegant rhythmic designs were by no means revolutionary, but in terms of the successful application of abstract pattern design to ceramics, his achievements were considerable. Without significantly altering the range of colours used, he re-thought the various colour combinations available and shifted the balance between them. Initially, existing shape designs were used, such as John Adams's 'Cucumber' bowls from the 1930s, and **Claude Smale's** gourd-shaped vases from 1950. From the mid-1950s, however, Read introduced Scandinavian-style freeform organic shapes into the range, including scooped and asymmetrical bowls and hourglass vases. Although Read's work is unmistakably English in appearance, the designer does appear to have had some awareness of Swedish ceramics, especially the work of Stig Lindberg at Gustavsberg.

One new British company to emerge as a significant design force at the end of the decade was the **Hornsea Pottery** (founded 1949). Designs by **John Clappison** from 1960 – such as 'Home Decor', 'Studiocraft' and 'Lattice' – were in a completely new idiom. The work of **Hans Coper** (1920–81) seems to have been a source for some of their shapes. Interestingly, during the early years after the war many British studio potters, such as Coper and **Lucie Rie** (b.1902), played an important role in supplying domestic tableware for the home market, until full-scale unrestricted industrial production was resumed.

Lucie Rie's approach to studio pottery was entirely different from the Leach tradition that prevailed in Britain before the war. In addition to a new lightness of form, Rie introduced a new style of abstract surface decoration using sgraffito, most of her pots being decorated with bands of incised parallel or cross-hatched vertical or diagonal lines. Many potters, such as **Irwin Hoyland** (b.1916) and **Waistel Cooper** (b.1921), were influenced by Rie to adopt incised and sgraffito techniques. Cooper's ash-glazed stoneware pots, whether created in the form of a tall-sided flared bowl or a narrow-necked pod-shaped vase, were boldly experimental. Inspired by the landscape of Iceland, where he lived for five years after the war, Cooper was 'fascinated by the contrast of glazed and unglazed surfaces'.[5] His work represented a cross-over between that of Rie and Coper. For his powerful vessel forms Hans Coper looked back to the resonant shapes of ancient Chinese bronzes. The special potency of his work lies in the inner strength of these vessels, which are detached and self-composed. Coper created the phenomenon of the vessel within a vessel, or rather, the vessel upon a vessel: a series of distinct and contrasting shapes welded together. The abraded textures on their surface also resemble the patina on ancient bronzes.

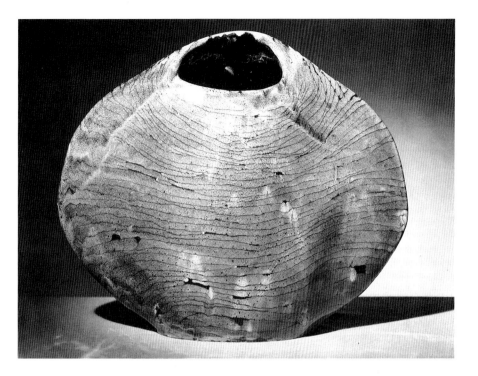

In an article entitled 'The New Look in British Pottery', written in 1955,[6] Dora Billington emphasized the strong influence of Picasso's ceramics on both figure-based ceramic sculpture and the graphic style of pottery decoration in Britain at this time. Picasso's admirers included **James Tower** (1919–88), whose work has itself had a lasting influence on studio potters through to the 1980s.

Vase, James Tower, 1957.

Italian and German Ceramics

When **Pablo Picasso** (1881–1973) settled at Vallauris in the South of France during the summer of 1947 he broke the mould of post-war studio pottery. Although he was untrained in the techniques of throwing and modelling in clay – or perhaps because of this lack of indoctrination – his ceramics were to have a liberating effect on potters throughout Europe. At the same time, however, it is significant that the place in which he chose to establish himself was a traditional pottery-making centre, and that like many potters he fed on tradition, whilst at the same time pushing forward the boundaries of his adopted medium. It was the Italians, in fact, who responded most positively to Picasso's initiatives. His work gave the seal of approval to the type of ceramics that was being created there already, his spontaneous approach to clay being instinctive to many Italians. The attention given to Picasso provided justification for the idea of the artist-ceramicist – a popular concept in Italy.

Porcelain coffee service designed by Giovanni Gariboldi for Richard Ginori, 1954.

In Italy the ceramic industry remained largely workshop-based. In 1955 Conte Vittorio Zappi referred to 'the free initiative of Italian workers, often united in small *schools* or *botteghe*, as in centuries past', and he described how Italian craftsmen display 'an attachment to local traditions, united with an intelligent taste for what is new.'[7] Whereas in Scandinavia industrial production was dominated by a small number of major factories, resulting in a unified aesthetic, in Italy small scale or one-off production encouraged a high degree of diversity and individuality. According to one contemporary commentator: 'Fundamentally, Italians are individualists and they do not like to repeat the same thing endlessly. The craftsman is therefore continually searching for new ways of expressing himself, while at the same time competing with cheap mass produced articles.'[8] This reference to the crafts competing with industry is important because it indicates that in Italy by this date the crafts had become an industry.

The closest parallel to Picasso's ceramics in Europe at the time was the work of **Guido Gambone** (1909–69). After the war he established the **Faenzerella** pottery in Vietri, the term *Faenzerella* meaing small *faenzera*, or small ceramics factory. Gambone was influenced by the spontaneity and humour of Italian medieval pottery, preferring this to the refinement and conscious artistry of later Italian Renaissance maiolica. Like Picasso his work was both painterly and

sculptural, and he was particularly receptive to the peasant pottery of other cultures, especially South America. This interest is reflected in his many anthropomorphic and winged vessel forms, which have the same suggestion of ritual potency and symbolism as many ancient Peruvian vessels, and often take on the same mysterious stirrup spout form. Fertility and the image of the mother also played an important role in Gambone's ceramics. His work was characterized by a casual artistry which disguised his deeper skill and commitment. He was fascinated by the technical possibilities of clays, glazes and enamels, and he was constantly attempting to push forward the boundaries of ceramics through his own experimentation. His hallmark was the use of thick bubbled lava-like glazes in which the blurred surface decoration was suspended as if under water. The abstract qualities of his glaze textures and colours became an end in themselves, even when his subject matter was apparently figurative.

Another multi-talented ceramic artist, **Marcello Fantoni** (b.1915), was more of a sculptor than a potter. Pastoral mythology was the dominant theme of his work of the mid-1950s, in which figures of satyrs and Pan-like flute players formed the main subject. At this stage there was a distinct change in Fantoni's aesthetic: his sculptures became more stylized, and vessel forms took on gigantic proportions up to four feet high. Each figure was divided into planes, brightly painted in contrasting coloured enamels. Towards the end of the decade Fantoni's style changed again: colour was reduced to a dull monochrome, and attention was focused instead on low-relief abstract motifs resembling hieroglyphs on the surface of monumental figures and vessels.[9]

Salvatore Meli (b.1929) created pots that were extravagant both in shape – handformed, lumpy, asymmetrical vessels, sometimes gourd-shaped, sometimes 'winged' – and in decoration. They were usually painted in primary coloured enamels with fantastical figures and animals. More restrained was the work of the German-born **Rolando Hettner** (b.1905), who settled in Italy in 1937. His earthenware pots were generally symmetrical in shape with schematic surface decoration divided into clear sections by means of lines incised in the clay body. Stylistically some pieces were reminiscent of Paul Klee. **Fausto Melotti** (1901–86) was less concerned with decorative imagery than with the surface texture and shape of the vessel itself. Like Hans Coper, he experimented with composite vessel forms, such as a cylinder, a sphere and a cupped bowl all welded together. For **Lucio Fontana** (1899–1968) clay was one of several different media in which he created his 'Concetto Spaziale' sculptures: optical illusions representing abstract forms projecting into space. His work demonstrates the seriousness with which clay was treated as a means of artistic expression.

Surrealism was an important element in Italian ceramics, and it formed the basis of the work of the prodigiously creative **Piero Fornasetti**

(1913–88), who produced literally hundreds of designs for printed plates and tableware during the 1950s. His vocabulary incorporated anything from newsprint to architectural drawings. His 'Themes and Variations' plates numbered five hundred in all, each one a variation on the same enlarged engraving of a female face.

The influence of surrealist painters, such as Yves Tanguy and Max Ernst, can be discerned in the work of **Antonia Campi** (b.1921). Trained as a sculptor at the Brera in Milan, she joined the **Società Ceramica Italiana di Laveno** (founded 1883) in 1948. Here she designed for mass production and serial production, as well as producing unique pieces. At Laveno she was given complete artistic freedom, resulting in work of astonishing originality. For mass production Campi created a range of small bowls and vases in 1954 that were asymmetrical and organic in form, some composed of groups of vessels fused together to form composite vases, some starkly painted in black and white, as if half in shadow. Campi's work was highly sculptural even when she was designing functional wares. An umbrella stand from 1954 resembles a wood carving by Barbara Hepworth, while her astonishing 'Torena' washbasin of 1959 was in the shape of a giant mushroom.[10]

In Campi's limited edition and unique pieces experimentation with form and colour became highly complex. In 1955 she began to create her 'Fantasia' vessels. These pieces adopted an extravagant rococo idiom, with vases raised on rocky pedestal bases, and spiky coral-like handles projecting diagonally into space. Some pieces retained a vestige of function whilst others were created as pure ceramic sculpture. Like Fantoni and Meli, Campi used brightly coloured enamels to decorate her pottery and to break up further the surfaces of her already jagged forms. One of her most important creations was a huge relief wall panel that was created for the Milan Triennale in 1951. Constructed in sections, it was a complex abstract work, painted in bright enamels with irregular geometric patterning. According to Enzo Biffi Gentili, Campi gave up her experiments on the 'Fantasia' series 'in order to avoid any incorrect, unwanted associations with modernist ceramic bric-a-brac, with the approximated, lop-sided free forms and asymmetries of the likes of ViBi'.[11] The Turin-based **ViBi** mass-produced exaggeratedly sculptural bowls and vases with looped handles and projecting rims. Whereas at Laveno there was a sincere attempt to push forward the boundaries of industrial ceramics as an artistic medium in their own right, ViBi adopted Campi's aesthetic formula for purely commercial reasons.

Apart from the SCI, the two principal manufacturers during the 1950s were **Richard Ginori** (founded 1896) and **Ceramica Pozzi** (founded 1906). At Ginori the principal designer was **Giovanni Gariboldi** (1908–71), who created tableware and tiles, decorated with printed linear abstract patterns. Tiles and sanitary ware were the mainstay of the Italian ceramics industry after the war, a fact underlined by the parameters

of **Gio Ponti's** (1891–1979) involvement in the industry as a freelance designer during the 1950s. As well as designing colourful textured glazed tiles for **Ceramica Joo** for use on the exterior of buildings, he also created a classic sleek angular sink and toilet design for **Ideal Standard** in 1953, which won a Gold Medal at the Milan Triennale the following year.

It was through the Triennales that Italian ceramics were brought to the attention of an international audience, and thus became the inspiration for industrial designers all over Europe. Even the German factory, **Rosenthal** (founded 1880), got the bug when in 1955 it introduced its 'New Look' range of outrageously shaped porcelain vases designed by **Beathe Kuhn** (b.1927). She also created some of the Miróesque surface patterns with which they were decorated and, in addition, artists were brought in from outside, such as **Jean Cocteau** (1889–1963) and **Klaus Bendixen** (b.1924). It was during the 1950s that Rosenthal first began employing well-known designers from other countries. In 1954, for example, the American design team of **Richard Latham** (b.1920) and **Raymond Loewy** (1893–1986) created the 'Service 2000' tableware design, with its elegant hourglass vessel forms and neatly looped lid handles.

'Torena' sanitary ware designed by Antonia Campi for Società Ceramica Italiana di Laveno, 1959.

Finnish Ceramics

The achievements in Finnish ceramics during the 1950s were nurtured by one company, **Arabia** (founded 1873). In addition to fostering progressive modern design for production, the factory took an enlightened view of studio pottery and ceramic sculpture, and the role they could play in stimulating the industry. Within the main factory site on the outskirts of Helsinki facilities were provided for a large group of studio potters to work under Arabia's patronage producing unique pieces, without any additional obligation to design for industry. The association of these potters with Arabia brought the company considerable acclaim, particularly when their works were exhibited abroad in international exhibitions.

In **Kaj Franck** (b.1911) Arabia found a designer well equipped to modernize its industrial production. Franck, who was head of the design department for utility ware, 1945–73, also worked as a glass designer at Iittala and Nuutajärvi. He, therefore, had a decisive influence on the entire Finnish tableware industry for a quarter of a century. At Arabia he produced designs that united the principles of Modernism with the expressive colour aesthetics of the New Look. His most important innovation at Arabia was his 'Kilta' (or 'Guild') service of 1953, produced in a range of coloured glazes – white, black, green, blue and yellow. The principle was similar to that employed in Russel Wright's 'American Modern' service, allowing consumers

Condiment set designed by Kaj Franck for Arabia, c.1955.

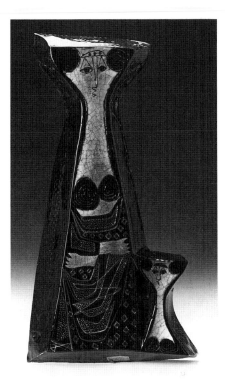

Wall plaque by Birger Kaipiainen for Arabia, 1951.

to select their own preferred colour combinations, the colours themselves having been pre-selected by the designer to co-ordinate in whatever combination they were arranged. The shapes of 'Kilta', however, were much simpler and less stylized than those of 'American Modern', a particular novelty being the production of square and rectangular platters. The most revolutionary feature of this service, none the less, was not so much the actual shapes as the fact that they were standardized – for example, the body of the cup was the same as the body of a sugar bowl or a cream jug. Furthermore, the total number of pieces within the range was reduced as a result of each being designed to serve a number of different functions. Although 'Kilta' got off to a slow start in the market, it gradually became widely accepted, until by the end of the decade it was so popular that it remained in production until 1974.

The art department at Arabia was set up in 1932, and although initially studio potters were expected to contribute ideas towards industrial production, they became increasingly independent until by the 1940s they were no longer expected to act as designers, simply as artists. Some came as temporary visiting artists, others were long-term employees. Many had backgrounds outside the field of ceramics, resulting in the tremendous range and freedom of the work produced within the department. Some artists produced sculptural work, such as **Sakari Vapaavuori**, others concentrated on graphic effects, such as **Oiva Toikka** (b.1931); some potters experimented with organic form, others were interested in the technical possibilities of different ceramic bodies.

Birger Kaipiainen (1915–88) produced highly decorative relief wall-plaques of attenuated figures or figure groups, and later, complex composite sculptures, some free-standing, of awkward thin-legged birds. **Rut Bryk** (b.1916) specialized in decorative tile panels, often cellular in structure with patterns impressed into the clay body, or sometimes figurative with outlines in relief filled in with rich translucent coloured glazes. **Toini Muona** (1904–87) combined experimentation with innovative attenuated and organic-shaped vessels with the decorative effects produced by flambé glazes. Particularly successful were her tall wavering 'Grass' vases produced from the early 1940s. **Friedl Kjellberg** (b.1905) created gourd-shaped vessels with coloured glazes, and also paper-thin porcelain bowls with rice grain decoration, a range of which were later put into serial production. **Aune Siimes** (1909–64) also worked with fine porcelain, sometimes experimenting with form to produce orchid-like vases with petal-thin walls, sometimes experimenting with pattern, creating decorative effects from a combination of white and coloured china clay bodies.

Kyllikki Salmenhaara (1915–81) is perhaps the best known of all the Finnish potters working during this exciting period. She used coarse stoneware bodies to create vessels in highly unusual and exaggerated forms: some tall and attenuated, with high rounded shoulders and tight necks, thinly glazed; some squat and wide, their sides drawn in and out abruptly from minimum to maximum width, their unglazed chamotte body producing a rough natural texture and bright earthy colours. These bowls and vases were inspired by the unconventional forms of ancient South American ritual vessels, and in this respect and in their concern with the texture of the clay, they are similar to the works of Hans Coper. Interestingly, however, in spite of their historical inspiration they looked astonishingly modern, some virtuoso pieces even earning the nickname of 'Flying Saucers'.

When looking at the Scandinavian ceramic factory system it is important to distinguish between the very different arrangements in Sweden and Finland. In the former unique pieces were created by staff designers in the factory studios, but the emphasis was on design for serial and mass production, with studio work being seen as a way in which new ideas for advances in production were originated as a result of free experimentation. In Finland, however, the factory acted as the patron of individual artists and potters producing one-off ceramics, and it promoted studio pottery in its own right as an independent medium separate from industrial ceramics.

Swedish and Danish Ceramics

In the field of both industrial and studio ceramics Sweden was a world leader, her achievement being dominated by one firm, **Gustavsberg** (founded 1825), and the work of this firm being crowned by the achievement of one outstanding designer, **Stig Lindberg** (1916–82). In Sweden progress in the ceramics industry had continued steadily during the early 1940s, whereas in other countries it was brought to a complete halt by the war, so that by 1950 Sweden was virtually a decade ahead in terms of its development. The reason for Gustavsberg's particular pre-eminence, however, was the quality of its designers. **Wilhelm Kåge** (1889–1960) carried it through the war years and, having handed over the art directorship to his pupil, Lindberg, in 1949, continued working in the factory studio until the end of the 1950s. It was the combination of two such strong leaders that resulted in Gustavsberg's particular design excellence.

Kåge's most important mass-produced designs date from the 1930s, whereas during the 1950s he concentrated on studio wares and serial pieces. His 'Soft Forms' dinnerware of 1938 set the tone for the 1950s and continued in production throughout that decade. During the 1940s Kåge turned to the medium of tin-glazed earthenware to produce his Picassoesque face plates. Also dating from this period were his 'Vaga' bowls and vases in white stoneware. With their unusual organic and asymmetrical forms and wavy-edged rims, these pieces were evidently

inspired by the plastic forms of contemporary Swedish glass. The closest parallels are to the frilled 'Kantara' bowls designed by Sven Palmqvist at Orrefors in 1944. Kåge's output from the 1950s was dominated by his 'Farsta' stonewares in which he concentrated on the exploration of new shapes and surface textures.

The creative interaction between studio and industrial production, so characteristic of Scandinavian design in general, is especially apparent in Stig Lindberg's work. Like Kåge he chose stoneware as the medium for his boldest experimentation. The shapes of his unique wares from the 1940s were subtly organic, delicately potted and thin-walled, decorated with reduction glazes in muted shades. As with the pots made by **Berndt Friberg** (1899–1981), also working in the Gustavsberg studio at this time, the strongest aesthetic influence was Chinese Sung Dynasty ceramics. As well as one-offs, Lindberg also created designs for serial-produced stonewares, such as his 'Reptile' vessels with their scaly relief-moulded texture, and a vase shape resembling the tail of a lizard. This newly developed organic idiom later influenced the form of Lindberg's production tablewares, such as his 'LA' service in earthenware and his 'LB' service in bone china. His unusual 'Pungo' and 'Veckla' stoneware bowls and vases from the mid-1950s were perhaps the most dramatically organic of all the shapes he designed.

Lindberg was one of a rare breed of designers with an equal interest in both form and decoration. He delighted in colour and pattern, and it was for this reason that he approached the design of tin-glazed earthenware with such enthusiasm, because it provided him with a wide scope for producing lively, colourful and visually stimulating designs. Occasionally his early designs were representational, such as a bowl painted with washing hanging on a line dating from the 1940s. Typical of the early 1950s were his leaf-shaped bowls painted with leaf-vein patterns, and his 'Spectrum Leaf' vessels painted in rainbow colours, some produced in conventional forms, others organic and asymmetrical. Later in the 1950s he adopted a more geometrical style in which the dominant element was pattern rather than colour, with designs such as 'Domino' being produced in black and white on straight-sided cylindrical vases and square bowls. The 'Domino' range presaged the 1960s, particularly the influence of Op Art on pattern design.

In the late 1950s studio potters who had no input into the design of production wares were employed at Gustavsberg; among them was **Anders Liljefors** (1923–70). Whereas in the work of Stig Lindberg craft and industry had been integrally combined, during the 1960s a greater distance would emerge between studio pottery and production ceramics, and the hitherto fruitful interaction between the two would become more strained, each party pulling in a different direction.

Gustavsberg's main competitor within Sweden was **Rörstrand** (founded 1726), whose leading designer at this period was **Carl-Harry**

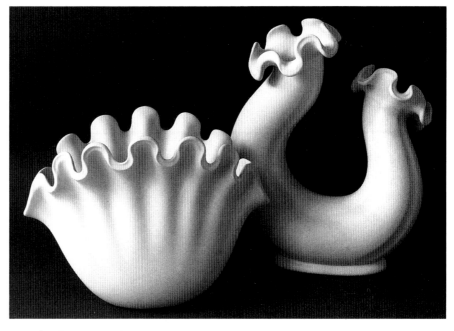

'Vaga' bowl and vase designed by Wilhelm Kåge for Gustavsberg, 1949–50.

'Domino' vase and bowl designed by Stig Lindberg for Gustavsberg, 1955.

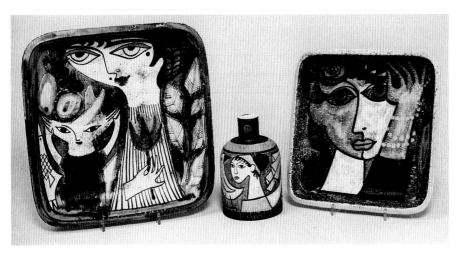

Dishes and vase painted by Mari Simmulson, Upsala-Ekeby, 1950s.

Faience bowl designed by Stig Lindberg for Gustavsberg, 1942–55.

Stalhane (b.1920). Like Lindberg he designed both studio and production wares, his speciality in the former being tall, narrow-necked vases – called 'Frozen Music' – in high-fired stoneware or bone china. The art director at Rörstrand during this period was **Gunnar Nylund** (b.1904), who worked concurrently in the same position at the Strömbergshyttan glassworks. He designed a wide range of simple organic-shaped studio wares, some of which were produced as miniatures. **Hertha Bengtson** (b.1917) also designed for Rörstrand throughout the 1950s, her most well-known design being the high-handled sculptural organic 'Blå Eld' or 'Blue Fire' tableware with its moulded textured surface resembling the impress of basket weave. Throughout the period **Marianne Westman** (b.1925) designed lively and colourful printed designs for tableware and kitchenware, several of which won awards at the Milan Triennales.

Of the numerous other Swedish ceramics firms active during the 1950s, some of the most interesting formed part of the **Upsala-Ekeby** group (founded 1886), where the leading designer and art director, 1953–57, was **Sven Erik Skawonius** (1908–81). It was at Upsala that the talented Estonian artist, **Mari Simmulson** (b.1911), created her Picasso-inspired figurative designs painted on square and triangular platters.

In the field of studio pottery the most outstanding Swedish ceramicist from the 1950s was **Signe Persson-Melin** (b.1925), who distinguished herself by winning the Lunning Prize in 1958. She went against the progressive trends in Swedish industrial design by producing Japanese-inspired teawares of a traditional nature, and by working quite separately and independently from the industry. The traditional nature of Persson-Melin's work links her more closely with many of the studio potters working in Denmark at this time, such as **Per Linnemann-Schmidt** (b.1912) at **Palshus**, and **Eva Staehr-Nielsen** (1911–76) and **Nathalie Krebs** (1895–1978), who collaborated at **Saxbo** (founded 1930) from 1932 onwards, the former making vessels, the latter specializing in glazes. There are also resemblances between her work and the industrial tableware designs of the studio potter **Gertrud Vasegaard** (b.1913) for **Bing and Grondahl** (founded 1853), particularly in the faceted shape of the latter's wicker-handled teapot of 1956. In Demark the studio pottery aesthetic of the 1930s dominated industrial production throughout the 1950s. **Axel Salto** (1889–1961), the leading ceramic designer from before the war at **Royal Copenhagen** (founded 1775), continued to play a major role in the production of studio art wares. His strongly vegetal organic vessels and sculptures became increasingly surreal during the 1950s, culminating in some astonishing large-scale works representing giant grotesque bud-like forms.

Fashion

By Anthea Jarvis

American Fashion

Before the Second World War, American fashion had little sense of national identity and style. Since the mid-19th century Paris had been the fashion mecca for wealthy American women who set the trend in society, and Paris style and Parisian couturiers dictated what both American designers and ready-to-wear manufacturers produced. America's only distinctive contribution to international fashion was via the Hollywood film industry. **Gilbert Adrian** (1903–59) designed clothes for most of MGM's most glamorous stars, including Greta Garbo and Joan Crawford, during the 1930s and 1940s, and his figure-hugging crepe or satin evening sheaths, and broad-padded shoulders on daywear, influenced the aspirations of a generation of moviegoers worldwide. With the outbreak of war, America's contact with Parisian couture was cut off, and the fashion world was obliged to look to homegrown talent to fill the void. American fashion was to develop in two directions: on the one hand, classic, elegant, meticulously tailored clothes in the Parisian tradition; on the other hand, a truly indigenous American style, a relaxed, simple yet sophisticated look, inspired by country and work clothing.

Among the classicists, the giant was **Charles James** (1906–78), who produced his best-known work in America, though he was English-born and worked also in London and Paris. A master cutter and dressmaker, he worked in the French couture tradition, yet most of his designs were extraordinarily radical. His best-known creations, evening dresses for the wives of America's top diplomats and businessmen, had a monumental quality, in which fabric was engineered to form shapes hitherto unimagined. His "Clover Leaf" ballgown of 1953 for Mrs William Randolph Hearst is one of fashion's most stunning creations, in stark ivory and black satin, with a perfectly sculpted strapless bodice, and a skirt fluting into four equal stiffened points.[1] An eccentric and difficult man, he was obsessed by his work and his search for perfection. He regarded his clothes as works of art, and spent endless time in their creation, to the despair of his clients.

Mainbocher (Main Rousseau Bocher) (1890–1976), America's first internationally known designer, left his native Chicago for Paris, where he opened a couture house in 1929. His clothes had typical Parisian understated elegance, and a major influence on his work was Vionnet's bias cut.[2] He returned to New York in 1940 and, together with **Norman Norell** (Norman Nevinson) (1900–72), continued the French couture

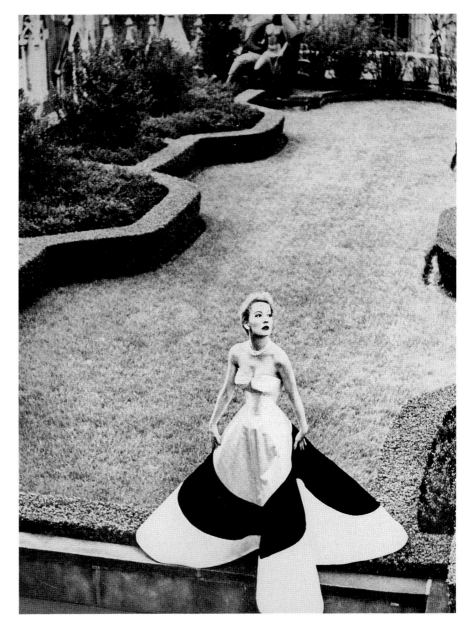

tradition in America. Norell was revered as a master of the classic style in the 1950s, and his work had a great influence on subsequent generations of American designers.

Fashion in a purely American idiom was initiated by **Claire McCardell** (1906–58). She was trained at the Parsons School of Design in New York, and her unconventional designs came to public notice during the war when America was isolated from European fashion and luxury fashion fabrics from across the Atlantic were unavailable. McCardell used American fabrics hitherto disregarded, such as calico, seersucker, denim and wool jersey, to create simple, unpretentious, relaxed clothes, suitable for wearing

'Clover Leaf' ballgown by Charles James, 1953.

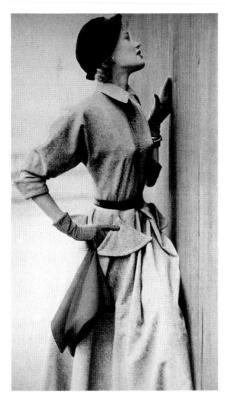

Wool jersey dress by Claire McCardell, 1949.

any time of day. Hating padding and hard angular shapes, she adapted aprons and traditional work clothing into fluid, elegant and functional garments, such as her 'popover' wraparound dress of 1943. She pioneered the idea of interchangeable separates, later developed by **Bonnie Cashin** (b.1915), who started her career designing for films, but moved to New York to work as a fashion designer in 1949. Her clothes were designed for a new lifestyle, for the young liberated woman constantly on the move with little time or space for complicated, formal clothes. They were timeless, casual and comfortable, made in high-quality natural fabrics, especially suede, leather and wool jersey, to high standards of workmanship. Her layered look, developed in the late 1950s, was inspired by Chinese dress and by the fringed jerkins, ponchos and boots traditionally worn in the American West and in Mexico.

British and Irish Fashion

When the Incorporated Society of London Fashion Designers was set up in 1942, the idea of an established and organized haute couture in London was entirely new. Before the war, London was very much the satellite of Paris, and some of the larger Paris houses, such as Worth and Paquin, had their own London branches. British designers were expected to work anonymously; their clothes were sold under the name of the fashion house or London store that employed them, and little notice or publicity was given to British fashion in the international fashion press. One exception was **Norman Hartnell** (1901–79) who opened a couture business in Bruton Street in 1923, where he was fortunate in attracting the patronage of society women, who loved his glittering evening gowns, elaborately beaded, sequinned and embroidered, and his picturesque wedding dresses.

With the effective sealing-off of Paris in 1940, a group of London designers saw an opportunity for British fashion to fill the resulting void, and especially to supply the lucrative American markets. The Incorporated Society of London Fashion Designers (ISLFD) was therefore formed, with Government assistance via the Board of Trade, to help members with supplies of fabric during wartime restrictions, and to produce a joint collection to tour South America. The original eight members were Hardy Amies, Norman Hartnell, Edward Molyneux, Digby Morton, Worth (Elspeth Champcommunal), Victor Stiebel, Bianca Mosca and Peter Russell. After the war the members of ISLFD presented joint London Collections, Paris-style; first largely for export to North and South America, but after the end of rationing in 1949, for the home market as well. The Society remained a useful co-ordinating umbrella organization for British couture fashion throughout the 1950s, ensuring publicity and press coverage

for its members who, by the middle of the decade, also included John Cavanagh, Michael at Lachasse, Michael Sherard, and Ronald Paterson.

Several of the Society members also designed for ready-to-wear manufacturers. The number and quality of fashion wholesale businesses in London was an important aspect of British fashion, there being no comparable industry in France. The leading wholesalers organized themselves into an association under the title of the Fashion House Group of London, which in the mid-1950s had twenty-seven members, including **Dereta** (founded 1946), **Dorville** (founded *c.*1919), **Jaeger** (founded 1883), **Marcus**, **Linzi**, **Rima** and **Susan Small**. Within a month of the Paris couture shows the London manufacturers could have a quality copy available in the British shops at a fraction of the cost of the original. One of the smaller fashion houses noted for the originality of its printed cottons was **Horrockses Fashions** (incorporated 1946), a subsidiary of the textile manufacturing company **Horrockses, Crewelson & Co. Ltd** (founded 1798). Horrockses employed artists, such as **William Gear** (b.1915), and young college-trained designers, among them **Pat Albeck**. **Alastair Morton** (1910–63), the art director at Edinburgh Weavers, also worked freelance designing printed patterns for Horrockses Fashions from 1948 onwards. The dresses, with their fresh, innovative, often abstract, prints were sold to an appreciative market in America as well as in Britain.

Hardy Amies (b.1909) started his career as designer for the small couture sportswear firm of Lachasse, which specialized in women's tailored

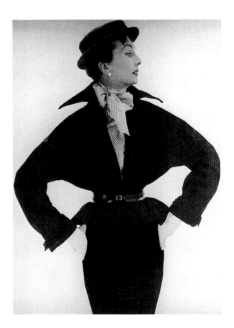

Black poult jacket by Victor Stiebel, 1951.

suits for informal wear. He founded his own couture house in Saville Row in 1946, and immediately received large orders from the American buyers because of his established reputation for classically tailored, well-proportioned suits and coats, considered the epitome of British good taste. Amies considered the suit the most important item in a woman's wardrobe, calling it 'the livery for living'.

Digby Morton (1906–83) preceded Amies as a designer at Lachasse. Under his guidance the basic tailored suit was transformed from a utilitarian garment fit for the moors, into inventively cut, chic daywear suited to any occasion. In 1934 he opened his own couture business, continuing to specialize in tailored outfits and practical daywear. After the war his clothes were very successful in America, where he worked from 1953 to 1957 as a designer for various US companies. Lachasse was to continue to employ talented designers: **Michael at Lachasse** (Michael Donellan) was employed from 1945 to 1953, when he left to open his own fashion business as **Michael of Carlos Place** (1953–71): and **Owen of Lachasse** carried on the tradition of elegant tailored fashion until the 1970s.

Victor Stiebel (1907–76) came to fashion design, like Hartnell, through designing stage and revue costumes while a university student. He ran his own fashion business from 1932 to 1940, and from 1945 to 1963 worked as designer for **Jacqmar** (incorporated 1948).[3] Many of his clothes had a dramatic panache that contrasted with the discreet English style of Amies and Morton; stark contrasts in black and white, and an inventive use of striped and jersey fabrics were characteristic of his style.

John Cavanagh (b.1914) obtained his fashion training in Paris, where he worked for Molyneux[4] and Balmain.[5] He opened his own couture house in London in 1952, continuing to design clothes in Molyneux's understated elegant style, with subtle yet apparently simple cut. Most Irish-born designers, like Cavanagh, emigrated to work in London or Paris, but **Sybil Connolly** (b.1921), though London trained, chose to work in Dublin, first as a designer for Richard Alan, a Dublin store, then from 1957 as head of her own couture house. Her clothes were particularly popular in America. She exploited Ireland's traditional textiles: fine linen, homespun tweeds, crochet and lace, using rich natural colours and interesting textures in her classic and very wearable designs.

Paradoxically, as the decade of high-profile couture in Britain was ending in the second half of the 1950s, the youth fashion revolution was beginning. During the 1960s London, for a brief period, was to become the fashion capital of the world. **Mary Quant** (b.1934) opened her first shop, 'Bazaar', on the King's Road, Chelsea, in 1955, and created a look for a new type of fashion consumer, the independent affluent working girl in her late teens or early twenties, who saw traditional couture, aimed at an older generation, as stuffy, dull and irrelevant. The couture tradition was in any case in decline

worldwide as a result of changes in women's lifestyles, rising costs and difficulties in the supply of skilled workers. Most of the London houses closed in the early 1960s, the only survivors being Hardy Amies, Norman Hartnell and Lachasse.

Italian and Spanish Fashion

Italy had been of little importance in the fashion world prior to the Second World War. The only designer of international status was **Elsa Schiaparelli** (1890–1973), who never worked in her native country but set up her fashion house in Paris, where her original talent and her special blend of chic outrageousness continually made fashion headlines in the 1930s. In the changed fashion climate after the war, however, her originality deserted her and she was content to follow her fellow-designers' lead until she retired in 1954.

In the late 1940s Italian fashion began to emerge on the international scene. With the financial backing of the Italian Government, Signor G.B. Giorgini organized the Alta Moda fashion shows in the Pitti Palace in Florence, with the aim of attracting American journalists and buyers. These shows remained the hub of Italian couture until about 1960 when, with the opening of several new fashion houses in Rome, the focus shifted to the capital. Italian couture in the main followed the line set by Paris, interpreted with a particular emphasis on feminine prettiness. Daywear sometimes displayed a characteristic use of burning colour: flame, ochre, or emerald green. All the Italian collections showed romantic evening dresses, pastel drifts of silk organza, covered with jewelled or appliquéd flowers.

The area in which Italian design strongly influenced the world's manufacturers was knitwear. From the early 1950s onwards Italian boutiques were selling oversize chunky-knit sweaters, with cowl or polo necks and wide armholes, in bright, eye-catching colours, or vivid stripes. Sold originally for après-ski wear, they rapidly became one of the basics of the leisure wardrobe for the young of both sexes.

Emilio Pucci (b.1914), a Florentine nobleman and an Olympic skier, entered the fashion world unexpectedly when his skiing outfit was featured in an American magazine in 1947. He opened a small couture house in Florence in 1950, specializing in silk scarves and shirts printed in vivid unexpected colour combinations – cerise, violet, lime green – and in original and distinctive patterns, many based on Florentine art and architecture. His brilliant prints, made up into beach and resort wear, were extremely popular with the European and American jet set, and owning a Pucci garment became a status symbol. In the later 1950s he produced his prints on uncrushable silk jersey for evening wear.

Roberto Capucci (b.1929) opened his fashion

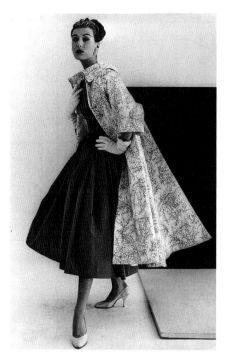

Dress and coat, John Cavanagh, 1957.

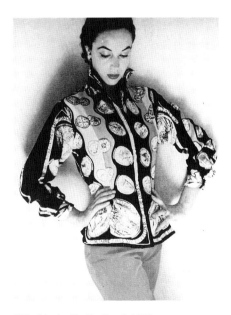

Silk shirt by Emilio Pucci, 1955.

White pique suit by Christobal Balenciaga, 1953.

house in Rome in 1950, but showed regularly in the Alta Moda shows in Florence. His designs were strikingly original and inventive, in the mould of Balenciaga or Charles James. Like theirs, his clothes showed an architectural quality, and a mastery of cut.[6]

Apart from Balenciaga, who chose to work in Paris, Spain's leading couturier was **Manuel Pertegaz** (b.1918), who worked in Barcelona. Like his compatriot, he was a master tailor and his clothes were cut on classically simple, elegant lines, often using traditional Spanish fabrics. In 1953 *Harper's Bazaar* illustrated 'a deceivingly simple dress intricately composed of coarse white lace'.[7] The general trend of Spanish couture, centred on Barcelona, was for flattering feminine styles, with much decorative use of embroidery, braiding and lace appliqué.

French Fashion

'Paris is more feminine than ever . . . Paris rounds every line . . . The big story is a curving opulent day silhouette that is the most elegant fashion for decades.' Thus *Harper's Bazaar* reported on the Paris Couture Collections in Spring 1947, in particular the collections at the new fashion house of Christian Dior, whose 'Corolle' line, christened the 'New Look' later in the year by an American journalist in *Life* magazine, was heralded as the first major post-war fashion. The Second World War, and its aftermath of austerity and rationing, had caused fashion to be effectively frozen for half a decade. Clothes for women during this time had been dictated by shortages of materials and by the all-pervasive image of uniform, resulting in masculine, square-shouldered jackets and short skimpy skirts, flattering neither bust nor waist. Dior's 'Corolle' line, with its emphasis on the curves of the female figure, with tiny nipped-in waists on suits and dresses, padded hips, and long, full, mid-calf length skirts, was calculated to have immediate appeal to women in the post-war world, longing for prettiness, femininity, luxury and elegance. It hit exactly the right note at the right moment, and re-established Paris again as the centre and heart of the fashion world.

The Paris fashion industry had, in fact, survived remarkably intact throughout the war, in spite of the German Occupation from 1940 to 1944. The city's fashion supremacy had been built up over the previous century. In the 1920s and 1930s the numerous couture houses had become well organized under the powerful Chambre Syndicale de la Couture Parisienne, half union and half guild, which was to prove particularly valuable to the industry in protecting its interests during the war years. Not only were the Germans dissuaded from transporting the French couture industry wholesale to Vienna or Berlin, but large numbers of skilled workers were allowed to continue at their posts in the couture workshops, enabling many of the cou-

ture houses to remain open, showing twice-yearly collections, and evading many of the wartime restrictions on material. Thus Paris was well placed to re-establish its prestige as the world's fashion centre in the immediate post-war years.

Christian Dior (1905–57), whose name became synonymous with Paris fashion throughout the world during the late 1940s and 1950s, was in fact a relative newcomer to the couture world. He worked briefly as a designer for the house of Piguet in the late 1930s,[8] and for the couturier, Lucien Lelong, between 1944 and 1946.[9] Dior's designs impressed Marcel Boussac, the French textile magnate, who was looking for a designer to invigorate his own fashion business, but he was persuaded instead by Dior to finance a new couture house under his own name. Thus, with generous and secure financial backing, Dior showed his first collection to the public on 12 February 1947, and caused a fashion sensation.

The 'Corolle' line, in which the skirt 'bursts out into fullness like a flower',[10] called for unusually intricate workmanship, and a structure underneath that had not been seen in women's fashion for many years. Many of the model gowns could literally stand up by themselves. The tiny wasp waists were moulded by built-in boned corsets, the jackets were rounded over the bosom with padding, and below the waist so stiffened and cupped that they stood right away from the body. The hips were padded too, and the skirts stiffened and interlined. It was not in fact a New Look; it followed logically from the fashionable line developing in the late 1930s, which had been ended abruptly by the war: Mainbocher had shown wasp-waisted dresses in Paris in 1939, for example.[11] In many ways Dior's New Look was reactionary and an anachronism, making women once more subservient to their clothes, but it caught the public imagination, seeming to promise women exhausted and depressed by the war everything they thought they wanted. In spite of some adverse criticism for its extravagance, within a year it was accepted everywhere, and with particular enthusiasm in America which, for the duration of the war, had been completely cut off from Parisian influence.

Dior's main concern was with shape and line; he knew little of cutting and tailoring, but he had an unfailing eye for proportion. The shape of each new model was worked out as a muslin toile before the type, texture or colour of the fabric was chosen. After the success of 'Corolle', Dior continued with his same basic shape, which had been swiftly adopted by virtually all the other Paris courturiers, making his changes in detail fashion news. His 'Envol' collection, Spring 1948, showed jackets and coats with loose, fly-away backs, and skirts scooped up into a wing-shaped bustle. The 'Zig-Zag' collection in the autumn of the same year introduced cascading asymmetrical panels on skirts. In 1950 the silhouette was vertical, with stem-slim pencil skirts, and much use of narrow vertical pleating. 'Clothes touch every inch of one's body,'

reported *Harper's Bazaar*. This narrow line was to continue for another two years, finding typical expression in Dior's *princesse* day dresses in wool jersey, clinging to the ribs, appearing high-waisted with a band or bow below the bust, and covered with a tiny fitted, cropped spencer jacket. The 1953 'Tulip' line continued the long stalk of a body, but introduced width and roundness at the bust and shoulders, with wide necklines and full sleeves, but from 1954 onwards a different mood was discernible, a new relaxation and ease in fit and structure. Dior's H, A and Y lines of 1955 and 1956, featured widely in the fashion press, were in fact following trends set by other designers, notably Balenciaga, rather than leading them. His last collection in autumn 1957, just before his sudden and unexpected death, featured the 'Chemise' dress, a loose fitting unwaisted style, almost the complete antithesis of his New Look ten years earlier.

If Dior's New Look of 1947 was in fact an old look cleverly re-packaged to appeal to the mood of the time, genuinely new looks were being created in Paris at the same time by the Spanish couturier, **Christobal Balenciaga** (1895–1972), generally considered to be the greatest 20th-century designer. He was, however, rarely recognized as such by the press or the public during his lifetime, partly because of his own wish to shun publicity, and partly because his designs were often too subtle or too avant garde to be generally appreciated.

Balenciaga's origins were obscure. He came from a peasant family from Guetaria on the north coast of Spain, and from an early age he ran his own dressmaking establishment, learning by experience, personally choosing fabrics, and cutting, sewing and fitting himself, so that, unlike Dior, he became a master craftsman in all branches of couture. He ran a successful business in Barcelona in the 1930s, but finding the atmosphere in Franco's Spain uncongenial, moved to Paris where, except for the war years, he worked until his retirement in 1968. His native heritage was an important influence on his work, particularly the colours and shapes of traditional Spanish costume – flamenco dresses, the jewelled outfit of the bullfighter, the austerity of monk's habits – but he also stood out from his contemporaries because of his obsession with perfection in cutting and stitching, and the elimination of all superfluous detail. His work was described as 'effortlessly classical' by Carmel Snow, the American Editor of *Harper's Bazaar*.

Immediately after the war, Balenciaga was designing suits with full skirts and fitted jackets, with the crisp outline and the hint of rich embroidery and trimming that were typical of Spanish ceremonial dress. A *fin de journée* suit of white linen, shown in April 1948, had the jacket and hemline of the full gored skirt bordered with black *Pointe de Venise* lace. But Balenciaga was already moving away from fitted, structured shapes, and in October 1949, when all the ready-to-wear manufacturers in Europe and America were showing wasp-waisted jackets and padded hips, he showed suits with no waist at all: brief,

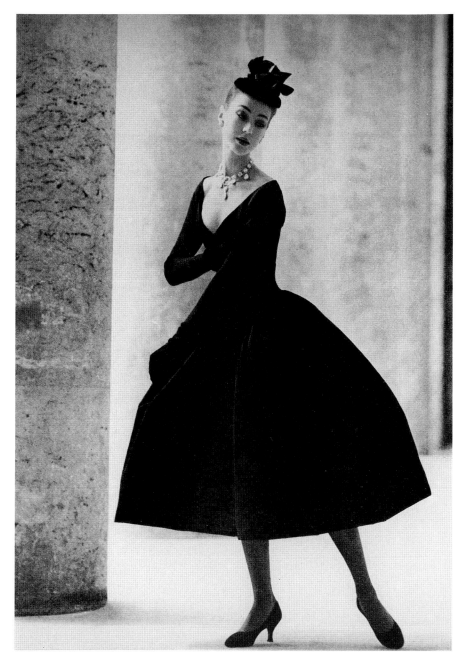

Black faille dinner dress by Christian Dior, 1955.

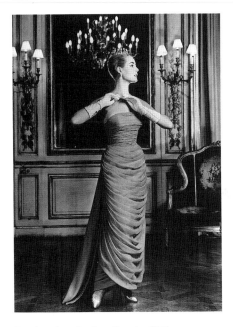

Evening dress by Jean Dessès, 1957.

stiff little jackets worn with narrow skirts. 'The Box line is the newest suitline', announced *Harper's Bazaar*.[12] For evening Balenciaga produced pure fantasy in a dramatic Spanish manner, creating shapes never before thought possible in silk taffeta and lace, such as his double balloon cape of 1950. The 1953 Spring Collection introduced suits with tunic tops based on fisherman's smocks: 'a line that promises to sink deep into fashion: cut completely straight . . . blown like a sail over a narrow skirt,'[13] foreshadowing the fashions of the next decade. Also ahead of its time was a coat in his 1954 Spring Collection in white ribbed cotton, knee length, collarless, standing out all round the body like a cask. Balenciaga's loose, easy cut of jackets and coats, teamed with shortened sleeves and soft collars, led logically to the 'sack' dresses of 1957, imitated later in the year by Dior. Perfectly straight, unfitted and narrowing at the hem, they were wildly popular and far-reaching in their influence. Always an uncompromising purist, Balenciaga retired from couture and closed his house in 1968 because he felt the era of couture was finished, and the new youth-led fashion world did not suit his talents.

In 1954 the major event in the fashion world was the comeback of **Gabrielle 'Coco' Chanel** (1883–1971), who had closed her house in 1939 and retired to Switzerland for the duration of the war. She had found herself in complete opposition to the highly structured clothes of the New Look, which she considered tortured the human body into all sorts of unnatural shapes. She thought clothes should be simple and relaxed, ageless and dateless, and above all, easy to wear. Those she showed in her first collection had changed little from the 1930s, and were undramatic, but supremely comfortable; her classic suit had a neat collarless cardigan jacket and slightly flared skirt, and was worn with a soft feminine blouse with a pussycat bow. The press reaction in 1954 was lukewarm, but Chanel was proved right in her judgment of what women wanted. Her clothes sold rapidly, and her second collection was a sensation. Her casual, softly shaped clothes reinforced Balenciaga's unfitted line, and ushered in a new relaxation in fashion for the second half of the decade. Her shapes were ideal for the ready-to-wear industry, and by the end of the decade variants of her cardigan suit could be found in all the wholesale manufacturers' ranges.

Amongst the French couturiers who struggled through the war years to achieve new fame and prosperity in the post-war Paris fashion renaissance, one of the most original was **Jacques Fath** (1912–54). His gift was for sexy, figure-hugging, daring shapes which, superbly cut and tailored, became elegant acceptable clothes. He was particularly fond of asymmetrical effects, accentuated by drapery or button trimming, and by angles and points which appeared in collars, cuffs and skirt panels. His choice of colour was very personal, and as well as using black and white in dramatic contrast, he mixed blue and green, or yellow and orange, in

his outfits. His clothes appealed particularly to young and sophisticated society women, and he had a large following of private customers, including Rita Hayworth.

Jean Dessès (1904–70) was noted for the soft feminine fluidity of his clothes, many of which were created by draping fabric directly on the dummy. His formal evening dresses, made of intricately draped or layered sheer fabrics, were particularly successful. Another designer to base her personal style on drapery was **Alix Grés** (b.1910). Turning to dress design from a study of sculpture, she created draped and pleated dresses that had the classic simplicity and perfection of a Greek statue. Her preference was for jersey fabrics; wool jersey for daywear, silk for evening wear, perfectly expressing the fluid nature of her designs.

A new talent to emerge in the second half of the decade was **Pierre Cardin** (b.1922), who trained with both Schiaparelli and Dior, and showed his first couture collection in 1953. His strikingly simple shapes for dresses and coats in the later 1950s were ahead of their time, and he has always been experimental and innovative in cut, material and scale. Particularly in tune with the fashion mood of the 1960s, he was to be called the 'Space Age Designer' by the fashion press.

Sheath dress by Pierre Cardin, 1957.

Furniture

American Furniture

It was in the related fields of furniture and architecture that America made its most significant contribution to post-war design. Many of the most influential furniture designers were trained as architects, such as **Eero Saarinen** (1910–61), **Florence Schust Knoll** (b.1917) and **George Nelson** (1908–86). Even **Charles Eames** (1907–78), whose attention became focused almost exclusively on furniture design, said of his work: 'I think of myself officially as an architect. I can't help but look at the problems around us as problems of structure – and structure is architecture.'[1] During the late 1940s and the 1950s the ideas and techniques that these young designers had evolved during the war were put into production by enlightened firms, such as **Herman Miller** (founded 1923) and **Knoll** (founded 1937). The New Look in furniture was taken very seriously by its leading exponents: it involved not just the adoption of a new style, but a radical rethinking of function, structure and materials. Sculpture was another equally important influence, and several of the most successful furniture designs of the early post-war period were conceived by sculptors, namely **Harry Bertoia** (1915–78) and **Isamu Noguchi** (1904–88).

Charles Eames first came to public attention in the Museum of Modern Art's 'Organic Design in Home Furnishings' competition of 1940, where he won first prize with Eero Saarinen for a moulded plywood shell armchair. During the war he continued his experiments with plywood, and in 1946, he won a contract with Herman Miller to put his new plywood chairs into production, using the Evans Products Company as the fabricators. Three different versions were produced: a lounge chair made entirely of wood (the LCW), and a dining chair and a lounge chair with tubular steel legs (the DCM and the LCM, respectively). They were made of five-layer plywood and were originally produced in ash, walnut and birch, the latter sometimes stained either red or black. Eames's second great achievement was the development of a moulded plastic armchair. The initiative for this design was another competition held at MOMA in 1948, this time for Low Cost Furniture. The plastic seat was produced in nine different colours. A wide choice of bases was also available, varying from standard tubular steel legs, to wire cage (known as the cat's cradle) and wire strut (known as the Eiffel Tower) steel rod frames, and even a version with wooden rockers. Other chairs designed by Eames later in the 1950s included a wire chair dating from 1952; a plush leather upholstered lounge chair and

Multi-purpose platform bench designed by George Nelson for Herman Miller, late 1940s.

ottoman with a moulded plywood frame veneered in rosewood from 1956; and a range of aluminium chairs with ribbed naugahyde or nylon upholstery from 1953.

As design director at Herman Miller from 1946, George Nelson acted as a magnet in attracting talented individuals to design for the company, as well as making significant direct contributions himself. His own output was very wide ranging both in concept and style: he designed basic functional unit furniture and office furniture with a minimum of external styling (such as his various 'Storagewall' systems of the late 1940s); he produced some of the most gloriously irreverent, colourful and amusing seating in the history of furniture (namely his 'Coconut' chair and 'Marshmallow' sofa;[2]) and he also created sculptural but practical furniture of great elegance and sophistication (as in his swagged leg armchair of 1958).

A sculptor whose potential as a furniture designer was immediately recognized by George Nelson was Isamu Noguchi. He worked in the organic modernist style, and in the glass-topped table that he designed in 1946, he used just such a piece of sculpture as the support for the freeform table top. Later Noguchi went on to design furniture for Knoll. His work for them, however, was in a different style, for by this date light skeletal wire sculpture of the type produced by Harry Bertoia was displacing the weightier and more monumental organic aesthetic of the 1930s. In his series of 'Rocking' stools a circular wooden base and seat are joined together by a spiralling framework of steel rods.

In 1943 Hans Knoll (1914–55) formed a business partnership with Florence Schust, whom he would later marry, thus creating Knoll Associates. Florence Knoll's approach to design was pragmatic, and she once referred to herself

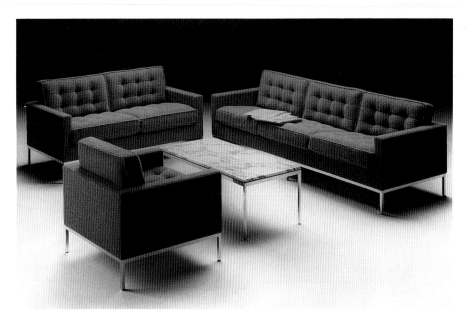

Steel bar framed seating designed by Florence Knoll for Knoll Associates, mid-1950s.

as a 'meat and potatoes' furniture designer who just did the 'fill-in' work that no one else had applied themselves to: 'I designed sofas because no one else was doing sofas . . . I did it because I needed the piece of furniture for a job and it wasn't there, so I designed it.'[3] Her steel bar framed furniture, although rather anonymous in style, was extremely influential. The designers upon whose work Knoll's reputation was largely based were Eero Saarinen and Harry Bertoia. Saarinen's breakthrough came with the 'Womb' chair designed in 1946. Made of moulded plastic and upholstered in fabric over a layer of latex foam, the 'Womb' chair was intended by the designer to 'achieve psychological comfort by providing a great big cup-like shell into which you can curl up and pull up your legs'.[4] Throughout his career Saarinen had been aiming to create the perfect organic chair, unified in shape as well as in materials. His 'Pedestal' furniture from 1956, which included the 'Tulip' chair, was the closest he ever came to achieving this goal. Technical innovation was an important feature of American 1950s furniture, and a lengthy period of time spent striving to overcome technical difficulties was the norm at both Knoll and Herman Miller. This was certainly true with the development of Harry Bertoia's 'Diamond' chairs, the seats of which were made from a sculptured grid of bent wire formed by hand on a wooden jig.

Although Knoll and Herman Miller dominated the American furniture industry during the 1950s in terms of their design innovations, in production terms they did not service more than a fraction of the population. More significant in this respect was the popular and successful furniture and furnishings designer, **Paul McCobb** (1917–69). With his low-cost but high-quality 'Planner' range manufactured by the **Winchenon Furniture Company** of Michigan, he

gained widespread acceptance for the concept of modular furniture, which had been originated by George Nelson.

Aiming to establish their position among the top rank of American furniture manufacturers during the 1950s was the independent design-led company of **Laverne Originals** (founded 1938), run by **Erwine** (b.1909) and **Estelle** (b.1918) **Laverne**. Between 1949 and 1955 they employed **William Katavolos** (b.c.1924), **Ross Littell** (b.1924) and **Douglas Kelley** (b.c.1924) to design furniture that they sold through their own gallery. In 1957 the Lavernes themelves became involved in the design of furniture, their most notable achievement being the 'Champagne' chair, a variation on Saarinen's 'Tulip' chair, but made from transparent plexiglass. The work of **Vladimir Kagan**, of **Kagan Inc.**, was shaped by the aesthetic of Carlo Mollino. Although technically Kagan did not attempt to emulate the contortions of Mollino's elaborately structured bent wood furniture, stylistically there is no mistaking his source of inspiration. A sculptural furniture designer of a more independent sort was **Paul Laszlo**, of **Laszlo Inc.**, whose surreal creations sometimes went beyond even the excesses of Mollino.[5]

European Furniture

According to **Jean Royère** (1902–81), writing in 1952: 'There is practically no furniture industry in France . . . The better product is still made by hand . . . Prices are proportionally high . . . All this greatly hinders the expansion of a modern style in France.'[6] Ironically, however, in spite of his penetrating comments on the problems besetting the French furniture industry, it was Royère himself who perpetuated a retrogressive approach to furniture design after the war. Superficially he embraced the New Look, but at heart he was still working in the tradition of the great 'décorateurs'. He adopted all the decorative motifs and idioms of the modern style – organic shapes, knob feet and finials, bright clashing colours – but he did not re-think the basic functions of the furniture he was designing. His most interesting designs were those involving wrought iron, which he exploited in a highly inventive and imaginative way in both furniture and structural furnishings.

Another French designer who relied heavily on metal as the basic structure for his furniture – principally steel rod and perforated sheet metal – was **Mathieu Matégot** (b.1910). Padding and upholstery were reduced to a minimum, and functional rather than decorative considerations were the shaping forces on his designs. His most famous design was his three-legged 'Nagaski' chair with its scooped oval perforated sheet-metal seat set on a tubular steel frame.

The two most committed Modernist designers working in France during the 1950s were **Charlotte Perriand** (b.1903) and **Jean Prouvé** (1901–

84). The former had worked with Le Corbusier, and both played an active role in the Union des Artistes Modernes before the war. Rooted in the heavier structural forms evolved during the heyday of Modernism, however, neither appeared to appreciate fully the potential for making lighter furniture after the war. Prouvé's monumental steel-framed furniture retained a rawness about it which was in contrast to the increasing slenderness and sophistication of the metal furniture being produced in other countries. He and Perriand often worked together, their furniture being serial-produced by **Steph Simon** in Paris.

The source of inspiration for the work of most other European designers can be traced to one of the innovators in Italy, Scandinavia and the USA. Such is the case with the Dutch designers, **Jaap Penraat** and **Friso Kramer**, who often collaborated on furniture designs, and also with **Egon Eiermann** working for **Wiede & Spieth** in Germany. Around 1950, for example, he produced a design for a moulded plywood lounge chair, strongly influenced by Eames's classic LCW design created in 1946. In some cases the influences were probably unconscious; in other cases they were clearly calculated. **Terence Conran's** (b.1931) early enthusiasm for Italian design resulted in the creation of sub-Fornasetti printed sideboards, sub-Roberto Mango cone chairs and sub-Ponti 'Superleggera' chairs.

Britain's contribution to progressive furniture design in the 1950s was limited. The Scottish firm, **Morris of Glasgow** (founded 1902), showed early promise after the war with their cloud-shaped occasional table designed by **Neil Morris** (b.1918), and their springy 'Allegro' chair designed by **Basil Spence** (1907–76), both from the late 1940s. Taking advantage of the breakthroughs in aeroplane plywood technology that had been made during the war, Morris specialized in laminated furniture veneered with exotic hardwoods. Although many organic-shaped tables were to be produced later in the decade – such as the boomerang tables made by **Heal's** (founded 1810) and **Liberty** (founded 1875) – it was Morris of Glasgow who set the trend.

The two most important designers working in Britain during the 1950s were **Robin Day** (b.1915) for **Hille** (founded 1906), and **Ernest Race** (1913–64) for his own company, **Race Furniture** (founded 1945). The latter achieved instant success with his enamelled steel rod 'Antelope' and 'Springbok' chairs used at the Festival of Britain. With its spindly legs and arms, its ball feet and its brightly coloured painted seats, the 'Antelope' chair came to epitomize the 'contemporary' style. Race had, in fact, been experimenting with metal-framed furniture since the end of the war, his earliest designs being in cast aluminium alloy (the BA range). Robin Day's armchair designs of the early 1950s had one-piece backs and arms made of pre-formed curved plywood set on a steel underframe. A classic Robin Day reclining armchair design, with tray-like wooden armrests and an angular upholstered seat, was immortalized on the well-known 'Homemaker' plates. His best-known and most widely used design from the 1950s, however, was the sturdy and functional 'Hillestak' chair, with its plywood seat and back and its solid beech legs.

The main problem with British furniture in the 1950s was that it remained rooted in outmoded idioms, such as the sideboard and the three-piece suite. Whereas in other countries designers had re-thought the basic function of domestic furniture and had come up with new ideas – such as room dividers, flexible lounge chairs and modular seating units – British manufacturers simply adopted the prevailing decorative style and applied this to the old seat and carcase furniture. Some firms were more progressive than others. **Howard Keith**, for **HK Furniture** (founded 1933), absorbed Italian styling into the design of his easy armchairs; and **Robert Heritage** (b.1927), for **Evans** (founded 1936), introduced a low-slung style of sideboard, and decorative features such as Fornasetti-like printed panels on doors. But in general British furniture in the 1950s rarely rose above the level of the mediocre. One firm that achieved lasting recognition as a result of its receptiveness to new ideas from abroad was **Kandya**. At the start of the decade, it employed a Danish designer, **Carl Jacobs** (b.c. 1925), to create a plywood stacking chair. Made of beech, the plywood forming the seat was bent round so that it folded into itself, forming a neat strong joint.

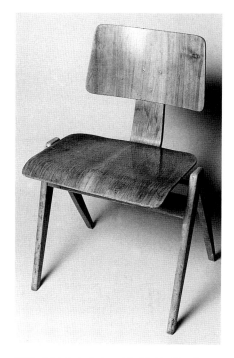

'Hillestak' chair designed by Robin Day for Hille, 1951.

'Antelope' chair designed by Ernest Race for Race Furniture, 1951.

Italian furniture on show in the exhibition of 'Modern Italian Design' held at Manchester City Art Galleries in 1956.

Italian Furniture

Carlo Mollino (1905–73) worked principally as an architect after the war, and it was out of specific private architectural commissions that his furniture designs arose. Treating wood as a plastic medium, and approaching each item of furniture as if it was a piece of sculpture, he designed surreal organic chairs, desks and tables with complex and extravagant contorted and curvilinear forms. The aerodynamic streamlining and moulded plywood technology used in aeroplane manufacture were decisive influences on his work, and his own interest in flying and in aerial acrobatics were the inspiration for some of his looped structural forms.[7]

One of the first manufacturers to be re-established after the war was **Rima** (founded 1916). Its designer, **Gastone Rinaldi** (b.1920), was obsessed with the potential of tubular steel and iron rod furniture, and these materials formed the basis of all his designs during the 1950s. From the middle of the decade he designed an innovative series of sofas, including the half-moon shaped 'Saturno' sofa of 1958.

As with many Italian firms, **Cassina's** (founded 1927) transformation into one of the leading furniture manufacturers in Italy came about as a result of the company's collaboration with outside architects. Its partnership with **Franco Albini** (1905–77), however, came rather too soon after the war, before public taste had become attuned to his particular brand of austere Modernism. (Later Albini worked successfully with **Carlo Poggi** (founded 1949), who produced his stark and uncompromising 'Louisa' easy chair in 1950, and with **Pierantonio Bonacina** (founded 1889), a manufacturer of traditional wicker furniture, who produced his shapely 'Margherita' armchair, also in 1950.)

Cassina's collaboration with **Gio Ponti** (1891–1979), which began in 1947, was to prove more fruitful, resulting in 1957 in the 'Superleggera' or 'Super Light' chair (model 699), inspired by the classic slender-legged cane-seated fishermen's chairs traditionally made at Chiavari, and still being produced at this date by the **Sanguinetti** family.[8] Although it looked rather fragile the chair was, in fact, extremely strong. Ponti's chair designs were mostly angular, with tapered legs, features which can be seen in his 'Distex' armchair (model 851) of 1954. However, his work was very varied and the same year he produced a design for a demountable easy chair (model 852), known as the 'Round' chair because the padded and upholstered seat and seatback were both in the form of ovals.

Ponti had yet another side to his character. He was an active supporter of, and collaborator with, the decorative graphic artist, **Piero Fornasetti** (1913–88). The partnership generally involved Ponti designing an interior or some seat and carcase furniture, the surface of which Fornasetti would then decorate with his novel black and white printing technique. With his untiring imagination Fornasetti created an unlimited supply of designs, anything from lepidoptera to leopards. His architectural desks recalled the decorative schemes of the 19th-century English furniture designer, William Burges, in whose work Fornasetti had a particular interest.[9]

Apart from Ponti, the three architect-designers who created the standard ranges for Cassina during the 1950s were **Carlo de Carli** (b.1910), **Gianfranco Frattini** (b.1926) and **Ico Parisi** (b.1916). During the 1950s de Carli contributed regular articles to *Domus* outlining his ideas about the importance of creating 'living' furniture.[10] He wanted the legs and frames of his furniture to appear as if they had grown out of each other, as if they were part of an organic whole. Gianfranco Frattini specialized in upholstered armchairs, and his work characterizes the committed, but somewhat cautious, approach to design pursued by Cassina at this period. Ico Parisi produced only a handful of designs for Cassina, but his work was always memorable. He specialized in capturing sweeping movement in the outline of his chair and sofa designs. The pieces in suite 813, for example, including an elegant kidney-shaped settee and a barrel-shaped armchair, have a structure which actively envelops the sitter; whilst in armchair 839 the frame is in the form of a hoop. In his drinks cabinets, tables and desks for the American company, Altamira, Parisi exploited the formula of tapered X- and K-shaped structural supports, which gave his furniture its distinctive lightness.[11]

From 1948 Pirelli employed **Marco Zanuso** (b.1916) to investigate the potential usage of various form of rubber within the furniture industry. Out of this **Arflex** (founded 1951) was born, achieving immediate success at the 1951 Milan Triennale with Zanuso's revolutionary 'Lady' chair. This chair introduced the technique

of upholstering furniture using rubber webbing as the support and foam rubber as the padding. In 1954 came the 'Sleep-O-Matic' sofabed, which had the same tubular steel frame structure and upholstery as the earlier easy chairs, but which now provided a mechanism for dual purpose day-time/night-time use. Arflex also worked successfully with a number of other progressive architect-designers, including Franco Albini, who created the sprightly wooden cross-legged 'Fiorenza' armchair in 1952, and **Lodovico Belgiojoso** (b.1909), **Enrico Peressutti** (1908–75) and **Ernesto Rogers** (1909–69) from the architectural practice, BBPR (founded 1933).

The other leaders in furniture technology during the 1950s were **Tecno** (founded 1953), established by Gaetano Borsani and run by his two sons, Fulgenzio and **Osvaldo Borsani** (1911–85), during the 1950s, with the latter acting as the firm's principal designer. Like Marco Zanuso, Osvaldo Borsani is indelibly associated with one particular design from the 1950s, his P40 reclining chaise longue of 1955. This was in fact preceded by the D70 sofabed which relied on a similar mechanism, but in terms of its appearance the P40 chair was an altogether more sophisticated design. Advertisements emphasize its flexibility and mobility: not only did it open and close up from the centre, but the headrest and footrest were also movable. Technologically it was very advanced, and its visual appearance was designed to emphasize rather than disguise its radical modernity.

Leading the way into the 1960s was the firm of **Gavina**, for whom **Achille** (b.1918) and **Piergiacomo** (1913–68) **Castiglioni** designed the curvaceous 'San Luca' armchair in 1960, with its astonishing contoured arms and seatback. The visual sophistication of this chair in terms of its shape and its materials illustrates how far the Italian furniture industry had developed during the course of the decade from its rough and ready beginnings after the war.

Scandinavian Furniture

Although the Finns and the Swedes made valuable contributions, it was the Danes who clearly dominated this field.[12] The designer whose work best characterizes Danish furniture from the 1950s is **Hans Wegner** (b.1914). For **Fritz Hansen** (founded 1872) he created the first version of his 'Chinese' chair, inspired by the elegantly curved round-backed chairs with S-shaped armrests produced in China during the 17th century. This led on directly to his classic design, 'The Chair', for **Johannes Hansen** (founded 1915), made of solid oak or mahogany, with a woven cane seat and a low seatback perfectly sculpted to fit the contours of the human body. Although he created a series of interesting designs during the decade, it was impossible for Wegner to improve on 'The

Chair'. Well known abroad was his three-legged stackable dining chair, mass-produced by Fritz Hansen from 1951. Although most of Wegner's designs were in wood, he did produce some incorporating metal, such as the L-shaped steel-framed chairs with leather upholstery designed in 1959 for Copenhagen Airport, showing how comfortably he was able to combine traditional and modern materials.

Similar in this respect was **Poul Kjaerholm** (1929–80), who designed for the firm of **Ejvind Kold Christensen** from 1955 onwards. He used flattened bent steel bar as the frame for many of his chairs, with upholstery in taut string, woven cane, or leather. Kjaerholm was clearly working in the European Modernist tradition: his uncompromising and highly sophisticated structures were pared down to a minimum in terms of their stylistic features and materials. Henrik Sten Møller makes the comment that Kjaerholm's furniture has 'something to do with appearing, not with being'.[13]

Arne Jacobsen's (1902–71) 'Ant' chair of 1952 for Fritz Hansen was the most successful mass-produced chair of the decade. Throughout the 1950s Jacobsen produced variations on this basic design, such as his Series 7 group from 1955 onwards. At the end of the decade, whilst working on the furnishings for St Catherine's College, Oxford, he designed what would later become known as the 'Oxford' chair, the apotheosis of his exploration of the plywood theme. St Catherine's is the ideal setting in which to see the full range of Jacobsen's 1950s furniture. Lecture rooms, libraries and study bedrooms – all are furnished with his chairs, including the graceful and shapely upholstered 'Swan' and 'Egg' easy chairs from 1958. The shells of both were made from moulded fibreglass-reinforced polyeurethane, padded with latex foam, and upholstered in leather, vinyl or fabric, with star-shaped bases of polished cast aluminium.

Apart from Jacobsen, the other major production furniture designer in Denmark after the war was **Børge Mogensen** (1914–72), who from 1942 to 1950 was design director for the United **Danish Co-operative Societies (FDB)**, and after-

'Series 7' chair designed by Arne Jacobsen for Fritz Hansen, 1955.

Steel-framed chair designed by Hans Wegner for Johannes Hansen, 1959.

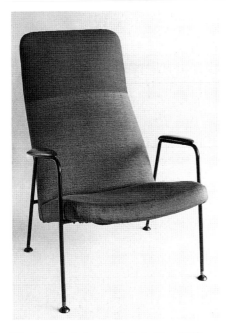

'Kontour' reclining armchair by Dux, 1958. This popular Swedish design was exported to the UK, where it was manufactured under licence and sold through Heal's.

wards worked freelance with a number of different cabinetmakers, such as **L. Pontoppidan**. Trained as a cabinetmaker, Mogensen produced furniture that was at once traditional in terms of materials and forms, and progressive in terms of its careful consideration for people's everyday needs. At the other end of the spectrum was the flamboyant sculptural furniture of **Finn Juhl** (1912–89) for **Niels Vodder** (founded 1918). Interestingly, both he and Mogensen were trained by Kaare Klint, and both were committed to wood as the basic structure for their furniture, but whereas Mogensen emphasized its solidity and strength, Juhl focused on its lightness and its artistic potential as a medium for organic sculpture. According to Bent Salicath: 'Finn Juhl's work should be experienced musically in a room that preferably he himself has also helped to create – then he has the whole composition, and so expresses himself clearly and consciously – often self-consciously, which is an artist's prerogative.'[14] The musical analogy is especially pertinent because of the pronounced rhythmical qualities of Juhl's designs.

The quality of Danish furniture at this time was unparalleled, the reason being that quality control was strictly self-regulated by the furniture makers themselves. Firms producing good modern design included **Søren Willadsens**, **France & Sons**, **P. Jeppesens** and **Søborg Møbelfabrik** (founded 1890). **Peter Hvidt** (b.1916) and **Orla Mølgaard-Nielsen** (b.1907) formed a highly successful partnership in 1944, and it was this team that designed the popular 'Ax' chair produced by Fritz Hansen in 1950. Other freelance designers included **Ejner Larsen** (b.1917) and **A. Bender Madsen** (b.1916), who designed together for **Willy Beck**; and **Nanna** (b.1923) and **Jorgen** (1921–61) **Ditzel**, who designed a 'basket to sit in' for Pontoppidan in 1950 and an eggshaped hammock for **Wengler** in 1959. Finally, at the end of the decade a dynamic new talent emerged in the form of **Verner Panton** (b.1926), whose work heralded the new era of international design that would dominate the 1960s. He looked to new materials – plastics and steel wire – to find the inspiration for a new furniture vocabulary, a process of experimentation that resulted in his exciting 'Cone' chairs of 1958–9 manufactured by **Plus-Linje**.

The leading Swedish designer from the early post-war period was **Carl-Axel Acking** (b.1910), who worked freelance from 1939 designing for a number of manufacturers, such as the **Svenska Møbelfabrik** at Bodafors, and **Nordiska Kompaniet** (founded 1902) in its workshops at Nyköping. NK produced some of the best moderately priced furniture of the period under the enlightened management of Rudolf Kalderen and Elias Svedberg. Svenska Møbelfabrik was part of the important 'Brå Bohag' group (meaning 'Good Furnishing' group), an association of furniture and textile manufacturers, which also included both **AB Ljungs Industrier** (founded 1945), where the leading designers were **Folke Ohlsson** (b.1919) and **Alf Svensson** (b.1923). There were still some independent cabinetmakers, such as

Erik Chambert (1902–88), operating in Sweden at this time, but they were rapidly being overtaken by industrial production. Marquetry was their particular speciality.

Although not as prolific after the war, the Finnish architect, **Alvar Aalto** (1898–1976) did continue to design furniture which was produced by his own firm, **Artek** (founded 1933). His most important design from this period was his fanvaulted stool of 1954. A new figure to emerge in Finland during the 1940s was **Ilmari Tapiovaara** (b.1914), who devoted his energies to design for industrial production for the manufacturers, **Asko** (founded 1931) and **Keravan Puuteolisuus**. Tapiovaara worked primarily as an interior designer, and it was as a result of major commissions – such as the Domus Academy in 1947 and the Tech Student Village at Espoo in 1951–52 – that many of his designs arose. For the former he designed a series of prefabricated wooden chairs with plywood seats. For the latter he first conceived the idea of the 'Lukki' ('Daddy Long Legs') chairs, of which several spindly metal-legged variants evolved during the first half of the 1950s, produced by the firm of **Lukkiseppo**. Other designers worked for Asko as well as Tapiovaara, including the talented **Olli Borg** (1921–79). The main Helsinki department store, **Stockmann**, also took on a manufacturing role, its most prominent designer during this period being **Olof Ottelin**. In addition, **Antti Nurmesniemi** (b.1927), who was to become more well known during the 1960s, produced the classic horseshoe-shaped wooden sauna stool for the Palace Hotel in Helsinki in 1952.

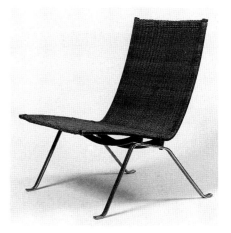

Steel and cane chair designed by Poul Kjaerholm, E.K. Christensen, 1957.

Glass

British and Czech Glass

Czechoslovakia's cultural isolation after the war determined that its glass industry took a very different course to that pursued by other glass-making countries in Europe. During the late 1940s and 1950s it distinguished itself in the new field of art glass. Art glass was, literally, glass designed or decorated by artists. In Czechoslovakia they were employed in large numbers. They often worked in studios (such as those at Nový Bor and Železný Brod) with their own technicians quite separate from the main factories, producing unique or experimental works and freely exploring ideas suitable only for one-off or serial production. In this respect Czechoslovakia's achievements were quite different from those of Scandinavia, where industry provided the discipline and stimulus for the artist to create. Although some unique pieces were produced in Finland and Sweden, for example, they were generally executed by a master-glassblower or a master-engraver in the factory, not by the designer. By contrast, art glass in Czechoslovakia might be hand-enamelled or hand-engraved by the actual artist. In other words, the creative skills of the artist were directly employed: artists became applied artists, and they had to master the technicalities of a craft in order to be able to express themselves. Because of this, Czech art glass was highly individual in its expression, and it had a strong influence on the international studio glass movement that emerged during the 1960s.

Until the 1957 Milan Triennale and the Brussels World Fair of 1958, however, Czech art glass was virtually unknown abroad. These were the first international exhibitions in which Czechoslovakia participated, and most foreign observers were taken aback at the creative activity that had been flourishing there since the war. This seemed especially surprising in view of the fact that the industry had been nationalized in 1945, and had been badly hit by trade embargos during the early 1950s. Nationalization, however, had not simply involved a change of ownership but complete reorganization and reform. In the words of one designer who lived through these changes, **Alois Metelák** (1897–1980), the aim of making the new art glass was 'to acquaint the world with our culture and the creative ability of our people, their invention and sense for colour, the depth of their feeling and the richness of our spirit and country.'[1]

The decorative character of Czech glass made it unlike that being produced anywhere else in Europe after the war. Whereas in most other glass-making centres attention was focused on organic and sculptural forms, on the creation of textural effects, or on colour and patterning within the metal itself, the majority of Czech artists explored the possibilities of decoration on the surface of the glass. Enamelling, a technique which had long been associated with Bohemia, was revived in the late 1940s by **Stanislav Libenský** (b.1921). Working on glass that was extremely thin, Libenský refined a technique of painting with delicately coloured transparent enamels, creating an effect rather like water-colour. He also combined enamel painting with engraving, the effect of which can be seen on his 'Crucifixion' vase of 1947.[2] Some artists, such as **Jiří Harcuba** (b.1928), **Ladislav Oliva** (b.1933) and **Karel Wünsch** (b.1932) concentrated on engraving alone. Using the technique of etching Harcuba produced net-like patterns created from an interplay of fine criss-crossed or zigzagging lines, whilst Wünsch created designs based on molecular structures. Sand-blasting was used to create a dense matt texture. Harcuba used this technique for some of his primitive Picassoesque engravings of animals, whilst for Oliva it provided a means of exploring textural contrasts within his relief-engraved abstract designs. Deeper relief cutting was used by **René Roubíček** (b.1922) in his sculptural carved vessels. In these pieces the glass was treated like crystal, with figures emerging from it as if carved from stone.

During the late 1950s most Czech glass artists produced abstract rather than representational designs, the inspiration for which often came directly from the latest trends in abstract painting. **Karel Vaňura** (b.1937) produced bold abstractions which exploited to the full the graphic potential of engraving and the painterly effects of coloured enamels. These techniques were usually combined, but were sometimes used individually if, for example, the artist wished to explore the visual effect of either texture or colour on their own. Patterns relying entirely on enamels, such as those created by **Vladimír Kopecký** (b.1931), treated the surface of the vessel as a canvas. Sometimes enamels were so thickly applied that they were completely opaque and thus resembled oil paintings. Some of Kopecký's works show the influence of 'tachisme', others of colour field painting. Both he and Vaňura trained at the Academy of Applied Arts in Prague with Professor Kaplicky, who had a distinctly art-orientated approach to glass decoration.

The designers who worked more closely with industry and who produced designs more suitable for production were generally trained by Professor Stipl, another of the influential teachers at the Academy. One of his pupils, **Pavel Hlava** (b.1924), for example, used prismatic cutting to create geometrical faceted sculptural objects in richly coloured underlay glass. Cutting was also used to shape the works of **Ludvika Smrčková** (b.1903), who had been a prominent designer before the war, and **Adolf Matura** (1921–78). They both adapted the cutting formula to suit the softer-edged organic forms of the 50s.

Engraved vase by Jiří Harcuba, 1961.

Bowl designed by Per Lütken for Holmegaard, 1955.

Candlestick designed by Andries Copier for Leerdam, 1956.

Some artists designed blown and manipulated forms in hot metal. The studio arrangement encouraged an experimental approach, a striking example of which can be seen in René Roubíček's tripod sculpture of 1960, blown by Josef Rozinek, which resembles a creature from a science fiction fantasy.[3] Other designers, such as Stanislav Libenský working with his wife **Jaroslava Brychtová**, created sculptural effects by means of casting. A bowl of 1954 was cast in the form of a human face in deep relief.[4]

Surface decoration, however, was more common in Czech glass than the manipulation of form, and it is this characteristic which links it with concurrent developments in Britain. Engraving was the only aspect of glass design in which the British made a significant contribution during the 1950s, with the leading designers, such as **Helen Munro-Turner** (1901–77), **Laurence Whistler** (b.1921) and **David Peace** (b.1915), all working independently. Each developed their own distinctive graphic style, Munro-Turner with her accomplished wheel engraving, Whistler with his delicate stipple effects, Peace with his fluid wheel- and diamond-engraved calligraphic inscriptions. The great pioneer in British glass engraving during the 1950s was the artist **John Hutton** (1906–78), who devised a new method of engraving on glass using a hand-held movable wheel. Hutton produced the engraved glass screens for Coventry Cathedral, showing angels drawn in a spectral style: bony and attenuated figures with streaming hair, exaggeratedly long trumpets and vast feathery wings.

Danish and Dutch Glass

Danish glass during the 1940s and 50s was dominated not just by one factory, **Holmegaard** (founded 1825), but by a single designer, **Per Lütken** (b.1916). He succeeded the talented **Jacob Bang** (1899–1965) as art director at Holmegaard in 1942. Bang, who originally trained as an architect, was as dominant during the inter-war period as Lütken has been since the war, and in fact it was he who paved the way for Lütken's success by adopting a genuinely modern aesthetic during the 1930s. Looking at some of Bang's designs from this period it is hard to believe they date back sixty years. In several of his works he appears to have made a quantum leap out of his own time and into the future, in his clean-lined 'Primula' jug and tumblers from 1930, for example, and in two 'abstract expressionist' vases, one from 1934 decorated with drip-trailed molten glass, a second from 1939 with frenetic linear engraving resembling the arbitrary incisions of skates on ice.[5] However, these pieces actually pre-date abstract expressionism by up to ten years.

On the whole, though, it was plain undecorated wares with which Bang was associated, and when he returned to glass design in 1957 as the art director at **Kastrup** (founded 1845), it was in this idiom that he picked up where he had left off fifteen years earlier. His austere cylindrical vases of 1958, produced in opal and smoked glass, bore a strong resemblance to laboratory glass, taking the clinical 'less is more' approach to design to an extreme. Jacob Bang also designed some unusual jugs and bowls in opaque white 'opaline' glass for Kastrup, and in the same medium in 1958, **Nanna** (b.1923) and **Jorgen** (1921–61) **Ditzel** produced a boldly sculptural vase, shaped like a double mushroom cloud, on a tall pedestal base. In tableware **Bent Severin** designed a range of hourglass-shaped drinking glasses with solid bases in which a single tear-shaped air bubble was suspended.

If anything Lütken was able to relax rather than tighten the rules when he took over in the early 1940s at Holmegaard. His background was in painting and his first few years with the company were characterized by gleeful uninhibited artistic experimentation. The style he experimented with was the organic, and in the same way as the studio glassmakers of the 1960s and 70s, one can sense his pleasure in discovering for himself the marvellous ductility and plasticity of glass in its molten state. Vases are decorated with blobs and trails of hot glass, sometimes coloured, and shallow bowls are sheared into curious surreal seaweed-like forms. Two bowls from 1946 have handles shaped as if with the imprint of a thumb.

After this period of intense experimentation during the 1940s Lütken's creations from the 1950s, although still strongly organic, were more restrained. By this time he was designing mass-produced and serial wares, rather than one-off or limited edition art pieces. Lütken's work until 1958 remained strongly organic, although not all his designs were wayward and asymmetrical. Some undoubtedly were, such as his 'Beak' vases of 1952, the narrow necks of which were shaped like the expectant open mouths of chicks in the nest. Others, however, took on rounded but regular forms, such as his thick-walled 'Heart' vases of 1955 produced in diminishing sizes, and a generously proportioned circular fruit bowl of the same year, whose heavy walls appear to sag inwards at the rim. Colour was used sparingly in most of these works; some were produced in clear crystal, others in very pale blue or smoked glass. It was rarer, but not unknown, for rich underlay colours to be used, such as violet or red, until the end of the decade when a change occurred and brighter body colours were introduced. At the same date (1958) vessels became cylindrical, so there was a complete shift in aesthetic both in form and colour.

Holmegaard's serial art glass and tableware was not overly expensive, and it had a strong international appeal to the style-conscious middle classes. The glass produced in Holland by the **Dutch United Glassworks** at **Leerdam** (founded 1765) and **Maastricht** was pitched at a similar market. At Maastricht the work of **Max Verboeket** reflected current trends in organic and plastic form, combined with the painterly effects of abstract expressionism. Trailed threads of

coloured glass were suspended in clear glass bowls, which had been manipulated into contorted and twisted shapes.

Head of the Unica Studio at Leerdam since before the war was **Andries Dirk Copier** (b.1901) who, like Per Lütken at Holmegaard, was a tirelessly inventive and original designer of both utility and art glass. Always one step ahead of his competitors, Copier's conical and flanged tablewares from the late 1950s presaged the more clean-lined symmetrical forms of the following decade, whilst in art glass he pioneered the development of free-blown vessels of irregular form. It was Copier who appointed **Floris Meydam** (b.1919) and **Willem Heesen** (b.1925) as designers at Leerdam, and during the 1950s they created many of the abstract art wares that brought the company international acclaim. Meydam worked mostly in the new freeform style, combining fluid shapes with vivid but controlled use of colour, while Heesen specialized in surface decoration and texture. Their experiments, like those of the Czech glass artists, were to act as an inspiration for the American studio glass movement in the 1960s.

Finnish Glass

With the innovative organic vessels designed by Alvar Aalto during the mid-1930s, there were signs that the Finnish glass industry had at last found its own voice. In spite of this early breakthrough, however, the strength of the new design-led industry after the war was still miraculous. Finland leapt from infancy to maturity, apparently missing out all the laborious stages of development in between.

A key figure during the 1940s was **Gunnel Nyman** (1909–48); it was she who effected this transition. During the war, and afterwards until her death in 1948, she worked freelance for the three leading Finnish glass companies, **Riihimäki** (founded 1910), **Iittala** (founded 1888) and **Nuutajärvi** (founded 1793). Her first breakthrough design came in 1941, a bowl called 'Facet' that Brigitta Mathiesen describes as 'the first purely sculptural article in the Finnish art glass tradition'.[6] It was shallow and thick-walled, with a gently uneven rounded sculptural outline, the rim sliced off at an angle. It was followed in 1947 by 'Munankuori', or 'Rose Petal', an eggshell-shaped opaque glass bowl for Iittala. In general, however, Nyman produced works of quite different character for each of the three manufacturers by whom she was employed. At Riihimäki her works emphasized the plastic qualities of the free-blown and twisted molten glass. At Iittala vessels took their final shape at the grinding stage once the glass had cooled. Although asymmetrical, they were also sharply angular, their clean lines emphasizing the refractive qualities of the crystal. At Nuutajärvi Nyman returned to soft forms, but this time her vessels were more attenuated, and they were

Glass birds designed by Kaj Franck for Nuutajärvi, 1957.

decorated internally with linear serpentine patterns, veils of smoke-like colour, or masses of tiny bubbles. This last process was also used for more moderately priced functional jugs and tumblers. Nyman's work remained in production throughout the 1950s, and in 1951 she was awarded a posthumous Gold Medal at the Milan Triennale.

The year 1951, known as the 'Milan Miracle', was a golden one for Finnish design, with the Finnish stand at the Triennale arousing widespread astonishment, and Finland scooping the lion's share of the awards. **Tapio Wirkkala** (1915–85), the designer of the Finnish section, won three Grand Prix awards, for his glass, for his exhibition design and for his laminated birchwood bowls. In all, thirty of his designs for Iittala were included in the display, an amazing achievement for a designer who had only begun his career in 1946. The display was mostly art glass, the unusual shapes of which reflected Wirkkala's background in sculpture, but it also included examples of functional jugs, tumblers and lampshades. Some pieces were experiments in pure abstraction, others had naturalistic sources. Wirkkala produced groups of objects which explored variations on a theme, such as his jagged ice block bowls, his surreal lichen vessels, his leaf-shaped bowls, his chanterelle mushroom-shaped vases, his bamboo vessels and his foal foot vases. His works in other media reflected similar preoccupations.

At the 1954 Triennale it was **Timo Sarpaneva** (b.1926) who came to the fore, with a group of works which were, if anything, even more abstract and sculptural than those of Wirkkala. The pieces on show included five different variants of his blade or rudder-shaped 'Lancet' sculptures; and five variations on the technique of 'injecting' air pockets into a solid mass of crystal, one of which, with a side cavity, was called 'Orchid', and another, with two valves, 'Heart'. Perhaps the most startling piece of all, however, was 'Kayak', a solid sculpture shaped like a dart. Sarpaneva's work also dominated the next Triennale in 1957, but this time it was his utility wares that attracted the highest acclaim,

Vessels by Venini, 1950s.

particularly his wide-ranging 'i-glass' series. These included variously shaped tumblers, bowls, plates, bottles and carafes. Both his art glass and his utility wares of the mid-1950s illustrate the increased importance of colour, the shades used in the 'i-glass' series being particularly subtle.

Iittala accounted for 50 per cent of Finnish glass production during the 1950s; it was this firms's superstar designers who were accorded the highest international acclaim. However, there were several talented designers working for Iittala's rivals during this rich and creative period. **Helena Tynell** (b.1918), for example, was employed from 1946 onwards at Riihimäki where, during the late 1940s, she designed a quasi-surrealist vase with a frilled wavy-edged rim. **Nanny Still** (b.1926) was taken on by the same firm in 1949, winning several awards at the Milan Triennales during the 1950s, and producing vessels which, both in shape (narrow-necked truncated vases) and surface finish (sand-blasted and acid etched), reflected the aesthetics of the period. Her 1959 'Harlequin' range of knopped stemmed goblets and jars with cone-shaped lids presaged the exciting designs of the 1960s.

Two important ceramics and glass designers, **Kaj Franck** (b.1911) and **Saara Hopea** (1925–84), worked alongside each other at both Arabia and Nuutajärvi during the 1950s. Franck's approach to tableware design in the two media was not dissimilar: his multi-coloured glass tumblers and pitchers have the same clean lines as his multi-coloured 'Kilta' ceramic kitchen and dinnerware. Franck was not such a rigorous Modernist as some of his works might imply, however. He was equally capable of producing non-utilitarian and decorative designs, such as his bird and fish ornaments, and fanciful pieces such as his stacking double carafe of 1957 known as 'Kremlin Bells', the fantastical shape of which recalls architectural features on the Kremlin in neighbouring Russia. Both Franck and Hopea took their functional production designs very seriously, however, and attempted to solve basic design problems such as stacking and standardization of form. Hopea's bright and colourful stepped cylindrical stacking tumblers with matching pitcher solved this problem admirably. For these she won a Silver Medal at the 1954 Triennale, whilst Kaj Franck was awarded the prestigious Lunning Prize in 1955.

Italian Glass

Of all the glass produced during the 1950s that produced by the Italians was the most colourful, both literally and metaphorically. The most important firm after the war was **Venini** (founded 1921) managed by the astute and talented **Paolo Venini** (1895–1959). Venini was most well known for its surreal 'Vaso Fazoletto' or 'Handkerchief' vase, the original concept devised by Paolo Venini and **Fulvio Bianconi** (b.1915), one of

several freelance designers employed by the firm during the 1950s. These vases were produced in a variety of shapes and sizes, some on a large scale, some 'pocket-sized'. Many were created in an updated version of traditional filigree or 'latticinio' glass – a technique known as 'zanfirico', which involved suspending fine spiralling threads of opaque white or coloured enamels within the clear glass to create a lace-like pattern. Others were produced in coloured stripes, in plain coloured overlays, or in opalescent glass. Because of their obvious novelty appeal Venini 'Handkerchief' vases were widely copied both in Italy and abroad – by Fontana Arte (Italy), Holmegaard (Denmark) and Chance (UK), for example. Original Venini pieces were characterized by an unmatched lightness and fluidity of form, and by their success in capturing the quality of soft cloth held in suspended animation.

Together Bianconi and Venini developed two other techniques of glass decoration which, like 'zanfirico', were inspired by textiles: 'vetro pezzato', and 'vetro tessuti'. In the former, squares of coloured glass were suspended in a patchwork; in the latter, the colour was in broad bands that were apparently interwoven. In a modified form and in a different more muted range of colours these techniques were taken up by **Barovier and Toso** (founded 1942) in their 'vetro pezzati' and 'vetro parabolico' vases, many of the latter being produced in a combination of brown, white and purple. Glass produced with straightforward stripes was known as 'canne', from the canes of different coloured glass from which it was composed. A fifth decorative technique used canes in cross-section and was known as 'murrine'. This glass had a dense and vivid mosaic-like appearance, and the technique was sometimes used for an entire vessel and sometimes as a broad band of pattern within an otherwise plain vessel. More rarely, techniques of surface decoration were adopted, such as the 'inciso' process of creating a matt effect by engraving the surface of the vessel with fine and densely compacted horizontal lines. Some of these pieces were designed by Venini in conjunction with **Tobia Scarpa** (b.1935) between 1957 and 1961.

Some purely sculptural pieces were produced in coloured underlay glass, such as organic vessels with holes pierced in the walls of the body, creating large apertures. Also sculptural were the numerous tall-necked decanters produced by Venini throughout the decade, and the sometimes extravagant, sometimes outsized stoppers with which they were crowned. Shapes were designed by Bianconi, **Gio Ponti** (1891–1979) and by Venini himself. A typical Bianconi decanter might be decorated with one or two bold horizontal bands in a contrasting bright colour, such as red and orange; stoppers were often exaggeratedly large and spherical. A typical Ponti decanter might be in the shape of a stylized female figure, or it might be excessively tall, narrow and attenuated with a tear-shaped stopper. Another designer working briefly for

Venini during the late 1940s and early 1950s was the Swedish ceramic artist, **Tyra Lundgren** (b.1911), who created a range of leaf-shaped bowls decorated with suspended enamel threads, and 'vetro fenicio' vases, also in striped glass, with pincered fly-away rims.

Second in standing to Venini was the firm of Barovier and Toso where the designers were **Ercole Barovier** (1889–1974) and later his son, **Angelo Barovier** (b.1927). The former was responsible for the internally patterned wares resembling textile designs, some in the form of a chequered design, some decorated with triangular harlequin patterns. Barovier and Toso experimented boldly with colour and texture in glass throughout the decade. Angelo Barovier created abstract sculptural forms in which speckles of colour or tiny bubbles were suspended. Both Venini and Barovier and Toso also produced large quantities of glass lampshades. The Milanese firm, **Fontana Arte** (founded 1933), specialized in this particular field, producing elaborately sculptured glass pendant lights and wall lamps, as well as artist-designed mirrors and wall plaques, often strongly influenced by surrealism. Its expensive and exclusive art glass was advertised throughout the decade in *Domus*. The Murano firm of **Vistosi** (founded 1945) also specialized in lighting. **Gino Vistosi** designed the 'Modelli Brevattati' chandelier, in which flat discs of glass were suspended on hooks from a metal frame, a device which lent itself to lightfittings and installations on both a domestic and a public scale.

The most decorative of all the glass designers working at Murano during the 1950s was **Dino Martens** (1894–1970). For **Aureliana Toso** (founded 1938) he created exaggerated non-functional vessels, such as jugs with incredibly long spouts and looped handles, or vases with twisted necks or pierced walls. These were decorated with fragments of different-coloured filigree glass fused together in an apparently arbitrary and incoherent way. Initially thin-walled and transparent, towards the end of the decade Martens' designs became denser in texture and opaque in colour, with increasing use of glittering metallic enamels. The only other glass designers of the period to compare with Dino Martens were **Luciano Gaspari** at **Salviati** (founded c. 1859), and Fulvio Bianconi who, during the late 1950s, worked independently producing a remarkable range of abstract and figurative works inspired by the ceramics and glass of Picasso. He often worked like a painter using trailed molten glass on the surface of the vessel.[7] As with his earlier work for Venini, his colours were vivid and intense. Art glass was also produced by **Gino Cenedese** (1907–73) of the **Cenedese** glassworks (founded 1945), with whom Bianconi sometimes collaborated.

Quite different in spirit were the designs of **Flavio Poli** (1900–84) for **Seguso Vetri D'Arte** (founded 1937). In some ways Poli's aesthetic was closer to that of the Scandinavians, at least in terms of the simplicity of his thick-walled organic vessels, but his work is immediately distinguishable simply because of his vivid use of colour. Usually at least two different colours, such as red, green, yellow or purple, were cased within the clear crystal in the form of stripes, concentric circles or borders complementing the vessel's outline. The forms themselves were simple and monumental, as in his various elliptical valve-shaped vases. Seguso also produced some exaggerated and contorted vessels, the forms of which were further distorted by **Giorgio Ferro** at **AVEM** or **Arte Vetraria Muranese** (founded 1932). Taken to extremes, the manipulation of molten glass resulted in the grotesque 'Atomic' vases created by **Vinicio Vianello** in 1953–54, amorphous vessels with alarming digit-like protuberances.[8] Vianello also worked for **SALIR** or **Studio Ars Labor Industrie Reunite** (founded 1923), for whom he created his 'Torre Vegetali', or 'Vegetal Towers', resembling demented organic Towers of Babel. SALIR was best known for its innovative engraved glass, however, which was designed by various artists, including **Franz Pelzel** (1900–68) and **Serena dal Maschio** (1920–74).[9]

Swedish Glass

In spite of increased competition during the 1950s from other Scandinavian manufacturers, Sweden's glass industry continued to move forward from strength to strength. **Orrefors** (founded 1898), which had acted as the design leader during the 1920s and 1930s, continued to play a prominent role after the war, but under new direction. Simon Gate had died in 1945, and **Edward Hald** (1883–1980) retired as manager in 1944. He continued to act as artistic advisor to the company after the war, but from 1944 onwards the lead at Orrefors was taken by a group of younger designers: **Nils Landberg** (b.1907), **Sven Palmqvist** (1906–84), **Ingeborg Lundin** (b.1921) and **Edvin Öhrström** (b.1906).

During the mid-1940s Landberg developed his 'Serpentine' range, in which a coloured spiral was encased within the thick clear crystal of the organic vessel walls. During the early 1950s he produced a series of abstract pattern designs which were engraved on shallow bowls and tulip-shaped vases. These vases led to his remarkable thin-stemmed 'Tulip' glasses dating from the mid-1950s onwards, which the master glassblower at Orrefors, Henry Karlsson, described as 'the most difficult . . . and most exciting thing I ever did'.[10] Sizes and shapes varied, but the tendency was towards ever more exaggerated stem length. At the end of the decade he designed a series of heavy dark green underlay vessels, at least one of which – a bottle-shaped vase with a faceted body and a tall narrow neck – reveals Landberg's propensity towards attenuation of form in thick-walled as well as thin-walled vessels.

During the mid-1940s Sven Palmqvist produced his opalescent 'Kantara' and 'Selena'

Engraved vase designed by Nils Landberg for Orrefors, early 1950s.

'Fuga' bowls designed by Sven Palmqvist for Orrefors, early 1950s.

ranges; the former light and wavy-edged; the latter thick-walled and freely organic. At this period Palmqvist also began to develop an interest in coloured glass with his 'Sang de Boeuf' range. Colour was central to the concept of both his 'Ravenna' and 'Kraka' art glass, and his mass-produced centrifugally cast 'Colora' bowls during the 1950s. The idea for 'Ravenna' glass came as a result of a trip to Ravenna to see the colourful Byzantine mosaics. Visually some of these pieces also bear a resemblance to stained glass, particularly those with arch-shaped 'windows' in the vessel walls. In the 'Kraka' technique the effect was of a fine mesh of coloured threads and tiny bubbles.

Ingeborg Lundin, the Balenciaga of glass, started working for Orrefors in 1947. Her most well-known design was her giant 'Apple' vase of 1957, but before this she designed a large quantity of highly unusual engraved glass, and a number of light and elegant thinly blown tableware ranges which were the epitomy of refinement. Lundin produced two distinct types of graphic design, one figurative, one abstract. Many of her subjects were treated in a light-hearted surrealistic vein, such as a vase engraved with disembodied heads and feet.[11]

Edvin Öhrström's first major achievement shortly after joining Orrefors in 1936 was to develop the 'Ariel' technique. This involved sand-blasting a design into a blank, then folding a layer of molten glass over the vessel in such a way that pockets of air were trapped in the depressions. The design cut into the vessel was thus captured in air within the vessel walls. Having invented this technique Öhrström spent the next twenty years exploiting its potential. During the 1940s he produced a number of figurative designs strongly influenced by Picasso. During the 1950s he prepared a series of designs called 'Vattenlek', based on the theme of 'Water Play', in which willowy figures, seaweed and sea creatures are depicted as if under water. The 'Ariel' technique was of course ideally suited to this form of subject matter. Some of his later

designs were entirely abstract; whilst a range of the moderately priced wares represented simple linear patterns, or a repeated motif such as a leaf blade.

Vicke Lindstrand (1904–83) had worked at Orrefors for over a decade before the war, but from 1950 onwards he worked for **Kosta** (founded 1742) where he produced an astonishingly wide range of designs. His repertoire included figures, sculptures, engraved designs, coloured underlay glass, and various technically experimental and abstract works. Lindstrand's particular gift was his instinctive sense of rhythmic control; in fact, one of his engraved vases was called 'Joyful Rhythm'. It was this quality of combined liberation and restraint that made his work so dynamic and stimulating.

At Kosta's sister company, **Boda** (founded 1864), an entirely different design policy was pursued, with the appointment in 1953 of the artist, **Erik Höglund** (b.1923). The Picasso-inspired Höglund went against the trend towards increasing sophistication of form and decoration within the glass industry, and consciously re-introduced primitivism and technical imperfection into glass-making. Helena Dahlbäck Lutteman refers to him as the 'enfant terrible' of the Swedish glass industry, 'one of those who punctured the myth that Scandinavian design is always clean-cut and refined'.[12] Höglund designed three basic types of vessel: anthropomorphic vases and carafes; bowls deeply engraved with primitive drawings of figures and animals; and simple irregularly bubbled hand-blown coloured vessels.

One of the most talented but under-rated designers of the period was **Bengt Orup** (b.1916) at **Johansfors** (founded 1891) from 1951. He created designs for cut, engraved, pressed and free-blown glassware, covering the whole gamut from art glass to production wares.[13] Orup's ability to create works of pure sculpture, on a par with those of Timo Sarpaneva in Finland, is revealed in his surreal 'Vegetal Form'.[14] His tablewares, particularly his jug and tumbler sets, were always thoughtfully shaped and interestingly decorated, whether by linear cutting or by

Bowl by Erik Höglund for Boda, 1955.

etching. Towards the end of the decade Orup's works became increasingly bold and experimental.

Hugo Gehlin (1889–1953) worked at **Gullaskruf** (founded 1926) during the early years of the decade, designing pieces that were boldly, perhaps even uncomfortably, organic, some of his designs remaining in production after his death in 1953. Gullaskruf had traditionally specialized in well-designed pressed glass, and during the 1950s **Arthur Percy** (1886–1976) continued this tradition with his various press-moulded bowls and vases. His designs included fluted leaf-shaped dessert dishes, the 'Reffla' series of grooved organic-shaped vases and the 'Randi' range of opaque white glasswares moulded on the exterior with a simple grid-like abstract pattern. During the late 1950s **Kjell Blomberg** adopted an uncompromisingly severe and geometrical style, similar to that of **John Selbing** (b.1908) at Orrefors, which involved creating a composite vessel from two dissimilar shapes, such as a sphere and a cone.

At **Reijmyre** (founded 1810) **Monica Bratt** (1913–61) worked as the art director from 1937 onwards. During the mid-1940s she was producing quasi-surreal wavy-edged bowls, not dissimilar to the 'Kantara' bowls of Sven Palmqvist at Orrefors. During the late 1950s she collaborated with **Paul Kedelv** (b.1917). Earlier Kedelv had worked at **Flygsfors** (founded 1888), where he had created a popular and eye-catching series of bowls and vases called 'Coquille', which captured the essential ductility of molten glass. This was organic design taken to extremes – hence the title 'Fantasia' given to one particularly extravagant table decoration.[15] Equally fantastical, if not more so, were the designs of **Gunnar Nylund** (b.1904) at **Strömbergshyttan** (founded 1933). Nylund's works, produced in thick coloured underlay glass, were strongly sculptural. As well as manipulating and contorting the basic form of the vessel, he also sometimes pierced holes in the glass, creating effects rather like those seen on a Barbara Hepworth sculpture.

Pukeberg (founded 1871) was just starting to establish itself in the field of decorative glass during the late 1950s, at which date **Uno Westerberg** (1914–85) was employed. He created shapes reminiscent of those developed during the 1940s by Stig Lindberg at Gustavsberg, but in colours and techniques more closely resembling Italian glass. Finally, at **Lindshammar** (founded 1905) in 1957, **Gunnar Ander** (1908–76) created a range of coloured tall thin-stemmed pedestal vases and lidded bonbon dishes which, whilst obviously prompted by Nils Landberg's 'Tulip' glasses, heralded the more regular symmetrical forms of the early 1960s.

'Illuminata' wallpaper designed by M. Cinderby for Sanderson, 1956, illustrating the type of lightfittings being produced in Britain by the mid-1950s.

Lighting

American and British Lighting

In addition to his work at Herman Miller, **George Nelson** (1908–86) also ran an independent industrial design practice – George Nelson Associates – from 1947 onwards. It was this group that created the influential plastic 'Bubble' lampshades in 1952, produced by the **Howard Miller Clock Company** who also manufactured Nelson's 'Atom' clock. Made from a skeleton globe of steel wire, they were spray-coated with a layer of translucent plastic which allowed the light to shine through, but protected the eye from the glare of the naked bulb. The plastic was tautly stretched, forming a skin that took on the exact contours of the wire frame, thus emphasizing the sculptural qualities of the shades. The 'Bubble' lamps were produced in a wide range of organic forms – spherical, ovoid, compressed, attenuated – just like the shapes of soap bubbles formed when soap suds are blown through a ring. Both the innovative production techniques and the elegant shapes of these lamps were widely copied throughout the USA, so that by the end of the 1950s the formula had become

Table lamps produced by the Dutch firm, Philips, during the 1950s, similar in style to much American lighting of the period.

hackneyed, and it is now difficult to appreciate what a fresh solution it originally was.

Another lighting designer whose work was so extensively plagiarized that he himself received very little credit for his own inventions was the sculptor, **Isamu Noguchi** (1904–88). He arrived at lighting design as a result of early experiments with internally lit 'Lunar' light sculptures during the 1930s. In 1948 he designed a small wooden-framed tripod lamp, with a translucent cylindrical plastic shade, for **Knoll** (founded 1937). Although the materials were modern, the style was that of a traditional Japanese paper lantern. It was to Japanese culture that Noguchi again returned when he created his inspired 'Akari' lamps in 1952, but this time he also adopted the traditional Japanese medium of paper instead of plastic. These large spherical lampshades were revolutionary not for their shape, but for the fact that they could be produced so cheaply and flat-packed as a result of the concertina action of the thinly banded wire or bamboo frame. The word 'akari', meaning light, refers both to illumination and physical weightlessness.

The German-born **Greta von Nessen** (*c.* 1900–*c.* 78) took over the running of her husband's lighting company, **Nessen** (founded 1927), after his death in 1942. Walter von Nessen was an architect trained at the Bauhaus, and Greta von Nessen upheld the same ideals in her Modernist lighting designs of the 1950s. In her 'Anywhere' lamp of 1952, the dome-shaped metal lampshade and the cantilevered aluminium stand have the same clean lines as Poul Henningsen's lamps of the 1920s, but also the confident stylistic curvilinearity of the post-war period. The title of the lamp suggests unlimited flexibility in terms of the type of interiors in which the light could be used, and also the way in which it could itself be displayed, either as a table lamp or hung up as a

fixture on the wall. Design for multi-purpose use was an important factor during the 1950s.

British lighting after the war tended to follow stylistic fashions from abroad. The most progressive firm was **Rotaflex**, which manufactured a range of ribbed moulded plastic lampshades designed by the architects, **John** and **Sylvia Reid**, described in an advert as being 'new-look', as well as 'light, bright, strong and easily washable'.[1] Their ribbed texture was inspired by Noguchi's 'Akari' lamps, while their shapes were derived from Nelson's 'Bubble' lamps. John Reid also designed for the firm of **George Forrest & Sons**, for whom he created his most interesting and skilful design: a counter-poised hanging lamp made from bars of light metal alloy, each painted in a different colour, based on the principle of a Calder mobile.[2] Interestingly, however, Nelson's 'Bubble' lamps appear to be pre-dated by the 'Chrysaline' lampshades produced by the firm of **W.S. Chrysaline** at the start of the decade. These were described in the *Decorative Art Studio Yearbook* for 1951–52 as being 'built on a wire frame cellulosed white and sprayed twice cocoon-wise with plastic while they are rotated. Shrinkage while drying produces the curves between the wires.'

On the whole Britain was stronger on engineering and technology than on the aesthetics of design, although at **Troughton and Young** (founded 1946), the spun metal 'Versalite' reflectors designed by **Alfred Burgess Read** (1898–1973) satisfied both criteria. Designed soon after the war, they could be positioned as either up-lights or down-lights, and were intended for multiple use as shades for wall, ceiling, table and floor lamps. Other leading established engineering-led firms were **GEC** (General Electric Company) and **Best and Lloyd** (founded 1840), whilst a plethora of new firms sprang up during the early 1950s, such as **Hiscock & Appleby**, producing lighting in the 'contemporary' style, characterized by tripod metal rod stands, asymmetrical positioning of lampshades and whimsical decorative details such as coloured knob feet.

Italian Lighting

As in so many other branches of the applied arts during the 1950s, it was the Italians who struck out in new directions. Lighting design, in particular, was a field in which the Italians excelled. The most inventive lighting designer to emerge in Italy during the 1950s was **Gino Sarfatti** (b.1912), who set up his own company, **Arteluce** (founded 1939), just before the war. Sarfatti's enthusiasm and commitment to this company were legendary. Not only did he design almost their entire output during the 1950s, but he exerted direct control over technical research, manufacturing, marketing and distribution. His work was championed by many of the leading architects of the day, such as Alberto Rosselli, who described his work as having a 'new

energy'.[3] For them Sarfatti was one of a rare breed of lighting engineers whose work was a positive inspiration to work with.

Sarfatti was prolific, as well as being remarkably varied and flexible in his output. He could design any variety of lighting fixture, from a simple Modernist floor lamp to a complex ceiling installation. A typical design was model 2072 from 1953, Sarfatti's version of a Calder mobile. This pendant lamp had five circular convex double-disc shades made of perspex, each pair a different size and a different colour (red, blue, brown, white and yellow), suspended at varying heights from a bent steel-rod frame. Colours – particularly primary colours – were obviously important to Sarfatti because almost exactly the same scheme was used on model 191, a wall lamp from 1951.[4] A table lamp from 1951 resembles a cluster of toadstools, each down-turned cupped metal shade painted in a different colour, and in model 2076, a ceiling lamp from 1954, multi-coloured enamelled metal bars, terminating at each end with a strip of neon, were attached apparently at random, as if by magnetic force, to a central cylindrical support. In each of these designs Sarfatti achieved the maximum variation in terms of form and colour, thus ensuring that his lighting fixtures would attract the attention in the same way as an unusual sculpture or a bold abstract painting. It is in this context that Sarfatti's work should be considered. His light fittings, although not widely available outside Italy, were extremely influential. Arteluce acted as a liberating force in the field of international lighting.

Another individual who used lighting in a sculptural way, but who can hardly be called a lighting designer, was the artist **Lucio Fontana** (1899–1968). He created one-off lighting installations for exhibitions, such as the 1951 Milan Triennale, and for public buildings, such as two Milan cinemas designed by Luciano Baldessari in 1953.[5] In these installations he recreated the visual effects originated in his 'Spatial Concepts' in metal and on canvas, exploring ideas about space through experiments with light and shadow. In his famous Triennale light sculptures he created a huge scribbled arabesque in neon in one hall, and produced optical effects resembling slits in the ceiling of another room.

In the work of the Milan-based firm, **Fontana Arte** (founded 1933), sculpture and lighting were again combined, although in a rather more consciously contrived way. Fontana Arte produced high-quality 'objets d'art' in glass and metal, including mirrors, vases and bowls as well as a wide variety of wall, table and floor lamps. As its name implies, art was its primary consideration. Typical of its work were the elaborate tulip bulb chandeliers with cupped or tear-shaped glass shades, which spawned many imitators. Wall brackets and table lamps were often surreal in design: one example represented a disembodied hand holding a torch.

Less glamorous but more functional were the high-quality lightfittings made by **Stilnovo**, whose name – New Style – reflected its progress-ive design policy. Its products were popular with leading architects, some of whom also created designs for it, among them **Achille** (b.1918) and **Piergiacomo** (1913–68) **Castiglioni**.[6] Other designers included **Gaetano Scolari** and **Giampiero Aloi**. Stilnovo lightfittings were cleanlined and functional, making use of the latest materials such as perspex and anodized aluminium. Like Arteluce it led the way rather than slavishly following contemporary fashions, and although some of its designs were light-hearted, they never descended to kitsch. Their confident modernity and their simple solutions to complex lighting needs made them immediately distinctive.

The Castiglioni brothers designed for several other lighting manufacturers as well as Stilnovo, principally **Arredoluce** and **Flos** (founded 1959). Their most striking design from the 1950s was the huge 'Taraxacum' lampshade for Flos, made from spun fibreglass tightly stretched over a wire frame, parts of which projected blades through the skin-like white covering,.

Arredoluce also commissioned designs from the multi-talented **Ettore Sottsass** (b.1917). In a series of pendant lamps from 1956–57 several variously shaped enamelled metal shades were strung together by threads, recalling the sculptures of Naum Gabo. His tripod table lamps stood poised on slender insect-like legs, a trait exaggerated by the reversible metal shade, a feature that allowed the light source to be directed either upwards or downwards. In addition, Sottsass carried out many experiments independently, some of which were illustrated in *Domus*, such as a series of lampshades made of folded and bent aluminium sheet.[7] His relationship with Arredoluce was typical of the emergent industry in Italy at this time. The 1950s was a period in which the Italian lighting industry was expanding rapidly, with many new firms entering the market, such as **O-luce** (founded 1946) and **Azucena** (founded 1947), often seeking to establish their identity by forming partnerships with prominent architects.

Pendant lamp attributed to Gino Vistosi, late 1950s. Murano glassworks, such as Vistosi, played a major role in the Italian lighting industry.

Scandinavian Lighting

Lighting design was taken very seriously in Scandinavia, particularly in Denmark – which captured a large share of the export market – but also in Sweden and Finland. The leading firm in Denmark was **Louis Poulsen** (founded 1892). Its reputation was built on the achievements of **Poul Henningsen** (1894–1967), who began to work for them as early as 1924, but who produced some of his most outstanding designs – such as the 'PH5' and the 'Artichoke' pendant lights – during the 1950s. Heningsen practised as an architect at the time of the emergent Modern Movement, and his design philosophy evolved through having to re-think the design of familiar everyday objects on the basis of functional need. Through architecture, too, he arrived at his conception of lighting as a fundamental and integral component within

'PH5' pendant lamp, designed by Poul Henningsen for Louis Poulsen, 1958.

an interior, rather than as a decorative accessory. His enamelled aluminium 'PH5' pendant lamp of 1958 satisfied both these requirements, its staggered cupped shades serving both to diffuse the light source and to prevent glare. It was an updated version of an earlier lamp designed in 1926 made of opal glass and brass, but the 'PH5' could be mass-produced from sheet metal and was more sophisticated in its control of the light source. During the 1950s aesthetic requirements were increasingly important too, and in this design they were catered for by the different colour combinations in which the lamp was produced, including red, blue, lilac and white.

Henningsen designed lighting to meet the differing requirements of public and domestic interiors. For the former a large-scale and visually striking design was often demanded – the equivalent of the now outmoded chandelier – and thus the impressive 'Artichoke' lamp came into being. This large pendant lamp was originally designed for the Langelinie Pavilion in Copenhagen in 1958. It takes its name and cone shape from the globe artichoke, its 'leaves' being made of copper sprayed clear on the upper surface and pink on the underside. The strong light at the centre was diffused by the leaves which also guarded the eye from glare from whatever angle the lamp was viewed. The 'Artichoke' lamp was one of the most stunning and beautiful creations of the 1950s. Poulsen also commissioned designs from other leading architects of the day, such as **Arne Jacobsen** (1902–71).

The other major lighting manufacturer in Denmark specialized in lampshades rather than lightfittings. This was the firm of **Le Klint** (founded *c*. 1944), whose principal designers were the furniture designer **Kaare Klint** (1888–1954) and his son **Esben Klint** (1915–69). The Le Klint formula could not have been simpler: modestly priced lampshades made of pleated paper, sometimes plastic-coated, in a variety of

shapes – some round, some angular, some conical. A particularly strong design was the 'Avocado' pendant lamp illustrated in the *Decorative Art Studio Yearbook* for 1959–60. Le Klint lampshades were successfully exported and widely copied abroad.

Of a more commercial nature were the lamps produced in Sweden by **Atelje Lyktan** (founded 1934), where the resident designer was **Hans Bergström**. Lampshades were made of the newest materials – such as a film of plastic sprayed over a wire frame – or covered in lively printed fabrics – such as those designed by Stig Lindberg for Nordiska Kompaniet. The lamps themselves took on unusual and exaggerated forms, and were supported or suspended by inventive frames or structures. Whilst some of Bergström's designs were rather derivative and followed the latest fashion trends too slavishly, others were highly original and visually adventurous.[8]

Finnish lighting design in the 1950s was confidently progressive, the two leading manufacturers being **Taito** and **Stockmann**. Taito was directed by the talented metalwork designer, **Paavo Tynell** (1890–1973). Fittings were generally made of brass, and lampshades were made from polished aluminium spun into a variety of inventive shapes, from pointed cones to bell jars to helmets, many with tiny perforations allowing pinpricks of light to show through, and providing ventilation. The two principal designers at Stockmann were **Lisa Johansson-Pape** (b.1907) and **Yki Nummi** (b.1925). The former was a committed functionalist for whom the quality of the light source was more important than the casing in which it was housed. Consequently, she developed a neutral and almost anonymous style using metal and plastic as her chosen materials. Yki Nummi's work was more sculptural, and made more expressive use of new materials, such as perspex. It was not unusual to see acrylic being used as a glass substitute in a lampshade during the 1950s, but it was unusual for it to be used as the stand of a lamp as well, which is what Nummi did in his consciously progressive 'Modern Art' table lamp of 1955. Later designs explored the malleability of plastic, as in the large 'UFO' hanging lamps of 1960.

Two other Finnish designers of repute who became involved in lighting design during the 1950s were **Alvar Aalto** (1898–1976) and **Tapio Wirkkala** (1915–85). Aalto designed a floor lamp for his own company, **Artek** (founded 1933), in which the shade was composed of contoured strips of enamelled metal in graduated bands flaring upwards above a straight narrow rod stand. Tapio Wirkkala had worked extensively as an exhibition designer on behalf of Finland at the Milan Triennales during the 1950s, as a result of which he developed a particular interest in lighting design. In 1959 he created two new angular light bulbs for **Airam**, designed so that they could also serve in themselves as lamps. This innovative re-shaping of the traditional round light bulb won Wirkkala a Gold Medal at the Triennale of 1960.

Metalwork

British and Italian Metalwork

Whereas on the Continent the initiative for change came from enlightened manufacturers, in Britain the revival in silver design was brought about largely by the high standard of metalwork teaching at the Royal College of Art, and by the patronage of the Worshipful Company of Goldsmiths. **Gerald Benney** (b.1930) set up his own workshop as an independent silversmith in 1955, and during the late 1950s he also designed in silver and pewter for the Sheffield firm, **Viners** (founded 1907). He was strongly influenced during the early part of his career by the clean lines, smooth surfaces and organic shapes of Danish silver, and by the sculpture of Henry Moore. But by the end of the 1950s it was Benney himself who was setting the trends for developments during the following decade. He was the first silversmith to decorate his vessels with a matt abstract textured surface, a formula that was widely copied during the 1960s. Benney also led the way in the move towards increasingly attenuated vessel forms in the late 1950s. Coffee pots became taller, and spouts were drawn out longer and narrower, to create supremely elegant forms. Attenuation and a rough surface texture were combined on a stunning pewter Martini set for Viners in 1958, a design that was also ahead of its time in the adoption of cylindrical vessel shapes. Benney completely broke the mould of British silver with his unusual rosebowl centrepieces of the late 1950s. Their lids were in the form of spiky metal sculptures, not dissimilar in style to the work of the 'iron age' sculptor, Lynn Chadwick.[1]

In his illuminating book, *Hand and Machine*, **Robert Welch** (b.1929) has described the creative interaction of working concurrently as both a craftsman silversmith in his studio at Chipping Campden, and an industrial designer for the stainless steel manufacturer, **Old Hall** (founded 1904).[2] Welch's pleasure in tackling the challenges of the two disciplines during the 1950s was evident in his enthusiastic approach to the two media. In silver he was able to let himself go, as he did to great effect in his remarkable seven-light candelabrum of 1958, inspired by a visit to a Jackson Pollock exhibition at the Whitechapel Art Gallery. The knobbly undulations on the uprights of the candelabrum resemble both dripped paint and dripping wax, and thus the imagery of the piece reflects its function. In stainless steel the freedom of having worked as an independent craftsman prompted creative ideas about how to overcome technical problems in a spontaneous and visually innovative way. Welch's first stainless steel tableware range, 'Campden', was jointly designed with **David Mellor** (b.1930), who was responsible for the cutlery, and produced from 1956 onwards by Old Hall in Bloxwich and **Walker and Hall** (founded 1843) in Sheffield. Simple in aesthetic, in manufacture and in construction, 'Campden' won a Design Centre Award in 1958, and Welch soon had the satisfaction of seeing his stainless steel tableware enter into successful competition with that being exported by the Swedish manufacturer, Gense, which he so much admired.[3]

Robert Welch and David Mellor shared a similar outlook on design during the 1950s, and a genuine commitment to designing for production. Mellor produced some accomplished unique silverwares during the mid-1950s, but by the end of the decade the runaway success of his 'Pride' teaset and cutlery for Walker and Hall determined that his career was set on the path of designing for production, with increasing specialization in cutlery. 'Pride' cutlery was advertised in *House and Garden* in October 1959 as 'the new tradition in silver . . . completely modern in

Flower centrepiece designed by Lino Sabattini for Christofle, 1959.

Necklace designed by Bent Gabrielsen Pedersen for Georg Jensen, 1957.

design', and it was available in both sterling silver and E.P.N.S. It won the Council of Industrial Design's Design of the Year Awards in 1957, as did the 'Pride' tea service in 1959.

The last major figure to emerge from the Royal College of Art in the 1950s was the Australian-born **Stuart Devlin** (b.1931). Devlin is unique in asserting retrospectively that Scandinavian design had a restrictive rather than a liberating influence on his own work.[4] He is best known, however, for a silver and nylon coffee service made in 1958, the shapes of which were undoubtedly influenced by the Scandinavian aesthetic he now rejects. The matching coffee pot and hot milk jug are of severely attenuated tapering form, the coffee pot with a black nylon base and handle, the milk jug in contrasting white; both have sharp beak-like spouts, and neither have handles to interfere with their purity of line. Since the 1960s, however, Devlin has concentrated on rich surface decoration, so these pieces, however striking, must be considered as atypical of his later *oeuvre*.

After Henning Koppel in Denmark, the most inventive silver designer in Europe during the 1950s was **Lino Sabattini** (b.1925). Sabattini's elegant and sophisticated silver and electroplate designs for the French firm, **Christofle** (founded 1839), for whom he worked as director of design between 1956 and 1963, were in perfect sympathy with the aesthetics of the New Look. His fresh approach resulted from the fact that he did not in fact train as a silversmith; he developed his modelling skills through an apprenticeship to the German refugee potter, Rolando Hettner, and it was as a result of working with soft malleable clay that he developed his fluid approach to the shaping of silver. Like Rosenthal with its Studio Line range, Christofle adopted a policy of working with star international designers, such as **Gio Ponti** (1891–1979) and **Tapio Wirkkala** (1915–85), during the 1950s in order to increase the prestige of its products.

The principal stainless steel manufacturer in Italy during the early post-war period was **Sambonet**, a family firm, headed from 1954 by the artist and architect, **Roberto Sambonet** (b.1924). Sambonet dominated the market for stainless steel flatware and cooking utensils, and Roberto's best-known design was his fish kettle of 1954, for which he won a Compasso d'Oro award.

Scandinavian Metalwork

Esbjørn Hiort, writing in 1954, described the situation in Denmark as follows: 'The time-honoured ideal of designer-craftsmen is, in our era of specialization, becoming more and more rare . . . Present development is clearly toward co-operation between the producer, who sets the problem, the designer, who creates the abstract basis, and the craftsman – or several craftsmen each with his own speciality – who makes the concrete article.'[5] At **Georg Jensen** (founded 1904) there was a distinct shift in aesthetic after the war, a development that the company referred to in their adverts as '. . . the old name . . . – the new design . . .'[6] Organic sculpture became the dominant stylistic force. Silver was treated as a fine art rather than a branch of the applied arts, and the man who effected this transformation, **Henning Koppel** (1918–81), was himself trained as a sculptor before the war.

As a silver designer Koppel continued to work like a sculptor, making preliminary drawings and shaping models out of clay. When he spoke about his work it was in terms of its relation to natural phenomena: 'When I see how a branch grows organically out of the trunk of a tree, I am inspired by this, and I suppose I seek to create the same organic unity between the body of a jug and its spout or lip.'[7] His earliest works were the most overtly organic: brooches and earrings resemble the forms of dividing amoebae, and necklaces and bracelets look like the interlocking bones of a human spine. From 1952 onwards Koppel designed a series of covered dishes for serving fish or ragouts. These long-lidded vessels were elegant and curvilinear, particularly the 'Eel' dish of 1954 which was so lithe that it looked as if it might slither off the table. According to Koppel: 'Silver demands rhythm. I like the shape to be vigorous and alive with movement.'[8] A continuous rhythm was encapsulated in the contours of a round bowl of 1951 which has both an undulating rim and an undulating foot. The handles of Koppel's jugs and teapots also have a wayward springy quality that adds to the energetic appearance of the vessels.

Another jewellery designer working for Georg Jensen who also adopted an organic form of expression was **Bent Gabrielsen Pedersen** (b.1928). His most accomplished design was for a necklace, the cast interlocking sections of which resemble the winged seeds of the sycamore. **Søren Georg Jensen** (b.1917) was also a sculptor, a fact reflected in his quirky pod-shaped cruets with their nipped and kinked forms resembling contemporary Swedish ceramics by Stig Lindberg at Gustavsberg. Other designers, such as **Magnus Stephenson** (1903–84) and **Nanna Ditzel** (b.1923), produced quieter, less flamboyant designs. The latter created simple solid chunky jewellery. The former specia-

lized in functional tableware, much of it produced in stainless steel.

Stainless steel was the material of the future and, in order to survive, those firms supplying the middle market had to expand or modify their sphere of operations to incorporate it into their range of production. One firm that adapted very successfully was Jensen's competitor, **A. Michelsen** (founded 1841), which continued producing well-designed silverware in the 1950s by architect-designers such as **Erik Herløw** (b.1913), **Ibi Trier Morch** (1910–80) and **Ole Hagen** (b.1913), but also captured the rapidly expanding stainless steel market. To design their new stainless steel ranges they employed the multi-talented architect, **Arne Jacobsen** (1902–71). His sleek 'AJ' cutlery of 1957 has been so successful that it has remained in production for several decades.

In Sweden the 'Servus' cutlery range of 1953 designed by **Sigurd Persson** (b.1914) for the **Kooperativa Förbundet** (founded 1899) also hit upon a winning formula that has ensured its continuing production through to the present day. The major stainless steel producer in Sweden at this date, however, was **Gense**, where the leading designers were **Folke Arström** (b.1907) and **Pierre Forssell** (b.1925). Arström designed the 'Focus' cutlery ranges, of which there were a number of different variants. 'Focus de Luxe' from 1956, for example, had black plastic handles on its knives, forks and spoons, one of the first cutlery ranges to extend the use of plastic handles beyond knives alone. Forssell designed unusual shaped pieces, such as a set of conical cruets.

The leading independent Swedish silversmith of the 1950s was Sigurd Persson, who successfully bridged the gap between craft and machine production. He aimed to achieve classic simplicity rather than eye-catching novelty in his metalwork shapes, and it was after seeing Persson's work that Robert Welch decided to pursue the same dual course in his own career: 'Scandinavia loomed large as an influence in the mid-'50s; the philosophy of the Scandinavians, so popular at that time, designing simple, everyday objects that were functional and beautiful and which most people could afford, greatly appealed to me.'[9] The other leading Swedish silversmith of the 1950s was **Sven Arne Gillgren** (b.1913), who worked as art director at **Guldsmedsaktiebolaget** (founded 1867) in Stockholm between 1942 and 1975. His designs, such as a cocktail set of 1958, pointed the way towards the ever more attenuated forms of the early 1960s.[10]

Finland is not generally associated with the manufacture of silver. However, during the late 1950s there was a very fruitful partnership between the glass designer, **Tapio Wirkkala** (1915–85), and the Finnish silver manufacturer **Kultakeskus**. Wirkkala's designs included various different types of adjustable candelabra: one set had spikes that could be pinned into a board; another set was stabilized by movable brackets, allowing them to be arranged in varied groupings.[11]

'Capriccio' furnishing fabric designed by Sara Provan for Konwiser, 1954.

Textiles

American Textiles

The firms that dominated the furnishing textile industry in America during the 1950s fell largely into four categories: firstly, large manufacturers already well established before the war, such as **Greeff** (founded 1933) and **Schumacher** (founded 1889); secondly, the new design-led furniture manufacturers, such as **Knoll** (founded 1937) and **Herman Miller** (founded 1923), which expanded their range of production to include furnishing fabrics; thirdly, a number of independent designer-manufacturers, such as **Ben Rose**, **Adler Schnee** (founded 1947), **Elenhank** (founded 1946) and **Angelo Testa** (1921–84), who produced short-run hand screenprinted furnishing textiles for the upper end of the market; and fourthly, enlightened commercial firms with a commitment to contemporary design, such as **Konwiser**, **L. Anton Maix** and **Schiffer Prints**, which commissioned work from freelance designers in the latest modern styles.

Rayon furnishing fabric designed by
Jacqueline Groag for David Whitehead, 1952.

During the early 1950s the fashion was for light-hearted colourful 'contemporary' patterns, such as those designed by **Paul McCobb** (1917–69). It was the young independent designers who led the way, rather than the older firms with their well-established markets. Often, however, once freelance designers had established themselves, they were then commissioned to produce work for one of the larger manufacturers. Angelo Testa, for example, designed a textile called 'Square Deal' for Schumacher in 1954 in a style he had originated more than ten years earlier. Testa played a key role in the development of post-war textile design, being one of the originators of the linear and dynamic 'contemporary' style. Superficially close in style, but rather more whimsical in outlook, were Ben Rose and **Ruth Adler**. Under the influence of Angelo Testa, Rose's work became focused on the decorative effects of pure abstract linear patterns. Titles such as 'Scan' and 'Schematics' indicate preoccupations with abstract concepts such as space and rhythm. A highly successful formula employed in many of his works was to create a pattern from the mass repetition of an everyday object, such as paperclips or the shapes of keyholes. Reproduced in this way these familiar items became components in an abstract rather than a representational design.

Ruth Adler formed a partnership in 1947 with the textile printer, Edward C. Schnee, to form Adler Schnee. Her made-to-order designs were hand screenprinted on a variety of furnishing fabrics such as linen, haircloth, and some of the latest combinations of natural and synthetic fibres. From the start of the decade she experimented with bold and irregular abstract patterns printed in strong blocks of colour. Whereas some designers deliberately emphasized the monotony of their designs by minute and exact repetition of similar motifs, Adler consciously broke the monotony by producing offbeat patterns that upset the conventional rhythms of textile designs. A typical example was 'Cuneiform',[1] inspired by the irregular rhythms of ancient Assyrian script. Adler led the way at the end of the decade in the move towards increasingly symmetrical designs. The cleverly titled 'Fission Chips' – referring not only to traditional English fare, but also to nuclear science – was composed of columns of circles and rectangles.[2] Although her work was never mass-produced, it received wide coverage in exhibitions; consequently, it had a much more significant effect than one would expect from limited run textiles.

The other important independent designer-manufacturer from the 1950s was run by the husband-and-wife team of **Elenor** and **Hank Kluck**, who together made up Elenhank Designers. During the late 1940s they printed from linoleum blocks, but later they adopted screenprinting, experimenting with both natural and synthetic fibres, such as the latest wonder fabric, fibreglass. Schiffer Prints also had a reputation for good-quality hand screenprints, which they commissioned from various prominent figures in the design world, such as **George**

Nelson (1908–86). In 1952 Nelson set up a fabrics division at Herman Miller, in charge of which was the architect, **Alexander Girard** (b.1907). Girard had a very positive approach to pattern design, and his lively abstract designs were bold and uninhibited. He himself was an avid collector of folk art, which explains his attraction to strong patterns and his fearless use of clashing colours. Girard popularized the idea of furnishing textiles as unashamedly decorative and stimulating elements within the interior.

Girard's equivalent at Knoll was the Hungarian-born **Eszter Hasraszty** (b.1910), who also had a penchant for bright colours. One of her best-known printed designs was 'Fibra' of 1953, which represented a pattern of knotted and twisted fibres enlarged as if under a microscope. She had a particular interest in improving the quality of industrially produced woven textiles for use as upholstery fabrics for Knoll furniture, and to this end she commissioned two talented handweavers, the Finnish-born **Marianne Strengell** (b.1909) and the American **Evelyn Hill** (b.1925), to design textiles suitable for machine production. Haraszty was succeeded in 1955 by **Suzanne Huguenin** (b.1930s), whose main achievement during the second half of the 1950s was the development of a 100 per cent synthetic machine-woven textile called 'Nylon Homespun' made from heavy-duty carpet yarns.

One of the most successful independent woven textile designers of the 1950s was **Jack Lenor Larsen** (b.1927), whose fearless experimentation resulted in his pushing forward the boundaries of weaving technology. He produced complex and varied weaves combining the maximum number of natural and synthetic fibres. In 'Remoulade' from 1956, for example, he combined linen, cotton, rayon, wool, silk, jute and metallic fibres. Summing up the American achievement in textile design after the war Larsen concluded that 'The 1950s were pivotal . . . This was to be the last decade in which American design was dominant. We experienced the great impact of Abstract Expressionism and of the corporate-design client, and with it, the first alliances of design and the Establishment.'[3]

British Textiles

Although by the 1950s the British textile industry was in decline in terms of the quantity of its output, the post-war years witnessed a renaissance in the quality of design. The leading figure of the decade was **Lucienne Day** (b.1917), who worked freelance for several leading companies, including **British Celanese** (for **Sanderson**, founded 1860), **Heal's** (founded 1810), **Liberty** (founded 1875), and **Edinburgh Weavers** (founded 1932). Her breakthrough came with the Heal's printed linen, 'Calyx', which won a Gold Medal at the Milan Triennale in 1951 and the International Design Award presented by the American Institute of Designers in 1952.

Whereas her commissions from other firms were occasional, Day enjoyed a sustained and highly creative partnership with Heal's throughout the 1950s, working in an instantly recognizable style which was at the same time varied and consistently innovative.

Heal's also employed numerous other freelance designers during this period, such as **June Lyon** and the young **Barbara Brown** (b.1932), as well as commissioning artists, such as **Paule Vézelay** (1892–1984) and **Harold Cohen** (b.1928), to produce textile designs. The latter produced a stunning abstract expressionist work called 'Vineyard'; the former produced a series of restrained abstractions based on simple shapes, such as 'Crescents' and 'Pennons'. Heal's deliberately picked artists who were enthusiastic about the idea of adapting their work for mass-production, and whose paintings were readily transferable into textile patterns. At the end of the decade it was Vézelay's opinion that: 'The whole standard of textile design has been raised in the most interesting way by the introduction of designs inspired by paintings. They have ceased to be something purely commercial and have formed a bridge between commercial art and fine art.'[4]

Throughout the 1940s and 1950s there was considerable interest in the idea of artist-designed textiles. After the war Zika Ascher of **Ascher Ltd** (founded 1942) persuaded many of the world's leading artists – including **Henri Matisse** (1869–1954), **Henry Moore** (1898–1986), **Graham Sutherland** (1903–80), **Alexander Calder** (1898–1976), **Barbara Hepworth** (1903–75) and **Ben Nicholson** (1894–1982) – to design patterns for an exclusive series of screen-printed silk scarves. In the field of furnishing textiles, an important exhibition was held at the ICA in 1953 called 'Painting Into Textiles'. Twenty-five artists produced work in the form of paintings intended to act as an inspiration for textile designs. Some of these were bought by the Lancashire firm, **David Whitehead** (founded 1949), others by the dress fabrics manufacturer, **Horrockses, Crewelson & Co. Ltd** (founded 1798), and they were subsequently printed without significant modification. Many of the artists whose designs were put into production, such as **Eduardo Paolozzi** (b.1924), **William Gear** (b.1915), **Donald Hamilton Fraser** (b.1929) and **John Piper** (b.1903), continued designing for the textile industry during the course of the decade, and the exhibition had the desired effect of showing that 'The Arts are not luxuries, leading gentle lives of grace and piety in a vacuum; they are a strong living force.'[5]

The manufacturer that established the most fruitful and creative relationship with the largest number of artists and designers was David Whitehead, indisputably the most progressive textile manufacturer in Britain during the 1950s. The range, size and quality of its output during this period was staggering. It was invariably the first choice with interior designers,[6] and the company was itself headed during the 1950s by an architect, John Murray. At the start of the

decade Murray had been quick to appreciate the talents of designers such as **Terence Conran** (b.1931),[7] **Marian Mahler** and **Jacqueline Groag** (b.1903), all of whom worked in the new 'contemporary' style popularized by Lucienne Day. Many of their designs were cheaply produced in rayon and were aimed at the middle market. After these early successes, and after buying a number of designs from the 'Painting into Textiles' exhibition, Murray went on to commission increasing numbers of designs from contemporary artists in order to broaden the range of textiles in production. He established highly successful partnerships with Henry Moore, Eduardo Paolozzi and John Piper, in particular, but many other artists also produced designs, including **Louis Le Brocquy** (b.1916) and **William Scott** (b.1913).

Eduardo Paolozzi, whilst establishing his name as a sculptor, worked successfully during the 1950s as a freelance textile designer, and actually taught textile design at Central School for six years between 1949 and 1955. There were close correspondences between some of his collages and textiles, in particular a design called 'Interiors' for **Primavera** from around 1953, while in his designs for Whitehead, scattered sculptural motifs are often to be found. At the end of the decade Paolozzi also co-designed

'Chartwell' furnishing fabric designed by Lisa Gronwell for David Whitehead, 1959.

'Ormeggio' furnishing fabric designed by
Enrico Paulucci for MITA di MA Ponis, 1954.

some textiles with his Independent Group
associate, **Nigel Henderson** (1917–84), such as
'Coalface' for the new firm, **Hull Traders**.

Emergent during the 1950s was the firm of
Tibor Ltd (founded 1955), headed by **Tibor
Reich**, who produced highly innovative printed
and woven textiles. Towards the end of the
decade Reich was already developing the printed
textural abstract fabrics, known as texture
prints, with which he was strongly associated in
the 1960s. He was also active in the field of carpet
design, and his 'Marble' Wilton carpet of 1954, a
linear abstract expressionist design for **I. & C.
Steele & Co.** (founded 1948) of Banbury, was one
of the most avant-garde industrial carpet designs
of the decade.[8] Later he produced bold textural
designs for **Stockwell Carpets** (founded *c*.1890).
The other progressive carpet manufacturers of
the period were **John Crossley** (founded 1803) of
Halifax and the Scottish firm, **James Templeton**,
where the principal designers were **John Palmer**
and **Gavin Hamilton**, respectively. Templeton
participated actively in the Festival Pattern
Group scheme, as did many other dress and
furnishing fabric manufacturers.[9]

Pre-eminent in the field of woven textiles
during the 1950s was **Marianne Straub** (b.1909),
who was closely associated during the 1950s with
both **Warner & Sons** (founded 1870) and **Helios**
(founded 1936). Warner also produced many
printed designs using either freelance designers,
such as **Hilda Durkin**, or commercial studios,
such as **Willy Herrmann** (founded 1903) in
Berlin. In the field of artist-designed woven
textiles, Edinburgh Weavers, the experimental
subsidiary of Morton Sundour, was the acknow-
ledged leader, working with many of the leading
British artists of the day.

Italian, Swiss and German Textiles

Italian textile manufacturers relied heavily on
artists for their printed designs, in a direct way by
commissioning patterns from leading painters,
and also indirectly by employing designers
whose work closely reflected the latest trends in
abstraction. In Italy it was accepted as a basic
principle that domestic interiors should incor-
porate works of art and art-inspired furnishings
in an integral way, not as mere accessories. This
is particularly apparent from looking at the
furnishing schemes designed by **Ettore Sottsass**
(b.1917), **Gio Ponti** (1891–1979) and **Piero For-
nasetti** (1913–88) – all of whom were involved in
one way or another with the textile industry
(Fornasetti produced his own printed table linen
and dress fabrics, for example). However, the
idea was also widely accepted throughout Italian
design circles during the 1950s. Strong printed
abstract textiles in bright colours were often used
for furniture upholstery. Gio Ponti's 'Distex'
armchair for Cassina was featured on the cover
of *Domus* in April 1954 upholstered in an
abstract print by Ettore Sottsass.

The two principal manufacturers in Italy after
the war were **JSA Busto Arsizio** and **MITA Di
MA Ponis**, although the more traditional Milan-
based **Fede Cheti** also played a prominent role
during the 1950s. MITA di MA Ponis was
associated at an early stage during the first half of
the 1950s with overtly painterly textiles, such as
those by **Enrico Paulucci** (b.1901). Ponis also
commissioned the artist, **Eugenio Carmi**
(b.1920), to design both furnishing fabrics and
large limited edition screenprinted wall-hang-
ings. JSA Busto Arsizio won widespread acclaim
for its progressive and innovative design policy
and received many awards, such as La Rinas-
cente's Compasso d'Oro. **Gigi Tessari's** lively
abstract 'Spago' design, for example, won a prize
at the International Centre of Art and Costume
in 1957. Amongst the well-known artists and
designers who worked for Manifattura JSA were
Gio Ponti, Ettore Sottsass, and the sculptors,
Gio Pomodoro (b.1930) and **Lucio Fontana**
(1899–1968). The former produced a design
called 'Tasmania' representing abstract picto-
grams against a sponged background. Fontana
reproduced in printed textile form the optical
illusions of his 'Concetto Spaziale' light sculp-
tures, ceramics and canvases.[10]

Apart from MITA di MA Ponis, JSA Busto's
main rival in the field of artist-designed printed
textiles was **Manifatture Tessuti Stampati** of
Milan, which produced the painterly designs of
Gianni Dova (b.1925) and **Roberto Sambonet**
(b.1924). The same freedom of expression was
applied to the carpets and rugs designed by
Ettore Sottsass. Sottsass had a close partnership
with the firm of **Redan**: as well as creating
patterns for its printed and woven textiles, he
also designed its showroom in Turin.[11] The
leading independent rug-designer in Italy during
the 1950s was **Renata Bonfanti** (b.1929), who
produced richly textured hand-made long-pile
tufted rugs with unusual abstract designs, recall-
ing the work of the American artist, Clyfford
Still.[12] In 1956 Bonfanti also began to design
machine-woven furnishing textiles, produced by
her own company. As with her rugs, textural
effects were the main concern of these designs.

Swiss taste in furnishing fabrics was less
inspirational, and is typified by the restrained
designs of the Zurich-based **Fischbacher**. Print-
ing schemes were usually restricted to one or two
colours, and patterns were consciously repeti-
tive. The Swiss pattern aesthetic of the 1950s, as
seen in the work of **Peter Hebener** for **Carl
Eschke**, appears to be more closely allied to that
of other countries during the 1960s. However, on
closer inspection the motifs in Hebener's designs
reveal their 1950s origins: they are, in fact, the
familiar 'contemporary' style hourglass and
molecular structure motifs of the early 1950s
enlarged on to a huge scale.

In Germany the two leading textile designers
of the 1950s were **Cuno Fischer** (1914–73) and
Elsbeth Kupferoth (b.1920). The latter produced
printed furnishing fabric designs for **Pausa AC
Mechanische Weberei** during the first half of the
1950s which were strongly influenced by the

aesthetics of Miró, particularly in one striking design called 'Espace'. Kupferoth was also capable of more controlled designs, as in her co-ordinated textile and wallpaper ranges for **Emtex**.[13] Cuno Fischer designed equally effectively for both printed and woven textiles. His masterpiece from 1955 was a machine-woven textile called 'Swing' for **Riedlinger Mobelstoff-weberei**, in which the rhythms of jazz, the aesthetics of Miró and the colours of Alexander Calder are all united in a single design. For **Weberei Frittlingen** he created a complementary printed pattern called 'Blues' in which abstracted figures sway to the music.

German textiles encompassed a wide range of styles. As in Switzerland the Modernist aesthetic was still popular, and was perpetuated by firms such as **Storck Gebruder**, with their meticulous machine-woven geometric patterned textiles. At the other end of the spectrum were the bold painterly abstract screenprints produced by **Steiger and Deschler**, several of which from the mid-1950s were strongly influenced by the paintings of Nicholas de Staël. The German contribution to international textile design must also include a record of two important commercial design studios which served the textile and wallpaper industries throughout Europe. The best known of these was the **Willy Herrmann** studio (founded 1903) in Berlin. In addition, the **Werkkunstschule** at **Krefeld** was a leading design school specializing in textiles and wallpapers, located near the important textile manufacturing district of Krefeld. It supplied progressive modern designs that were at the same time attractive and popular.

Scandinavian Textiles

Head of the Textile Design Studio at **Nordiska Kompaniet** (founded 1902) from 1937 to 1971 was **Astrid Sampe** (b.1909), who played a major role as a designer of both printed and woven textiles. Sweden's achievement before the war had largely been in the sphere of handwoven rather than industrially produced textiles. Sampe, however, retained the appearance of handweaving in designs that were suitable for machine production. Meticulousness and restraint were the essence of her woven designs. Whilst exploiting the virtues of natural fibres she also experimented with the new synthetic fibres that were becoming available after the war, overseeing production of the first fibreglass fabrics to be woven at the NK Textile Design Studio in 1951. Sampe was, in her own words, 'systematic to the point of dryness'.[14] Her work was abstract in a severely geometric style, which she herself has referred to as 'Mondrianist'. According to Helena Dahlbäck Lutteman: 'She was enthralled by his organisation of squares and lines, which to her mind epitomised the working of warp and weft in industrial looms.'[15] The 'Mondrianist' approach can be seen most

clearly in Sampe's woven linen table mats and tablecloths called 'Linenline' manufactured by **Almedahls Fabriker** (founded 1920) in 1955, and in some of her rugs produced by the **Kasthalls Mattfabrik** (founded 1889) in 1952, all of which were marketed by NK. A similarly systematic approach to pattern design and colour planning can be seen in her printed textiles. Rather than using contrasting colours, Sampe used a subtle scheme of colour gradation in her 'Windy Way' design.

Sampe was also responsible for commissioning textile designs, including the important 'Signerad Textil' ('Signed Textile') collection by artists and architects in 1954. She commissioned work from a wide range of designers, not just those trained in textiles, such as **Hans Krondahl** (b.1929) and **Marianne Nilsson** (b.1933), but those who could bring a fresh approach from their work in other media, such as the architect, **Sven Markelius** (1889–1972), and the ceramic designer, **Stig Lindberg** (1916–82). **Viola Gråsten** (b.1910) began her career as a weaver of traditional long-pile 'Rya' rugs inspired by Finnish

'Levende Sten' furnishing fabric designed by Axel Salto for L.F. Foght, 1950.

'Citrus' furnishing fabric designed by Maija Isola for Printex, 1956.

folk art, but in 1945 she was taken on at the NK Textile Design Studio in Sweden as a designer of printed and woven furnishing textiles. In her printed textiles Gråsten combined an interest in both geometric and organic patterns. In her woven textiles pattern was kept to a minimum and the visual interest was focused on texture. From 1956 Gråsten worked at the **Mölnlycke** factory (founded 1849) at Gothenburg, where she won international acclaim for her bold printed textiles.

The handweaving tradition continued strongly in Sweden after the war although, as in other branches of the applied arts, craftspeople often enjoyed a fruitful partnership with industry. One such designer-maker was **Alice Lund** (b.1900), who designed woven textiles for the firm of **Borås Wäferi** (founded 1870), but who also had her own studio at Hytting near Borlange. During the early 1950s **Ingrid Dessau** (b.1923) won considerable acclaim for her controlled abstract handwoven textiles, and during the second half of the decade she established a fruitful partnership with the carpet manufacturer, Kasthall.

The Finnish equivalent of Alice Lund was **Dora Jung** (1906–80), who set up her own weaving studio in 1932, but who also designed production table linen during the 1950s for **Tampella**. Like Astrid Sampe she was inspired by themes originating in the art of weaving itself: her 'Lineplay' table linen was decorated with a pattern resembling tautly strung warp threads. According to Dora Jung, 'more important than inventing the theme itself – which can occupy the mind for months – is the division of the surface, the rhythmic patterning of the cloth.'[16] Another prominent Finnish handweaver from this period was **Joy Silander-Lindfors**, who specialized in furnishing textiles and who also made tapestries in traditional Finnish folk patterns. Working in a modern abstract style in the traditional medium of 'Rya' rugs was **Eva Brummer** (b.1901), whose designs sometimes recalled animal patterning, such as zebra stripes.

In printed textiles it was not until the 1960s that Finland achieved international acclaim with the furnishing and dress textiles produced by **Marimekko**. Marimekko grew out of **Printex**, the former oilcloth company taken over and transformed by **Armi Ratia** (1912–79) in 1949. With the help of two talented designers, **Maija Isola** (b.1927) and **Vuokko Eskolin-Nurmesniemi** (b.1930), a bold approach to pattern design was adopted from the outset, with furnishing fabrics, such as Isola's 'Citrus' of 1956, being screen-printed in bright colours on a large scale. The same formula was applied to dress fabrics with great success during the 1960s.

The two leading printed furnishing textile manufacturers in Denmark during the 1950s were **L.F. Foght** (founded 1932) and **Unika-Vaev**. At L.F. Foght the ceramic designer, **Axel Salto** (1889–1961), created lively printed designs inspired by organic vegetable forms. Foght catered for a wide sector of the market. Its designs ranged from the commercially accessible

'contemporary'-style patterns by **Preben Vang-gaard**, to the austerely progressive two-colour linear abstracts of **Inge Toft** (b.1929). At Unika-Vaev the artist, **Aagaard Andersen** (1919–82), produced textiles inspired by abstract expressionism, whilst **Rolf Middelboe** (b.1917) created bold textural abstract designs in the mid-1950s, and later, a remarkable printed cotton wall-hanging called 'Unisol', composed of a wheel of radiating bands in the colours of the spectrum. Unika-Vaev also manufactured rugs and carpets, and in this field, as in furnishing textiles, it turned to leading artists and designers. Carpets were designed by Aagaard Andersen and by the versatile husband-and-wife team of **Nanna** (b.1923) and **Jorgen** (1921–61) **Ditzel**, and at the end of the decade a series of long-pile rugs was produced with abstract designs by **Verner Panton** (b.1926).

In woven textiles Denmark, like Sweden, had its own strong native tradition of restrained geometrical abstract design, exemplified by the work of **Vibeke Klint** (b.1927). She set up her own studio as a handweaver in 1951, producing furnishing textiles, rugs, shawls and table linen. From 1956 she created designs for the carpet manufacturer, **C. Oleson**.

'2 + 3' furnishing fabric designed by Annikki and Ilmari Tapiovaara for Heal's, 1960. Heal's commissioned textile designs from a number of leading international designers in 1960 for a special promotional exhibition. The Finnish furniture designer, Ilmari Tapiovaara, and his wife, Annikki, responded with this attractive nursery print.

Wallpapers

American Wallpapers

Whereas in the UK the textile and wallpaper industries were entirely separate, in the USA they were much more closely linked, and the latest trends in furnishing fabrics tended to filter through into wallpapers more quickly. Several of the leading American firms were prominent in both fields, such as **F. Schumacher** (founded 1889) and **Greeff** (founded 1933), as well as some smaller firms specializing in limited run hand-prints, such as **Ben Rose**. Mary Schoeser writes that: 'Matching fabrics and wallpapers were promoted in American during the War by firms such as F. Schumacher & Co. in New York. Many firms supplied co-ordinated fabrics . . . although Greeff appears to be the originator of the "collection" concept, whereby groups of fabrics and wallpapers – not co-ordinated, but based on one theme – were introduced and publicised together.'[1]

In America wallpapers were generally more informal in style than in Britain, a tendency illustrated by the reproduction in wallpaper form of the cartoons of **Saul Steinberg** (b.1914) by **Piazza Prints** (founded 1946) shortly after the war. Steinberg's work was well known from the *New Yorker*, and his quirky graphic style encap-sulated the bright and irreverent mood of the period. It was in America also that the trend for brightly coloured and boldly patterned kitchen wallpapers originated, a typical example being 'Slices' by **Herndon Papers** from 1953, in which the design was composed of slices of fruit in red, yellow and purple. Mary Schoeser comments that: 'Such still-life designs were particularly popular for kitchen and children's bedroom wallpaper and curtains and – in America – for dens, 'rumpus' rooms or other activity-related spaces.'[2] This relaxed approach to interior decor suited the trend towards an increasingly infor-mal layout in the post-war American house and, in particular, the fashion for open-plan interiors. The increased use of wallpapers was fostered by a new design trend – the fashion for using two complementary or contrasting wallpapers on different walls within the same room. One might be a 'quiet' pattern with small motifs; the other might be a 'loud' pattern, perhaps in brighter colours. Wallpaper manufacturers began to cater for this new trend by producing books that juxtaposed samples of complementary wall-papers, a trend that soon spread to Britain.

The type of light-hearted abstraction charac-teristic of the British 'contemporary' style was also found in American wallpapers, such as those produced by **Denst and Soderlund**

(founded 1947) of Chicago. Its wallpaper, 'The Broken Ladder', of 1952 uses the same type of knobbly stick motifs as are seen in many British designs of the period. Papers with small repeats and densely patterned interlocking linear motifs were characteristic of the early years of the decade. This formula was used in Denst and Soderlund's 'Deep Water' pattern by **Clarence Hawking** from 1952, a design in which tightly interwoven lines create a pattern of stylized fish. The pun used as the title of this design reflects the buoyant mood of the industry, and points to the fact that wallpapers were intended to liven up, as well as brighten up, the post-war interior.

'Interlace' wallpaper designed and manufactured by Ben Rose, *c.*1952.

'Deep Water' wallpaper designed by Clarence Hawking for Denst and Soderlund, 1952.

In the USA almost any subject might serve as the inspiration for a wallpaper, as in the ingenious designs of Ben Rose. Representational motifs were not used in a literal way, but as the basis for a semi-abstract pattern. The subject made the style more accessible. Colour effects and pattern were generally quite simple, as in Ben Rose's 'Interlace' design, representing enlarged knitted loops against a banded background. **Angelo Testa** (1921–84) was another designer whose work was well suited for use either as wallpapers or textiles, and who was similarly influential in popularizing lively abstract designs.

Not all American firms were as confident about the public acceptance of modern design as the independent Ben Rose, however. Many of Schumacher's designs relied on traditional motifs such as leaves and flowers, but presented in an updated graphic style, as in 'Pressed Leaves' of 1952. Schumacher also commissioned **Frank Lloyd Wright** (1867–1959) to design a series of fabrics and wallpapers, but these designs were disappointingly unadventurous in their approach to pattern and colour, and stylistically they appear to hark back to the 1930s.

British Wallpapers

The British wallpaper industry continued to be dominated after the war by the huge combine of firms known as the **Wall Paper Manufacturers Ltd** (founded 1899). The WPM's first post-war initiative was the 'Lancastria' range produced exclusively for the American market. The first volume of designs was colourful but essentially conservative, but in later volumes, which were also available in Britain, a broader range of material was introduced, including several 'contemporary' abstract patterns. Gradually through the 1950s the balance swung in favour of 'contemporary' designs, and the 1957–58 'Lancastria' book contains bold optical designs, such as 'Contour', and complex textural patterns, such as 'Raglan'.

The WPM's main independent competitor was **John Line** (founded 1880). It was John Line that was first off the mark in 1951 with a new range of wholeheartedly modern wallpapers called 'Limited Editions', commissioned from established artists, such as **John Minton** (1917–57), and young freelance designers such as **Lucienne Day** (b.1917) and **Jacqueline Groag** (b.1903). John Line also participated enthusiastically in the Festival Pattern Group scheme to devise abstract patterns based on crystal structures for use at the Festival of Britain. These screenprinted patterns, created by John Line's staff designers, **William Odell** and **Robert Sevant**, were a milestone in the adoption of modern design by the wallpaper industry, and showed a healthy commitment to the idea of experimenting with abstraction.

Block-printed abstract wallpaper designed by Graham Sutherland for Cole Son, *c.*1950.

The drawback with John Line's early initiatives was that they were too expensive to penetrate the mass market. This revolution was effected by the WPM, who in 1952 brought out their first 'Architect's Book of One Hundred Wallpapers', a selection of cheap machine-printed wallpapers produced by a variety of the WPM firms, with the lead being taken by the progressive **Lightbown Aspinall** branch (founded 1846) at Stockport. Many of these wallpapers were simple one or two colour abstract linear patterns, 'contemporary' both in graphic style and in their range of colourways. These papers were generally printed with small-scale repeats, thus making them particularly suitable for domestic interiors. In spite of a slow start, the scheme was a great media and public success, and further 'Architect's Books' appeared at two-yearly intervals throughout the 1950s. The same formula was retained, but the standard of the selection steadily improved because there were more good-quality modern designs to choose from.

In order to heighten its public profile the anonymous-sounding WPM adopted the trade-name of Crown, and it pursued an extremely active advertising and promotional campaign throughout the 1950s so as to consolidate its position as market leader. Building on the success of its earlier 'Architect's Books', the WPM launched its innovative 'Palladio' range in 1955, the initiative once again coming from the forward-looking Lightbown Aspinall branch, headed by Richard Busby. These large-scale patterns were genuinely progressive, and best suited to modern architect-designed spaces. They marked a turning point in the industry: whereas up until this date wallpaper design had lagged behind textile design in terms of its development, with the introduction of the 'Palladio' range wallpapers finally outstripped textiles. Particularly striking was the move towards large-scale repeats and, at the end of the decade, the adoption of bold geometric patterns.

The majority of British wallpapers during the 1950s were commissioned either from freelance designers or design studios, such as the **Willy Herrmann** studio (founded 1903) in Berlin, which produced many varied designs for both John Line and the WPM, some abstract, some representational. Often freelance pattern designers, such as **Daphne Barder** and **June Lyon**, worked in the fields of both wallpapers and textiles. Artists, such as **William Gear** (b.1915) and **Cliff Holden** (b.1919), were also in demand from both textile and wallpaper manufacturers. An early initiative after the war was the abstract wallpaper produced by **Cole and Son** (founded 1938), based on a design by **Graham Sutherland** (1903–80), which had been commissioned for the 'Exhibition of Historical and British Wallpapers' held at the Suffolk Galleries in 1945. At the end of the decade the fashion for bolder and more textural abstract designs became pronounced, a trend reflected in the wallpapers in John Line's screen-printed 'Folio' ranges. By this date artists were more at ease designing for

wallpapers because the styles of abstraction in wallpaper patterns closely reflected current trends in painting.

In 1956 'contemporary' designs accounted for only 20 per cent of the market. 'Effects by Heath', a pattern book produced in 1959 by the merchant, E.N. Heath, in which the patterns were entirely abstract, indicates that the end of the 1950s witnessed a surge in this area of the market. This suggestion is backed up by the fact that in 1960 wallpaper sales reached a record level of 115 million rolls, a 20 per cent increase on the previous year. The fashion for progressive wallpapers undoubtedly played a major part in increasing the demand. The title of another wallpaper pattern book, 'Byle Onward Decor', compiled by the merchant, E.C. Byle, reflects the fashion for modernity.[3]

'Contour' wallpaper by the Wall Paper Manufacturers Ltd in their 'Lancastria' range, 1957–58.

'Neue Form' wallpaper designed by Elsbeth Kupferoth for Marburger Tapetenfabrik, 1956–57.

German, Swiss and Scandinavian Wallpapers

Trends in interior decoration on the Continent were entirely different to fashions in Britain. The British had a particular taste for strongly defined printed patterns in both textiles and wallpapers; the Continentals, on the other hand, were in general more restrained in their tastes and less keen on surface patterns in the home.

In central Europe, notably Germany and Switzerland, the taste was for vinyl papers, often with an embossed rather than a printed pattern, and using a minimum of colour. Hygiene and cleanliness were considered of particular importance, a fact highlighted in the promotional literature for a wallpaper pattern book produced by the Swiss firm, **Salubra** (founded 1900) during the 1950s.[4] The main selling point of these designs was not the patterns but the fact that they were washable. The Swiss accepted wallpaper as background decor, but as a background in which the mood of calm or neutrality required just as much skill to create as a loud and busy pattern. Colours were muted, often pale grey and yellow, and when red was used it was closer to a pale salmon pink than the bright acid tones of the *House and Garden* colour schemes popular in Britain at this time. In terms of pattern, the keys were simplicity and a reliance on undisguised repetition. Since the 1920s Salubra had had a tradition of collaborating with leading progressive designers, such as the Wiener Werkstätte. In 1960 they produced the 'Bill-Salubra' Collection, based on the designs of the Swiss Modernist architect, painter and sculptor, **Max Bill** (b.1908).

In West Germany at the start of the decade there were thirty-seven wallpaper manufacturers, the most progressive of whom was **Rasch**, headed by Dr Emil Rasch (1904–71). Its design policy was decidedly international, which is how the British designer, **Lucienne Day** (b.1917), came to be employed, resulting in the transformation of a textile design for Heal's – 'Graphica' from 1954 – into a wallpaper called 'Prisma' the following year. Of all Day's designs from the first half of the decade this geometrical linear pattern was the most austere and rigorously Modernist, and it was highly significant, therefore, that it should have been selected by Rasch. Dr Rasch also commissioned work from the Japanese-American sculptor, **Shinkichi Tajiri** (b.1923), who designed a striking embossed vinyl design with a reflective surface called 'Raris', the pattern on which resembles the impression of thousands of tiny gramophone records.

Other firms active in Germany during the 1950s included **Schleu and Hoffmann** (founded 1919) of Beuel, who put into production some extremely avant-garde designs produced by the **Werkkunstschule** in **Krefeld**. The Werkkunstschule was a Design School specializing in textiles and wallpapers (Krefeld being a major textile-producing district) which like the **Willy Herrmann** studio in Berlin (founded 1903) served the industry both at home and abroad. A design called 'Reigen' from 1956–57 was a machine print in black on yellow, with a bold and unconventional abstract design that captured the impression of a wheel turning in slow motion.

The most well-known German pattern designer of the 1950s was **Elsbeth Kupferoth** (b.1920). It was she who introduced the American concept of co-ordinated textiles and wallpapers into the German industry. For **Emtex** she designed several co-ordinated ranges, such as a scribbly abstract expressionist design, 'Sylvana', and a nursery print called 'Audrey'.[5] For **Marburger Tapetenfabrik** (founded 1879) Kupferoth designed a wallpaper called 'Neue Form' ('New Form') in 1956–57, a pattern resembling fibres enlarged under a microscope.

Like Kupferoth, some of the leading wallpaper designers in Scandinavia, such as the Finn, **Viola Gråsten** (b.1910), and the Danish artist, **Aagaard Andersen** (1919–82), were also textile designers. It was during the 1940s that Scandinavian wallpapers first established their own distinct identity. Brightly coloured sprigs of flowers depicted in a pseudo-botanical manner were the most popular subject matter, as seen in 'Flora Danika' by **Bent Karlby** (b.1912), created for the Copenhagen firm, **Dahls Tapetfabrik**, in 1951.

During the first half of the 1950s, however, there was a shift away from literal representation towards abstract design, and an acceptance of the machine aesthetic in patterns with simple and regular repeats. Typical of this new genre was Viola Gråsten's 'G-Sträng' ('G String') of 1953 for the Swedish firm **AB Durotapet** (founded 1930), a machine print in which the designer attempted to convey the distorting effect of sound waves on a pattern of vertical lines. Another strong example of contemporary abstraction was Bent Karlby's 'Expansion' design, in which two interlocking mesh patterns were printed off register in contrasting colours. Not all production was immediately converted to machine, however: **Preben Dahlström**'s 'Ljus i Flaske' ('Light in Bottles') wallpaper for Dahls Tapetfabrik was colour printed from woodblocks in 1956. Roller printing was ideal, however, for Aagaard Andersen's 'Mille Points' ('A Thousand Dots') wallpaper for the Danish firm, **Rodia Tapetfabriken**, in the mid-1950s. It was equally well suited to **Folke Sundberg's** compact angular linear designs, such as 'Alle' from 1953 for the Swedish firm, **Engblads Tapetfabrik**. Later Sundberg produced some simple grid and lattice designs for the Norwegian manufacturer, **Vallo Tapetfabrik**. His work was typical of the Scandinavian wallpaper aesthetic, which was visually stimulating but not visually overwhelming.[6]

'Expansion' wallpaper designed by Bent Karlby for Dahls Tapetfabrik, 1956.

Notes on the text

Books listed in the bibliography are referred to in the notes by the surname of the author. Other books or articles are detailed in full. 'Coll.' refers to 'collection of'. 'Ill.' means 'illustrated in'.

1. The New Look

1 Quoted in DORNER, p.9
2 See *Vogue*, May 1948, pp.78–9
3 See GRANDISON and KENNA; HINE; HORN; PEARCE; PEEL and POWELL in General Bibliography
4 HUNTER, S., 'USA' in *Art Since 1945* (Thames and Hudson, London, 1959), p.285
5 *The Studio*, Jan. 1955, pp.18–21
6 Quoted in HARROD, T., 'The Forgotten '50s' in *Crafts*, May/June 1989, pp.30–33
7 'Contemporary Furnishing Fabrics' in *Vogue Export*, no. 6, 1951, p. 62
8 Coll. Whitworth Art Gallery, Manchester
9 'Textile Design Inspired by Paintings' in *Furnishing World*, Aug. 1959, p.31
10 NOGUCHI, I., *A Sculptor's World* (Harper and Row, New York, 1968), p.27
11 'Proverbs of Hell' in BLAKE, W., *The Marriage of Heaven and Hell*
12 'Stile de Niemeyer' in *Domus*, Jan. 1953, pp.8–9
13 BRANZI, p.41
14 See *Decorative Art Studio Yearbook*, 1952–53, p.22
15 Such as Wilhelm Kåge at Gustavsberg and Vicke Lindstrand at Orrefors and Kosta
16 In Britain, for example, Danish goods were imported by Finmar and Danasco
17 Finland lost land to the USSR after the war, and was also obliged to pay significant war damages
18 SEGERSTAD, p.30
19 ibid, pp.34–5
20 Quoted in HIESINGER and MARCUS, p.xv
21 ibid, p. 98

2. The Emergence of the New Look

1 *Rococo – Art and Design in Hogarth's England* (Victoria and Albert Museum, London, 1984)
2 MØLLER, V. S., *Henning Koppel* (Carlsberg Foundation, Copenhagen, 1965)
3 GOMBRICH, E. H., *The Sense of Order* (Phaidon, Oxford, 1979), p.284
4 EIDELBERG, p.78
5 A view confirmed by the metalwork designer, Robert Welch (Conversation with author, 6/12/90)
6 ARNASON, p.141
7 ibid, p.274
8 Coll. Madame Arp-Hagenbach, Meudon. Ill. ibid, p.226
9 Quoted in GOZAK, A., *Aalto vs. the Modern Movement* (Kustantaja Rakennuskirja Oy, Helsinki, 1981), p.78
10 I am indebted for this suggestion to Satu Grönstrand, formerly at the Iittala Glass Museum
11 Moore designed scarves and dress fabrics for Ascher, and furnishing fabrics for David Whitehead
12 *Vogue*, April 1947, p.47
13 *Vogue*, Sept. 1946, pp.60–1
14 *Vogue*, June 1945, p.67
15 *Vogue*, Sept. 1953, p.147
16 Coll. Whitworth Art Gallery, Manchester
17 For example, Gino Sarfatti's model 2072 hanging lamp for Arteluce, 1953, and June Lyon's 'Mobile' furnishing fabric for Heal's, 1954
18 Coll. Tate Gallery, London
19 Coll. Tate Gallery, London
20 Coll. Museum of Costume, Bath
21 See *Domus*, Jan. 1953, p.1
22 Coll. Museum of Costume, Bath
23 Quoted in HANKS, p.115
24 HIESINGER and MARCUS, p.98

3. New Shapes

1 *Alvar Aalto: Furniture and Glass* (Museum of Modern Art, New York, 1984), p.1
2 FEHRMAN and FEHRMAN, p.17
3 'Stile de Niemeyer' in *Domus*, Jan. 1953, pp.8–9
4 Quoted in PAGE, p.206
5 Shown at the Ideal Home Exhibition, London, 1956
6 HIESINGER and MARCUS, p.98
7 Quoted in GANDY and ZIMMERMANN-STIDHAM, p.152
8 HIESINGER and MARCUS, p.98
9 *Vogue*, March 1953, p.109
10 In this context the title of Andrea Branzi's book on Italian design, *The Hot House* (Thames and Hudson, London, 1984), is especially pertinent
11 *Vogue*, April 1950, p.86
12 ibid, p.81
13 *Vogue*, April 1952, p.31
14 The exhibition opened at the Italian Institute, London, in 1955 and travelled to Manchester City Art Gallery and the Walker Art Gallery, Liverpool, in 1956
15 READ, H., 'Great Britain' in *Art Since 1945* (Thames and Hudson, London, 1959), p.232
16 ibid, p.232
17 'Forme, arredamenti, oggetti' in *Domus*, Feb. 1953, pp.29–38
18 See GOMBRICH, E.H., *The Sense of Order* (Phaidon, Oxford, 1979), pp.20–31
19 ibid, p.24
20 ibid, p.58
21 Quoted in PAGE, p.206
22 *Vogue*, April 1947, p.91

4. New Patterns

1 Text from exhibition of 'Post-War Textile Design' held at Whitworth Art Gallery, Manchester (28/3/90–28/5/90)
2 GOMBRICH, E.H., *The Sense of Order* (Phaidon, Oxford, 1979), p.62
3 See 'Paintings into Textiles' in *The Ambassador*, no. 11, 1953, and no. 4, 1954, recording an exhibition at the Institute of Contemporary Art, London, of textile designs commissioned from artists
4 ARNASON, p.329
5 They were copied by Marian Mahler in a design for David Whitehead in 1952, for example. Coll. Victoria and Albert Museum, London (circ. 14 – 1953)
6 Coll. Victoria and Albert Museum, London (circ. 385 – 1953)
7 *Design*, no. 43, 1952
8 See Chapter Five – *New Imagery*: 'The Appliance of Science'
9 See *Decorative Art Studio Yearbook*, 1957–58, p.64 and p.69
10 Illustrated in HINCHCLIFFE and MENDES, pp.148–9
11 *Vogue*, April 1954, p.103, and March 1954, p.65, respectively
12 *Decorative Art Studio Yearbook*, 1953–54, p.81
13 *Domus*, Sept. 1954, p.60
14 Quoted in *Astrid Sampe – Swedish Industrial Textiles* (Nationalmuseum, Stockholm, 1984), p.45
15 MATHEY, F., 'Bissière' in *Les Années Cinquantes* (Centre Pompidou, Paris, 1988), p.123
16 Coll. The Museum of Modern Art, New York
17 *Vogue Export*, no. 5, 1952, p.57
18 *Domus*, Nov. 1959, p.43
19 Quoted in CAPLAN, p.46
20 *Domus*, April 1959, p.29
21 *Domus*, Dec. 1958, pp.5–22
22 *Domus*, Sept. 1959, pp.13–18
23 'Pattern and Texture in Architecture' in *Decorative Art Studio Yearbook*, 1954–55, p.14
24 As in the Festival Pattern Group Scheme for the Festival of Britain
25 See, for example, *Domus*, Nov. 1957, pp.43–9
26 Information from Gerald Benney. (Conversation with author, 12/12/90)
27 See *Decorative Art Studio Yearbook*, 1959–60, p.106
28 Such as the 'Diamantina' Country Club, Caracas. See *Domus*, Dec. 1958, pp.5–22
29 See *Domus*, Sept. 1953, pp.38–9, and advert for JSA Busto Arsizio in *Decorative Art Studio Yearbook*, 1960–61

5. New Imagery

1 *Vogue*, Dec. 1945, p.63
2 Institute of Contemporary Art, London, 1953
3 Quoted in Tate Gallery catalogue re. T.314
4 BRION, M., 'School of Paris' in *Art Since 1945* (Thames and Hudson, London, 1959), p.16

5 Thomas, M.H., 'Festival Pattern Group' in *Design* nos 29–30, 1951, p.13
6 ibid, pp.14–17
7 Curtis, p.56
8 'I reali collegamenti fra arte e vita d'oggi' in *Domus*, July–Aug. 1952, pp.61–3
9 *Decorative Art Studio Yearbook*, 1952–53, p.6
10 Ill. in Goodden, p.92
11 Information from records belonging to Leslie Gooday
12 Coll. Orrefors Museum, Småland, Sweden
13 *Decorative Art Studio Yearbook*, 1951–52, p.6
14 *Vogue*, Feb. 1947, p.33
15 Quoted in Caplan, p.46
16 Designer: Werner Geipel
17 *Domus*, April 1954, p.63

6. The New Look and the New Lookalikes

1 Noguchi, I., *A Sculptor's World* (Harper and Row, New York, 1968), p.27
2 Gentili, E.D., 'Antonia Campi – "Le Chant Tordu De La Terre"' in *Keramikos*, June 1989, p.74
3 Information derived from conversation with the author, 4/10/90
4 Wright, M. and R., *Guide to Easier Living* (Simon and Schuster, New York, 1950), p. 42
5 Phillips, P., 'The New Look' in *Age of Austerity, 1945–1951*, ed. Sissons, M. and French, P. (Penguin, Harmondsworth, 1964), p.153
6 ibid, p.154
7 Segerstad, p.34

Directory: Ceramics

1 Eidelberg, p.90
2 Los Angeles County Museum of Art, *The Ceramic Work of Gertrud and Otto Natzler* (Los Angeles, 1966), preface by Otto Natzler
3 Letter to Alan Peat. I am indebted to Alan Peat for allowing access to his unpublished research and manuscript on Midwinter
4 Ill. in Niblett. p. 9
5 Letter to the author, 30/11/90
6 *The Studio*, Jan. 1955, pp. 18–21
7 Compagnia Nazionale Artigiana, *Italian Contemporary Handicrafts* (Italian Institute, London, 1955), p.4
8 ibid, p.6
9 *Decorative Art Studio Yearbook*, 1959–60, p.106
10 Ill. in 'Due protagonisti del design ceramico: G. Andlovitz e A. Campi', in *Bagno e Accessori*, July–Aug. 1989
11 Gentili, E.B., 'Antonia Campi – "Le Chant Tordu De La Terre"' in *Keramikos*, June 1984, p.74

Directory: Fashion

1 *Harper's Bazaar*, Oct. 1953, p.64
2 Madeleine Vionnet (1876–1975) ran a fashion house in Paris between 1922 and 1940. A superb cutter and dressmaker, she cut her toiles from material draped on a lay figure. She evolved her bias cut in 1926, then a totally new way of working with fabric
3 The London fashion house, Jacqmar, also employed Bianca Mosca as designer between 1940 and 1946
4 Edward Molyneux (1891–1974), an Englishman, opened a fashion house in Paris in 1919. After the Second World War, he had houses in London and Paris until he retired in 1950
5 Pierre Balmain (1914–82) worked as a designer for Lucien Lelong towards the end of the war. He opened his own house in 1946
6 See *Harper's Bazaar*, Sept. 1956, p.75
7 *Harper's Bazaar*, March 1953, p.61
8 Robert Piguet (1901–53), a Swiss, set up a fashion house in Paris in 1933. He designed little himself, but bought designs from freelance designers.
9 Lucien Lelong (1889–1958) opened a fashion house in Paris in 1923. From 1937 to 1945 he was President of the Chambre Syndicale de la Couture Parisienne.
10 *Harper's Bazaar*, April 1947, p.29
11 *Vogue*, June 14th 1939, pp.44–5
12 *Harper's Bazaar*, Oct. 1949, p.51
13 *Harper's Bazaar*, April 1953, p.50

Directory: Furniture

1 Quoted in Fehrman and Fehrman, pp.17–8
2 The latter was actually designed by Irving Harper of George Nelson Associates, although Nelson's name is usually associated with the design
3 Larrabee and Vignelli, p.77
4 Page, p.209
5 See *Decorative Art Studio Yearbook*, 1953–54, p.46
6 *Decorative Art Studio Yearbook*, 1952–53, pp.7–15
7 Centre Georges Pompidou, *Mollino – L'Etrange univers de l'architecte Carlo Mollino* (Paris, 1989), pp.13–15
8 Compagnia Nazionale Artigiana *Italian Contemporary Handicrafts* (Italian Institute, London, 1955), fig. 34
9 Fornasetti showed great interest in a Burges Escritoire acquired by Manchester City Art Galleries in 1979. See correspondence during 1979–80 at MCAG
10 *Domus*, Jan. 1952, pp.15–24; Feb. 1952, pp.50–1; May 1953, pp.24–9
11 *Domus*, March 1954, pp.57–72
12 The industry was ably supported by the well-organized and active Copenhagen Cabinetmakers' Guild, and by a highly developed export trade. Wholesale importers, such as Finmar and Danasco, for example, made furniture available in the UK on a wide scale
13 Møller, H.S., *Danish Design* (Rhodos, Copenhagen, 1975), p.117
14 ibid, p. 109

Directory: Glass

1 Quoted in Arnošt, Drahotova and Langhamer, p.39
2 Coll. Manchester City Art Galleries
3 Ill. in Arnošt. Drahotova and Langhamer, p.147
4 Ill. in Klein and Lloyd, p.258
5 Ill. in Lassen and Schülter, pl. 66
6 *Gunnel Nyman – Glass Research IV* (Finnish Glass Museum, Riihimäki, 1987), p.75
7 *Domus*, Oct. 1958, p.39
8 *Domus*, May 1953, p.51
9 *Domus*, Nov. 1952, pp. 48–9
10 Herlitz-Gezelius, p.91
11 *Decorative Art Studio Yearbook*, 1953–54, p.118
12 'Erik Höglund' in *The Lunning Prize* (Nationalmuseum, Stockholm, 1986), p.92
13 See *Decorative Art Studio Yearbooks*, 1955–60
14 *Decorative Art Studio Yearbook*, 1956–57, p.96
15 ibid, p.98

Directory: Lighting

1 *House Beautiful*, Sept. 1958
2 *Ideal Home Yearbook*, 1953–54, p.115
3 *Domus*, Oct. 1952, p.57
4 ibid, Cover
5 *Domus*, Sept. 1953, pp.38–41
6 *Domus*, Jan. 1959, p.34
7 *Domus*, Feb. 1955, pp.47–51
8 See *Decorative Art Studio Yearbook*, 1956–57, p.126

Directory: Metalwork

1 Such as his 'Winged Figures' (1955) and 'Dragonfly' (1951), both in the coll. Tate Gallery, London
2 Welch, pp.16–17
3 ibid, p.121
4 Telephone conversation with the author, October 1990
5 Hiort, p.10
6 *Decorative Art Studio Yearbook*, 1958–59, p.129
7 Quoted in Møller, V.S., *Henning Koppel* (Carlsberg Foundation, Copenhagen, 1965)
8 ibid
9 Welch, p.16
10 *Decorative Art Studio Yearbook*, 1960–61, p.92
11 *Decorative Art Studio Yearbook*, 1959–60, pp.64–5

Directory: Textiles

1 *Decorative Art Studio Yearbook*, 1951–52, p.8
2 *Decorative Art Studio Yearbook*, 1959–60, p.74
3 Hiesinger and Marcus, p.125
4 'Textile Designs Inspired by Paintings' in *Furnishing World*, Aug. 1959, p.29
5 *The Ambassador*, no. 11, 1953, pp.71–90
6 Information from the architect, Leslie

Gooday, in a conversation with the author, 13/12/90

7 Later in the decade Conran established his own textile firm, Conran Fabrics

8 *Decorative Art Studio Yearbook*, 1954–55, p.141; 1955–56, p.71; 1957–58, p.40

9 See *Decorative Art Studio Yearbook*, 1953–54, p.90, for Templeton FPG carpet. See *Design*, nos 29–30, 1951, for general article on the 'Festival Pattern Group'

10 See advert for JSA Busto Arsizio in *Decorative Art Studio Yearbook*, 1960–61

11 *Domus*, Feb. 1955, pp.38–9

12 *Domus*, Nov. 1959, pp.44–5

13 *Decorative Art Studio Yearbook*, 1957–58, p.64 and p.69

14 Quoted in *Astrid Sampe – Swedish Industrial Textiles* (Nationalmuseum, Stockholm, 1984), p.45

15 ibid

16 Quoted in SEGERSTAD, p.42

Directory: Wallpapers

1 SCHOESER, M., *Fabrics and Wallpapers – Twentieth Century Design* (Bell & Hyman, London, 1986), p.83

2 ibid, p.91

3 Coll. Whitworth Art Gallery, Manchester

4 Coll. Whitworth Art Gallery, Manchester

5 *Decorative Art Studio Yearbook*, 1957–58, p.64 and p.69, respectively

6 HAMILTON and OMAN, pp.426–7

Bibliography

General

ARCENEAUX, M. *Atomic Age: Art and Design of the Fifties* (Troubadour, San Francisco, 1975)

ARNASON, H.H. *History of Modern Art* (Harry N. Abrams, New York, and Thames and Hudson, London, 1986)

Art Since 1945 (Thames and Hudson, London, 1959)

BANHAM, M. and HILLIER, B. *Festival of Britain – A Tonic to the Nation* (Thames and Hudson, London, 1976)

BAYLEY, S. *In Good Shape 1900–1960* (Design Council, London, 1979)

BAYLEY, S. (ed.) *The Conran Directory of Design* (Conran Octopus, London, 1985)

BAYLEY, S., GARNER, P., SUDJIC, D. *Twentieth Century Style and Design* (Thames and Hudson, London, 1986)

BONY, A. *Les Années 50* (Editions du Regard, Paris, 1982)

BOOKER, C. *The Necrophiliacs: Study of the Revolution in English Life in the Fifties and Sixties* (Collins, London, 1969)

BORNGRÄBER, C. *Stilnovo: Design in den 50er Jahre* (Fricke, Frankfurt, 1979)

BRANZI, A. *The Hot House – Italian New Wave Design* (Thames and Hudson, London, 1984)

BURNS, M. and DI BONIS, L. *50's Homestyle* (Thames and Hudson, London, 1988)

CARRINGTON, N. *Colour and Pattern in the Home* (Batsford, London, 1954)

CASTELLI, V. (ed.) *Il Design Italiano Degli Anni '50* (IGIS, Milan, 1988)

CENTRE GEORGES POMPIDOU *Les Années Cinquantes* (Paris, 1988)

CHRISTOPHER, J. and CHRISTOPHER, R. *Design for Modern Marriage* (Hurst & Blackett, London, 1958)

COLLINS, M. *Towards Post-Modernism: Design Since 1851* (British Museum, London, 1987)

COMAGNIA NAZIONALE ARTIGIANA *Italian Contemporary Handicrafts* (Italian Institute, London, 1955)

Modern Italian Design (Manchester City Art Galleries, 1956)

COULSEN, T. *A Bibliography of Design in Britain 1851–1970* (Design Council, London, 1979)

COUNCIL OF INDUSTRIAL DESIGN *Design in the Festival* (HMSO, London, 1951)

CURTIS, P. *Modern British Sculpture* (Tate Gallery, Liverpool, 1988)

DETROIT INSTITUTE OF ARTS *Design in America: The Cranbrook Vision* (Harry N. Abrams, New York, 1983)

FARR, M. *Design in British Industry: A Mid-Century Survey* (CUP, Cambridge, 1955)

FRENCH, P. and SISSONS, M. (eds) *Age of Austerity, 1945–1951* (Penguin, Harmondsworth, 1964)

GARNER, P. *Contemporary Decorative Arts: 1940 to the Present Day* (Quarto, London, 1980)

GRANDISON, W. and KENNA, R. *Somethin' Else: 50s Life and Style* (Richard Drew, Glasgow, 1989)

HARRIS, N. *The Forties and Fifties: An Illustrated History in Colour* (Macdonald, London, 1975)

HENNESSEY, W.J. *Russel Wright, American Designer* (MIT, Cambridge MA, 1983)

HEWISON, R. *In Anger: Culture in the Cold War 1945–60* (OUP, Oxford, 1981)

HIESINGER, K.B. and MARCUS, G.H. *Design Since 1945* (Philadelphia Museum of Art, Philadelphia, and Thames and Hudson, London, 1984)

HINE, T. *Populuxe* (Alfred Knopf, New York, 1986)

HILLIER, B. *Austerity/Binge* (Studio Vista, London, 1975)

The Style of the Century, 1900–1980 (Herbert Press, 1983)

HOPKINS, H. *The New Look: A Social History of the Forties and Fifties* (Secker and Warburg, London, 1964)

HORN, R. *Fifties Style: Then and Now* (Columbus, 1975)

HULDT, A.H. and STAVENOW, A. *Design in Sweden* (Gothia, Stockholm, 1961)

JEZER, M. *The Dark Ages: Life in the United States 1945–1960* (South End Press, Boston, 1982)

KARLSEN, A., SALICATH, B., UTZON-FRANK, M. *Contemporary Danish Design* (Danish Society of Arts and Crafts and Industrial Design, Copenhagen, 1960)

KATZ, S. *Classic Plastics* (Thames and Hudson, London, 1984)

KIDDER SMITH, G.E. *Italy Builds* (Architectural Press, London, 1955)

The New Architecture of Europe (Prentice Hall, London, 1962)

KULTURZENTRUM, LUDWIGSBURG *Fifty Fifty: Formen und Farben der 50er Jahre* (Ludwigsburg, 1987)

LEWIS, P. *The 50's* (Heinemann, London, 1979)

MAENZ, P. *Die 50er Jahre: Formen Eines Jahrzehnts* (Gerd Hatje, Stuttgart, 1978)

MACCARTHY, F. *All Things Bright and Beautiful 1830–1970* (Allen and Unwin, London, 1972)

MACCARTHY, F and NUTTGENS, P. *Eye for Industry: Royal Designers for Industry 1936–1986* (Lund Humphries, London, 1986)

MACDONALD, S. and PORTER, J. *Putting on the Style: Setting Up Home in the 1950s* (Geffrye Museum, London, 1990)

MACFADDEN, D.R. (ed) *Scandinavian Modern Design* (Cooper Hewitt Museum, New York, 1982)

MILLER, D. and NOWAK, M. *The Fifties: The Way We Really Were* (Doubleday, New York, 1977)

MØLLER, H.S. *Danish Design* (Rhodos, Copenhagen, 1975)

MUSÉE D'ART MODERNE DE ST. ÉTIENNE *L'Art en Europe: Les Années Décisives, 1945–53* (Skira, Geneva, 1987)

MUSEUM VILLA STUCK *Die Fünfziger: Stilkonturen Eines Jahrzehnts* (Munich, 1984)

NATIONALMUSEUM, STOCKHOLM *Dansk 50 Tal* (Stockholm, 1981)

The Lunning Prize (Stockholm, 1984)

NEUTRA, R. *Survival Through Design* (OUP, New York, 1954)

ORNAMO *The Ornamo Book of Finnish Design* (Helsinki, 1962)

PAGANI, C. *Italy's Architecture Today* (Hoepli, Milan, 1955)

PANSERA, A. *Storia e Cronica della Triennale* (Longanesi, Milan, 1978)

PEARCE, C. *Fifties Sourcebook* (Quarto, London, 1990)

PEEL, L. and POWELL, P. *50's and 60's Style* (Apple Press, London, 1988)

PICA, A. *Storia della Triennale 1918–1957* (Il Milione, Milan, 1957)

PONTI, L.L. *Gio Ponti* (Thames and Hudson, London, 1990)

PULOS, A.J. *The American Design Adventure* (MIT, Cambridge, MA, 1988)

ROGERS, M.R. *Italy at Work* (Compagnia

Nazionale Artigiana, Rome, 1950)

SEGERSTAD, U.H.A. *Modern Finnish Design* (Weidenfeld & Nicholson, London, 1969)

SERVICE CULTUREL CGER *Les Fifties en Belgique* (Brussels, 1988)

SHEFFIELD CITY ART GALLERIES *Homespun to Highspeed: A Century of British Design 1880–1980* (Sheffield, 1979)

The Forgotten Fifties (Sheffield, 1984)

SOCIETY OF INDUSTRIAL ARTISTS *Designers in Britain* vols 1–5 (Wingate, London, 1947–57)

SOCIETY OF INDUSTRIAL DESIGNERS *Industrial Design in America* (New York, 1954)

SPARKE, P. *Italian Design* (Thames and Hudson, London, 1989)

Design Sourcebook (Macdonald, London, 1986)

(ed.), *The Plastics Age* (Victoria and Albert Museum, London, 1990)

STAAL, G. and WALTERS, H. (eds) *Holland in Vorm: Dutch Design 1945–1987* (The Hague, 1987)

STADT MUSEUM, OFFENBACH *Fünfziger Jahre* (Offenbach, 1984)

VICTORIA AND ALBERT MUSEUM *Finlandia: Modern Finnish Design* (London, 1961)

The Way We Live Now – Designs for Interiors 1950 to the Present Day (London, 1979)

British Art and Design 1900–1960 (London, 1983)

WICHMANN, H. *Italien Design 1945 Bis Heute* (Neues Sammlung, Munich, 1988)

WISKEMAN, E. *Italy Since 1945* (Macmillan, London, 1971)

ZAHLE, E. (ed) *Scandinavian Domestic Design* (Methuen, London, 1963)

Ceramics

AAV, M. *Kyllikki Salmenhaara* (Museum of Applied Arts, Helsinki, 1986)

ALAMARO, E. 'L'Isola Gambone' in *Keramikos*, June 1989

Arti Pratiche – La Ceramica in Italia (Aristide Palonbi, Rome, 1958)

BALDINI, U. *Marcello Fantoni* (Florence, 1973)

BAYNTON, V., MAY, H., MORTON, J. *The Beswick Collector's Handbook* (Kevin Francis, 1986)

BIRKS, T. *Hans Coper* (Collins, London, 1983)

Lucie Rie (Alphabooks, Sherborne, 1987)

BODELSEN, M. *Dansk Keramik* (Glyndendal, 1960)

BOJANI, G.C. *Presenze Negli Anni Cinquante* (Museo Della Ceramica, Laveno, 1989)

BOJANI, G.C. and DALPOZZO, T. *Servizi da Tavola di Industrial Design* (Manifestazioni Internazionali Della Ceramica, Faenza, 1979)

Il Design di Ricerca e Ceramica Bitossi (Museo Internazionale Delle Ceramiche, Faenza, 1989)

CLARKE, G. and HUGHTO, M. *A Century of Ceramics in the United States 1878–1978* (E.P. Dutton, New York, 1979)

CROSS, A.J. *Pilkington's Royal Lancastrian Pottery and Tiles* (Richard Dennis, London, 1980)

CUNNINGHAM, J. *Collector's Encyclopedia of American Dinnerware* (Collectors Books, Kentucky, 1982)

DAHLBÄCK LUTTEMAN, H. *Stig Lindberg – Formgivare* (Nationalmuseum, Stockholm, 1982)

Wilhelm Kåge (Nationalmuseum, Stockholm, 1989)

DEX, L. *Hornsea Pottery – A Collector's Guide, 1947–1967* (Beck Books, Hull, 1989)

EATWELL, A. *Susie Cooper Productions* (Victoria and Albert Museum, London, 1987)

EIDELBERG, M. *Eva Zeisel: Designer For Industry* (Le Château Dufresne, Montréal, 1984)

GALLINA, L. and SANDINI, S. *Terraglie di Laveno* (Nicolini, Laveno, 1985)

GAUTHIER, S. and PRÉAUD, T. *Ceramics of the 20th Century* (New York, 1982)

GOWING, C. and RICE, P. *British Studio Ceramics in the 20th Century* (Barrie and Jenkins, London, 1989)

HALD, A. and LINDQVIST, M. *Berndt Friberg – Stengods Gustavsberg* (Keramiskt Centrum, Gustavsberg, 1979)

HANNAH, F. *Ceramics – Twentieth Century Design* (Bell & Hyman, London, 1986)

HAWKINS, J. *The Poole Potteries* (Barrie and Jenkins, London, 1980)

HIORT, E. *Modern Dansk Keramik* (Jul Gjellerups, Copenhagen, 1955)

HOUSTON, J. (ed.) *Lucie Rie* (Crafts Council, London, 1980)

KESTNER MUSEUM *Rosenthal – Hundert Jahre Porzellan* (Hanover, 1982)

KLEIN, B. *The Collectors Illustrated Price Guide to Russel Wright Dinnerware* (Exposition Press, New York, 1981)

KUMELA, M. *Toini Muona: Arabia 1931–1970* (Museum of Applied Arts, Helsinki, 1988)

KUMELA, M., PAATERO, K., RISSANEN, K. *Arabia* (Oy Wartsila AB, Helsinki, 1987)

LOS ANGELES COUNTY MUSEUM OF ART *The Ceramic Work of Gertrud and Otto Natzler* (Los Angeles, 1966)

Gertrud and Otto Natzler Ceramics – Catalogue of the Collection of Mrs Leonard M. Sperry (Los Angeles, 1968)

MALMÖ MUSEUM *Gunnar Nylund* (Malmö, 1973)

NATIONALMUSEUM, STOCKHOLM *Gustavsberg 150ar* (Stockholm, 1975)

NIBLETT, K. *Dynamic Design – The British Pottery Industry 1940–1980* (Stoke-on-Trent City Museum and Art Gallery, Stoke-on-Trent, 1990)

OPIE, J. *Scandinavia – Ceramics and Glass in the Twentieth Century* (Victoria and Albert Museum, London, 1989)

PASOLI, E. (ed.) *Diesegno & Design – La Piastrella di Ceramica dalle Origini al Futuro* (EDI.CER, Modena, 1986)

PELTONEN, K. *Birger Kaipiainen* (Museum of Applied Art, Helsinki, 1989)

PONTI, G. *Ceramica alla 9a Triennale di Milano* (Domus, Milan, 1953)

RAMIÉ, A. *Picasso: Catalogue de l'Oeuvre Céramique Édité, 1947–1971* (Madoura, Vallauris, 1971)

RAMIÉ, G. *Picasso's Ceramics* (Secker and Warburg, London, 1975)

SCARBOROUGH ART GALLERY *Style for the Mass Market – An Exhibition of Hornsea Pottery, 1949 to the Present Day* (Scarborough, 1985)

UNTRACHT, O. *Saara Hopea Untracht* (WSOY, Porvoo, Helsinki, Juva, 1988)

WATSON, O. *British Studio Pottery* (Phaidon/Christies, Oxford, 1990)

Fashion

AMIS, H. *Just So Far* (Collins, London, 1954)

BALMAIN, P. *My Years and Seasons* (Cassell, London, 1964)

BATH MUSEUM OF COSTUME and BRIGHTON ART GALLERY *Norman Hartnell* (Bath and Brighton, 1985)

BERTIN, C. *Paris à la Mode* (Victor Gollancz, London, 1956)

BRADBURY, S. *The Bagot Collection* (Stoke-on-Trent City Museum and Art Gallery, Stoke-on-Trent, 1983)

CARTER, E. *Magic Names of Fashion* (Weidenfeld & Nicolson, London, 1980)

CHARLES-ROUX, E. *Chanel and her World* (Weidenfeld & Nicolson, London, 1981)

COLEMAN, E.A. *The Genius of Charles James* (Brooklyn Museum, New York, 1982)

CREED, C. *Maid to Measure* (Jarrolds, London, 1961)

DE MARLY, D. *The History of Haute Couture 1850–1950* (Batsford, London, 1980)

DIOR, C. *Dior by Dior* (Weidenfeld & Nicolson, London, 1957)

DORNER, J. *Fashion in the Forties and Fifties* (Ian Allen, London, 1975)

DRAKE, N. *The Fifties in Vogue* (Heinemann, London, 1987)

HARTNELL, N. *Silver and Gold* (Evans, London, 1955)

HINCHCLIFFE, F. and MENDES, V. *Ascher – Fabric, Art, Fashion* (Victoria and Albert Museum, London, 1987)

KEENAN, B. *Dior in Vogue* (Octopus, London, 1981)

LEE, S.T. (ed.) *American Fashion* (André Deutsch, London, 1976)

LYNAM, R. (ed.) *Paris Fashion* (Michael Joseph, London, 1972)

MCDOWELL, C. *McDowell's Directory of Twentieth Century Fashion* (Frederick Muller, London, 1984)

METROPOLITAN MUSEUM OF ART, NEW YORK *The World of Balenciaga* (New York, 1973)

SCHIAPARELLI, E. *Shocking Life* (J.M. Dent, London, 1954)

SCHREIER, B. *Mystique and Identity: Women's Fashions of the 1950s* (Chrysler Museum, Norfolk VA., 1984)

THAARUP, A. *Heads and Tails* (Cassell, London, 1956)

TURNER WILCOX, R. *Five Centuries of American Costume* (A & C Black, London, 1963)

Furniture and Lighting

ALOI, R. *Esempi di Arredamento Moderno di Tutto il Mondo* 6 vols (Hoepli, Milan, 1950–53)

Esempi di Arredamento Moderno di Tutto il Mondo: Tavoli – Tavolini – Carelli (Hoepli, Milan, 1955)

Mobili Tipo (Hoepli, Milan, 1956)

Esempi di Arredamento Moderno di Tutto il Mondo: Sedie – Poltrone – Divani (Hoepli, Milan, 1957)

BARONI, D. *Arflex '51 '81* (Arflex, Milan, 1981)

CAPLAN, R. *The Design of Herman Miller* (Whitney Library of Design, New York, 1976)

CENTRE GEORGES POMPIDOU *Mollino – L'Étrange Univers de l'Architecte Carlo Mollino* (Paris, 1989)

CONWAY, H. *Ernest Race* (Design Council, London, 1982)

DAL FABBRO, M. *Furniture for Modern Interiors* (Reinhold, New York, 1954)

DEN PERMENANTE *Fritz Hansen, 1872–1972* (Copenhagen, 1954)

DITZEL, J. and DITZEL, N. (eds) *Danish Chairs* (Høst, Copenhagen, 1954)

DOMUS *Quaderni di Domus: Libri Nella Casa – Camini – Illuminazione – Tavoli – Letti* (Domus, Milan, 1945–1951)

DREXLER, A. *Charles Eames Furniture from the Design Collection* (Museum of Modern Art, New York, 1973)

FABER, T. *Arne Jacobsen* (Alex Tiranti, London, 1964)

FEHRMAN, C. and FEHRMAN, K. *Postwar Interior Design: 1945–1960* (Van Nostrand Reinhold, New York, 1987)

FUTAGAWA, Y. and SPADE, R. *Eero Saarinen* (Thames and Hudson, London, 1971)

GANDY, C.D. and ZIMMERMANN-STIDHAM, S. *Contemporary Classics: Furniture of the Masters* (McGraw-Hill, New York, 1981)

GARNER, P. *Twentieth Century Furniture* (Van Nostrand Reinhold, New York, 1980)

GOODDEN, S. *A History of Heal's* (Heal & Son, London, 1984)

GRAMIGNA, G. *1950–1980 Repertory: Pictures and Ideas Regarding the History of Italian Furniture* (Arnoldo Mondadori, Milan, 1985)

GREENBERG, C. *Mid-Century Modern* (Harmony Books, New York, and Thames and Hudson, London, 1984)

HANKS, D.A. *Innovative Furniture in America from 1980 to the Present* (Horizon Press, New York, 1981)

HATJE, G. (ed.) *New Furniture – Neue Mobel – Meubles Nouveaux* (Niggli, Teuffen, 1952–59)

HIORT, E. *Modern Dänische Möbelkunst* (Stuttgart, 1956)

JALK, G. *The Copenhagen Cabinetmakers' Guild Exhibitions*, vol. 3, 1947–56, vol. 4, 1957–66 (Technologisk Instituts Forlag, Copenhagen, 1987)

KARLSEN, A. *Møbler Tegnet af Borge Mogensen* (Arkitektens Forlag, 1982)

KAUFMANN, E. *Prize Designs for Modern Furniture from the International Competition for Low-cost Furniture Design* (Museum of Modern Art, New York, 1950)

LARRABEE, E. and VIGNELLI, M. *Knoll Design* (Harry N, Abrams, New York, 1981)

LARSON, L. *Lighting and Its Design* (New York, 1964)

LYALL, S. *Hille: 75 years of British Furniture* (Victoria and Albert Museum, London, 1984)

MANG, K. *History of Modern Furniture* (Harry N. Abrams, New York, 1978)

MIESTAMO, R. *The Form and Substance of Finnish Furniture* (Asko, Lahti, 1980)

MUSÉE DES ARTS DÉCORATIFS, BORDEAUX *Jean Prouvé – Meubles 1924–1953* (Bordeaux, 1989)

MUSEUM OF DECORATIVE ARTS, COPENHAGEN *Hans J. Wegner en Stolemager* (Copenhagen, 1989)

MUSEUM OF MODERN ART, NEW YORK *Alvar Aalto: Furniture and Glass* (New York, 1984)

NELSON, G. *Chairs* (New York, 1953)

Storage (New York, 1954)

NELSON, G. and WRIGHT, H. *Tomorrow's House* (Simon and Schuster, New York, 1945)

NOYES, E. *Organic Design in Home Furnishings* (Museum of Modern Art, New York, 1941)

PAGE, M. *Furniture Designed by Architects* (Whitney Library of Design, New York, 1980)

PELTONEN, J. *Ilmari Tapiovaara* (Museum of Applied Arts, Helsinki, 1984)

PHILLIPS, D. *Lighting* (London, 1966)

PILE, J.F. *Modern Furniture* (John Wiley, New York, 1979)

RUSSELL, F. (ed.) *A Century of Chair Design* (Rizzoli, New York, 1980)

SANTINI, P.C. *The Years of Italian Design – A Portrait of Cesare Cassina* (Electa, Milan, 1981)

SEGERSTAD, U.H.A. *Modern Scandinavian Furniture* (Nordisk Rotogravyr, Stockholm, 1963)

SEMBACH, K-J. *Contemporary Furniture – An International Review of Modern Furniture, 1950 to the Present Day* (Design Council, London, 1982)

SPARKE, P. *Furniture – Twentieth Century Design* (Bell & Hyman, London, 1986)

TEMKO, A. *Eero Saarinen* (Prentice Hall, London, 1962)

WHITECHAPEL ART GALLERY *Modern Chairs: 1918–1970* (London, 1970)

Glass

ADLEROVA, A. *Masters of Czech Glass 1945–1965* (Dan Klein, London, 1983)

ALOI, R. *Esempi di Decorazione Moderna di Tutto Il Mondo – Vetri D'Oggi* (Hoepli, Milan, 1955)

ARNOŠT, F., DRAHOTOVA, O., LANGHAMER, A. *Bohemian Glass* (Crystalex, Nový Bor, 1985)

AVELINE, M. (ed.) *La Verrerie Européene Des Années 50* (Musées de Marseille, Marseille, 1988)

BEARD, G. *Modern Glass* (Studio Vista, London, 1968)

BOJ, A. *Glas Av Monica Bratt* (Bellmansmiljo, 1981)

BRENTNALL, M. *John Hutton — Artist and Glass Engraver* (Associated University Presses, London and Toronto, 1986)

COOKE, F. *Glass – Twentieth Century Design* (Bell & Hyman, London, 1986)

CORNING MUSEUM OF GLASS *Glass 1959 (New York, 1959)*

DOMUS *Vetri alla 9a Triennale di Milano* (Domus, Milan, 1952)

ERICSSON, A-M. *Arthur Percy – Konstnar Och Formgivare* (Nordiska Museum, Stockholm, 1980)

GASPARETTO, A. *Il Vetro di Murano* (Venice, 1958)

GRONERT, V. and RICKE, H. *Glass in Schweden 1915–1960* (Prestel-Verlag, Munich, 1986)

HERLITZ-GEZELIUS, A.M. *Orrefors – A Swedish Glassplant* (Atlantis, Stockholm, 1984)

HOLMÉR, G. *Från Boda Till New York – Konstnaren Erik Höglund* (Carlsson, Stockholm, 1986)

Paul Kedelv – Från Trä Till Glas (Smålands Museum, Växjö, 1990)

HULDT, A. *Nils Landberg* (Kalmar Konstmuseum, Kalmar, 1986)

IITTALA GLASS MUSEUM *Iittala in the Triennales of Milan* (Iittala, 1987)

Alvar and Aino Aalto as Glass Designers (Iittala, 1988)

KLEIN, D. and WARD, L. *The History of Glass* (Orbis, London, 1984)

KOIVISTO, K. and NIEMISTO, K. *The Modern Spirit – Glass From Finland* (Finnish Glass Museum, Riihimäki, 1985)

KOIVISTO, K. and MATISKAINEN, H. (eds) *Gunnel Nyman – Glass Research IV* (Finnish Glass Museum, Riihimäki, 1987)

LASSEN, E. and SCHLÜTER, M. *Dansk Glas 1926–1985* (Arnold Busck, Copenhagen, 1987)

LASZLO, A. *Svenskt Konstglas* (Sellin & Blomqvist, Stockholm, 1989)

MARIACHER, G. *Vetri Di Murano* (Bestetti, Milan, 1967)

MUSÉE CURTIUS *Aspects de la Verrerie Contemporaine* (Liege, 1958)

MUSEUM OF APPLIED ARTS, HELSINKI *Timo Sarpaneva: Sculpture in Vetro* (Helsinki, 1987)

NATIONALMUSEUM, STOCKHOLM *Svenskt Glas 1915–1960* (Stockholm, 1987)

NEUWITH, W. *Italian Glass 1950–1960* (Waltraud Neuwith, Vienna, 1987)

OPIE, J. *Scandinavia – Ceramics and Glass in*

the Twentieth Century (Victoria and Albert Museum, London, 1989)

PEACE, D. *The Engraved Glass of David Peace* (Ruskin Gallery, Sheffield, 1990)

POLAK, A. *Modern Glass* (Faber, London, 1975)

RABAN, J. (ed.) *Modern Bohemian Glass* (Artia, 1963)

REIHNÉR, A. *Edvin Öhrström* (Orrefors Glasbruk, Orrefors, 1987)

Ingeborg Lundin (Orrefors Glasbruk, Orrefors, 1989)

RICKE, H. and THOR, L. *Swedish Glass Factories: Production Catalogues 1915–60* (Prestel-Verlag, Munich, 1987)

SMÅLANDS MUSEUM *Erik Höglund – 30ar Med Glas Och Brons* (Växjö, 1990)

STENNETT-WILLSON, *The Beauty of Modern Glass* (Studio Publications, London, 1958)

STEUBEN GLASS *British Artists in Crystal* (Steuben Glass Co., New York, 1954)

Engraved Crystal by Steuben Glass (Steuben Glass Co., New York, 1961)

SUHONEN, P. *Tapio Wirkkala* (Finnish Society of Crafts and Design, Helsinki, 1985)

THIRY, M. *De l'Art Déco aux Années 50: Le Verre et le Crystal Belges dans le Monde* (Charleroi, 1987)

THOR, L. *Legend I Glas – En Bok Om Vicke Lindstrand* (Liberforlag, Stockholm, 1982)

UNTRACHT, O. *Saara Hopea* (WSOY, Porvoo, 1988)

WARNECKE, A. *Kultur in Glas und Porzellan 1925–1965* (Hamburg, 1965)

WIDMAN, D. *Sven Palmqvist 1906–1984* (Kalmar Konstmuseum, Kalmar, 1984)

Metalwork

ALOI, R. *Esempi di Decorazione Moderna di Tutto Il Mondo: Gioelli, Sbalzi, Argenti* (Hoepli, Milan, 1954)

HAYCRAFT, J. *Finnish Jewellery and Silverware: An Introduction to Contemporary Work and Design* (Helsinki, 1960)

HIORT, E. *Modern Danish Silver* (Zwemmer, London, 1954)

HUGHES, G. *Modern Silver throughout the World 1880–1967* (Studio Vista, London, 1967)

MARELLI, E. *Lino Sabattini; Intimations and Craftsmanship* (Mariano Comense, 1979)

MØLLER, V.S. *Henning Koppel* (Carlsberg Foundation, Copenhagen, 1965)

PERSSON, S. *Modern Swedish Silver* (Lindqvists, Stockholm, 1951)

Sigurd Persson Silver (Arne Tryckare, Stockholm, 1979)

SCHWARZ, W. *Georg Jensen* (Jensen and Wendel, Copenhagen, 1958)

SMITHSONIAN INSTITUTE *Georg Jensen Silversmithy: 77 Artists, 77 Years* (Washington D.C., 1980)

WELCH, R. *Hand and Machine* (Robert Welch, Chipping Campden, 1986)

WORSHIPFUL COMPANY OF GOLDSMITHS *Modern British Silver* (London, 1963)

The Goldsmith Today (London, 1967)

25 Years of Stuart Devlin in London (London, 1983)

Textiles and Wallpapers

BURY, H. *A Choice of Design 1850–1950: Fabrics by Warner & Sons Ltd.* (Warner & Sons, London, 1981)

GERMANISCHES NATIONALMUSEUM *Cuno Fischer* (Nuremberg, 1978)

GOODDEN, S. *A History of Heal's* (Heal and Son, London, 1984)

HAMILTON, J. *An Introduction to Wallpaper* (HMSO, London, 1983)

HAMILTON, J. and OMAN, C. *Wallpaper – A History and Illustrated Catalogue of the Collection in the Victoria and Albert Museum* (Sotheby's, London, 1982)

HINCHCLIFFE, F. *Fifties Furnishing Fabrics* (Victoria and Albert Museum, London, 1989)

HOSKINS, L., PINNEY, M., TURNER, M. *A Popular Art – British Wallpapers 1930–1960* (Silver Studio Archive, Middlesex, 1989)

KATZENBACH, L. and KATZENBACH, W. *The Practical Book of American Wallpaper* (J.B. Lippincott Co., Philadelphia and New York, 1951)

KOCH, A. *Dekorationsstoffe Tappen/Teppiche* (Koch, Stuttgart, 1953)

LARSEN, J.L. *Jack Lenor Larsen: 30 Years of Creative Textiles* (Jack Lenor Larsen, New York, 1981)

MARTIN, E. and SYDHOFF, B. *Swedish Textile Art* (Liberforlag, Stockholm, 1980)

MUSEUM OF MODERN ART, NEW YORK *Textiles USA* (New York, 1956)

NATIONALMUSEUM, STOCKHOLM *Astrid Sampe – Swedish Industrial Textiles* (Stockholm, 1984)

NOLOT, P., TEYNAC, F., VIVIEN, J. *Wallpaper – A History* (Thames and Hudson, London, 1982)

SCHOESER, M. *Marianne Straub* (Design Council, London, 1984)

Fifties' Furnishing Textiles (Warner and Sons, London, 1985)

Fabrics and Wallpapers – Twentieth Century Design (Bell & Hyman, London, 1986)

WOODS, C. *Sanderson 1860–1985* (Sanderson, London, 1985)

Illustration Acknowledgments

r – right, l – left, a – above, b – below, c – centre

Alan Carter 10 r, 14 a, 20, 24 b, 30 br, 33 br, 34 b, 38 l, 55 a, 58 a, 64, 75 br, 82 bl, 82 br, 89 b, 90 al, 94 l, 95 r, 102 a, 115 b, 116 a, 132, 133, 136, 140 a; Andrew Cox 40 al, 46 br, 49 r, 61, 79 a, 80 bl, 94 r, 95 c, 127 b; Antonia Campi 14 b, 22 a, 53, 54, 113 a; Arflex 93 c; By Courtesy of the Trustees of the British Museum 22 b, 74 al; Cadbury Schweppes Group 30 br; Cannon Hall Museum, Barnsley 18, 75 bl, 131; Cassina s.p.a. 49 c; Christian Dior *Back Cover* (photo: Willy Maywald); City of Bristol Museum and Art Gallery 48 r; Cotton Board 8 l (photo: John French), 29 (photo: David Olins), 48 l (photo: John French), 101 (photo: John French), 119 a (photo: John French), 122 al (photo: David Olins), 122 r (photo: David Olins); Courtesy of the Board of Trustees of the Victoria and Albert Museum 27 bl, 36, 40 l, 41 br, 43 al, 45 bc, 45 br, 60 a, 73, 88 r, 96 bl, 109, 111, 112, 113 b, 125 r, 129, 141, 142, 144, 146 l, 147, 148 r, 150, 151; Courtesy of the British Council 33 al, 56 al; Eduardo Paolozzi 50 l; Gerald Benney 81 b; Gustavsberg Porslin 74 r, 98 ar, 115 a, 116 b; *Harper's Bazaar* 7, 45 ar, 56 ar, 117 (photo: Philip Stearns), 118 l (photo: Lillian Bassman), 118 r (photo: Richard Dormer), 119 b (photo: Richard Dormer), 120 (photo: Louise Dahl-Wolfe), 121 (photo: Richard Dormer); Howard Smith 58 br; *Huddersfield Examiner* 9 a; Iittala–Nuutajärvi Oy 11 a, 25, 27 br, 28 b, 43 bl, 56 br, 57; Jessica Rutherford 33 bl, 127 a; Johannes Hansen 39 r, 106; Kalmar Konstmuseum 98b (photo: Rolf Lind); Knoll International 16, 38 r, 124; Kunstindustrimuseum, Copenhagen 41 rl, 91, 100, 130 a, 145; Leeds City Art Galleries 28 al, 97 a; Leslie Gooday 21, 37 a, 89 al, 92 l; Louis Poulsen & Co. A/S 19, 138; Macmillan Publishing Co. Inc, 13 b; Malcolm Bishop 46 al, 50 c, 52 a; Manchester City Art Galleries 10 l, 32, 42, 43 r, 44, 55 b, 59 a, 65 b, 69 ac, 71 bl, 71 ar, 71 br, 78 b, 83 l, 84 al, 84 r, 86, 87 a, 95 l, 96 al, 96 br, 98 al, 98 cr, 102 b, 103, 108, 110 b, 123, 126, 137, 148; Mr and Mrs W. Treuherz 74 bl, 76, 78 a, 128 l; Oy Arabia AB 17 a, 47 a, 114; Private Collection 34 a, 82 a, 110 a; Robert Welch 139; Rosenthal Archives, Selb/Germany 12, 46 ar; Royal Pavilion, Art Gallery and Museum, Brighton 17 b, 52 b, 60 b, 80 al, 89 ar, 125 l, 140 b; Smålands Museum 57 r, 72 c, 134; St Catherine's College, Oxford 41 a; Statens Kunstmuseer, Stockholm 105; Suomen Lasimuseo 24 a, 75 a, 80 r, 90 br, 105 a; Taideteollisuusmuseo, Helsinki 35, 40 r, 79 b; *The New Yorker* 107; The Tate Gallery 27 a, 30 al, 31, 49 l, 62, 66 l, 68, 85; The Whitworth Art Gallery, University of Manchester 15, 23, 28 ar, 30 ar, 33 ar, 63, 65 a, 66 r, 67, 71 al, 72 r, 77, 83r, 84 bl, 88 l, 90 bl, 97 b, 104, 135, 143, 146 r, 149, *Frontispiece*; The Worshipful Company of Goldsmiths 11 b, 26, 37 b, 47 b, 51 l, 51 r, 70, 81 a; Trustees of the National Museums of Scotland 45 bl, 69 ar, 130 b; Turner Glass Collection, University of Sheffield 72 l (photo: Chris Johnson-Green); Vitra Design Museum, Weil am Rhein, Germany 9 b, 39 l, 50 r, 58 bl, 59 b, 60 c, 93 l, 93 r, 128 r; Warner Fabrics plc 87 b, 99.

Every effort has been made to trace the copyright of the images used in this book. The author apologises for any errors or omissions.

Special thanks to Alan Seabright and Mark Cobley, photographers at Manchester City Art Galleries. The author is particularly indebted to Alan Carter for allowing his collection to be extensively photographed for use in this publication.

Pilkington's

The photography in this book was made possible through the generous sponsorship of Pilkington's Tiles.

Index